Palestinian Literature and Film in Postcolonial Feminist Perspective

ROUTLEDGE RESEARCH IN POSTCOLONIAL LITERATURES

Edited in collaboration with the Centre for Colonial and Postcolonial Studies, University of Kent at Canterbury, this series presents a wide range of research into postcolonial literatures by specialists in the field. Volumes will concentrate on writers and writing originating in previously (or presently) colonized areas, and will include material from non-anglophone as well as anglophone colonies and literatures. Series editors: Donna Landry and Caroline Rooney.

1. *Magical Realism in West African Fiction: Seeing with a Third Eye* by Brenda Cooper
2. *The Postcolonial Jane Austen* edited by You-Me Park and Rajeswari Sunder Rajan
3. *Contemporary Caribbean Women's Poetry: Making Style* by Denisede Caires Narain
4. *African Literature, Animism and Politics* by Caroline Rooney
5. *Caribbean–English Passages: Intertextuality in a Postcolonial Tradition* by Tobias Döring
6. *Islands in History and Representation* edited by Rod Edmond and Vanessa Smith
7. *Civility and Empire: Literature and Culture in British India, 1822–1922* by Anindyo Roy
8. *Women Writing the West Indies, 1804–1939: 'A Hot Place, Belonging To Us'* by Evelyn O'Callaghan
9. *Postcolonial Pacific Writing: Representations of the body* by Michelle Keown
10. *Writing Woman, Writing Place: Contemporary Australian and South African Fiction* by Sue Kossew
11. *Literary Radicalism in India: Gender, Nation and the Transition to Independence* by Priyamvada Gopal
12. *Postcolonial Conrad: Paradoxes of Empire* by Terry Collits
13. *American Pacificism: Oceania in the U.S. Imagination* by Paul Lyons
14. *Decolonizing Culture in the Pacific: Reading History and Trauma in Contemporary Fiction* by Susan Y. Najita
15. *Writing Sri Lanka: Literature, Resistance and the Politics of Place* by Minoli Salgado
16. *Literature of the Indian Diaspora: Theorizing the Diasporic Imaginary* by Vijay Mishra
17. *Secularism in the Postcolonial Indian Novel: National and Cosmopolitan Narratives in English* by Neelam Srivastava
18. *English Writing and India, 1600–1920: Colonizing Aesthetics* by Pramod K. Nayar
19. *Decolonising Gender: Literature, Enlightenment and the Feminine Real* by Caroline Rooney
20. *Postcolonial Theory and Autobiography* by David Huddart
21. *Contemporary Arab Women Writers* by Anastasia Valassopoulos
22. *Postcolonialism, Psychoanalysis and Burton: Power Play of Empire* by Ben Grant
24. *Land and Nationalism in Fictions from Southern Africa* by James Graham
25. *Paradise Discourse, Imperialism, and Globalization: Exploiting Eden* by Sharae Deckard
26. *The Idea of the Antipodes: Place, People, and Voices* by Matthew Boyd Goldie
27. *Feminism, Literature and Rape Narratives: Violence and Violation* edited by Sorcha Gunne and Zoë Brigley Thompson
28. *Locating Transnational Ideals* edited by Walter Goebel and Saskia Schabio
29. *Transnational Negotiations in Caribbean Diasporic Literature: Remitting the Text* by Kezia Page
30. *Representing Mixed Race in Jamaica and England from the Abolition Era to the Present* by Sara Salih
31. *Postcolonial Nostalgias: Writing, Representation and Memory* by Dennis Walder
32. *Publishing the Postcolonial: Anglophone West African and Caribbean Writing in the UK 1948–1968* by Gail Low
33. *Postcolonial Tourism: Literature, Culture, and Environment* by Anthony Carrigan
34. *The Postcolonial City and its Subjects: London, Nairobi, Bombay* by Rashmi Varma
35. *Terrorism and Insurgency in Indian-English Literature: Writing Violence and Empire* by Alex Tickell
36. *The Postcolonial Gramsci* edited by Neelam Srivastava and Baidik Bhattacharya
37. *Postcolonial Audiences: Readers, Viewers and Reception* edited by Bethan Benwell, James Procter and Gemma Robinson

38. *Culture, Diaspora, and Modernity in Muslim Writing*, edited by Rehana Ahmed, Peter Morey, and Amina Yaqin
39. *Edward Said's Translocations: Essays in Secular Criticism*, edited by Tobias Döring and Mark Stein
40. *Postcolonial Memoir in the Middle East: Rethinking the Liminal in Mashriqi Writing* by Norbert Bugeja
41. *Critical Perspectives on Indo-Caribbean Women's Literature* edited by Joy Mahabir and Mariam Pirbhai
42. *Palestinian Literature and Film in Postcolonial Feminist Perspective* by Anna Ball

Related Titles:
Postcolonial Life-Writing: Culture, Politics, and Self-Representation by Bart Moore-Gilbert

Palestinian Literature and Film in Postcolonial Feminist Perspective

Anna Ball

NEW YORK AND LONDON

First published 2012
by Routledge
711 Third Avenue, New York, NY 10017

Simultaneously published in the UK
by Routledge
2 Park Square, Milton Park, Abingdon, Oxon OX14 4RN

Routledge is an imprint of the Taylor & Francis Group, an informa business

© 2012 Taylor & Francis

The right of Anna Ball to be identified as author of this work has been asserted by her in accordance with sections 77 and 78 of the Copyright, Designs and Patents Act 1988.

All rights reserved. No part of this book may be reprinted or reproduced or utilised in any form or by any electronic, mechanical, or other means, now known or hereafter invented, including photocopying and recording, or in any information storage or retrieval system, without permission in writing from the publishers.

Trademark Notice: Product or corporate names may be trademarks or registered trademarks, and are used only for identification and explanation without intent to infringe.

Library of Congress Cataloging-in-Publication Data
Ball, Anna.
 Palestinian literature and film in postcolonial feminist perspective / by Anna Ball.
 p. cm. — (Routledge research in postcolonial literatures ; 42)
 Includes bibliographical references and index.
 1. Arabic literature—Palestine—History and criticism. 2. Arabic literature—20th century—History and criticism. 3. Feminism and literature—Arab countries. 4. Postcolonialism in literature. 5. Motion pictures—Palestine. I. Title.
 PJ8190.P3B35 2012
 892.7'0989274—dc23
 2012010858

ISBN: 978-0-415-88862-2 (hbk)
ISBN: 978-0-203-09866-0 (ebk)

Typeset in Baskerville by IBT Global.

To my parents, who showed me the many freedoms
that can be found through the creative imagination—
and to the authors and filmmakers of Palestine, who
continue to seek their own freedoms through their creativity

Contents

List of Figures		xi
Note on Transliteration		xiii
Acknowledgements		xv
	Introduction: Permission to Re-narrate	1
1	En-gendering Palestine: Narratives of Desire and Dis-Orientation	18
2	Women Writing Resistance: Between Nationalism and Feminism	46
3	Masculinity in Crisis: From Patriarchy to (Post)Colonial Performativity	72
4	Bodies Beyond Boundaries? Transitional Spaces and Liminal Selves	101
5	Imagining the Transnational Feminist Community	131
	Conclusion: Postcolonial Feminist Futures	157
Notes		165
Bibliography		199
Filmography		217
Index		219

Figures

1.1	Sumaya, the *mukhtar's* daughter: a powerful figure of alternative female desires.	40
1.2	Khleifi's gaze turns to the intimate realms of the bridal chamber, where male and female 'scripts' of honour and agency must be privately rewritten.	42
3.1	The deadpan ES (pictured here with his anonymous lover from Ramallah, who he must meet at the checkpoint due to her inability to cross into Jerusalem): a silent witness to the emasculating injustices of the Israeli occupation.	88
3.2	Khaled (left) and Said (right), figures of a close and genuine 'fraternal' friendship.	92
3.3	A haunting presence: Said's mother senses her son, already lost to the subterranean world of self-destruction.	96
4.1	Map of the West Bank Wall, 2006.	104
4.2	Abu Shukri and his son lay an illegal water pipe that will enable them to settle in the barren borderland.	119
4.3	An image of freedom, mobility and connection: an outstretched hand caresses the breeze at the start of the film crew's journey.	124
5.1	Palimpsestic layers of image, text and voice create a portrait of mother-daughter intimacy that transcends diasporic distance.	139
5.2	Children from the Dheisha refugee camp in the West Bank and from Shatila refugee camp in Beirut come to meet and hold hands at the Israeli-Lebanese border.	142

Note On Transliteration

This book uses a simplified system of transliteration for Arabic terms that denotes *'ayn* with an open inverted comma ('), and *hamza* and *alif* with a closed inverted comma ('). Proper names and place names are spelled as they are commonly found in English language publications. With the exception of instances where it has been appropriate to transliterate specific words according to a particular regional dialect, the transliteration adheres to Modern Standard Arabic.

Acknowledgements

This book would not have been possible without the many people who have educated and supported me along the way. I am especially grateful to Dr Anastasia Valassopoulos, whose passion for and knowledge of her field has inspired and guided me since my PhD studies. A special thank you to Dr Dalia Said Mostafa for her patient and careful guidance on Arabic terminology and transliteration. Any errors of course remain my own. I am extremely grateful to the wonderful team of academics who educated me during my PhD at the University of Manchester, including Professor Laura Doan, Dr Anke Bernau and Professor Hoda Elsadda. Many thanks, also, to Professor Caroline Rooney for her insightful engagement with my research, and for sparking the idea for this book during my Viva. At Nottingham Trent University, I am particularly grateful to Professor Patrick Williams for his expert guidance and generous support, and to all at the Centre for Colonial and Postcolonial Studies at NTU. In Nottingham, a special thank you to Catherine Clay, Sarah Jackson and Bethan Stevens for their wonderful friendship and support. In Manchester and Sheffield, thank you to Becky, Alicia and Rizwana for their patience, good humour and sense of perspective on all things academic and otherwise.

One of the many pleasures of working on this book has been the opportunity to communicate with some of the authors and filmmakers discussed within it, and in every case, they have responded generously and graciously. I am extremely grateful to Michel Khleifi and Sindibad Films for their kind permission to reproduce film stills from *Wedding in Galilee*; to Mona Hatoum and the White Cube Gallery for permission to reproduce a still from *Measures of Distance*; to Elia Suleiman for his permission to reproduce a still from *Divine Intervention*; to Annemarie Jacir for her permission to reproduce a still from *like twenty impossibles*; and to Bero Beyer at Augustus Film for his permission to reproduce stills from *Paradise Now*. I am also very grateful to Arab Film Distribution for their permission to reproduce a still from Masri's *Frontiers of Dreams and Fears*; to Axiom Films for their permission to reproduce a still from *'Atash*; and to the Palestinian Society for the Study of

International Affairs (PASSIA) for their permission to reproduce the map of 'The West Bank Wall'.

Many thanks to Salma Khadra Jayyusi and Columbia University Press, for granting me permission to reproduce lines from 'Abdallah Radwan's poem 'You Are Everything', Laila 'Allush's 'The Path of Affection', Rashid Husain's 'First', Tawfiq Zayyad's 'What Next?' and Zayyad's 'Here We Shall Stay', from *An Anthology of Modern Palestinian Literature*, ed. Salma Khadra Jayyusi, copyright © 1992 Columbia University Press. Thank you to Bloodaxe Books for granting me permission to reproduce lines from Mahmoud Darwish's 'A State of Siege', as it appears in their 2007 edition of *The Butterfly's Burden*, and from Naomi Shihab Nye's 'Gate 4-A', as it appears in *Tender Spot*. Poetry from *19 Varieties of Gazelle* (text copyright © 2002 Naomi Shihab Nye) is used by permission of HarperCollins Publishers. Thank you to The Permissions Company, Inc., on behalf of BOA Editions, Ltd., www.boaeditions.org., for permission to print material from *Red Suitcase* (© 1994 Naomi Shihab Nye) and *You & Yours* (© 2005 Naomi Shihab Nye). Last but by no means least, a huge thank you to Suheir Hammad, to Zohra Saed at UpSet Press and to CypherBooks for their very kind permission to reproduce lines from *Born Palestinian, Born Black* and *ZaatarDiva* respectively.

Finally, thank you to my parents and brother for their endless support and inspiration—and to my partner, Lee Johnathan Garland, for his unwavering patience, belief and love. I could not have written this book without them.

Introduction
Permission to Re-narrate

'Answer, if you hear the words under the words–
otherwise it is just a world with a lot of rough edges,
difficult to get through, and our pockets
full of stones.'
—Naomi Shihab Nye, 'The Words under the Words'[1]

All narratives take the reader on a journey of one kind or another, but the particular narrative journey embarked upon within this book—through a 'postcolonial feminist' account of Palestinian literature and film—is an attempt to chart a new discursive route into a particularly fraught territory: that of Palestinian self-representation. The necessity of undertaking such a journey emerges from the peculiar sense in which critical inquiry into Palestinian culture, particularly in the 'Western' academy,[2] is currently subject to a number of discursive limits that, just like the roadblocks and checkpoints that regulate Palestinian territory itself, have tended to restrict the narratives that can be produced about Palestine, and the disciplines in which they can be studied. Academics and creative practitioners alike have often found themselves grappling with restrictions on what the Palestinian American critic Edward Said termed 'permission to narrate' when it comes to the task of formulating critical or imaginative accounts of Palestinian history, culture and identity.[3] Small wonder, then, that many scholars, even in disciplines of apparent relevance to Palestinian culture—most notably, postcolonial studies—have chosen not just to tread carefully, but often to steer well clear of such territory altogether (of which, more later). This book, though, does not seek permission to construct a single 'acceptable' or 'official' narrative of Palestinian identity. Instead, it explores the compelling yet largely unacknowledged narratives of gender-consciousness that emerge from Palestinian literature and film when approached from a postcolonial feminist perspective. In doing so, it seeks to *re*-narrate Palestinian culture and identity in a way that reveals its multi-layered and polyphonic qualities, and establishes new critical locations from which creative, cross-cultural, interdisciplinary dialogues might emerge. It therefore performs what the Palestinian American poet Naomi Shihab Nye describes (in the lines taken as the epigraph to this introduction) as listening to 'the words under the words': reading in a way that is attentive to the alternative voices, ideas and stories too often

obscured from view by the reductive surface narratives of stereotype and polemic that have tended to dominate the representation of Palestine.[4] Why, though, should these powerful alternative narratives appear when examined from a 'postcolonial feminist perspective'?

The terms 'postcolonialism', 'feminism' and 'Palestine' do not tend to feature together in critical literature very often, but as it will become clear over the course of this book, they in fact bear ready and productive alliances. A 'postcolonial feminist perspective' enables the critic to interpret and communicate variously defined feminist goals and gendered experiences in a way that is resistant to the hegemonic assumptions of Western feminisms, while it also acknowledges that the task of creating liberating alternatives to colonial power structures must necessarily entail a feminist attentiveness to the forms of inequality and oppression that circulate around gendered experience and identification. A 'postcolonial feminist perspective' therefore combines the insights of both postcolonialism(s) and feminism(s) in its recognition of the need for just and creative alternatives to the intersecting power structures of colonial and patriarchal oppression. It is from this distinctive perspective that Palestine comes into focus in an interesting way—for while Palestine itself can be read as a nation in urgent need of liberating alternatives to the injustices of Israeli occupation, a significant body of Palestinian creative expression also demonstrates a desire to interrogate both colonial and gendered power structures in order to imagine emancipating alternatives to its current realities. From this perspective, the Palestinian literature and film examined within this book not only *invites* a postcolonial feminist approach, but also engages in something akin to this process for itself.

There is also a deeper shared commitment that unites postcolonial, feminist and Palestinian creative perspectives, though, and this is their dedication to the recovery of narratives and voices that have been silenced or marginalised by more dominant discourses. While several critics have argued that historical narratives of Palestinian experience have frequently been suppressed in favour of the accounts presented by Israel,[5] Nurith Gertz and George Khleifi have noted that Palestinian creative practitioners have sought to counter this narrative suppression by formulating their own multi-layered accounts of Palestinian experience and identity through the mediums of film, literature, art and criticism.[6] While the subject matter of such works may not always be explicitly political (though the struggle for Palestinian self-determination often emerges as a major theme), the very act of creative expression can be read as politically potent when viewed against the backdrop of narrative silencing and erasure that has traditionally thwarted Palestinian self-representation, both political and creative. Against this backdrop, it becomes possible to appreciate the political as well as cultural significance of projects such as 'Dreams of a Nation', co-founded by the Palestinian filmmaker Annemarie Jacir and the scholar Hamid Dabashi, which aims to create an archive of Palestinian cinema and connected resources to replace that

which was lost or destroyed during the Israeli Siege of Beirut in 1982;[7] or of the annual Palestine Festival of Literature, 'PalFest', founded by the author Ahdaf Soueif, which brings authors from around the world to audiences in Palestine who would otherwise be unable to access such cultural material due to the restrictions on travel for Palestinians.[8] Projects such as these not only testify to the significance of cultural expression as a recognition of the Palestinian people's humanity, but also nurture and preserve the narratives of Palestinians themselves. Collectively, they reveal that cultural expression is not a luxury but an essential need for Palestinians, akin to what the great anti-colonialist Frantz Fanon termed a 'literature of combat': a body of creative work that operates as a tool of resistance through its ability to voice suppressed narratives and mobilise a collective political consciousness through its construction of a 'national culture'.[9]

Fanon's ready translation into the Palestinian context (which was also recognised by the early Palestine Liberation Organization or PLO, which was greatly influenced by other elements of Fanon's writings[10]) gestures towards some of the broader alliances to be found between Palestinian narratives and postcolonial discourse. As a field that emerged out of the desires of colonised peoples to locate alternatives to the power structures of colonialism and imperialism, a key premise of postcolonialism has been the construction of a discursive space that resists hegemonic colonial narratives by shifting the marginalised voices of the colonised from the peripheries to the centre of cultural consciousness. It is therefore a source of some irony that Palestine itself currently remains largely marginalised within postcolonial studies, for reasons that I shall explore in a moment. Yet the narratives of resistance, national identity and cultural experience that surface through postcolonial discourse also bear their own sites of silencing, and it is these to which feminist scholars may seek to draw attention by locating the alternative expressions of history, experience and imagination that emerge from women or others who are excluded from the dominant patriarchal narrative (whether authored by the coloniser, or by those within the colonised nation). Both postcolonialism and feminism, then, involve an identification with the margins; but a distinctively postcolonial feminist perspective entails a multi-directional act of 'writing back' to not one but many centres of power—including those sites of cultural privilege and silencing that may exist within Western feminist discourses, or indeed within postcolonialism. Despite their shared ethos, though, these discourses also generate certain forms of friction when examined alongside one another, and this means that the terrain traversed in this book is by no means uncontested, nor unproblematic. In order to prepare the ground for the specific narrative journey that I undertake over the course of the next five chapters, it is necessary to map out the disjunctions as well as connections between these fields that must be negotiated en route: disjunctions that relate specifically to the place of Palestine in postcolonial studies, to the nature of feminist discourse in relation to Palestine and to the comparative approach

adopted in this book, which creates obstacles and possibilities of a different kind, relating particularly to questions of form and language—and indeed, to my own authorial subject-position.

Connections and Disjunctions (1): Palestine and the Postcolonial

For all of the connections between the Palestinian narrative and the ethos of postcolonial studies, it remains the case that—with the exception of a handful of scholars including Edward Said, Ella Shohat, Joseph Massad, Smadar Lavie, Patrick Williams and Anna Bernard—Palestine remains largely 'off-limits' in the realm of the postcolonial. Is this, as Williams suggests, 'a triumph of the Israeli propaganda machine', or might there be other reasons for this puzzling silence on what Williams describes as 'the worst example of colonialism in the modern world'?[11] This silence, it seems, is not simply a product of the suppression of the Palestinian narrative, but of the contested nature of the terms 'colonial' and 'postcolonial' when it comes to speaking of Palestine.

While Palestinian scholars have long advocated the colonial paradigm as a means to understand their relationship to Israel,[12] it is only recently that this concept has received acknowledgement in other arenas—including, for example, among Israeli 'new historians' such as Gershon Shafir and Ilan Pappé.[13] According to the colonial paradigm, Palestine can be understood as the victim of colonisation at a number of moments in its history, but while it was the object of conquest by empires ranging from the Persian to the Greek, and from the Roman to the Ottoman in eras past,[14] its modern colonial condition can be said to begin with the establishment of the British mandate for Palestine in 1922 (the culmination of several years of British presence in the region), which followed the fall of the Ottoman Empire to European powers at the end of the First World War, and its subsequent partition into territories administered by Britain and France. During its political and administrative control of the region, Britain ceded to growing Zionist pressure and established plans for a 'Jewish national home' within Palestine, overriding the promises it had made to the Arab population for an independent Arab state.[15] These plans were put into action via a process of partition approved by the UN in 1947, which sought to divide mandated Palestine into separate Israeli and Palestinian states—a move against which Palestinian Arabs fought but ultimately lost. With the foundation of the State of Israel in 1948, Zionism, the Jewish political movement that underpinned the foundation of the State of Israel, can be interpreted as a new form of colonialism that replaced the British mandate. As several critics have been keen to point out, not only did Zionist ideology appear to be heavily influenced by models of European colonialism,[16] but the Zionist establishment of a Jewish homeland in Palestine also bore a striking resemblance to the 'settler colonies' founded in North and South America, Australia, South Africa and on the Indian subcontinent,[17]

which aimed to exploit the land of the colonised population and ultimately to erase (or enforce apartheid upon) the native population.[18] Israel subsequently occupied the remaining territories of Palestine that it did not seize in 1948 during the Six-Day War or *Naksa* (the 'setback') of 1967, and this occupation can be understood as colonial in nature not only due to its stringent administrative control of the population and appropriation of resources within these territories,[19] but also due to the fact that Israel continues to receive heavy financial and political support from the U.S. government, locating it as one of several territories within the Middle East subject to what critics such as Rashid Khalidi and Derek Gregory view as a manifestation of contemporary Western imperialism in what they term the 'colonial present'.[20] Consequently, the colonial paradigm reveals Palestine as subject to intersecting colonial processes at the hands of the British, Zionist and North American political powers. Indeed, as Massad notes, 'to call it *Palestine* [not Israel, or the Palestinian/Occupied/Disputed Territories] is to refer to it as a colonized space in both the pre-1948 and post-1948 periods and to signal its continued appellation as such for a postcolonial period still to come'.[21]

Yet this thesis has been hotly contested from a number of angles, particularly by Israeli scholars who have tended to treat the description of Zionism as a form of 'colonialism' as strictly taboo. Certainly, it is necessary to recognise that Israeli colonialism bears many 'peculiarities'.[22] Crucially, as Ella Shohat puts it, 'unlike colonialism, Zionism . . . constituted a response to millennial oppression'[23] and emerged as the result of a stateless people's victimisation, not of another nation's desire for territorial expansion; hence its description among some Israeli critics as 'colonization without colonialism', which emphasises the process of territorial settlement over other colonial concerns such as exploitation or dominance of the native peoples.[24] Indeed, this backdrop of 'millennial oppression' seems to distinguish Zionism from other forms of colonialism in the minds of many scholars, who shy away from criticism of Israel out of a misguided sense that to defend the Palestinian right to self-determination and thus to question the current basis of the Israeli State might be taken as evidence of 'anti-Semitism': a gross contortion of the commitments to ethics and human rights that underpin many people's support of the Palestinian cause (which are, ironically, those very same commitments that demand rigorous opposition to anti-Semitism).

This paradoxical stance was famously adopted by that strident supporter of the Algerian anti-colonial struggle, Jean-Paul Sartre, who became the subject of what Benita Parry describes as 'a disappointed and just account [by Edward Said] of a silence that can be explained, if not justified, by Sartre's anguish over the fate of the Jews in Europe'.[25] Aside from the ethical complexities that accompany the discussion of Zionism, though, the absence of a 'mother country' in the Zionist settlement of Palestine constitutes a further 'contradistinction to the classic colonial paradigm'.[26] From the Zionist perspective, the act of colonising Palestine could be viewed as a *return* to a homeland and as the ending of the Jewish people's diasporic existence, rather than as

an act that created around 750,000 Palestinian refugees in 1948 alone.[27] It is this very different vantage-point on Zionism which renders its relationship to 'colonialism' so complex for many critics; for while some dismiss any relationship between Zionism and colonial or postcolonial discourse, others in fact see Zionism itself as discourse of emancipation that liberated the Jewish people from their diasporic existence and broke free from the constraints of British-mandated Palestine: an administration that was viewed as oppressive by some Jewish communities who contested the limits placed by the mandate on Jewish immigration, making it the target of Jewish resistance movements in the 1940s.[28] Some scholars therefore argue that Israel can be viewed as a postcolonial nation in its own right.[29] Indeed, as Massad points out, 'socialist variants' of Zionism presented themselves as an alternative, even an affront, to a capitalist and imperialist world order: a truly 'postcolonial' model of nationhood.[30] Thus the various interpretations of the relationship between Israel/Palestine and colonialism renders its classification complex and reveals a 'synchronicity of the colonial and the postcolonial' which might most aptly be described through Massad's deliberately paradoxical term, the '"post-colonial" colony'.[31] It is for this reason that I sometimes employ the term '(post)colonial' (rather than simply 'colonial', 'post-colonial' or 'postcolonial') within this book, in contexts where I wish to denote something of the ambivalent synchronicity of Palestine's colonial conditions and postcolonial desires. Why, though, have the majority of postcolonialists failed to engage with this challenging yet rich and vitally important ground for debate? The answer might lie not only with Palestine, but with the dynamics of postcolonial studies itself.

Despite Donna Robinson Divine's claims in *Postcolonial Theory and the Arab-Israel Conflict* that Edward Said's prominent legacy in postcolonial studies 'demands that postcolonialism champion the Palestinian cause',[32] evidence of a sustained postcolonial defence (or indeed thorough exploration) of Palestine is in fact somewhat lacking. As Anna Bernard points out in her own study of the relationship between Palestine and the postcolonial, Palestine tends to figure only symbolically on the peripheries of postcolonial discourse, the Palestinian appearing either as a figure of 'abject' homelessness, as in Bhabha; or as an exception to the largely celebratory poststructuralist models of diaspora as indicative of a liberated, 'borderless world' (an extremely troubling idea for Palestinians, as revealed in Chapter 4 of this book).[33] Ironically, it is limited and restrictive figurations of Palestine such as these that have fed a more general resistance to what has sometimes been read as a 'polemical' treatment of Palestine among postcolonialists,[34] who fail, according to Philip Carl Salzman, to engage in critique of the Palestinian's status as 'other' (which might, among other things, entail the destabilisation of images of Palestinians as either simply 'powerless victims' or 'resistance fighters').[35] Over the course of this work, I hope to demonstrate that there is ample room for postcolonial analysis to move beyond this limited set of tropes by inciting a range of discourses of immense relevance to Palestine, which establish

Introduction 7

diverse and self-reflexive reassessments of Palestinian culture and identity: from Fanonian discourses of resistance to those of postcolonial performativity; from theories of nationhood and nationalism to those of diasporic 'transnations' and 'borderlands'. One of the many advantages of widening the scope of study in this way is that it may also reveal some important challenges to the pre-conceptions of postcolonial discourse itself—relating, for example, to the assumptions of 'poststructuralist' postcolonialisms, which, as Bernard notes, are radically contested when translated into a Palestinian context;[36] or to 'unfashionable' models of nationhood and anti- or neo-coloniality, which remain, according to Shohat, concepts of pressing importance within Palestine's landscape of contemporary colonialism.[37] Indeed, Palestine arguably presents an important affront to the limitations of what Anne McClintock describes as the implied temporal linearity present in the term 'post-colonialism', which renders it 'prematurely celebratory' within a world still very much confronting colonial phenomena.[38] This does not have to render postcolonialism (particularly not in its unhyphenated form, which has come to denote a conceptual movement beyond straightforwardly temporal ways of interpreting the term) an historically inappropriate discourse for the study of Palestine, however. Rather, it demands a renewal of the truly radical potential of the discourse, by viewing the 'postcolonial' as 'not in any sense an achieved condition, but . . . an anticipatory discourse, looking forward to a better and as yet unrealized world', as Williams puts it.[39]

Palestine also presents an excellent opportunity to address a concern shared by both Anne McClintock and Ella Shohat: that, as McClintock puts it, 'the singular category of the "post-colonial" may license too readily a panoptic tendency to view the globe within generic abstractions voided of political nuance'.[40] Similarly, Shohat warns that 'the concept of the "postcolonial" must be interrogated and contextualized historically, geopolitically and culturally'; the task in hand, therefore, is to locate a 'flexible yet critical usage that can [not only identify] historical and geographical contradictions and differences, but also [reaffirm] historical and geographical links, structural analogies, and openings for agency and resistance'.[41] Nuanced, sensitive employment of postcolonial discourse therefore presents a vital opportunity to reveal the simultaneous disjunctions and connections between Palestine and other colonial (or indeed postcolonial) contexts. Yet there is a further way in which I seek to open up, renew and diversify postcolonial conceptualisations of Palestine within this book—and that is by employing a gender-conscious framework of reference.

Connections and Disjunctions (2): Palestine and Postcolonial Feminism

Why might it be so important to inflect the postcolonial analyses performed over the course of this work with a feminist commitment to

gender-consciousness? The answer lies in the mutually illuminating qualities of 'postcolonialism' and 'feminism' when they operate alongside one another. In 'Notes on the "Post-colonial"', Shohat writes that one of the implications of the term 'postcolonial' is a shift beyond the binary power structures of the colonial relationship, towards what she terms 'decentred multiplicities of power relations' within and beyond the nation itself—notably among, for example, 'colonized men and women'.[42] As such, postcolonial discourse reveals important sites of gendered struggle and self-representation, for as Miriam Cooke notes in the broader context of the Middle East, women have 'written themselves into postcolonial struggles' in a variety of ways, sometimes through self-identified feminist struggle but also, at other times, through nationalist activity, engagement with religious discourse or other forms of cultural identification, and the very act of 'naming their participation in their people's conflicts' constitutes 'a form of combat' in its own right.[43] Indeed, Lindsey Moore extends this argument to suggest that the 'productive crisis' that accompanies the very term 'postcolonial' (in its desire to rupture temporal, ideological and power-based structures) presents a challenging but potentially empowering alternative to the often limiting narrative of 'national' experience as the primary construct through which gendered narratives have often had to be mediated.[44] As such, the use of postcolonial discourse may in fact enable previously unacknowledged narratives of gendered experience and imagination to emerge.

Turning to the variety of critical tools presented under the broad banner of 'feminism' also offers much to postcolonial discourse, however. As Reina Lewis and Sara Mills argue in their introduction to *Feminist Postcolonial Theory: A Reader*, feminist enquiry establishes alternative ways of 'mapping' postcolonialism by revealing the multi-directional relationships between power, equality, identity and struggle that operate around a multiplicity of subject-positions. A gender-conscious focus may also serve to establish alternative narratives of postcolonial experience, authored from the perspectives of those who are often 'written out' of dominant, often male-authored narratives (not only of anti-colonial struggle, but also of postcolonial theory itself).[45] Consequently, feminist-informed analysis might encourage postcolonialists to reassess and extend their understanding of core postcolonial commitments, such as the nature of 'resistance', 'oppression' or 'liberation'. Thus a 'postcolonial feminist' framework enacts a two-way critique, serving both to 'racialize [read also 'contextualise', 'nationalise'] mainstream feminist theory and to insert feminist concerns into conceptualizations of colonialism and postcolonialism'.[46]

These productive alliances are all the more important to bear in mind when translating postcolonial feminist insights into a Palestinian context, because they may help to overcome what Anastasia Valassopoulos describes as the many 'problematics' that have tended to accompany the study of feminist issues in the Arab world, particularly when advanced from within the

Western academy.⁴⁷ Central among such 'problematics' are the apparently 'universalising' assumptions of some Western feminist theory, and indeed the cultural associations borne by feminism in the Arab world. The writer and critic Audre Lorde expresses the first of these concerns through her identification of what she terms 'unthinking racism' in the views of some Western feminists, who assume their cultural perspectives to be shared universally and so present their discourse as one of benevolent redemption for those of cultures less 'fortunate' (here, we might instead use the term less powerful) than their own. This kind of stance reproduces a binarised and hierarchical set of power relations suspiciously similar to 'paternalistic' formulations of colonialism, while failing to consider questions of cultural difference.⁴⁸ It is within this context that feminism has sometimes been regarded as an attempt to import Western values and to further Western cultural influence by certain social sectors (particularly nationalists resistant to Western colonial intervention) within the Arab world (a view offered up for debate in Chapter 2 of this book). This has, in turn, led to a level of ambivalence in the use of the term 'feminism' within an Arab and indeed Palestinian context. As Badran and Cooke note in the introduction to their remarkable collection of Arab feminist writing, *Opening the Gates*, there was for a long time no unequivocal term for 'feminism' in Arabic, the nearest equivalent being *nisai*: a term which can mean either 'feminist' or 'feminine/womanly', depending on context and interpretation,⁴⁹ though more recently, the term *al-nasawiyya* has entered into common usage as an equivalent of the term 'feminism'. In a specifically Palestinian context, meanwhile, there is evidence that some apparently 'feminist' organisations may resist the use of the term 'feminism' precisely because they feel it may limit receptiveness to their work.⁵⁰ As Rita Giacaman, a Palestinian woman's health scholar, states in interview:

> We [at Women's Affairs, a resource and research centre] are against the use of the word 'feminist' precisely because of the western connotations it harbours. Look, we are trying to build a movement which all Palestinian women feel is habitable ... If we are going to frighten off a single woman because of the word, then it is better to ditch the word. So instead of calling our programme a feminist agenda, we'll call it an agenda for women ... It is how we agree and define the agenda that is important, not which label we pin to it.⁵¹

Here, Giacaman paradoxically reveals that despite a technical resistance to the *term* 'feminism' due to its Western connotations, what might be described as a feminist commitment to advancing women's well-being, equality, representation and inclusion is well and flourishing. Indeed, Giacaman herself states that within her organization, 'we have a very strong feminist ideology—*Palestinian* feminist, not Western feminist'.⁵² Over the course of the following chapters, I hope it will become evident that one of the most convincing reasons for a

postcolonial feminist approach to Palestinian culture is that gendered concerns are a prominent feature of Palestinian cultural expression, and indeed (post)colonial experience, whether they are labelled as 'feminist' or not.

While my use of the term 'feminism' is founded in a basic commitment to equality of rights, opportunity and representation for men and women, and in a resistance to oppression on any grounds, including those of sex, gender or sexuality, it is important to acknowledge that the term can retain a level of fluidity and multiplicity which enables it to translate across cultural perspectives and experiences. Indeed, it is the postcolonial feminist Chandra Talpade Mohanty who reminds us that 'Western feminism' should no more be viewed as a 'monolith' than should all 'Third World women': feminisms are multiple, contingent and, like gender itself, constructed in relation to a variety of social and ideological circumstances.[53] For Valassopoulos, it is precisely this multiplicity of the term that enables a productive process of what she describes as 'feminist postcolonial cultural translation' to take place at the various '"locations" of encounter' between different feminist and cultural perspectives.[54] This kind of self-reflexive, multi-directional enquiry transcends both universalism and a limiting 'cultural relativism' that views cultural difference as an impassable boundary,[55] and it informs the approach within this book, which similarly seeks to acknowledge both the connections and disjunctions between postcolonial feminist theories and Palestinian creative explorations of gender. Despite the apparent singularity of the 'postcolonial feminist perspective' that appears in the title to this book, then, that 'perspective' should be understood as a constantly shifting line of sight that examines its subject matter from a plurality of angles, while also, at times, seeking to turn that gaze back on itself. It is not only Palestinian cultural expression that appears in a different light when examined from a postcolonial feminist perspective, then; what constitutes the 'postcolonial feminist' is also placed under scrutiny.

The 'feminist postcolonial translations' performed over the next five chapters are facilitated by a range of critical tools that include the work of postcolonial feminist theorists such as Chandra Talpade Mohanty, Gloria Anzaldúa and Sara Ahmed; of less traditionally gender-conscious works by postcolonialists such as Edward Said, Frantz Fanon and Homi Bhabha; and of feminist work not often encountered in a postcolonial context, such as that of Judith Butler. Many of these theoretical tools have not previously been applied to a Palestinian cultural context, but they circulate at a transnational level through the broad reach of postcolonial feminist studies, and my use of them operates according to Said's concept of 'travelling theory', through which he argues that even though some theoretical concepts may fail to translate fully across cultural contexts, the very act of attempting such translations is transformational in its own right as it may reveal crucial insights 'about theory itself—its limits, its possibilities, its inherent problems . . . the

relationship between theory and criticism . . . and society and culture'.[56] The postcolonial feminist perspective of this text is also strongly indebted to the significant body of work that has emerged from literary, cultural and sociological scholars who examine issues of gender specifically within a Middle Eastern or Arab cultural context, including Miriam Cooke, Evelyne Accad, Fedwa Malti-Douglas, Fatima Mernissi and Leila Ahmed.[57] Scholars such as these present vital alternatives to Western feminist interpretations of gender discourses in the Middle East and in Arab culture, and their insights have been employed in highly productive ways by an exciting new wave of scholarship that approaches cultural expression by Arab women from what might be termed a postcolonial feminist perspective. Important examples of such work include the edited collection, *Intersections: Gender, Nation, and Community in Arab Women's Novels*, and recent texts such as Valassopoulos' *Contemporary Arab Women Writers* and Lindsey Moore's *Arab, Muslim, Woman*.[58] While this book is inspired by such critical approaches, it differs from them in two important respects. Firstly, it adopts a feminist approach that views texts by both men and women as important subjects of feminist analysis, and as capable of gender-conscious concerns. Secondly, it hones the remit of its study down from the traditionally transnational scope of such works to a nationally specific focus on Palestinian creative expression. These shifts in focus strike me as essential because while Palestinian creative expression certainly resonates with broader understandings of Arab cultural identity at a number of levels, it also emerges from an historical and political context that sets it apart from any other cultural context in the Arab world, and as such, presents a highly distinctive site of (post)colonial analysis. It is my belief that the tendency towards transnational studies of Arab creative expression has at least partly obscured the very specific trajectory of gender-conscious expression under construction in Palestinian literature and film; a trajectory that only becomes wholly apparent when texts by both men and women are examined alongside one another, and which reveals this dialogue as integral to Palestine's anti-colonial struggle. Not only does this act of refocusing reveal a very different version of Palestine's 'national narrative', but it also establishes a startling portrait of the extreme self-reflexivity, complexity and creativity of Palestinians' self-image—an image in stark defiance of the reductive tropes that have often been used to characterise Palestinians.

The most important impetus for adopting a postcolonial feminist perspective therefore lies with the literary and filmic texts themselves, which establish many of the critical trajectories that I pursue further within the book. This, then, is the multi-directional, much-disputed critical and theoretical territory that I traverse, in order to establish an alternative polyphonic narrative of Palestinian cultural identity, experience and imagination. Yet there is one final set of dynamics to this critical territory—and this relates to the textual politics of comparative study.

Palestinian Literature and Film: A Comparative Approach

The approach adopted within this book is comparative in two ways: firstly, it deals with texts originally written in a variety of languages, and from a variety of cultural contexts; and secondly, it engages in analysis of both literary and filmic work. While there is much to be gained through this comparative approach, it is also important to demarcate the inevitable limits of this kind of project, and the first such limit emerges in relation to the scope of analysis. The creative texts examined within this book comprise but a small selection of the vast body of literary and filmic work that has been produced by Palestinian authors and filmmakers living within either pre-1948 or post-1948 Palestine and its substantial diaspora.[59] Given my preoccupation with the dynamics of Palestine's contemporary colonial condition, all of the texts examined in this book were created either during or after the British mandate, at a wide range of points in Palestine's history—from poetry produced shortly before and after the *Nakba* of 1948,[60] to fiction of the first and second *Intifadas*,[61] to films directed from a number of diasporic subject-positions within the last few years—in order to indicate the many formulations of (post)coloniality and feminism that emerge out of these different historical moments and geographical locations. This book must not, however, be read as an historical or geographical survey of literature and film: such a project is well beyond the scope of the present study. Instead, the selection of texts has been driven by their relevance to the key concepts at stake within this particular study: postcolonialism and gender-consciousness. A further consideration has been my desire to balance rereadings of seminal texts by some of the canonical authors and filmmakers in the field—such as Fadwa Tuqan and Michel Khleifi—with work by more recent arrivals in the field set to make important contributions to the debate—such as, for example, Annemarie Jacir and Suheir Hammad. I very much hope that the selective textual engagement undertaken within this book will pave the way for many future studies of a wider range of work.

There is a further limitation on the texts open for consideration within this study, though—and that limitation relates to language. As a scholar working within the interdisciplinary and comparative but primarily Anglophone fields of postcolonial and gender studies, my choice of texts has been limited to those available either in English translation, or with English subtitles. The necessity of this is partly due to my own limitations: though a student of Arabic for many years, my interest in Palestinian creative expression stems largely from sources written in English, which remains the most accessible language to me, and to the many other scholars working in the primarily Anglophone fields of comparative literary, cultural, postcolonial and gender studies in the UK.[62] The range and quality of texts available in translation, however, also convince me of the tremendous untapped potential for the study of Palestine beyond the realms of Arabic language and Middle Eastern

studies courses. There are undeniable limitations related to the use of texts in translation—not least, the loss of literary devices dependent on the phonetic qualities of language, the potential for the loss of cultural references and the possibility of flawed, partial or incorrect translation, all of which the scholar must remain conscious, and indeed in my textual analyses, I exercise a necessary caution when it comes to making linguistically based assertions about matters of word choice or literary device. Despite this significant limitation, though, I remain convinced that there is also much to be gained through engagement with texts that would otherwise remain entirely inaccessible to an audience illiterate in Arabic. Indeed, according to Waïl S. Hassan, working with texts in translation may even prove an enriching experience for those proficient in the original language, as it may invite them to perceive the text 'less in terms of equivalence than of negotiation, wandering (*erre*) or play' in a way that makes them attentive to the instabilities of meaning and alternative interpretations present within it.[63] While this book is aimed primarily at students and scholars within Anglophone fields of study, those who work with Palestinian texts in their original Arabic may also therefore find that new possibilities arise from studying familiar texts in an unfamiliar language (both literal and critical).

For all of its problems, then, working with texts in translation is both possible and at some levels productive, and here, I turn to the model of comparative literary studies as a well-established field in which precisely this kind of cross-cultural, interdisciplinary scholarship takes place. While some have warned that reliance upon texts in English translation may enforce the Anglophone academy as a site of centralised, dominant authority to which other discourses must adapt,[64] others such as Hassan have argued that turning to translated Arabic literature might in fact perform a vitally important destabilisation of the Anglophone tendencies of the postcolonial academy. In his article 'Postcolonial Theory and Modern Arabic Literature: Horizons of Application', Hassan offers a powerful rationale for the interdisciplinary study of postcolonial and Arabic theory and literature, even in translation:

> [The] emergent canon of postcolonial-literature-as-world-literature privileges texts written in English at the expense of enormously varied literatures written in other, especially non-European languages [. . .] The current impasse in postcolonial studies may therefore be overcome by opening the field to comparative literary studies and to comparative critical methodologies that rigorously interrogate the limits of postcolonial theory's founding discourses, from the multiple perspectives of Arabic, African, and Asian philosophies, realities, cultural worldviews and cultural memories.[65]

While my interrogation of postcolonial theory itself may not be as far-reaching nor as multi-directional as Hassan indicates here, the exploration of literary

and filmic sources originally in Arabic, and of critical material drawn from scholars of Palestinian history, politics and culture such as Rashid Khalidi, Hisham Sharabi or Faisal Darraj, begins to perform the refraction of the 'postcolonial canon' that Hassan finds so necessary.[66] The comparative study of Palestinian literature and film is also facilitated by the conscious efforts of a number of scholars and practitioners dedicated to making a range of Palestinian literature and film readily available to an Anglophone audience. The renowned poet and literary scholar, Salma Khadra Jayyusi, has made a major contribution through the publication of her *Anthology of Modern Palestinian Literature*: a collection of poetry, short stories, extracts of fiction and criticism in English translation by authors writing over the course of the twentieth century.[67] Poetry by Palestinian authors features in anthologies of Arabic poetry in English translation such as Nathalie Handal's *The Poetry of Arab Women*, while a number of other anthologies dedicated specifically to Palestinian poetry or short stories also provide useful resources.[68] In recent years, organisations such as the women's filmmaking NGO 'Shashat' have consciously sought to promote access to Palestinian cinema (including within Palestine itself, where access can often be limited due to the restrictions of the Israeli occupation). In the UK, the annual London Palestinian Film Festival, supported by the Palestine Film Foundation, provides ready access to releases by established and emergent filmmakers. Production companies such as Sindibad Films and distributors such as Arab Film Distribution have also served to increase the circulation of Palestinian cinema to international audiences. A number of critical works that engage in Anglophone discussions of either literature or film have also begun to emerge, and between them, they facilitate comparative literary and filmic discussion. Here, Hamid Dabashi's edited collection, *Dreams of a Nation*, constitutes a seminal contribution to the study of Palestinian cinema, as does George Khleifi and Nurith Gertz's *Palestinian Cinema: Landscape, Trauma and Memory*.[69] Literary studies include edited collections such as Kamal Abdel-Malek's *Israeli and Palestinian Identities in Literature and History*,[70] and Ami Elad-Bouskila's monograph *Modern Palestinian Literature and Culture*.[71] Resources such as these offer important routes into the study of Palestinian literature and film for an Anglophone audience, and the range of such materials will only increase as they receive prominence through a wider remit of scholarly attention.

With the exception of a few works such as Kamal Abdel-Malek's *The Rhetoric of Violence: Arab-Jewish Encounters in Palestinian Literature and Film*,[72] the majority of criticism produced to date has tended to remain restricted to the study of either literature or film (or, more recently, to the study of popular culture, as in Rebecca Stein and Ted Swedenburg's edited collection *Palestine, Israel, and the Politics of Popular Culture*).[73] Within this study, though, I view it as vitally important to work across both of these genres. While adopting a comparative approach to the study of these different creative forms inevitably limits the range of either literary or filmic texts that can be placed

under scrutiny and reveals a number of important distinctions between the forms, this approach also generates insights into the historical, cultural and ideological connections that circulate across creative forms, not least, relating to the politics of gender, and (post)colonial power relations, when they are placed in dialogue. Indeed, working within the inherently interdisciplinary field of postcolonial studies, the comparative study of these two different forms strikes me as a natural and productive decision (though there are clearly more detailed studies of either form waiting to be written). There is one further act of crossing between cultural boundaries entailed in this work, though, and that relates to the politics of my own subject-position.

As a white, Western, British woman approaching the study of Palestinian culture from a comparative perspective, it is necessary to recognise that I am also implicated in the problematic networks of power that circulate around the act of representation. As someone who is not a 'native informant' on Palestinian culture, the specific insights I offer are mediated through critical and textual rather than 'lived' understanding, but even a flawed and partial act of representation such as this risks reproducing the forms of discursive privilege that have often served to suppress the voices of Palestinians. The filmmaker, poet and curator Annemarie Jacir notes that 'like many colonized peoples, Palestinians have been the subjects of other people's films and research, and have often been perceived as exotic others, as victims or terrorists [. . .] [but there is] a complete absence of our own voices and images [in widespread circulation]'.[74] Even well-intentioned acts of representation may therefore serve to speak *for* rather than seek to *listen to* or forge dialogue with the voices and perspectives of Palestinians themselves. This proves all the more problematic when such acts of representation are produced from within a political and social system such as the UK that has, at various points in history, also been the author of that same people's oppression. Indeed, my engagement with feminist enquiry into Palestine also invokes a highly problematic legacy since, as Fedwa Malti-Douglas notes, gendered critique of Arab society has frequently formed the basis of Orientalist and colonial discourses determined to prove the 'inferiority' of the 'other'. Malti-Douglas therefore asks a provocative question: 'If the Arabs already have a bad press (as we know they do), are gender critics not aggravating this problem by raising questions that should better remain dormant?'[75] In other words, might not the very act of seeking to counter the silencing of Palestinian and gender-conscious narratives ultimately end up working within or even reinforcing the mechanisms that have constructed Palestine's oppressive alterity?

This is a troubling situation indeed—yet I would suggest that the price of *refusing* to speak for fear of alignment with such ideas would be the perpetuation of a further, unbreakable silence—not simply of the Palestinian narrative, but of the forms of solidarity and dialogue that may in fact be established with Palestine's own 'others'. While there is surely no infallible solution to this double bind, one response must surely be to employ this

discursive privilege in a way that is willing to test and trouble its own foundations. The approach that I adopt here, then, is one of full acknowledgement when it comes to the limitations, privileges and power dynamics that accompany what Adrienne Rich terms the 'politics of location'. By 'recognising our location, having to name the ground we're coming from, the conditions we have taken for granted',[76] Rich suggests that it becomes possible to identify and negotiate the sites of difference and of common ground that emerge across critical and cultural locations. It is also through this attentiveness to the politics of location that the critic might become receptive to the *return* of their gaze, or indeed to challenges to their critical preconceptions. Said articulates this view in what can be read as a powerful call for cross-cultural, self-reflexive dialogue:

> We Palestinians sometimes forget that—as in country after country, the surveillance, confinement, and study of Palestinians in part of the political process of reducing our status and preventing our national fulfilment except as the Other who is opposite and unequal, always on the defensive—we too are looking, we too are scrutinizing, assessing, judging. We are more than someone's object. We do more than stand passively in front of whoever, for whatever reason, has wanted to look at us. If you cannot finally see this about us, we will not allow ourselves to believe that the failure has been entirely ours. Not any more.[77]

In this passage, Said reminds the critic that they must not write on behalf of but in response to the creative, complex, imaginative and even contradictory narratives of Palestinians themselves, who are also engaged in this process of self-scrutiny. Over the course of this work, I therefore seek to construct a variety of postcolonial feminist dialogues around various moments of 'self-scrutiny' that have emerged in Palestinian literature and film, which engender a similarly self-reflexive scrutiny in postcolonial feminist consciousness itself.

In Chapter 1, I establish the 'gendering' of Palestinian narratives of nationhood that emerges partly in response to Zionist expressions of gendered, sexualised and Orientalist desire for Palestine, before exploring the willingness of canonical literary and filmic figures such as Mahmoud Darwish and Michel Khleifi to interrogate patriarchal gender norms and so reimagine the very structures of nationhood within their filmic and literary narratives. In Chapter 2, I turn to the work of two canonical female authors, Fadwa Tuqan and Liana Badr, in order to investigate the very different ways in which they construct 'resistance narratives' that recognise the interplay and tensions between the 'postcolonial' and 'feminist'. Chapter 3 explores a range of filmic and literary texts by late twentieth and early twenty-first century male creative practitioners in which maleness and masculinity are placed under scrutiny, and colonial, anti-colonial and postcolonial power dynamics are presented as deeply implicated in its imaginative construction. Chapter

4, meanwhile, turns to the potential relevance of a distinctive strand of postcolonial feminist theory termed 'border-theory' to the discourses of power relations, embodied experience and (dis)identification that have sprung up around Palestinian borders as potentially 'queer' spaces in the literary and filmic imagination. Chapter 5 moves beyond historic Palestine to consider the intimate ties that diasporic creative practitioners seek to construct with the Palestinian homeland through models of transcultural feminist solidarity—models which ultimately open up beyond the Palestinian community to all of those who wish to stand in postcolonial feminist solidarity with Palestine. This is just one of the possibilities upon which I reflect further in the conclusion to the book, entitled 'Postcolonial Feminist Futures'. Here, I consider briefly some of the debates and sites of future study that may be opened up by examining Palestinian literature and film from a postcolonial feminist perspective. Collectively, these chapters offer an array of insights into the many different ways in which Palestinian authors and filmmakers are 'looking [at], scrutinizing, assessing' structures of (post)coloniality and gender for themselves, and they invite us to consider the ways in which they serve to re-narrate Palestinian experience, self-representation and creativity.

It is time, then, to set out on the journey that I have begun to map over the preceding pages, and there is no better way to begin than by returning for a moment to the words with which this Introduction began: words passed on by the poet Naomi Shihab Nye from her grandmother, in which she asks us to

'Answer, if you hear the words under the words–
otherwise it is just a world with a lot of rough edges,
difficult to get through, and our pockets
full of stones.'[78]

In listening to these words, I hear a call for attentiveness to the many layers of stories, voices and meanings that emerge through sensitive acts of reading and interpretation. I also hear a powerful testament to the transformative potential of creative expression within the 'rough-edged', (post)colonial world, and a vivid reminder of how those senses of belonging and identity that may appear burdens filling 'our pockets with stones' also offer us touchstones to the past, and material with which to build new homes and futures. It is in answer to these 'words under the words' that I embark on my narrative journey through the contested terrains of the postcolonial, feminist and Palestinian imaginations, and invite you to come with me.

1 En-gendering Palestine
Narratives of Desire and Dis-Orientation

It is only appropriate that a postcolonial feminist study of Palestinian literature and film should begin by turning to a concept that has been profoundly influenced by critical dialogue between postcolonialism and feminism, and that lies at the heart of Palestinian creative consciousness: nationhood. If postcolonialists established the view that 'nations are narrations',[1] constructs that are not simply cartographic entities but power structures created and controlled through the production of knowledge and representation, then feminist scholars have subsequently inflected this discourse to show the ways in which such 'narrations' are *gendered*, revealing further axes of sexed and gendered power in operation within that very nation.[2] As a result, postcolonial feminist scholarship has shifted gender-conscious analysis from the margins to the centre of how we understand nations to be 'imagined'. For Palestine, whose embattled national condition has sometimes been summed up in pertinently corporeal terms as a conflict over 'land and bodies',[3] these insights offer a fresh angle from which to approach what Said famously described as the perpetual 'questions' of Palestine's national desires and identifications.[4] Yet any account of the gendered narrations that have constructed filmic and literary visions of Palestine will inevitably reveal a further set of power dynamics at stake. These are the dynamics of colonialism: a discourse that is in itself constituted through gendered tropes and symbols that resonate with many elements of postcolonial theory, including Said's conceptualisation of 'Orientalism'. As a first step towards 'en-gendering' postcolonial feminist analysis in the service of a greater understanding of Palestinian cultural consciousness, this chapter therefore examines the gendered tropes, symbols and iconographies mobilised in both Orientalist and Palestinian nationalist narratives, which reveal the competing desires, senses of belonging and identities that underpin Palestine's complex national existence. In doing so, this chapter asks: how is Palestine *en-gendered*, brought into creative being, through gendered narrations of its nation?

In order to answer this question, a fuller explanation of each of these central propositions—that 'nations are narrations', and that such 'narrations' are gendered—is required. The idea of the 'nation as narration' neatly describes

a move within postcolonial theory to reveal how the nation, like other categories of belonging or identity (such as gender), is constructed. Such a view is heavily informed by Benedict Anderson's work *Imagined Communities*, which argues that nations are 'imagined political communities' realised through 'image[s] of communion', kinship, inclusion and exclusion.[5] This does not mean that nations do not exist and are simply *imaginary*; rather, the nation must be understood as not only a geographical but also a discursive construct through which a particular communal identity comes into being. As Anderson puts it, 'communities are to be distinguished not by their falsity/genuineness, but by the *style* in which they are imagined'.[6] This process of 'imagining' takes place through narratives that formulate notions of shared origins, space and identity, which quickly come to be naturalised and understood as 'ancient' or ahistorical. The idea of the 'nation as narration' bears further implications for postcolonialists, however, who are mindful of the potential for narratives to be employed as a means to exploit and dominate others, or indeed to resist such domination. As Said writes in *Culture and Imperialism*, 'the power to narrate, or to block other narratives from forming and emerging, is very important to culture and imperialism'; yet narratives have also become 'the method colonized people use to assert their own identity and the existence of their own history'.[7] Here, the intersecting narratives of Israel and Palestine operate as a pertinent example; for while the State of Israel is often presented as 'ancient', it was established in its current form in 1948 as a direct product of the British mandate of Palestine, and Palestine's subsequent struggle to establish an independent nation-state can consequently be read as a manifestation of anti-colonial nationalism formulated in response to these narratives of domination.[8]

From a postcolonial perspective, then, viewing the 'nation as narration' should not be taken as evidence of its imaginary nature. Rather, as Said notes, it reveals that 'all representations ... are intimately tied up with worldliness, that is, with power, position and interests'.[9] For Said, the 'worldly' status of narrative is only too evident in the imperialist underpinnings of what he termed 'Orientalist' discourse, through which a hazily defined realm of 'the Orient' or 'East' as one of inherent 'otherness' came into being within the Western imagination. Orientalism operated through 'a *distribution* of geopolitical awareness into aesthetic, scholarly, economic, sociological, historical and philological texts' that collectively gave life to a 'manifestly different ... world' formulated in terms that fed the Western imperial desire to 'understand ... control, manipulate' territories other than its own.[10] Thus narratives of the Orient became implicated in what Foucault understood as the 'power/knowledge' relationship, in which 'the exercise of power perpetually creates knowledge and, conversely, knowledge constantly induces effects of power'.[11] Imperialist power therefore came to be exercised and reproduced through the narrative construction of the Orient as 'other'—an image that, as we shall see, played a significant role in Palestine's own colonisation. The coloniser

does not hold a monopoly on the 'worldly' implications of narratives, though. For the colonised, narratives of national collectivity may assume immense material importance, as they do in the lives of Palestinians, for whom nationalism is not simply about inclusion or exclusion but also, as Tom Nairn puts it, about 'no more disappearance. For the majority of the collectivity, the collectivity itself remains the sole redemptive possibility'.[12] The redemptive possibilities of community are heavily evident in Palestine, where national identity endures in spite of a lack of national self-determination through narratives of cultural communion and belonging, which construct Palestine as an 'ethno-nation'.[13] 'Imagined' as narratives of national communion may be, they offer a powerfully resistant potential when such a collectivity is placed under threat of erasure. Clearly, then, it is possible for several different narratives to construct different versions of nation, even within the same space, and this has certainly been the case in Palestine, where colonial, Orientalist, Zionist and Palestinian nationalist narratives have all come to bear on variously defined versions of Palestinian space in ways that imagine its origins and identity in radically different manners.

From a postcolonial *feminist* perspective, though, a further narrative emerges within this discursive mesh: gender. As a significant quantity of feminist scholarship has now shown, colonial and Orientalist narratives are underpinned not only by desires for national domination, but by a complex interplay of sexed, gendered and sexual desires, forms of representation and power politics.[14] These desires inevitably find their response in narratives of anti-colonial nationalism, which produce gendered and sexualised dynamics of their own. Postcolonial feminist scholarship has traced the gendered nature of national narratives even further, however, by suggesting that feminisation is inherent in the very 'birth' of nationhood as a concept. As Anne McClintock notes, the English word 'nation' is derived from the Latin term *natio*: to be born, a derivation that constructs the nation as a 'family', guarded over by a maternal and fecund 'mother'.[15] This 'image of communion', to use Anderson's phrase, finds an echo in the Arabic term *al-watan al-umm*: the 'motherland' or 'homeland', a trope that resonates across many cultures and not only describes the place of one's birth or origins but also associates that territory with the fertile, nurturing and domestic qualities of traditional femininity. This association is also apparent in the figure of the 'mother of the nation', who appears in numerous cultural contexts—from the UK's 'Britannia' and France's 'Marianne', robust female figures denoting protection and guardianship who also became 'maternal' figures of the 'paternalist' project of Empire, to portrayals of Egypt as Isis, ancient goddess of motherhood, magic and fertility, through iconography that emerged during the Egyptian revolution of 1919 against the British occupation.[16] These symbolic connections between woman and nation can perhaps be read as no more than extended metaphors for the deep-rooted desire for protection and belonging inherent in the very idea of the nation. In *Gender and Nation*,

however, Nira Yuval-Davis makes the critical observation that such discourses do not readily translate into social empowerment. The symbolic construction of 'woman' as iconic guardian of national identity carries a heavy burden for real women, who come to reproduce the nation 'biologically, culturally and symbolically'.[17] As a result, women occupy an ambivalent position within narratives of the nation, as Yuval-Davis explains:

> On the one hand . . . they often symbolise the collective unity, honour, and the raison d'être of specific national and ethnic projects, like going to war. On the other hand, however, they are often excluded from the collective 'we' of the body politic, and retain an object rather than a subject position . . . In this sense, the construction of womanhood has a property of 'otherness'. Strict cultural codes of what it is to be a 'proper woman' are often developed to keep women in this inferior power position.[18]

Casting women in the role of 'woman-as-nation' consequently enforces her affiliation with nature rather than with society, with origins rather than evolution and with the traditionally feminine roles of mother, nurturer and object of desire (rather than active desirer). The nation therefore emerges as a narrative in which women feature as symbols, but lack access to any representational control: a classically patriarchal manifestation of power/knowledge.[19] As Chapter 2 of this book explores, such a discursive construction of womanhood places very real social pressures on women and means that when they seek to formulate narratives in which they do not play the role of 'mother of the nation', their stories may be considered unacceptable, subversive and even unnatural.

In the context of Palestine, as for many other colonised nations, though, the patriarchal nature of the nationalist narrative must also be understood in relation to the gendered dynamics of colonial discourse. From this perspective, the imagery of desire, sexual union, penetration, fertilisation, love and family that emerges within the masculinist national imagination (the primary subject of this chapter) must be read in the context of similarly gendered narratives formulated within the Orientalist and Zionist imagination, which also view Palestine as an 'alluring' space of desire ripe for fertilisation and hence, for patriarchal mastery. The en-gendering of Palestine examined over the course of this chapter cannot, therefore, be read simply in terms of women's discursive exclusion and thus as a specifically *female* tragedy. Rather, the desire for patriarchal power that emerges within these narratives also dramatises a struggle for representational, territorial and political power in which both men and women are implicated—though not always in equal ways.

A postcolonial feminist perspective therefore reveals the complexity and ambivalence of the narrative construction of nationhood, rather than simply affirming its authority. This perspective does not undermine the importance

of the nation, though; rather, this inherent instability might make it all the more productive, as Homi Bhabha suggests in his essay, 'DissemiNation: Time, Narrative and the Margins of the Modern Nation':

> The linear equivalence of event and idea that historicism proposes, commonly signifies a people, a nation, or a national culture as an empirical sociological category or a holistic cultural entity. However, the narrative and psychological force that nationness brings to bear on cultural production and political projection is the effect of the ambivalence of the 'nation' as a narrative strategy. As an apparatus of symbolic power, it produces a continual slippage of categories, like sexuality, class affiliation, territorial 'paranoia', or 'cultural difference' in the act of writing the nation.[20]

Here, Bhabha recognises that, far from authenticating any single claim to national identity or desire, national narratives expose the very multiplicity of the nation as a construct. For Bhabha, though, this unstable multiplicity offers a means to challenge exclusive claims to power and authority that may render the nation a limited, even oppressive construct. Instead, diverse and competing narratives of national desire and belonging are able to surface alongside one another.

Bhabha's observation offers a contentious but productive context to this chapter, which seeks to trace the interplay of gendered, territorial and national identities and desires that emerge through three key narrative perspectives that have collectively en-gendered Palestine: those of Zionist discourse, of early Palestinian nationalist narratives and of later Palestinian deconstructions of the national narrative. These three perspectives are analysed over the course of three sections. The first two sections, 'Virgin Territory: Colonial Discourse and the Fertile Imagination' and 'Wedded to the Land: Figuring National Desire through the Feminine', each examine the competing 'feminisations' of the land that appear firstly in Orientalist, colonial and Zionist discourse, and secondly in the Palestinian nationalist imagination. Though Zionist and Palestinian nationalist narratives hold opposing perspectives, sexualised and gendered tropes appear in both discourses and appear to inform one another, in ways that reveal their conflicting yet dialogic natures. The third section, 'Nation as Multiple Narration: Dis-Orienting Desire in the Films of Michel Khleifi', builds on these insights in order to explore the way in which one of Palestine's most prominent and significant filmmakers simultaneously deconstructs the gendered paradigms of both Orientalist and national desire within his films, particularly within his daring work *Wedding in Galilee* (1987).[21] As such, his work begins to shift Palestine's national narrative beyond the confines of patriarchal discourse by allowing space for multiple alternative narratives of national desire and belonging to emerge. Collectively, these chapters establish gender as a central feature within

colonial, anti-colonial and postcolonial feminist narratives of Palestine. If narrations en-gender nations, then this chapter tries to reveal how telling the story differently, through the eyes of a gender-conscious narrator, might 'give birth' to a compelling new understanding of Palestine.

Virgin Territory: Colonial Discourse and the Fertile Imagination

In his memoir-come-travelogue, *Palestinian Walks: Notes on a Vanishing Landscape*, the Palestinian lawyer, activist, author and hill-walker Raja Shehadeh records his perceptions of the changes undergone by the Palestinian landscape in which he has lived since a child. Through his accounts of seven *sarhat* (wanderings or walks in which the traveller roams freely, at will and without restraint—a task of increasing difficulty under Israeli occupation), Shehadeh describes how the landscape once so familiar to him is vanishing beneath successive layers of restriction, construction and usurpation, as new names, narratives and settlements emerge at the hands of the Israeli State. As he reflects in the introduction to his book, though, this desire to erase the Palestinian presence within the landscape in order to inscribe a new master-narrative is nothing new:

> Palestine has been constantly re-invented, with devastating consequences to its original inhabitants. Whether it was the cartographers preparing maps or travellers describing the landscape in the extensive travel literature, what mattered was not the land and its inhabitants as they actually were but the confirmation of the viewer's or reader's political beliefs [. . .] Western travellers and colonizers . . . simply would not see the land's Palestinian population. When they spared a glance it was to disregard the Palestinians with prejudice and derision, as a distraction from the land of their imagination.[22]

As a 'land of the imagination', Palestine has long provided a space onto which travellers and colonisers could project their own fantasies of control, ownership and even belonging. Yet as Shehadeh notes, such fantasies also had very real repercussions for those within the landscape. In their desire to authenticate their own vision of Palestine, such narratives systematically sought to erase the presence of others who might have their own competing stories of Palestine to tell: its Arab inhabitants. Through this narrative erasure, Palestine was presented as a blank page to be written upon, a *terra incognita*—virgin territory, ripe for fertilisation and population. Yet however hard these 'fertile imaginations' sought to suppress the existence of the 'other' in their narratives of colonisation and settlement, the 'absent presence' of Arab Palestinians (to use a particularly apt phrase, given the surreal category of 'present absentee' employed by Israel in the aftermath of 1948)[23] continued to surface through fears and even desires

of the 'other', which often found expression in gendered and sexualised terms. This section therefore traces the narrative construction of Palestine as 'virgin territory' in the Zionist imagination, and in doing so, reveals the highly gendered and sexualised nature of the imperialist, colonial and Orientalist narratives that sought to justify mastery of the land.

The construction of Palestine as a 'virgin land' was central to the Zionist project of settling in Palestine. While Western imperial and colonial discourse functioned as a useful model for Zionism, a key distinction was that 'unlike the "classical" European colonial enterprises, the Zionist movement was historically disinterested in either culturally uplifting the natives or exploiting their labor'.[24] Instead, the task in hand was simply to locate an empty land that could become a home for the Jewish population, and this desire emerges in the narrative erasure of the Arab Palestinian population within many elements of Zionist discourse. One of the abiding claims of the Zionist movement was that Palestine presented 'a land without a people for a people without a land'.[25] As Said notes in *The Question of Palestine*, such a slogan was quite simply inaccurate: the British Census for Palestine (a source commonly cited by Israeli historians) recorded the 1914 population at 689,272 persons comprised of 'no more (and perhaps less)' than 60,000 Jews.[26] Even in 1969, though, Golda Meir, then prime minister of Israel, stated that when Zionists first came to Palestine,

> there was no such thing as Palestinians . . . It was not as though there was a Palestinian people in Palestine considering itself as a Palestinian people and we came and threw them out and took their country away from them. They did not exist.[27]

Elsewhere, scholars such as Haim Gerber have taken pains to trace the origins of Palestinian identity, and have shown that while it may not have existed in the same form as European models of nationhood when Zionists first arrived in Palestine, it nevertheless has a lengthy territorial and cultural history in the region.[28] Here, though, Meir's limited understanding of Palestinian nationhood elides the presence of any recognisable community of people on the land whatsoever: that Palestinians 'did not exist' *in any legitimate form* is the implication of her statement. Far from being an anomalous inaccuracy in representations of Palestine, the erasure of the land's native inhabitants operates as a recurrent trope in both colonial and Zionist discourse—and significantly, its implications are also gendered and sexualised.

In her work *Imperial Leather: Race, Gender and Sexuality in the Colonial Contest*, Anne McClintock writes that the narrative of male travel and territorial expansion entailed in the imperialist project can be understood as 'an erotics of ravishment' whereby the land to be colonised was represented as 'virgin' territory desirable for both its 'purity' and its potential 'fertility', which could be achieved by 'penetrating' the landscape through the 'massive thrust of

male technology' and civilisation brought from the West.[29] These tropes are particularly apparent in the writing of Theodor Herzl, the 'father' of modern political Zionism who was integral to founding the State of Israel. In *Old-New-Land*, Herzl describes Palestine as a 'natural, God-given' space that 'lay unseen and forgotten for long territories': a 'virgin land' in which Zionist settlers would 'restore fertility to the soil'.[30] As McClintock notes, though, there are political consequences to such a discourse:

> The myth of the virgin land is also the myth of the empty land, involving both a gender and a racial dispossession [. . .] Within patriarchal narratives, to be a virgin is to be empty of desire and void of sexual agency [. . .] Within colonial narratives, the eroticizing of 'virgin' space also effects a territorial appropriation, for if the land is virgin, colonized peoples cannot claim aboriginal territorial rights.[31]

The representation of Palestine as a highly desirable, virgin but potentially fecund 'land without a people' within Zionist discourse functions in precisely these terms for its Arab inhabitants, whose claims to territorial control would come to be progressively supplanted by the Jewish population. What can be read as an act of territorial usurpation, though, was instead represented according to a rhetoric of fertility. Zionism was replete with the imagery of 'making the desert bloom';[32] the strong, virile young 'Sabra' (representative of an idealised model of a new Jewish masculinity) would be both 'deflowerer and inseminator of his mother/virgin land'[33] and master of a new civilisation that, like all colonial enterprises, operated on the understanding that

> a civilized man . . . could cultivate the land because it meant something to him; on it, accordingly, he bred useful arts and crafts, he created, he accomplished, he built. For an uncivilized people, land was either farmed badly . . . or left to rot.[34]

Thus, the Zionist wilderness narrative of the virgin land can also be understood as a typically colonial 'rescue fantasy' that claims to save the land from itself, to 'tame' its 'primitive' nature and to render it productive.[35] For Said, the Zionist representation of Palestine 'as an empty territory paradoxically "filled" with ignoble or perhaps even with dispensable natives' establishes Zionism as a narrative of colonial domination.[36] He states:

> Zionism essentially saw Palestine as the European imperialist did [. . .] It allied itself . . . with the imperial powers in carrying out its plans for establishing a new Jewish state in Palestine [. . .] Zionism not only accepted the generic racial concepts of European culture, it also banked on the fact that Palestine was actually peopled not by an advanced but by a backward people, over which it *ought* to be dominant.[37]

For Said, further proof of Zionism as a form of colonial mastery is to be found in the links between Zionist narrative and the gendered discourse of 'Orientalism', which informed the European imperialist mindset.

Said's description of Orientalism as an 'exclusively male province' has been challenged by postcolonial feminist thinkers such as Reina Lewis, who note the complex but complicit position of Western women within Orientalist and imperial discourse,[38] but his initial analysis of Orientalism as a 'male power fantasy' of control over a feminised Orient still rings true in relation to Palestine.[39] Said writes that

> Along with other peoples variously designated as backward, degenerate, uncivilized, and retarded [. . .] the Oriental was linked . . . to elements in Western society (delinquents, the insane, women, the poor) having in common an identity best described as lamentably alien.[40]

Perversely, however, the 'lamentably alien' qualities of the Orient also rendered it a site of voyeuristic fascination, an imaginative ground for working through the repressed desires and fears within the Western unconscious. Shohat suggests that this simultaneous sense of repulsion and desire, disdain and fascination, typically finds expression in Orientalist texts through implicitly sexualised representations of the landscape as a site of 'irrational primitivism' and 'uncontrolled instincts' in which the 'exposed, barren land and blazing sands metaphorize the exposed, unrepressed "hot" passion and uncensored emotions of the Orient . . . as the world of the out-of-control Id'.[41] Barbara McKean Parmenter, meanwhile, notes that on the rare occasions when Arab inhabitants of Palestine are recognised within Hebrew literature, they tend to be viewed in Orientalist terms as figures of simultaneous fascination and threat: both 'part and parcel of the landscape . . . alluringly exotic, wild, and in touch with the harsh desert', and testament to 'the darker side . . . of nature . . . irrational [and] uncivilized'.[42] The male Arab subject's imaginative location within territories of the wild, untamed and unknown paradoxically connects him to the 'feminine' realm of what Freud termed the 'dark continent': female sexuality, an indication both of the Arab subject's feminisation in Orientalist discourse, and of his connection to all that is feared and suppressed within Western cultural consciousness.[43]

This co-existent sense of sexualised desire and fear is typical of the Orientalist imagination, though Said leaves the implications of this frustratingly unexplored:

> Why the Orient seems still to suggest not only fecundity but sexual promise (and threat), untiring sensuality, unlimited desire, deep generative energies, is something on which one could speculate: it is not the province of my analysis here.[44]

One speculative response to Said's question, though, emerges in the form of the Israeli author Amos Oz's novel, *My Michael*: a text that dramatises the repression of the Palestinian presence within the Israeli narrative through its exploration of gendered and sexualised fears and desires. Set in 1950s Jerusalem but published in 1968, just after the Six-Day War or *Naksa*, the novel tells the story of a young, poetic, Israeli woman named Hannah Gonen, whose restricted existence as a wife and mother within the home leads to her nervous breakdown. This breakdown, however, is expressed through her retreat into fantasies focused on two Arab twins with whom she played as a child in pre-partition Jerusalem. Often simultaneously erotic and fearful, these fantasies can be read as projections of the Israeli anxiety concerning the repressed presence of the Palestinian 'other': a presence that Israel attempted to excise from its own carefully policed boundaries of state identity (just as Hannah's existence is also rigorously constrained in the service of producing the ideal Israeli home).[45] Hannah's fantasies therefore represent the 'return of the repressed' within the Israeli subconscious, and she describes this 'return' in classically Zionist terms. Beyond the boundaries of Jerusalem, for example, is the untamed wilderness where, in her imagination, the Arab 'other' resides: 'If you turn your head you can see in the midst of all the building a rocky field . . . the hills. The ruins. The wind in the pine trees. The inhabitants'.[46] In her fantasies, meanwhile, the Arab twins 'break through' the boundaries of her unconscious in terms that are both threatening and desirable: 'Silently the pair of them float over the neighbourhood at the end of the night. Naked to the waist, barefoot and light, they glide outside. Lean fists hammer on the corrugated iron'.[47] In these fantasies, Hannah affirms the association of the Arab 'other' with natural, uncivilised 'wild zones' deemed a threat to civilisation.

If read as a national allegory, then Hannah's breakdown presents some interesting possibilities of postcolonial interpretation. Hannah's own breakdown might be read as a representation of Israel's own fragile sense of 'self'—a fragility premised on its inherent sense of 'lack', not only of national security but of narrative authority, due to that inherent, repressed presence of the Palestinian 'other'. Yet Hannah also seems to offer a psychoanalytic interpretation up for analysis, as her fantasies suggest that 'lack' also generates desire. Here, that desire seems to be founded on the unavoidable but taboo intimacy between Israeli and Palestinian, 'self' and 'other', male and female. Consequently, Oz's novel can be linked to the imperialist tradition whereby the colonised 'native' is frequently represented as a sexually predatory figure towards Western women:[48] a trope that reveals much about the sexually repressed British Victorian mindset, and the imperial subject's fears of threats to his own 'masculine' colonial mastery. At one level, Oz therefore appears to confront the troubling conflation of racial, gendered and sexual 'otherness' within the Israeli imagination in a way that might be considered radical.[49] Yet as Yosefa

Loshitzky observes, 'it is interesting, but also disturbing, that Oz chose to metaphorize and embody Israeli fears through imaginary Arabs and imaginary women [. . .] Ultimately Oz's "binarist" and patriarchal writing distils to a projection of fears, neuroses and fantasies, to the "other" side of Israeli society: Arabs and women'.[50] Conscious of these problematic discourses as he may be, Oz nevertheless appears trapped within a mindset in which anything other than a 'virginal' Israel remains an aberration.

Oz's novel ironically reveals a more astute awareness of the gendered and sexualised dynamics of the Zionist imagination than Said's own analysis. For Said, though, evidence of the close connection between Orientalist and Zionist discourse was to be found more readily in the numerous negative descriptions of Palestinians as 'totally destitute of all moral sense', characterised by 'ignorance and stupidity', which frequently appeared in Western-authored accounts that informed Zionist opinion;[51] tropes which are implicitly gendered in their portrayal of Palestinians as 'savage', 'barbaric' and in need of a 'paternalistic' colonialism. For Said, then, the Orientalist characteristics of Zionist discourse affirm it as a narrative of masculinist colonial mastery. A further gendering of Palestine emerges within Zionist discourse, however, which complicates this interpretation. Palestine was not simply considered 'virgin territory' but was also presented as the 'motherland': a site to which the Jewish people would return home, displacing not 'natives' but 'illegitimate inhabitants'. Said himself recognises this when he writes:

> The colonization of Palestine proceeded always as a fact of repetition: the Jews were not supplanting, destroying, breaking up a native society. That society was itself the oddity [. . .] In Jewish hearts . . . Israel had always been there.[52]

Here, Said suggests that Zionism premised its national narrative of a Jewish homeland on Jewish roots in the region, and historical claims to Palestinian territory. Yet from Joseph Massad's perspective, the narrative of the Jewish 'motherland' is only further evidence of its colonial underpinnings, in that 'the image of the land as mother is linked inherently to the sexual and reproductive project of colonial-settler nationalism',[53] whereby settlers would be perceived as both 'children' newly born into the nation, and as future propagators of the land and population. Nevertheless, the representation of Palestine as the motherland also offered the Zionist project the idea of historical roots within what Daniel Monterescu describes as the 'conceptually split and historically troubled . . . Jewish sense of place (*ha-makom*)':[54] a 'conceptual split' that stems from a simultaneous desire to claim Israel as the 'promised land' and a reluctance to 'become native' (in other words, to be subsumed into Palestinian identity and culture). Instead, the Zionist quest for roots took place through a search for alternative ways of 'knowing' the land—through activities such as archeology and natural history, which

might yield alternative narratives of the landscape that linked them to it, while remaining distinct from 'native' culture. Indeed, agricultural activity became an important element of Zionist endeavor, as it employed modern industrial technology in order to fertilise the territory and produce actual roots in the form of crops to sustain the new national population, a process deliberately set apart from the traditional methods of Palestinian farmers. This agricultural discourse offers a very literal manifestation of the masculinist desire to fertilise a virgin territory, and so lay claim to it. As Barbara McKean Parmenter observes, the Hebrew term for this kind of 'knowledge of the land', *yedi'at haaretz*, has gendered connotations: 'The biblical meaning of *yedi'a* relates to sexual knowledge of a woman, so that knowledge of the land equates with physical possession'.[55] Here, knowledge is once again implicated in the production of power, just as gender is again implicated in discourses of national and territorial mastery. Consequently, the gendered tropes of Zionist discourse are strongly suggestive of both a masculinist and colonial desire for mastery—a mastery that emerged through the production of narratives of the Israeli 'self', and erasure of the narrative presence of the Palestinian 'other'.

Powerful as this logic of the land as both virgin and mother might appear within the Zionist narrative, though, it gave birth to a very different national narrative within the Palestinian imagination. From the Arab Palestinian perspective, Zionist colonial mastery of the motherland was not viewed as an act of fertilisation—but of rape. The gendering of the land in Zionist narratives could also, it seemed, be used to en-gender narratives of resistance and reclamation in the Palestinian imagination.

Wedded to the Land: Figuring National Desire through the Feminine

> Put it on record.
> I am an Arab
> And the number of my card is fifty thousand
> I have eight children
> And the ninth is due after the summer
> [...]
> My roots
> Took hold before the birth of time
> Before the burgeoning of the ages,
> Before cypress and olive trees,
> Before the proliferation of weeds.
> [...]
> Put it on record.
> I am an Arab.
> You stole my forefathers' vineyards

> And the land I used to till
> I and all my children,
> And you left us and all my grandchildren
> Nothing but these rocks.
>
> —Mahmoud Darwish, 'Identity Card'[56]

In *The Question of Palestine*, Said describes Mahmoud Darwish's early poem 'Identity Card' as a work that 'did not *represent* as much as *embody* the Palestinian' through its portrayal of the oppressive controls placed on Palestinian identity and territory by the Israeli State.[57] This poetic account of an encounter between an Israeli police clerk and Palestinian Arab also, however, operates as an ironic inversion of the demand for the Palestinian subject to legitimate his or her presence, as it instead produces a passionate articulation of the Palestinian's ancestral connection with the land, undermining the official rhetoric of Israeli ownership. Although not immediately apparent, a gendering of this territorial narrative also occurs within the poem. His account of a bond with the land that 'took hold before the birth of time' and has been kept alive through successive generations by his 'family of the plough'[58] casts Palestine in the role of a nurturing mother who has born many children. As revealed in the first stanza of the poem, the Palestinian subject may have been reduced to 'number fifty thousand' on his identity card, but he has 'eight children / And the ninth is due after the summer': population figures are appropriated as a resistant discourse of maternity here, for they testify to the endurance of the Palestinian people, despite repeated attempts to erase them from the land. Yet the fertility of the pre-colonial landscape imagined by the poem's narrator, brimming with 'cypress', 'olive trees' and 'vineyards', is juxtaposed with an uncultivated present-day image of a barren, meager existence in which the Palestinian people have been left with nothing but 'rocks': an image of territorial theft, even rape of the land. Darwish's poem therefore reveals the ways in which the colonial and Zionist representations of Palestine as fertile 'virgin land' and 'motherland' might be appropriated in order to foreground rather than erase the Palestinian presence, and to render the Israeli narrative of territorial belonging illegitimate. Most powerfully of all, though, Darwish's refrain of '*Sajjil*'—'Write down' or 'Record'— throughout the poem demands that this account of Palestinian identity and territorial belonging should be textually inscribed, and in doing so, he conveys the determination of Palestinians to construct an alternative master-narrative that reclaims and so en-genders a postcolonial Palestine. The question remains, though—what does this alternative en-gendering of Palestine reveal about the power relations not only between coloniser and colonised, but between men and women within the Palestinian nation itself?

Gender relations are embedded at the very heart of Palestine's national identity, and this is, in part, the product of its status as a colonised space. As Susan Slymovics puts it, 'all descriptions of Palestine as a contested, colonized

space ... illuminate gender issues where interactions between colonizer and colonized are imagined as relations between males and females'.[59] For the male colonised subject, the task in hand is therefore to reclaim his status as male 'self' rather than feminised 'other'. This assertion of masculine selfhood appears through motifs of familial relations in Palestinian nationalist expression, where the male subject is represented both as the patriarchal 'father'—the master, defender and inseminator of the 'motherland'—and as a 'son of the soil': a child of Palestine, legitimate heir to the land whose duty is to protect his 'mother' from harm.[60] Such affirmations of masculinity occur particularly frequently in poetry written at significant moments in the Palestinian anti-colonial struggle, such as the work of 'Abd al-Raheem Mahmoud, a poet who died fighting in 1948 and whose poem 'Call of the Motherland' describes the task of defending Palestine as a means for men to affirm their masculinity by acting as 'true lions on the battlefield'.[61] In the poem 'A Million Suns in My Blood', meanwhile, the famous 'resistance poet' Tawfiq Zayyad describes himself as the 'son' and 'offspring' of Palestine, who views the task of national resistance as a birthright transmitted through the familial 'bloodline' of the nation.[62] In works such as these, the affirmation of masculine selfhood also leads to the familiar symbolic construction of women as maternal guardians and propagators of the nation. Indeed, Massad notes that this highly binarised construction of traditional gender roles is embedded in the Palestinian Nationalist Charter, where, according to Joseph Massad, Palestinians are described 'as the children of Palestine, viewed as a mother'.[63] Envisioning the land as maternal and women as symbolic enactors of this 'mothering' discourse, Massad states that nationalist discourse constructs women as '"*manabit*", or the soil on which "manhood, respect and dignity" grow'.[64] As iconic guardians of national dignity and cultural identity, women come to perform a symbolic function that affirms patriarchal control of Palestine through their highly traditional supporting roles as wives and mothers. Indeed, this idealisation of traditional femininity is evident in 'Abdallah Radwan's poem, 'You Are Everything', subtitled 'For Palestine', in which he states that he sees in Palestine 'a mother, a sister, a wife', indeed an entire 'family' and 'tribe', who has nurtured him back to health through her love and warmth, casting him in the role of 'a child in your arms'.[65] Here, Palestine assumes several female roles at once, which represent the benevolent and protective structures of the national community for Radwan, who is himself the beneficiary of the nation's maternal care: a 'son' of the nation being tenderly raised as its future inhabitant. Consequently, the affirmation of masculine selfhood appears to be strongly dependent on the symbolic construction of traditional femininity at the hands of the male author.

Just as masculinity and femininity are discursively formulated in relation to one another, so are Zionist and Palestinian nationalist discourses when it comes to their respective claims to the land, which are advanced through images of fertility and propagation. As we saw in the previous section,

Zionist rhetoric sought to lay claim to Palestinian land through its ability to 'make the desert bloom' with modern technology that presented Zionist settlers as more 'civilised' than the Arab Palestinian farmers. Palestinian nationalist discourse, however, appropriates this trope in order to present the Arab propagation of the land as a natural, age-old practice and a birthright: the very basis of its national family. In her study of imagery used to represent the Palestinian homeland, Tina Sherwell notes that the Palestinian peasant woman became an iconic figure in artwork produced from the 1960s onwards, a time of renewed resistance in Palestine. Particularly significant is that such women would often be shown wearing traditional embroidered dress. Such dresses are significant within Palestinian culture as their embroidery patterns are specific to each region, meaning that 'in the aftermath of the loss of Palestine as homeland, the costumes have become a way of mapping the lost homeland onto the bodies of women . . . re-configur[ing] places lost to Palestinians':[66] a motif that appears in Jabra's poem 'In the Deserts of Exile', where he conveys the strong attachment he feels to the lost landscape of Palestine through an image of traditional femininity, describing the verdant fields dotted with flowers as akin to the embroidery patterns on women's gowns.[67] Similarly, Susan Slymovics identifies the practice of naming female Palestinian children after destroyed villages or towns as a way of inscribing Palestinian history into the very fabric of female identity.[68] In both cases, women assume a symbolic function as bearers of history and representatives of the homestead. Equally significant, though, is the appearance of the peasant woman within nationalist discourse. The figure of the male peasant or *fallah* bears a heavy weight within Palestinian cultural discourse, where he is a 'unifying symbol' of both authenticity and 'active resistance to outside intervention'.[69] Yet the specific figure of the peasant woman (*fallaha*) connects the traditional propagation of the land to her own fertility and as Sherwell notes, she is often represented in a variety of roles linked to propagation of both land and family, including participating in the harvest, and mothering her children. Thus, as a figure of both maternity and rural life, she offers a 'representation of the homeland in which a Palestine of the future is imaged as a return to a golden past of a land rich with crops and harmonious communities'.[70]

An interesting contemporary reworking of these tropes occurs in Hanna Elias' film *The Olive Harvest* (2004),[71] which dramatises the simultaneous struggle between two brothers for the same woman, and between Israeli settlers and Palestinian villagers for the land. Though set against the contemporary backdrop of the occupation (one brother, Mazen, has recently been released from prison, while the other, Taher, works on the Palestinian Legislative Council, which attempts to curtail the spread of Israeli settlements), the film constructs a somewhat traditional symbolic connection between the female character Raeda, and the land. Raeda, a village girl, is presented as an icon of traditional femininity, who wears embroidered dresses and

'smells of olives'. She is depicted as a participant within the olive harvest, during which traditional music and women's singing fill the orchard. At one point in the film, Raeda's father renders the link between female identity and the land explicit by telling her that the olive trees represent her 'aunt' and 'grandmother': they embody their family heritage and ties to the land, just as Raeda herself does. Yet the fact that Raeda must choose between two suitors complicates her straightforward function as a symbol of national unity. Both Taher and Mazen love Raeda equally, and her final inability to choose between them is represented in her fusion of their names into 'Maher' as she calls after them. According to Lina Khatib, *The Olive Harvest* can therefore be read as allegorical of the dual territorial claims of both Israelis and Palestinians, and of the need to recognise them as 'brothers' united in mutual love for the same land/woman.[72] The film also, however, dramatises the dilemmas facing Palestinians concerning the best way to love and care for their land: to engage in physical resistance, as Mazen does, or legislative struggle, like Taher. Equally, Raeda is presented as a figure torn between past and present, political and personal concerns. While the close connection between woman and land is therefore placed within a contemporary context in this film, it nevertheless upholds her primarily symbolic status as a figure of national desire.

While women's symbolic connection to the land is often mobilised by male authors in order to affirm their own ancestral claims, a particularly interesting inflection of this discourse occurs in Laila 'Allush's poem, 'The Path of Affection'. Born in the year of the *Nakba*, 'Allush has always officially been a citizen of Israel—yet in this poem, she reveals how her own sense of connection with the land unearths an alternative narrative that authenticates its Palestinian identity. The poem begins with her setting out on a journey to New Haifa, to meet her relatives. All around her, she sees Israel's presence inscribed on the land: 'The estrangement of signs, shops and graveyards', 'pawned trees on the hillsides', 'water sprinklers spinning so efficiently', 'modern tunes', 'modern buildings'.[73] Here, the discourse of modernisation so proudly displayed within Zionist rhetoric is represented as 'otherly', even unnatural from the perspective of the Arab inhabitant. Indeed, in her brief analysis of this poem (which deals with it in the original Arabic), Hanan Ashrawi notes that the 'foreignness' of the landscape is conveyed through the use of common Hebrew words: a feature of the poem that is lost in translation.[74] Nevertheless, the intrusive influence of Israel remains strongly apparent—but as the poem's narrator progresses on her journey, she discovers that she is able to look beyond the palimpsestic presence of Israel to find 'the land . . . gently defying it all'.[75] Looking at the landscape through Arab eyes, she perceives it as a nurturing, connective space in which she hears 'an apology for my father's wounds' and sees 'the shape of my Arab face' in the landscape and architecture around her, 'the trees . . . smiling at me with Arab affection', 'the red soil . . . shining / with Arab modesty'.[76] As in 'Identity Card',

the narrator's bond with the land therefore generates an alternative narrative of territorial belonging that undermines its official Israeli inscription. Yet 'Allush's account is very different in tone from the defiant, manly anger of Darwish's narrator. Instead, 'Allush locates her own claims to the territory through the gentle affection and modesty of the motherland, in a way that is redemptive and empowering for the female narrator. While this poem therefore draws on some of the traditional tropes of the motherland as nurturing and maternal, 'Allush engages with them in a way that casts her as more than simply a symbolic guardian of the land; she is also an active and individual figure within the poem, and the author of its imagined postcoloniality.

Exciting as this appropriation of gendered imagery may be, 'Allush's poem remains something of an anomaly, and the alliance between women and land that emerges in much nationalist discourse tends to affirm male rather than female agency. This is keenly evident in the masculinist tropes of territorial protectionism that functioned in early Palestinian nationalism, embodied in the popular tenet *ardi-'irdi*. Translated literally as 'my land is my honour', the phrase also has gendered implications due to women's status as guardians of the family's honour;[77] thus land and womenfolk are both presented as possessions of the patriarch, whose own honour is dependent upon their defence.[78] It is within this context that the image of Palestine as a victim of rape emerges. The linkage of colonisation with rape has been made by many anti-colonial and postcolonial thinkers, who not only cite rape as a strategy employed to suppress the 'native' population of a country, but who also view it as a metaphor for the colonial exploitation of the land.[79] For Palestinians, the very real concern of rape surfaced in the wake of Deir Yassin in 1948, when 245 Palestinian villagers were massacred during Israel's struggle for independence. The Red Cross reported this massacre to have involved the rape of women and butchering of children, and the fear of similar incidents is said to have informed the flight of other Palestinians from their homes during the *Nakba*.[80] This event continues to resonate as a source of horror and as a representation of vulnerability in the Palestinian imagination, and appears in a number of literary works.[81] Rape also surfaces as a metaphor for Zionist conquest in the Palestinian Nationalist Charter and in then PLO Chairman Yasir Arafat's address to the UN General Assembly, where he describes Zionism as a desire to 'rape the Palestinian homeland and to exploit and disperse its people'.[82] In literary discourse, too, Palestine is represented as a vulnerable woman; in Harun Hashim Rasheed's 'Poem to Jerusalem', for example, Jerusalem is personified as the 'weeping' female victim of a rape who must be rescued by her protectors, Palestinian men.[83] While the metaphorical link between colonisation and rape operates as a powerful representation of the sense of violation experienced by male and female Palestinians alike, it also enacts an elision of the distinction between the literal rape of women and crimes committed against the 'body politic' that is problematic in feminist terms. This metaphor once again relegates

female sexuality to the realms of the primarily symbolic, whereby women's violation assumes a political status as an affront to the patriarchal order of the nation. Indeed, the structural centrality of patriarchal relations to the discourse of land ownership emerges in the anti-colonial inversion of the rape metaphor, whereby *legitimate* and s*anctified* union with the land is represented through the image of the wedding.

Images of being wedded to the land abound in Palestinian poetry, and they present a discourse of heteronormative male desire in which Palestine is eroticised and personified as a 'lover'. Palestinian poetry is replete with such imagery: from 'Umar Shabana's 'The Book of Songs and Stones', in which Palestine is a woman holding roses (possibly, in their redness, also an image of sacrificial blood spilled) from her lovers,[84] to Abu Salma's vision of return to Palestine as a moment of sensuous romantic union at which he will 'kiss the moist ground' and a romantic attachment will blossom between the united 'lovers'.[85] According to Hanan Ashrawi, many of these love poems to the homeland can be read as expressions of their own sense of impotence and sterility, which may be manifested in expressions of male desire that verge on the sexist.[86] One such example of this emerges in Rashid Husain's poem 'First'. Imagined as a 'play' between two characters in an interrogation, and so, we might assume, enacting a dialogue between Israeli coloniser and colonised Palestinian, this poem renders the territorial implications of the marriage metaphor deliberately explicit:

> Interrogator: In this poem you are clearly saying that my wife loves you.
> The Poet: I am speaking of my land, I say I was there before you
> [. . .]
> I loved her before you, and she will always think of me first [. . .]
> I'll even enter your bed
> on your wedding night, and come between you[87]

In this poem, beloved Palestine is cast as the object of romantic rivalry between her new suitor, Israel, and her first love, the Arab people of Palestine. Rather than celebrating the love between bride and groom, though, the poem becomes something of an exercise in male jealousy and sexual prowess in which Palestine herself becomes no more than the ground on which a tussle for patriarchal power takes place.

The problematic nature of this reductive gendered characterisation of Palestine has not been lost on Palestinian critics. In his work *The Third Way*, Raja Shehadeh explores his temptation to fetishise the Palestinian landscape and to read it as a series of symbols that represent his stifled desire for the homeland. Yet Shehadeh perceives something reductive, even 'pornographic' in this kind of engagement with the land, as it ultimately denies him any sense of genuine emotional, personal or literal connection to it:

> When you are exiled from your land . . . you begin, like a pornographer, to think about it in symbols [. . .] You articulate your love for your land, in its absence, and in the process you transform it into something else [. . .] [Now] as I am looking at [an olive tree], it transforms itself before my eyes into a symbol . . . of our struggle, of our loss. And at that very moment I am robbed of the tree; instead there is a hollow space into which anger and pain flow.[88]

Palestine's transformation into no more than a set of symbols proves 'hollow' for Shehadeh because, just as he finds his own *sarhat* through the Palestinian hills to be subject to increasing restriction, so does this restricted narrative of Palestinian identity limit his own acts of wandering in the literary imagination. Shehadeh is not alone in this recognition. Despite the strident and somewhat masculinist tone of his early poem 'Identity Card', Mahmoud Darwish would later flourish into one of Palestine's most sophisticated poets whose meditations on the Palestinian condition would undergo constant transformation throughout his lifetime, exploring a multitude of facets of his existence that extend well beyond national concerns.[89] It is appropriate, then, that it should be Darwish who offers a pertinent deconstruction of the masculinist rhetoric that simultaneously exalts, reduces and silences women in his poem 'No More and No Less', in which he transforms his own voice into that of a woman to remind the reader that 'I am not a land / or a journey / I am a woman, no more and no less'.[90] In this 'radical' act of imagining a woman who sets the boundaries to her own identity and transcends the realm of the primarily symbolic, Darwish begins to rework the relationship between national desire and gendered identity in ways that might destabilise rather than simply affirm patriarchal power. This is the exciting possibility pursued still further by one of Palestine's most significant filmmakers: Michel Khleifi.

Nation as Multiple Narration: Dis-Orienting Desire in the Films of Michel Khleifi

The films of Michel Khleifi have been subject to both acclaim and controversy within and beyond Palestine. His work is distinctive within the Palestinian cinematic canon for its constant willingness to expand the Palestinian national narrative through a style of filmmaking characterised by a multiplicity and self-reflexivity of perspective. As Khleifi himself writes of his filmmaking practice:

> The prevalent political language aims at determining a harmony of concrete interests [. . .] My cultural action . . . aims at liberating spaces where everyone can be moved . . . [and] marvel at the world [. . .] My films' cultural world is made up of both reality and the

imagination . . . It is like a child's quest for identity: he or she needs these two levels—reality and dream—to approach life in a balanced and non-schizophrenic way.[91]

While Palestine remains at the heart of Khleifi's filmmaking, his engagement with nationhood therefore operates in a way that not only embraces its narrative nature, located just as much in 'dream' and subjective consciousness as reality, but that also seeks to expand rather than limit or unify narratives of national identity. Indeed, this trait recently emerged in his first solo film for fourteen years, *Zindeeq* (2009), the title of which can be interpreted as 'atheist', 'heretic' or 'freethinker'. This film portrays the return of a Palestinian filmmaker from Europe to his hometown of Nazareth, where he is forced to confront the conflicting narratives of nostalgia for the past and desire for the future that construct his own ambivalent relationship to Palestine. While in many ways a personal meditation on the creative imagination, the film is also a reflection of the complex social narratives of conflict that exist within the Palestinian community itself.[92]

It was his first film, however, which he made upon his return to his hometown of Nazareth in 1980 after a period of studying filmmaking in Belgium, that would ignite what George Khleifi has termed the 'fourth period' in Palestinian cinema: an era in which filmmakers rejected either the idealisation of the past or its portrayal of Palestinian history as one of unequivocal trauma, and instead 'attempted to extract the Palestinian narrative from the story of the actual land, the real place, and the life being played out there [. . .] deconstruct[ing] Palestinian society's image of unity and homogeneity'.[93] This film was his feature-length, prize-winning documentary *Fertile Memory* (1980),[94] a work in which Khleifi mediated the national narrative through the perspectives of two very different women. While the film draws on land-based motifs related to ideas of history and memory, the women who construct narratives of this land operate as much more than its symbolic guardians. Roumia, an elderly woman (and Khleifi's aunt), is a powerful figure of *sumud* (the quality of 'steadfastness' or 'resilience', an important form of resistance for Palestinians, who may possess no other form of agency than their simple refusal to give in)[95] as she refuses to give up her land in the Galilee, even after thirty-two years of pressure from Israel to do so. The other, Sahar Khalifeh (who would go on to become a famous novelist and feminist figure in Palestine), is a divorcee in her thirties who possesses a different kind of attachment to the land. She has returned to her hometown of Nablus from Libya and, despite the social stigma that she encounters as a single mother in her community, refuses to leave. Rather than operating as silent symbolic presences within the film, both women are instead the active narrators of their own stories, which deviate from the traditional national narrative in their accounts of what Viola Shafik characterises as the 'double occupation' they endure living not only under Israeli occupation, but also beneath 'their

men's claims of ownership and the restrictions imposed on them by patriarchal society as a whole'.[96] Thus the 'fertile memories' of these women not only yield alternative female-authored versions of Palestinian history, but they also reveal the many forms of gendered power, agency and knowledge that circulate within the nation. This simultaneous invocation and subversion of the national narrative is a recurrent feature of Khleifi's work, and it surfaces in particularly pertinent form in his 1987 film, *Wedding in Galilee*. By exploring the multi-layered desires that intersect in this film—not only between women and nation but between men and women, young and old, Israelis and Palestinians—the powerfully 'disorienting' qualities of his work emerge: a 'dis-Orientation' of the reductive Orientalist tropes of the Zionist gaze, *and* a 'disorientation' of traditional nationalist symbolism that achieves an infinitely richer, if more challenging, portrait of Palestinian existence.

Conflicts and disorientations of desire lie at the heart of *Wedding in Galilee*, and they are in fact evoked in the film's title, which neatly summarises its central premise. The film tells the story of a *mukhtar* (head or 'mayor') of an Arab village in the Galilee, Salim Saleh Daoud (played by Ali el Akili), who wishes to hold a traditional wedding for his son, despite the restrictions on life under Israeli governance. As Mary N. Layoun notes (and as suggested in the analysis of nationalist imagery in the previous section of this chapter), the wedding is a highly politicised trope in Palestinian cultural expression as it represents unity not only of the family but also of the nation. Hence the establishment of the State of Israel was represented as a 'violent conjugal separation' that tore a land and culture apart.[97] As a traditional celebration of union between individuals in the service of the propagation of the national 'family', the wedding within the film therefore operates as a powerful symbol of resistance. Indeed, the first *Intifada* (an event that began shortly after *Wedding in Galilee* was released, and which is seen by some to be symbolically foreshadowed in the film's destabilisation of traditional gender roles, which would also later occur during the *Intifada*)[98] is sometimes referred to as 'the Palestinian wedding',[99] as it was designed to unite the divided lands of beloved Palestine. In the film, the wedding celebrations are similarly designed to incite a sense of pride in the village, and there is a strong emphasis on tradition in Khleifi's portrayal of the wedding, which takes place over the course of a whole day and permeates every space of the village, drawing its inhabitants together. Yet the *mukhtar's* desires conflict with those of another patriarchal figure: the Israeli governor (Makram Khoury), under whose jurisdiction the village falls. Their competing desires emerge in the opening scene, in which Daoud sits in the governor's office in order to ask permission to hold his son's wedding: a necessity, given that there is a curfew imposed on the village and gatherings of people have been banned, since it is, according to the governor, 'one of those extremist villages'. In the encounter that plays out between governor and *mukhtar*, each the patriarch of their respective political systems, a deal is struck: the wedding can take place,

provided that the governor is present as the guest of honour. The premise upon which Khleifi establishes this wedding therefore disorientates its utopian nationalist connotations of unity and resistance. Instead, it becomes a motif of patriarchal rivalry and contested desire. Indeed, this disorientation of the wedding motif inadvertently evokes the assessment that was offered to Golda Meir of Palestine's suitability for settlement: 'The bride is beautiful, but she has got a bridegroom already', to which she was said to have responded that 'I thank God every night that the bridegroom was so weak, and the bride could be taken away from him'.[100] *Wedding in Galilee* challenges the power dynamics implied by Meir through its portrayal of the strong relationship between the Arab village and its traditions, and of the desire that connects it to its land. Yet conflicts and disorientations of desire do surface, and not only between the Israeli and Arab patriarchs, but also among the wedding participants themselves.

Early in the film, immense dissatisfaction at the wedding arrangements emerges within the patriarchal sphere itself. Many of the men within the village view the presence of the governor as an insult, and question whether it will be possible to hold a sense of pride in the celebrations when they take place on his terms. The groom (Nezih Akleh) displays unease at the situation, which his younger sister Sumaya (Sonia Amar) teasingly sums up when she tells him that he must choose between his 'bride or his patriotism'. Ironically, Daoud's wife appears to foresee this conflict when she warns her husband that he must 'try not to cause a split within the village and the family', though Daoud remains publicly adamant that the wedding will restore the village's identity. Privately, however, his patriarchal desires are in a state of disorientation. As his youngest son, a child of around eight or nine years old, lies sleeping, we hear Daoud asking him in a soft, wistful tone: 'Are your dreams like mine? . . . Why do I want you to learn my story by heart?' In these darkened, disorientating sequences of dream and meditation which punctuate the film, Khleifi offers an important deconstruction of the public narrative of authority and tradition presented by the patriarch, suggesting instead the competing desires and dreams that may circulate in his son's and his own mind, and indeed in Palestine's future.

A tension between public and private desire, and between repetition and disruption of the traditional national narrative emerges over the course of the wedding itself. Many of the performances of ritual and tradition that take place during the wedding do indeed affirm the gendered iconography of national unity, such as the songs sung by the men in the presence of the Israeli governor, the lyrics of which describe male qualities of strength, unity and brotherhood: a subtle display of resistance. The ritual cleansing and dressing of both bride and groom that occurs early in the film, meanwhile, presents them as glorious figures of idealised Palestinian identity who are significant for their representational rather than individual qualities. Yet over the course of the wedding, alternative forms of desire disrupt these gendered

narratives. In particular, the *mukhtar's* eldest daughter, Sumaya, displays strong desires of her own.

Confident, wilful and conscious of her own beauty, Sumaya is unafraid to demand attention from the young men in the village and indeed expresses a desire to leave there altogether, a display of independent agency that is met with a recommendation by her grandmother for her father to 'marry her off' in order to 'shut her up, and the others [those talking about her] too'. Sumaya, though, seems to have little interest in performing the traditionally feminine and nationally affirmative role of bride. While we see Samia (the bride, played by Anna Condo) standing static and passive so that she can be dressed by the other women, Sumaya slinks away to her own room where she

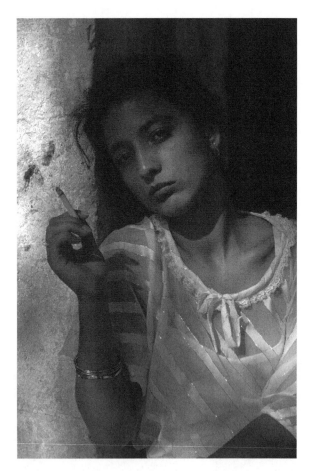

Figure 1.1 Sumaya, the *mukhtar's* daughter: a powerful figure of alternative female desires. *Wedding in Galilee* (1987), dir. Michel Khleifi. Image courtesy of Sindibad Films and Michel Khleifi.

gazes at her half-dressed body in the mirror. In a subversive and performative celebration of her own bodily agency, we see her experimenting with the large floating cloth of a *kuffiya*, a traditionally male headdress often worn as a symbol of national resistance, which she pulls about her head and torso as though attempting to find an identity that suits her.

This scene is particularly important for the way in which it subverts the 'scopophilic' voyeurism of both the male and Orientalist gaze. According to the film theorist Laura Mulvey, much Western mainstream cinema is characterised by 'scopophilia', 'pleasure in looking', which emerges as a specifically heterosexual *male* gaze in which women become the passive objects of visual pleasure.[101] The binary power dynamics of the 'male gaze' mirror those of the Orientalist gaze, in which, as Said writes, 'the Orient is *watched* [while] the European . . . is a watcher'.[102] Indeed, the Oriental woman appears in many Orientalist texts as a particular object of fascination, desire and visual pleasure, whereby 'the Western subject's desire for its Oriental other is always mediated by a desire to have access to the space of its women, to the body of its women and to the truth of its women'.[103] This desire for visual access to the Orient through its women again echoes the sexualised narrative of penetration, domination and patriarchal mastery intrinsic to the colonial narrative. Indeed, as Said observes, Western men's attitudes towards 'Eastern' women 'fairly stands for the pattern of relative strength between East and West and the discourse about the Orient that it enabled'.[104] In this scene, though, Khleifi subtly deflects both the male and Orientalist gaze. While Sumaya is semi-clad in this scene, the sight of her body is mediated through her own gaze into the mirror, which is angled in such a way that it denies complete visual access to the viewer. Equally, Khleifi subverts the common Orientalist trope of the 'veil' in this scene as her playful use of the *kuffiya* neither obscures her body substantially, nor operates as a symbol of feminine allure. Instead, it is a male garment that she has presumably 'borrowed' from a male relative, and with which she adorns rather than conceals herself in personal celebration of her own bodily desire and desirability. The lines of sight belong to Sumaya in this scene: the visual pleasure is all hers, and her semi-obscured body is a locus of visual and representational agency that cannot be claimed or penetrated by the voyeuristic viewer.

If Sumaya suggests something of an uncertain future for the national narrative through a bold break from tradition, then the bride herself provides an even more disorienting vision of Palestine in a scene that takes place within the bridal chamber, where the bridegroom is required to consummate the marriage so that the bed sheet bearing proof of his wife's virginity might be displayed to the village. Khleifi presents the bridal chamber as akin to Foucault's concept of the 'crisis heterotopia': a space constructed as 'other' to the rest of the public realm, in which individuals are able to undergo traumatic processes of transition in private, without threatening the exterior social order.[105] Crisis emerges within the marital chamber when the groom

is rendered impotent by the pressure of his father's expectations, and by the 'emasculating' presence of the Israeli governor.

The allegorical nature of the groom's impotence resonates with Samih al-Qasim's use of the image of troubled marital union in his poem of exile, 'You Pretend to Die', in which he imagines Palestine as the bride and the exiled Palestinian as the groom, but wonders how the 'marriage rights' might be performed when there is such distance between them.[106] An interesting response to al-Qasim's question emerges in this film, though—through Samia's actions. Upon realising her husband's inability to consummate their marriage, the bride decides to take her own virginity by breaking her hymen so that she might produce the evidence required to maintain her groom's honour. In private, though, this usurpation of phallic agency disrupts rather than affirms the patriarchal narrative: 'If a woman's honour is her virginity, then where is the honour of a man?' she asks. In her eloquent analysis of this film, Mary N. Layoun writes that at this moment, 'Samia claims Palestine—herself—for herself. And that taking suggests further a vision of self-possession that is simultaneously sensual, sexual, and personally and communally political'.[107] Yet Samia's claim to sexual agency operates as a paradoxical affirmation of the national narrative, in which any deviation from the 'scripts' of femininity or masculinity must take place within the private rather than public sphere, and in which female sexuality remains invested with collective as well as individual honour. For all of its disorientating dynamics, then, this scene ultimately places national above personal desire—yet it is the bride who chooses to author this narrative, and in doing so, to assume an ambivalent authority as both symbol and agent.

Khleifi's film presents a very different 'story' to that which the *mukhtar* would like his sons to 'learn by heart'. This alternative national narrative is multi-layered and multi-voiced, and reveals many competing forms of

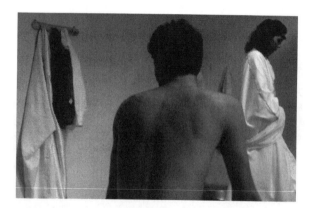

Figure 1.2 Khleifi's gaze turns to the intimate realms of the bridal chamber, where male and female 'scripts' of honour and agency must be privately rewritten. *Wedding in Galilee* (1987), dir. Michel Khleifi. Image courtesy of Sindibad Films and Michel Khleifi.

political and personal desire at stake. While it deconstructs the reductive tropes of colonial and Orientalist discourse, it also destabilises the similarly reductive gender discourse that circulates in the traditional nationalist imagination. This does not, however, render Khleifi's film 'anti-national'. Rather, it invites us to reconsider the symbolic and social construction of nationhood itself, so that, like the villagers in *Wedding in Galilee*, Palestine might also find a way of breaking from the repetitions and confines of history in order to tell the story differently. As Said writes, the desire to break from established narratives (colonial and otherwise) is essential in the task of representing Palestine, and in his own review of the film, he suggests that 'significant treatments of the Palestinian drama can come . . . only from nonestablishment and counterinstitutional viewpoints' such as Khelifi's.[108] Yet Khleifi's own desire to de/reconstruct such a narrative stems from an even deeper belief in the necessity of equality and individuality within the nation. Speaking of his aims in this film, he writes:

> As far as I was concerned, the Palestinian cause was a just one, but [. . .] we had to provide the world with another way of talking about us [. . .] Our weakness . . . derives from Arab society's archaic structures: patriarchy [. . .] [and] no recognition of the person as an individual nor of men's, children's and, above all, women's rights.
>
> These were the axes around which I wanted to organize my work [. . .] By moving towards other individuals, with all our contradictions but no fear, we will recover our faith in the past, the present and the future of our common destiny.[109]

Khleifi's view signifies a radical break from the traditional structures of nationalist discourse. Yet Khleifi is not alone in his creative desire to break from such structures; indeed, his work also points towards a tradition of gender-conscious Palestinian expression that stretches far before him into the past, and ahead of him into the present day. This alternative tradition of gender-conscious expression is explored over the course of the book, through the work of the many filmmakers and authors who, like Khleifi, challenge the structures of inequality and silencing within the nation in search of a truly postcolonial vision of Palestine. Khleifi's work represents an important conceptual starting-point for this study as it reveals that 'nation' is comprised of not one but *many* 'narrations', each of which have their own compelling stories of Palestine to tell.

En-gendering a Postcolonial Feminist Perspective

This chapter has sought to guide the reader towards an understanding of the competing desires and conflicting discursive territories that have come to shape Palestine's narrative construction of nationhood. Drawing on

postcolonial feminist critical frameworks such as gender-conscious use of Said's theory of Orientalism, and of the 'nation as narration', the chapter suggested the ways in which gendered and sexualised dynamics of patriarchal mastery could be seen to underpin colonial and Zionist narrative constructions of Palestine, evident in the classically colonial desire to construct Palestine as 'virgin territory'. These desires found their match, though, in the expressions of deep-rooted connection to this very same territory that emerged from its Arab Palestinian inhabitants. Palestinian nationalist discourse therefore responded directly to the gendered and sexualised tropes of colonial discourse by appropriating the dynamics of masculine mastery and patriarchal power for itself. Consequently, the narrative struggle between colonial and national visions of Palestine emerged as stridently patriarchal, and Michel Khleifi presented us with a potent motif of this power struggle between colonial and nationalist discourse in *Wedding in Galilee*, through the figures of the two patriarchs: the Israeli governor and the Palestinian *mukhtar*. Each of these figures wishes to assert their superior relationship with, and authority over, the 'bride' of Palestine; yet this film also reveals the multiple alternative desires that surface among Palestine's supposed 'brides' and indeed 'grooms' within the Palestinian community, rendering the heteronormative and patriarchal narrative of national desire unstable.

At one level, this chapter has sought to establish the productivity of reading the Palestinian situation as 'colonial', by revealing the ways in which narratives of Orientalist, colonial and national desire come to intersect within, and to shape, a range of Palestinian poetic and filmic expression. These works also, however, reveal the necessity of postcolonial *feminist* critique, for even narratives of apparently emancipating anti-colonial nationalism appear to construct a problematic set of power relations in which women are subjected to forms of discursive silencing analogous to those performed by colonial discourse. To put it simply, the paradox of the 'emancipating' nationalist narrative appears to be that *'women may symbolise the nation, but men represent it'* (italics in original).[110] From a postcolonial *feminist* perspective, this situation is deeply troubling as it reveals the structures of inequality that may circulate around gendered identity within national consciousness. As we saw in the final section of this chapter, though, some forms of Palestinian cultural expression prove remarkably conscious of the gendered power dynamics within the nation itself, and resist this symbolic silencing of women, even at the expense of narrative or national unity. That this highly progressive awareness of the complex interrelationship between colonial, national and gendered narratives should be found in the work of one of Palestine's most seminal filmmakers alerts us to the fact that Palestinian creative consciousness presents a particularly rich arena of postcolonial feminist possibility. In this opening chapter, then, the theoretical tools of postcolonial feminist discourse have helped to illuminate the presence of what might be considered a postcolonial feminist perspective *within Palestinian cultural expression itself,*

as a creative discourse that is already engaged in the task of dismantling and reformulating the gendered structures of nationhood.

In the next chapter, then, we move far beyond the view that 'women symbolise the nation, while men represent it', by turning to the astonishing narratives of personal and political struggle that have emerged from the pens of two of the most prominent female figures in Palestinian literary history: Fadwa Tuqan, and Liana Badr. In these narratives, Tuqan and Badr leave Orientalist and patriarchal desires far behind, and author their own versions of a concept that lies at the heart of Palestinian creative consciousness: resistance.

2 Women Writing Resistance
Between Nationalism and Feminism

Resistance infuses many elements of Palestinian identity and stands proudly as a central preoccupation of much Palestinian literature and film. From the sentiments of courage and defiance expressed by poets during the British mandate such as Abu Salma and 'Abd al-Raheem Mahmoud[1] to the surreal fantasies of affront to Israeli occupation in the films of Elia Suleiman,[2] creative expression has presented a medium through which writers and filmmakers have been able to express resistance to colonial domination and political injustice in a variety of ways. Indeed, much Palestinian creative expression seems to typify the views of the great anti-colonial theorist Amilcar Cabral when he states that 'to take up arms to dominate a people [is to] neutralise and paralyse ... their cultural life'; consequently, 'national liberation is necessarily an act of *culture*'.[3]

Yet as we saw in the previous chapter, cultural discourses of national resistance have often been formulated in vehemently patriarchal terms, which perpetuate deeply conservative structures of 'masculinity' and 'femininity'. Women therefore come to bear the 'burden of representation' within nationalist discourse as the 'symbolic bearers of the collectivity's identity and honour',[4] and as a result, find themselves restricted to highly traditional female identities, roles and behaviours. Women's position within the nationalist symbolic order is paradoxical, though. While female identity seems to be subject to discursive 'colonisation' at the hands of the patriarchal order, it is also through participation within the national symbolic order that women may gain protection and agency. As Elise G. Young writes:

> Nationalist ideology extols women, drawing upon phallocratic myths that sustain the reality of women's colonization. He calls his country 'she.' She is his domain. Within his domain, she stumbles over her occupied body, carrying the flag. The flag promises that she will be rewarded for her suffering. Her role in carrying the banner earns her the possibility of being counted [...] The flag earns her the possibility of protection. It also earns her rights and the right to advocate for rights. Without that, there can be no peace and justice.[5]

Faced with this complex interplay between their colonial oppression as Palestinians, their patriarchal oppression as women and the possibilities of agency afforded by their involvement within the nationalist cause, and indeed by their positions within 'private' realms such as the home, how do female Palestinian creative practitioners formulate and even reconfigure resistance within their writing? This chapter examines the ways in which two female Palestinian authors, the renowned poet and author of an autobiography, Fadwa Tuqan, and the novelist, Liana Badr, negotiate these tensions between nationalist and feminist commitments in their work. As their narratives reveal, these commitments have led to complex struggles that must be fought on many fronts, not only between the patriarchal and feminist or colonial and anti-colonial, but also between allegiances to the nationalist and feminist, the public and private, and the political and personal. The texts explored in this chapter therefore invite us to reconsider the creative conceptualisation of power, oppression and identification within narratives of Palestinian resistance, and in doing so, they draw us towards an imaginative understanding of what it might mean for the women and men of Palestine to be truly free.

The tension between anti-colonial nationalism and feminism has been the subject of much postcolonial feminist debate. Many critics, including Geraldine Heng, have noted that 'feminism' has often been viewed within the Third World as a Western import that is in fact at odds with nationalist commitments, the 'feminist' presenting a 'subversive figure, at once of a destabilising modernity and of a presumptuous Western imperialism'.[6] Indeed, Leila Ahmed writes:

> Colonialism's use of feminism to promote the culture of the coloniser and undermine native culture has ever since imparted to feminism in non-Western societies the taint of having served as an instrument of colonial domination, rendering it suspect in Arab eyes and vulnerable to the charge of being an ally of colonial interests.[7]

This was the case among anti-feminist nationalists in Egypt, for example, who claimed that calls for women's emancipation at the turn of the nineteenth century were the product of French and British interference in the region, and to be rejected on these grounds. Indeed, contemporary postcolonialists such as Spivak have also claimed that there is a certain 'inbuilt colonialism of First World feminism toward the Third',[8] evident in the universalising, culturally insensitive assumptions of 'global sisterhood' displayed by some First World feminists, who adopt a gendered version of the 'colonial rescue fantasy' in their approach to non-Western women. Yet as Kumari Jayawardena notes, 'women's movements do not occur in a vacuum but correspond to, and to some extent are determined by, the wider social movements of which they form part',[9] and it is possible to

identify the emergence of feminism(s) that can be considered distinctive to, and in tune with, the socio-political context of nations within the Middle East. Miriam Cooke makes the pertinent observation that the emergence of feminism in the Arab world in fact coincided with and arguably sprung from the struggles for liberation from colonial rule taking place in many Arab nations, which led to a broader desire for political agency, freedom and responsibility.[10] Thus, Nawar Al-Hassan Golley contends that certain strands of feminism (or feminisms) can 'be seen as indigenous' to the Arab world, 'an inevitable result of [. . .] the struggle between the dying traditional, religious, feudal Ottoman way of life and the rising modern, secular, capitalist European way of life'.[11] Consequently, Arab feminism embodies a 'double struggle' that takes place 'internally against the old religious, social, and economic order and externally against European colonisation'.[12]

While feminist consciousness may have developed hand in hand with nationalist resistance, that is not to say that they have always operated under the same auspices, nor that they have always been emphasised equally, and there are many tensions entailed in this 'double struggle'. Abu-Lughod observes that Egyptian conservative nationalists and Islamists keen to return to an idealised pre-colonial order found the internal, gendered element of this struggle deeply threatening to their own patriarchal systems.[13] Yet other nationalist reformers in Egypt 'locate[d] women's emancipation . . . at the heart of the development of nation and of society',[14] viewing it as an integral element of anti-colonial resistance, which was believed to be attainable only through the modernised nation. Indeed, opposing views on the necessity and nature of modernity arguably lie at the heart of the relationship between feminism and nationalism. Women have not always allied themselves so neatly with either of these positions, however. 'Islamic feminists', for example, positioned themselves differently by arguing for women's rights not on the grounds of modernisation, but on the need to return to the original commitments to justice, dignity and equality enshrined within the Qur'an, which they believe have been desecrated through the patriarchal socialisation of the Arab world.[15] Another prominent mode of struggle for gender equality has been through direct participation within nationalist struggle itself. Women have played vital roles in the liberation struggles of many Arab nations, including Syria, Yemen, the Sudan, and most recently, Egypt and Libya, during the 'Arab Spring'.[16] Indeed, in his classic study of the Algerian anti-colonial struggle, Fanon identified the multiple roles that Algerian women performed, not only through the 'traditional' realms of familial support but also through active participation in militant struggle.[17] While the ultimate goal of women's participation might have been that of gender equality, realised through the elevated profile of women within a liberated and reformed nation, the banner under which such battles tended to be fought were predominantly nationalist in nature—a strategy which, in the Algerian context, resulted in women's rights being considered secondary

and ultimately sidelined.[18] Yet as Suha Sabbagh writes, this mediation of any challenge to patriarchal norms through 'nationalist work' (*'amal watani*) has also been used as a 'form of "protection" to feminist objectives'.[19] Indeed, as noted in the introduction to this book, women have sometimes found it more productive to disassociate themselves from the specific cultural and political implications of the term 'feminism', seeking to advance their cause instead under the banner of less separatist and confrontational terms such as *tahrir al-mara'a* (women's liberation) which sit more easily within Palestinian society.[20] This is not to say, though, that gender inequality is felt or fought against any less keenly than it is under the auspices of a clearly labelled 'feminism'. Rather, it indicates that resistance to patriarchal authority and the struggle for gender reform are positioned in relation to nationalism in a range of nuanced, variously articulated and often highly strategic ways. Turning now to the Palestinian context in more detail, it becomes clear that any theorisation of a Palestinian postcolonial feminism must be attentive to the careful inflections, alliances and distances that are constructed between nationalist and gender-consciousness.

From the outset, nationalist and feminist commitments have been closely, if at times problematically, aligned in the Palestinian context. Ellen L. Fleischmann notes that while the birth of the Palestinian Women's Movement can be seen as 'the first articulation of Palestinian feminism', the women involved 'did not define themselves solely by gender, nor did they perceive a sharp break between nationalism and feminism'.[21] The Movement began in 1929 as a *political* mobilisation of Palestinian women, many of whom had been involved in charitable organisations, committees and protests against British policies. Tactics of the movement included participation in demonstrations, press and letter-writing campaigns in protest at the British mandate and social and development activities. Such activities focused mainly on efforts to end the British mandate and establish an independent Arab nation, but many of the strategies employed by the women can be considered implicitly feminist for the way in which they 'manipulat[ed] . . . traditional gender norms',[22] seeking to achieve their goals through fluid performances of gender that transformed potentially oppressive gender norms into forms of agency. One strategy, for example, was to insist on the 'traditional rights' of Arab women to live in segregation from men, so that British violations of this gender segregation (by 'forcing' them into protest alongside men) could be presented as morally repugnant, while at other times, the women would present themselves as active, independent, 'modern' women in order to gain support for their cause in the West.[23] This latter line was also taken by many male nationalist thinkers, such as Constantine Zurayak, who argued that the 'primitive, static mentality' of a feudal, tribal Palestine was to blame for their loss to the 'progressive, dynamic mentality' of Israel in 1948;[24] thus the *Nakba* of 1948 (which also saw the nationalists' opponent shift from the British mandate to the State of Israel) ironically provided the impetus for

a project of modernisation that would include the restructuring of gender norms in Palestinian society.[25]

In her essay '"The Women's Front": Nationalism, Feminism, and Modernity in Palestine', Frances S. Hasso explores the development of women's quest for emancipation within the nationalist struggle, and she concludes that much of its success was due to the fact that they 'worked within the limits set by a patriarchal gender order' so that men would not be threatened by their public activities.[26] The decision to operate primarily under the guise of nationalism in order to further women's goals was taken by many activists, including the prominent political figure Hanan Ashrawi, who stated her confidence in nationalism as a framework through which women's participation in decision-making processes and broader emancipation in society could be achieved.[27] That is not to say, however, that such participation did not bring about tangible improvements in women's social roles and lives. Hasso's research shows that women who participated in the Palestinian Federation of Women's Action Committees (an offshoot of the Democratic Front for the Liberation of Palestine established in the late 1970s and one of the most successful women's groups) believed that simply encouraging women to take *action* 'contributes to personal liberation for women . . . [by] helping to break down the isolation and ignorance that . . . had ensured women's acquiescence in patriarchal oppression'.[28] This is similar to the forms of consciousness-raising and the challenges to traditional divisions between public and private spheres brought about by earlier women's social participation.

Giacaman writes that the *Intifada* was not only a period of renewed resistance to the Israeli occupation but a 'revolution of rising expectations amongst Palestinian women . . . a consciousness change'.[29] This consciousness change stemmed from two main sources: firstly, the fact that women were able to participate actively as resistance fighters during the *Intifada*, affirming women's sense of independence and their own abilities; and secondly, that as a result of their active participation, attitudes towards the female body (and in particular, towards women's sexual honour) were forced to change.[30] This latter phenomenon appears in *Intifada* discourse through the figure of *Umm al-Asirah* (the mother of the female political prisoner), a figure who is radical, according to Nahla Abdo, because she not only appropriates the traditional nationalist figure of 'the heroic mother' who resists through the sacrifice of her sons, but because she also radically destabilises the gender structures of the honour/shame discourse that circulates around women's sexuality in many arenas of Palestinian society.[31] Whereas sexual violations or indiscretions of women are traditionally deemed to damage the honour of the whole family (meaning that men are expected to guard women's sexual honour closely), women's imprisonment and potential violation during the *Intifada* came to be seen as a source of honourable sacrifice for women, in a way that paradoxically released them from patriarchal expectations.[32] Certainly, reading the ultimate patriarchal violation—rape—as 'liberating' is highly troubling. Yet it is clear that women's

own suffering and resilience within the *Intifada* resulted in forms of agency previously unavailable to them, and energised their nationalist commitments (as we see in Buthina Canaan Khoury's documentary *Women in Struggle*, which conducts rare interviews with four female Palestinian ex-detainees in which the women speak about their experiences in prison, and the way in which this cemented their subsequent desires to participate within the nationalist struggle).[33] Thus women's direct participation in the nationalist struggle not only led to a widened spectrum of possible female roles and identities, but profoundly altered the gendering of nationalist discourse in itself.

Today, the lasting social gains of the first *Intifada* are recognised as somewhat limited within a post-Oslo period when the Israeli occupation continues to limit women's access to resources, and in which the establishment of the Palestinian Authority has brought about a profound alteration in the forms of feminist activism available to women. In particular, Islah Jad notes that the Palestinian Authority has gone to great lengths to 'negate the image of woman as militant [and] ... promote the ... early nationalist ideal of woman as fertile, self-sacrificing and steadfast',[34] while it has also encouraged a shift towards formalised and professionalised units of feminist activity, many of which operate through NGOs.[35] While patriarchal society certainly did not crumble during the *Intifada*, it nevertheless led to an awakening among many women, who came to view themselves as potential political leaders and agents as well as followers, with the power to remould the gendered structures of nationalist struggle. Indeed, it was during the *Intifada* that independent feminist centres such as the Women's Studies Centre in Nablus and the Women's Centre for Legal Aid and Counselling in Gaza were established, indicating a newfound confidence among women to assert themselves as forces for national development, and as gender-conscious agents.[36] It would take another seven years from the start of the *Intifada* for a decisively feminist statement of self-determination to appear, but this finally occurred in 1994 when the Palestinian Women's Charter was drawn up by a number of different women's organisations and presented to the Palestinian National Authority for inclusion in the constitution. This document was distinctive in its demands for reforms to laws that discriminated against women, and for the new state's compliance with international women's rights laws.[37] It also, according to the translation offered by Barbara Harlow, declared Palestinian women's unified determination

> to abolish all forms of discrimination and inequality against women, which were propagated by the different forms of colonialism on our land ... and ... reinforced by the ... customs and traditions prejudiced against women, embodied in a number of existing laws and legislations.[38]

This declaration situates the struggle for women's rights as dually resistant to the inequalities perpetuated by Israeli occupation, and those enforced

by patriarchal structures and institutions within Palestine. Thus it presents a nuanced articulation of feminist sentiment, and establishes the complex power play at stake for Palestinian women, a theme that emerges in all of the texts examined in this chapter.

That Palestinian women writers should explore these issues in their work, particularly during periods when nationalist resistance was blossoming, seems inevitable. What is extraordinary, though, is the variety of forms in which nationalism and feminism appear, and the distinctive relationship that each author constructs between them. For each of the authors examined within this chapter, 'resistance' takes a different form, and writing plays a different role in their own particular struggles. In the first section of this chapter, entitled '"I, Myself, Am a Poem": Interior Struggle in Fadwa Tuqan's *A Mountainous Journey*', the autobiography of one of Palestine's best-known poets, Fadwa Tuqan, becomes the battleground on which the tensions between nationalist and feminist, public and private allegiances are fought. While Tuqan did not identify as 'feminist', her concerns can be seen as indicative of early, emergent forms of 'invisible' feminist consciousness. In contrast with Tuqan's deeply personal inner struggle, the second section of the chapter, 'Smashing the Worn-Out Idols? Rewriting Resistance in Liana Badr's *A Compass for the Sunflower*', explores the portrayal of public and political female militancy displayed in Badr's novel, which rewrites the classic 'resistance narrative' by examining the competing structures of national and gendered agency that emerge among young women and men involved in the resistance, inviting, among other things, a gendered reassessment of postcolonial theorisations of armed struggle. Together, these works offer a compelling insight into the differently constructed battles in which these prominent female authors have had to fight, in order to imagine what it might mean to be free as Palestinians, and as women.

'I, Myself, Am a Poem': Interior Struggle in Fadwa Tuqan's *A Mountainous Journey*

Fadwa Tuqan is recognised as a 'major lyrical and outstanding nationalist'[39] writer within the revered tradition of Palestinian poetry,[40] a figure who possesses an almost 'mythological image . . . as a resilient woman who fought against British and Israeli imperialism by the power of her poetic discourse' in Palestinian cultural consciousness.[41] Though she began publishing highly acclaimed poems in the 1940s, many of these displayed a reflective introversion that was unusual during a highly nationalistic period of poetic expression.[42] It was during the 1960s and 70s that a political shift took place in Tuqan's poetry, and she began to produce works of such nationalistic power that the former Israeli minister of defence, Moshe Dayan, reportedly stated that 'one Fadwa Tuqan poem was the equal of [i.e. enough to recruit] twenty commandos'.[43] Yet in 1978, a very different creative voice emerged from

Tuqan—and it came as a shock to a Palestinian audience accustomed to the nationalist commitments of her poetry. This voice took the form of *sirah dhatiyyah* (autobiography)[44] and it revealed a life of deep inner torment and struggle; a 'mountainous journey' comprised of 'struggle, depravation and enormous difficulties'[45] undertaken not in the rocky terrain of public national struggle, but in the private, secluded world of the patriarchal home where, according to Tuqan, 'the female lived out her dark, pinched-up existence' (106). Tuqan's competing voices raise a number of questions for the postcolonial feminist reader. What is the relationship between Tuqan's public poetic persona and her private, autobiographical intimations? What might the 'inner journey' that she undertakes in the text reveal about the personal, gendered and national landscapes of Palestine? And to what extent might Tuqan's account of her 'mountainous journey' be read as a prototype of postcolonial and/or feminist commitment? By tracing the difficult route that Tuqan follows, from secluded girlhood to politically astute womanhood, it becomes possible to map out the distinctive path towards emancipation that she seeks as a Palestinian woman and as a poet.

A Mountainous Journey was first published in serialised form from 1978 to 1979 under the title *Rihla Jabaliyya, Rihla Sa'ba (A Mountainous Journey, A Difficult Journey)* in the Palestinian journal *Al-Jadid*, and was subsequently published in English translation in 1990 as part of Salma Khadra Jayyusi's Project of Translation from Arabic literature.[46] Completed in the late 1970s, it emerged at a time when an increasing number of prominent Palestinian female authors and public figures were publishing autobiographies, including the revolutionary Leila Khaled, and the journalist and activist Raymonda Tawil.[47] While, as stated in Fedwa Malti-Douglas' introduction to the text, the phenomenon of Arab women's autobiographical writing is nothing new,[48] the act of producing an autobiography, 'the ultimate site of confession and self-exposition',[49] nevertheless remains a daring act for a woman (particularly for Tuqan whose public, poetic voice establishes certain political expectations) as it opens the text up to either the traditionalist view that women's writing is 'too personal' and does not warrant serious attention,[50] or to general disapproval at the sharing of 'private' information about the family within the pubic sphere. Yet her text also acts as a forerunner in what would later become a vital genre in Palestinian culture: personal account literature, in which the narrative of the individual comes to function in the service of collective memory.[51] Tuqan's autobiography complicates this usual function, however, for rather than constituting a public narrative that supports the collective memory of events, hers is a deeply personal account that reveals sources of schism, even dissent from the official national narrative. For Tuqan, this fraught relationship between the personal and political, public and private, stems from one key source: her identity as a woman.

Tuqan does not identify herself as a feminist or even as a writer concerned directly with gender issues, and nor has her Palestinian readership tended

to interpret her in these terms. Instead, she has been celebrated as a poetic voice on a voyage of self-discovery—a line enforced in the Arabic book edition bearing an introduction by the renowned Palestinian poet Samih al-Qasim, which can be interpreted as an act of mainstream, male validation of the text.[52] Yet many elements of *A Mountainous Journey* can be interpreted in terms of what Badran and Cooke term 'invisible feminism'. This phenomenon, they write, emerges at times when 'patriarchal authorities suppress public feminist movements' and 'private . . . authorities within the family . . . enforce silence', meaning that while 'feminism [is] removed from sight . . . it is not necessarily extinguished'.[53] Instead, 'invisible feminism' takes the form of actions and expressions that may not be labelled as feminist or even recognised as such by the person enacting them, but which nevertheless seek emancipation for women and so participate within wider feminist discourses in circulation. Tuqan's autobiography is replete with 'invisible feminist' acts, and one of the key forms in which they appear is through her insistence on the political importance of her personal life, which refutes the nationalistic view of the personal as secondary to the political. The now iconic statement, that 'the personal is political', was first formulated by second-wave U.S. feminists of the 1960s and 70s, who were keen to break down the distinction between women's personal feelings and experiences, and their 'selfless' public activism. That there should ever have been a distinction drawn between these constructs is a source of some amazement to many Third World feminist critics, who have long insisted on the close-knit connection between conditions of domestic disenfranchisement, and women's desire for political involvement.[54] Interestingly, one key feminist whose work came to be associated with the slogan in the U.S. was Carol Hanisch, who argued that the 'consciousness-raising' groups that became popular in the U.S. during the late 1960s and 1970s, in which women shared their feelings about their individual lives, were not simply forms of personal therapy but of political significance as they revealed the varied but socially pervasive forms of oppression experienced by women.[55] This validation of women's innermost feelings as a topic of public concern and political significance is also the stance adopted by Tuqan in her autobiography, in which she imagines her readership as 'wayfarers on arduous paths' (11) similar to her own. Although emotional revelation marks Tuqan's text from the outset, her work is also resistant to the idea that her experiences can be read as indicative of all Palestinian women; rather, she treads carefully on the path between the personal and the political, leading her to a destination that is uniquely liberating, but performed through an insistence on individual rather than external or collective struggle.

The 'mountainous journey' that Tuqan describes in her autobiography begins with her birth into a wealthy, prestigious and highly conservative family in Nablus in 1917. Though Tuqan records that this was the year in which the British completed their occupation of Palestine, it is a more

personal act of apparent betrayal that creates the young Fadwa's sense of disenfranchisement in the world. She records that her mother, overwhelmed by the burden of six children already, had tried to abort her: a controversial revelation, given the reverence afforded motherhood in Palestinian society. From an early age, then, Fadwa experiences herself as partially negated and unwanted, emotions that she is no doubt attempting to lay to rest through the act of 'birthing' a complete narrative account of her life. Here, there is an obvious political analogy to draw between Palestine's emergence into an era of hostility and Tuqan's own entrance into the world. Yet the structures of oppression that negate the young Fadwa's existence are not, in her mind, those of the British colonial presence, but of another oppressive force experienced within the private realm of the home: her family.

Samih K. Farsoun describes the family, or *al-'a'ilah*, as the primary source of 'economic, psychological, and social security' within the often insecure Palestinian landscape, and as 'the basis of Palestinian identity'.[56] Many studies have noted, however, that in the period of the British mandate, and even more so post-*Nakba*, both of which provide the backdrop for parts of Tuqan's autobiography, the construct of the family underwent significant change as traditional models of the extended family, in which several generations would live together, began to disintegrate and give way to more insular forms of family life due to modernising influences and to the fragmentation of Palestinian society.[57] Fadwa's emphasis on family life within her text therefore presents an interesting dramatisation of this process, but even in its more insular form, patriarchal authority remains a structural principle of the family. As in many other cultures, the Palestinian family is organised according to a patriarchal and patrilineal structure, in which the father stands as the male head of the family, to be replaced by the eldest son upon his death. The mother, meanwhile, holds authority as a senior figure within the family, though this is usually limited to authority over the women and girls in the home. It is within the family homestead that these gendered power structures are affirmed in spatial terms. As Fatima Mernissi writes in her study of Arabo-Muslim culture, *Beyond the Veil: Male-Female Dynamics in a Modern Muslim Society*, the construct of the family provides a point of contrast from the *Ummah*, or community of Muslim believers. While the *Ummah* is a spiritual, communal, public realm, the family is the private realm where more 'worldly' contact occurs between the sexes; thus the public realm is accessible primarily to men, while the private, domestic realm is inhabited by women. Such spatial segregation rests, Mernissi explains, on the Muslim view of female sexuality as capable of producing *fitna*: social disorder, chaos, or strife.[58] So powerful is *fitna* that men must be protected from it through segregation of the sexes. Thus women in conservative, traditional Arabo-Muslim families are traditionally confined to the domestic realm, with any interaction into the public realm carefully regulated either through veiling or male chaperoning, particularly for women of the upper classes.[59] While many

liberal Western feminists have tended to read this system of gender segregation as unequivocally oppressive of women,[60] Mernissi argues that in fact, 'the seclusion of women [. . .] is seen by many Muslim women as a source of pride',[61] a way of protecting the purity of the female body, of affirming the power of women's sexuality and of designating a separate arena of authority to women. Yet within her autobiography, Tuqan portrays the secluded realm of the home as anything but empowering.

Despite the image of expansive travel evoked in the title of her autobiography, the 'mountainous journey' undertaken by Fadwa is performed within a highly restrictive domestic arena. Evoking classic images of female seclusion, she states that 'the reality of life in that bottled-up harem [was] humiliating submission' (106); for rather than the private realm operating as a form of sanctity, it instead clips the young, creative and romantic Fadwa's wings, confining her to a home that she views as a 'large coop filled with domesticated birds' in which it is women's vocation to 'hatch chicks' and feed others (110). We learn that Fadwa's confinement to this realm emerges precisely in accordance with the discourse of sexual regulation identified by Mernissi. As a thirteen-year-old girl, Tuqan is given a jasmine flower by a sixteen-year-old boy, much to her delight, and she confides to the reader the lofty romantic feelings that accompanied this event. When this becomes public knowledge, though, her brother Yusuf proclaims it a slur on the family's reputation.[62] Fadwa is taken out of school and confined entirely to the home in order to control her burgeoning romantic and erotic self-awareness, and to restore the family's honour. This is a move that will later prove deeply ironic, as one of the things for which the adult Tuqan's poetry will become best known is her 'liberation of the erotic' as a legitimate subject matter for a female poet.[63] At this stage in her life, though, the young Fadwa's removal from school, from the public realm and from intellectual stimulation condemns her to physical and mental imprisonment, and Tuqan describes herself as 'a wounded animal in a cage, finding no means of expression' (107), which instead bears its 'savage claws of hatred created and fomented in us by those who rob us of our freedom' (79). Here, Tuqan adopts a voice similar to that of Fanon's 'auto-destructive' colonial subject described in *The Wretched of the Earth*:

> At this fresh stage, colonial aggression turns inward in a current of terror among the natives [. . .] If this suppressed fury fails to find an outlet, it turns in a vacuum and devastates the oppressed creatures themselves.[64]

Indeed, Tuqan herself draws a similar (if perhaps culturally misguided) analogy, based on structures of social oppression, between the dancing of African Americans 'to a loud drumbeat to get relief from external pressures' (77) and her own (much-discouraged) love of dancing, singing and poetry as outlets for her repressed individuality. While turning inwards leads to self-destruction according to Fanon, though, inner struggle will later become

a vital means for Fadwa to liberate herself, as it is through this act that she reaches the realms of her poetic imagination.

There is a problematic sense in which Tuqan's account of her patriarchal 'imprisonment' might be seen to affirm the Orientalist assumptions of some Western feminist discourse, which would claim that accounts such as Tuqan's are typical of Arabo-Muslim women's experiences, revealing them to be a 'homogeneous oppressed group'.[65] Yet Tuqan's 'invisibly feminist' critique is in fact highly attuned to the individual and social nuances of her situation, presenting the careful sense of contextual awareness that, according to Mohanty, constitutes a vital element of responsible postcolonial feminist critique.[66] Perhaps the boldest rebuff to any potential Western feminist 'superiority complex' emerges in her description of her mother's feminist activities. While her mother was one of the first women to unveil in Nablus and a member of the women's committees, she was also forbidden from public demonstration by Fadwa's father, and subject to the same domestic seclusion as Fadwa, a seclusion that caused such deep unhappiness that she became complicit in Fadwa's oppression by venting her frustration against her through emotional cruelty. Tuqan therefore questions the reach of external gestures towards modernity within the private sphere. She also deconstructs the 'homogeneous oppression' of Palestinian women by recognising that her own plight is not simply premised on gender relations, but is also the product of the distinctive conservatism deemed fitting to a wealthy family of high status. Here, she seems to affirm Marxist analyses of the so-called 'woman question', which suggest that while working-class women are more thoroughly exploited than their middle- and upper-class counterparts, they are also freer to fight for social change as they are less bound by the need to maintain social prestige, and hence by social convention.[67] Indeed, Tuqan describes the unveiled country women who carried arms and food to the rebels in the mountains during the Arab Revolt against the British with immense envy. For Tuqan, their greater freedom of movement offers them meaningful possibilities of political engagement that stand in stark contrast to the 'trivialities' of female community within her home (110). Fadwa's own oppression, then, is constructed around a complex intersection of subject-positions relating to class, colonialism and gendered power structures within her home that cannot be reduced to an essential condition of 'the Palestinian woman'.[68]

Just as Tuqan's oppression raises complex questions about the relationship between the political and personal, public and private, male and female, so does her emancipation. Tuqan's psychological liberation from the gendered confines of her home takes place through the mental escapism of daydream and later, through poetry: a 'private realm' that could not be 'invaded' (51). As Lindsey Moore argues, this can be read as a process through which Tuqan manages to 'reclaim "self-seclusion"' though creative means, by 'transform[ing] [her] isolation into a "bridge" towards freedom'.[69] Poetry

certainly seems to achieve this transformation, as Tuqan's descriptions of her life once she encounters poetic writing for the first time shift from those of domestic drudgery to mental images of birds in flight, hills and trees: the natural landscape of her inner 'mountainous' struggles. Yet her access to poetic discourse is mediated through her brother Ibrahim, a renowned scholar, poet and 'voice of the Palestinian people' (71), whose somewhat traditional and nationally based views on poetry create a number of conflicts in Tuqan's search for her own poetic voice.[70] Ibrahim is described as broad-minded and endlessly kind to his sister, and his decision to teach her to write poetry seems to be founded in a genuine desire to validate her intellectual and creative talents as a young woman. He begins, for example, by teaching Fadwa to recite poetry by famous female elegiac poets. While this could be read as a statement of female solidarity and creative legitimacy, it also locates Fadwa's early access to poetry firmly within the tradition of *ritha'* (elegiac verse), in which poetesses composed eulogies to male relatives, an acceptable subject matter for a female poet.[71] Fadwa, though, develops a taste for the more emotive verse of poets such as Ibn al-Rumi, dismissed by her brother as 'too personal' in his concerns. Fadwa is therefore 'chaperoned' into the public realm of poetic discourse by male family members, including by her father following Ibrahim's death, who demands that she produce poetry in response to the political events that he follows in the public sphere. The hypocrisy of his demand is not lost on Tuqan, and in her mind, she raises what might be described as an implicitly feminist voice of personal dissent:

> A voice from within [me] would rise up in silent protest: *How and with what right or logic does Father ask me to compose political poetry, when I am shut up inside these walls? I don't sit with the men, I don't listen to their heated discussions, nor do I participate in the turmoil of life on the outside. I'm not even acquainted with the face of my own country, since I'm not allowed to travel.* (107)

Tuqan's alienation from the political sphere, and her consequent lack of connection to anti-colonial sentiment, therefore emerges as a product of patriarchal dominance. It is also through this alienation, though, that Tuqan begins to question the dominant Palestinian poetic tradition whereby poets are expected to privilege the political over the personal. Instead, Tuqan performs a subversive assertion of selfhood in her work, stating that 'a poet is, above everything else, a person before being political' (125).

This emphasis in Tuqan's poetry can be read as an implicitly feminist validation of the personal as a source of public and political concern in itself. Embracing her romantic tendencies and deep emotions, she begins to write love poetry, publishing it under the pseudonym 'Dananeer': the name of a slave-girl poetess, who, like many other such girls owned by the upper classes in the Middle Ages, composed and sang her own poetry. While there is a

certain irony to the fact that such poetesses were subjugated and sexualised figures,[72] Fadwa legitimises her appropriation of this discourse by stating that according to a male critic, Danaaneer was proven to be 'honourable and chaste' (73), thus proving that women could write of love without their honour being compromised (a view later affirmed in the Egyptian singer Umm Kulthum's portrayal of Danaaneer in a film made about her in the 1940s).[73] Tuqan's desire for male approval lingers in this careful justification, but with the emergence of the avant-garde Iraqi poetess Nazik al-Mala'ika in the 1940s, Tuqan finds she has a new role model to legitimate her break from tradition and she begins writing in free verse. Gradually, her own voice, unmediated by male influence, begins to emerge. By writing love poetry, though, Fadwa does not consider herself to be composing 'feminine' verse, but finding her own revolutionary voice: 'Love ... is the affirmation of my crushed humanity and its very salvation' (115), she writes; it is 'liberation', a 'merging with the "other"', an 'intensifying' of humanity (116). This is not the language of a sentimental poet but of a courageous woman undertaking an inner struggle. Indeed, her poem 'In the Flux'[74] reveals how this connection to the romantic, even erotic constitutes a crucial stage in Fadwa's journey to emancipation, as this poem describes her own sexual awakening as akin to the blossoming of the natural, external landscape—an imaginative terrain far removed from the rocky, barren existence of her former years. Intimate as Tuqan's tone may be, it can also be read as a daring validation of the desires of the private female body as legitimate rather than threatening and of public as well as private value.

This personal break-through coincides with another, more literal liberation from patriarchal rule through the death of her father in the year of the *Nakba*. Traumatic as both these events may be, Tuqan also locates a paradoxically liberating potential in them, writing that 'when the roof fell in on Palestine in 1948, the veil fell off the face of the Nablus woman' (133). Here, she identifies the rupture of traditional Arab society instigated by the *Nakba*, which led to social self-scrutiny and a desire to modernise Palestine in its quest for national independence. One result of this was the encouragement of women, particularly those in the upper echelons of society such as Tuqan, to enter into the public sphere and participate within the struggle, resulting in what Tuqan describes as her 'emergence from the harem' (117). Ultimately, though, it would take another extreme shift in Palestine's political environment for Fadwa finally to experience the political as personal. Writing of the June war of 1967, which saw the remaining portions of Palestine in the West Bank and Gaza Strip fall to Israeli occupation, Tuqan states that these events 'brought back to me my sense of being a social entity' (80). Though Tuqan wrote her autobiography in the late 1970s, she tellingly concludes this text with extracts of her diary from 1966–1967, indicating that this is the final stage in her 'mountainous journey'. These extracts are no more than small fragments, but they indicate a significant shift in her poetic and emotional consciousness. Though

hampered by writer's block with her poetry, she notes that she has begun to experience patriotic feelings inspired by the singing of the female musician Fayrouz: 'When I hear her songs about my country, my emotions rise and glow' (185), she writes, indicating that this is a journey into the political world in which she is not led by the demands of men, but inspired by the feelings of a creative, passionate woman. Yet there is no doubt that her feeling for the political realm stems from her personal experiences. For the first time, the public sphere finally seems to mirror Tuqan's private world: one of imprisonment, and of subjugating, occupying forces. Palestine, in other words, has become 'feminised' under occupation, and it is suddenly Tuqan rather than her male counterparts who possesses a deep connection to the psychological conditions of the external world. As we see in her poem 'Song of Becoming', an ostensibly political poem about the growth of revolutionary sentiment among a new generation, it is not only the young men who have blossomed into powerfully self-possessed subjects through their participation within the cause, but Tuqan herself (10); for as she writes in the final lines of her autobiography, 'all of a sudden I, myself, am a poem', though one 'burning with anguish, dejected, hopeful, looking beyond the horizon!' (191). The competing forces in her final statement—anguish and hope—reveal that the tensions between the inner and exterior, public and private, postcolonial and feminist are not eliminated over the course of Tuqan's 'mountainous journey'; rather, she learns to accept that they are inherent to her existence and her voice.

The postcolonial feminist implications of Tuqan's work are quite unique. While she frames her journey as one that takes her from the inner realms of her oppressive home to the external world of political commitment, the 'invisible feminist' struggles articulated within the text are absolutely crucial to realising this final goal. Tuqan has to find ways to write and think outside of patriarchal discourse before she can contemplate connecting with political struggle, conjuring her journey as a uniquely female, and in many ways feminist, quest for an anti-colonial politics. Yet perhaps the most powerful element of her autobiography lies in her willingness to reveal the internal contradictions and hypocrisies within the masculinist discourse of nationhood, and the limitations of apparently feminist routes to emancipation. Instead of relying solely on either of these routes, Tuqan's journey is founded in an absolute integrity of feeling and belief, a trust in her own heart to navigate the best route forwards. Though Tuqan does not label it as such, this gruelling but revelatory process can be related to the potentials of postcolonial feminist discourse, which similarly acknowledges the unique nature of every journey towards national and feminist, personal and political emancipation, and the central role that creative expression can play in this. Unique as Tuqan's journey may be, though, this postcolonial feminist interpretation of it also reveals paths towards emancipation that may be followed by others, who may one day also find themselves summoned to undertake their own mountainous journeys. When this time comes, perhaps these 'wayfarers on arduous paths'

(11) will hear Tuqan's voice echoing to them through the mountains, just as Fayrouz's songs had once called to her, revealing the way forwards.

Smashing the Worn-Out Idols? Rewriting Resistance in Liana Badr's *A Compass for the Sunflower*

The quest for postcolonial feminist agency takes a dramatic shift from inner struggle to external resistance in Liana Badr's 1979 novel of the Palestinian resistance, *A Compass for the Sunflower* (*Bousala min Ajl 'Abbad al-Shams*). Badr was born in Jerusalem in 1952 and raised in Jericho, but fled with her father to Jordan during the 1967 war and then to Beirut following the Black September of 1970, where she spent eleven years before escaping the Israeli invasion of 1982 by moving to Tunisia. She finally returned to the West Bank in 1994.[75] She is no stranger to political and cultural activism herself: during her time as a student at the University of Amman, she became involved in the Palestine Liberation Organisation, and while in Beirut, she worked with women's organisations in refugee camps. Upon her return to Palestine, she began working for the Palestinian Ministry of Culture. Many of Badr's works (which comprise both fiction and film) reflect these diasporic dislocations,[76] and *A Compass for the Sunflower*, which travels between timeframes and locations in the West Bank, Jordan and Lebanon, is no exception. Yet the focus within all of her works is on the Palestinian revolutionary struggle. This struggle may, at times, take place far from the homeland, but it nevertheless operates as a guiding force in her characters' lives, just as it has in Badr's own. In *A Compass for the Sunflower*, the character Shaher sums up this view neatly when he states that 'there are a lot of questions to be answered [. . .] [but] the one certainty is Palestine'.[77] This constant focus on political struggle means that it is possible to define Badr's writing according to what Barbara Harlow, drawing on the work of the Palestinian author and political figure Ghassan Kanafani,[78] terms 'resistance literature': literature produced within an arena of struggle, by authors actively engaged in that struggle, who express their ideas and feelings about resistance and liberation through their texts.[79] Following the theories of Cabral, Kanafani concluded that cultural expression is as important a form of resistance as armed struggle itself (and here, it is important to note the *mutuality* of these things), as like armed struggle, it offers an affirmation of collective political identity and presents a powerful narrative of resistance to colonial domination, which operates in part through the production and control of discursive representation.[80] Badr herself appears to concur with this view, as she states in interview that one of the ways in which the 'Palestinian movement outside [i.e. in exile]' formulated resistance was to 'work a lot in the cultural field to build the independent Palestinian characteristics in literature and arts'.[81] Badr, then, locates her personal, literary resistance firmly within the broader political battlefield.

While Badr clearly views her literary expression as part of a wider collective struggle, *A Compass for the Sunflower* also complicates the clear-cut 'resistance narrative' by raising some unsettling questions about the relationship between gendered and nationalist agency. In this text, Badr presents us with an array of different characters scattered across various sites of Palestinian experience (Jericho, Nablus, Amman and Beirut), who are all involved in some form of *muqawamah* (resistance) for the Palestinian cause. Despite the presence of iconic male *feda'iyeen* (resistance fighters) in the text, Badr focuses her novel through the first-person narrative of a young woman named Jinan, who is the metaphorical 'sunflower' in need of a 'compass' in the novel's title, constantly turning in different directions in search of (en)light(enment), growth and a way forwards for both herself and for the Palestinian resistance. This unusual focus on a young woman, a figure usually considered peripheral to or anomalous within the resistance, can be seen as an attempt to relocate revolutionary struggle within a gender-conscious framework of reference, and even performs what one character within the novel describes as the 'smashing' of 'worn-out idols' (77) through its challenge to the gendered symbolism of nationalism. Consequently, Badr's (en)gendering of the national struggle enables her to rewrite the 'resistance narrative' in ways that can be considered postcolonial feminist in nature.

Jinan, the young woman at the heart of the narrative, is described as a naturally spirited 'tomboy' of a girl who, from her earliest schooldays in Jordan when she is punished for organising a demonstration in support of Palestine, demonstrates an unyielding commitment to the Palestinian resistance by participating in numerous fields of activity: from nursing in the first aid centres of Jordanian camps to armed resistance among the *feda'iyeen*. Jinan's own diasporic movements map out a common trajectory in traumatic Palestinian existence (Jinan, like many Palestinians, is forced to flee the West Bank for Jordan during the June war of 1967, then flees from Jordan for Lebanon following the Black September in 1970, which ousted the Palestinian resistance from Jordan),[82] while her actions also map out the multifarious forms of resistance in which women have participated. Thus Jinan comes to represent a Palestinian 'everywoman' whose individual experiences are symbolic of the broader struggle. Some of Jinan's activities, while undertaken in the 'masculine' public sphere, assume a feminocentric and arguably feminist character. One example of this is her provision of literacy classes to Palestinian refugee women living in Lebanon through a women's centre: an activity that can be interpreted as both feminist and nationalist. Advancing women's literacy can be read as a feminist act since it imbues women with the possibility of self-representation at personal and political levels. Indeed, Frances Hasso has argued that 'everyday, individual acts whose focus is creating or maintaining dignity, self-definition, self-reliance and independence' can be interpreted as 'feminist',[83] and education seems to offer precisely these possibilities. Significantly, though, such activities do not have to be

self-proclaimed as feminist, and can equally be understood as nationalist, not least because the attempt to improve women's literacy within the novel is driven by a desire to enable them to communicate with their families elsewhere in the diaspora, hence keeping a sense of communal identity alive: a primary function of 'resistance literature'.[84] Equally, their education can be read as integral to the task of building a capable, modern Palestine founded in equality of opportunity: a truly postcolonial nation. As Philippa Strum notes in her sociological research into women's participation in the nationalist struggle, literacy programs and schools were frequently set up by the PLO in Lebanese refugee camps and, unlike earlier charitable work enacted primarily by 'elite women's groups' which patronised the poorer classes, such activities tended to be undertaken by 'grassroots organizers' and 'well-educated children of poorer families',[85] representing a shift in structures of class and social privilege that was deemed essential to revitalising the nationalist project. For Badr, education therefore emerges as a vital tool within the interrelated feminist and nationalist agendas.

Jinan's work as a nurse in a Jordanian hospital can also be seen as an acceptably feminine role, through which she affirms her nurturing, life-giving capacities as a woman, and works in a supporting role for her male colleagues. Jinan's experiences echo Leila Hudson's observation that women's roles in the resistance often tended to conform to the masculinist models of 'women's work', which were confined to the domestic, caring or administrative.[86] In the novel, Jinan is critical of the PLO's failure to address the way in which binarised, masculinist gender relations seem to underpin the reality of what is claimed as a 'progressive' revolution committed to 'women's liberation [and] transforming the old society' (20). Indeed, Badr suggests that women's primarily symbolic status within nationalist discourse may have undergone no more than a superficial change through an episode in which a male colleague criticises Jinan for her decision to wear a scarf over her head—which happens to be for no other reason than a lack of time to wash her hair. Though she apologises (somewhat tersely) for the fact that her 'scarf reminds [him] of the era of female seclusion', she confides in the reader as to what she wishes her retort had been: 'You ultra-progressive man, would you prefer us to wear either khaki uniforms or eastern dress so that you could . . . give us pluses and minuses?' (105). Here, Jinan implies that she has been subsumed into a masculinist discourse of nationhood in which women once again play no more than a symbolic function, as icons of the 'modern, liberated nation'. Thus, the declaration of Shaher (Jinan's *feda'i* lover) that she should 'forget everything that brings back the resentment you felt towards the old worn-out idols, because it's we who are smashing them' (77) does not ring entirely true, for Jinan may have become implicit in the resurrection of a nationalist iconography that, however hard she tries, she cannot shatter.

Badr's feminist critique of the gender inequality integral to the PLO may seem paradoxical, given that her characters clearly remain committed to

the nationalist cause, and that Jinan plays a number of vital roles under their auspices. Badr states in interview, though, that 'my struggle for emancipation as a Palestinian is inseparable from my struggle for genuine liberation as a woman; neither of them is valid without the other'.[87] From this perspective, any quest for feminist emancipation that takes place through nationalist discourse must entail the thorough scrutiny, even criticism of the gendered structures of the nationalist project, in order to ensure its efficacy in both nationalist and feminist terms. The interrelated nature of national and gendered, political and personal struggle emerges in another arena in which Jinan and her female friend Shahd both participate: that of armed resistance.

In *The Wretched of the Earth*, a study of anti-colonial rebellion that has inspired many resistance movements including the Palestine Liberation Organization, Fanon writes that the use of violence is not only justified but socially and psychologically necessary to both the collective and the individual. For the individual, violence operates as 'a cleansing force [that] frees the native from his inferiority complex [. . .] [and] restores his self-respect', while for the collective, it offers a 'common cause . . . a national destiny and . . . a collective history' that unifies the people.[88] In his writing on the Algerian liberation struggle, meanwhile, Fanon identified women's participation as absolutely central to revolutionary success, not only because he perceived the female body as a key site of colonial control, but also because this participation would enact a double liberation for Algerian women, and for Algeria, freeing them from both 'feudal traditions' and from colonialism.[89] These discourses merge for the female characters in *A Compass for the Sunflower*, for whom armed struggle initially seems to hold a unifying and psychologically cleansing potential. Just as armed struggle is said to restore the self-respect of the colonised subject, so might collective action free these women from the allegedly feminine passivity and powerlessness that characterises patriarchal social relations. Indeed, Jinan's own participation leads her to reject the confines of feminine identity. This reflects Julie Peteet's research, which shows that women integrated into military training within the PLO came to occupy a '"gender-neutral", or "desexed" position'.[90] Jinan similarly displays a desire to erase gender difference in her comment that 'in the end I . . . resented my woman's body . . . and no longer wore anything but khaki trousers' (19).

Such a rejection of individual, gender-conscious identity also emerges in interesting form in the autobiography of Leila Khaled, Palestine's (in)famous female militant who performed two plane hijackings while affiliated with the PFLP. In her autobiography, she writes that true commitment to the 'politicomilitary' phase of the revolution 'meant the final break with her past and relegating her private life and desires to a secondary position'.[91] The distinction that Khaled draws between the private and public realms portrays armed struggle as entry into a 'male' arena in which women must place nationalist concerns above their personal status as women, and even assume 'masculine'

identities. Yet women's entrance into this masculine sphere of resistance was often viewed as highly problematic, and in her postcolonial feminist study of Khaled's autobiography, Rajeswari Mohan pinpoints the 'crisis of authority and meaning' brought about by acts of female militancy:

> [Such women's] act of taking up arms against an enemy, their attitude of unflinching commitment to a cause, their acceptance of men as allies, and their contingent abandonment of 'feminine' values of nurturing, non-violence, and pacifism have led to their being seen by some . . . as grotesque aberrations of femininity.[92]

In *A Compass for the Sunflower*, Jinan encounters these views on her tours of the camps, where she finds that men are resistant to women's participation on the grounds that 'arms are never an ornament for a woman' and that female militancy would leave 'no place for men in the world anymore' (46–47), while the families of female resistance fighters view their activities as damaging to their daughters' social prospects. Consequently, many of the girls' families do their best to avoid gossip by arranging prompt marriages for their daughters (80). A similar attempt to contain the female militant's subversive bodily independence is evident in Leila Khaled's showering with marriage proposals following her public displays of militancy, which can be read as symbolic attempts to reposition her within the sexualised masculinist discourse of male desire and marriage.[93] Female militant activity may therefore be reintegrated into the patriarchal framework by its representation as no more than a temporary suspension of the gendered order, whereby women's armed struggle does not testify so much to a newfound political agency as to the utter desperation of a Palestine so emasculated by colonial occupation that its women must bear arms. While women's participation in armed struggle therefore nuances the classic 'resistance narrative' by revealing it as a forum for coexistence, cooperation and equality between the sexes, there is the danger that such participation is subsumed into the narratives of *'amal watani* (nationalist work) and of a masculinist vision of national emergency, whereby traditional gender roles will be restored once the resistance struggle is over.

Badr resists falling back into this masculinist narrative, however, by formulating a feminist critique of both women's and men's participation in armed struggle. In her work *Sexuality and War: Literary Masks of the Middle East*, Evelyne Accad draws on a combination of literary and interview material in order to critique what she views as the highly masculinist nature of Palestinian resistance, particularly in those strands of it committed to violence. She suggests the fundamental inability of those engaged in the resistance struggle to construct meaningful and equal social relations between men and women due to men's reliance on symbols of idealised womanhood, and of their own idealised manliness.[94] In *A Compass for the Sunflower*,

however, Badr is keen to critique the stereotypically 'masculine' rhetoric of violence present within the resistance struggle, and proposes a renegotiation of social relationships between men and women as a necessary element of national liberation. She implies this through Jinan's relationship with Shaher, a young *feda'i* whose commitment to the nationalist struggle leads to a profoundly progressive vision of Palestinian society. Shaher is presented as the antithesis of the clichéd Palestinian 'terrorist' portrayed in the Western media, a stereotype that Badr also debunks through the character Amer. Amer is a young man who has chosen the path of individual, self-destructive resistance rather than collective struggle, by hijacking a plane. Not only is Amer presented as both misogynistic and deeply reactionary ('Civilisation's a whore between the thighs of history' [60], he proclaims, critiquing the quest for Palestinian modernity), but he is also portrayed as both childlike and impotent in his course of action, a 'prisoner of his eternal hunger and thirst' (60) for a lost past. Despite a hint of pitying affection for the misguided Amer, Jinan sees that the path that he has chosen leads only to defeat, and believes that his model of outdated, individualist, machismo violence must be rejected. Shaher, meanwhile, is presented as a 'new man' unafraid to confront the institutions that govern relations between the sexes, including romance ('Who told you that love had to have a trademark with a certain name on it?' [35]), family ('[Just] tell them that . . . [we] understand one another emotionally and intellectually', he says somewhat teasingly, when told that Jinan's family would disapprove of their match [36]) and sexual conduct ('You're not like the sultan's slave girls who pretended to be pure and unsullied', he tells Jinan; 'You bury your nails deep in the mud but it doesn't suck you under, however dirty it makes you' [35]). Shaher's final statement suggests how a progressive revolutionary vision might encourage men as well as women to review traditional gender discourses, including that of honour (*sharaf*). By praising Jinan for her active, independent behaviour, he associates her honour not with guarded sexual conduct (the province of the insincere 'sultan's slave girls'), but with a natural and socially non-contrived commitment to the land.

In this, Shaher articulates one of the major discursive shifts that took place following the 1967 war, where national defeat forced men's attitudes to shift from the idea that honour should be defended at all costs to placing *al-ard qabl al-'ird*: 'Land before honour'.[95] This term not only made land rather than women's bodies the primary site of nationalist concern, but also invited a reassessment of the very nature of honour. No longer the primary concern nor property of the patriarch, women's sexual honour became something that belonged to the woman herself, and could be sacrificed or asserted for the national cause without desecrating her social standing, meaning that, for the first time, women began to discuss acts of sexual violence against them more openly.[96] Consequently, Badr perceives women's participation within the resistance as a vital opportunity for gender roles,

ideals and relationships to be reconfigured between both women and men. Such a reconfiguration is essential, Badr suggests, not just for women, but for the future of the whole nation.

Jinan's revolutionary romance with Shaher is not the only path towards freedom presented to her, though, and the final scene in the novel portrays her as still very much in need of a 'compass'. As she stands over the hospital bed of the wounded Shaher, a young man who believes that it is better to be 'moving forward in all different directions' (99) than rendered static by pausing for thought, Jinan feels a hand on her shoulder, gnarled 'like the trunk of an ancient olive tree' (115). The hand belongs to Umm Mahmoud, a woman who attends Jinan's literacy class, but who in fact has much to teach Jinan about alternative forms of female resistance. Umm Mahmoud is an icon of traditional womanhood, and of nationhood. Her 'abundant motherliness' (89), reflected in her title ('Umm' meaning mother, 'Mahmoud' the name of her first-born son, a marker of respect, given the importance of perpetuating the male bloodline in traditional Palestinian and Arab society), stands in stark opposition to Jinan's own understanding of resistance and female agency, and yet within the novel, Umm Mahmoud is imbued with qualities similar to those of the female militant. Motherhood can be considered a resistant discourse in itself, as through it, women reproduce and regenerate the nation, both physically (by providing future Palestinians) and ideologically (by raising them in a patriotic manner).[97] Thus, as Julie Peteet notes, women gain respect and status for their *batin 'askari*: military womb,[98] and while such women may not bear arms themselves, their provision of sons to fight for the cause is seen as a form of implicit participation, evident in the revered status of the *Umm al-shaheed* (Mother of the martyr), who is considered an inspirational figure embodying the ultimate sacrifice for the national cause.[99] Equally, women's domestic work—everyday tasks such as washing and cooking—is sometimes represented not as a form of subjugation, but of resistance. Through it, women display *sumud*, 'steadfastness' and 'resilience', by maintaining normality in everyday life, even under the extraordinary conditions of the occupation. Indeed, the qualities associated with *sumud*, which is considered integral to Palestinian identity, can be understood as traditionally feminine: stoicism, silent endurance and sacrifice for others.[100] Women in the novel display these qualities when, for example, they go to make coffee during a bombing raid, or when Umm Mahmoud stands beside Jinan in a moment of crisis, 'awesome and calm' (114). Thus traditional femininity is not only associated with passivity, but offers an alternative form of strength, founded in the model of women as *qawiyyi*, a word in feminine form that literally denotes 'strength', but which has further connotations as a term of praise for a woman who is 'a savvy, strategizing actor . . . who knows how to stand on her own, to maximize her resources, and to survive harsh circumstances with honour', and who generally has a strong character.[101] Crucially, however, these traits must be displayed in ways that affirm her ability

to perform traditional as well as non-traditional female roles; for example, as a wife, mother and housewife as well as in the workplace and various other public arenas.[102] Describing a woman as *qawiyyi* therefore imbues her with an ambivalent agency, for while it allows her to exercise typically masculine traits such as will, proactivity, industriousness and intelligence, it also sees her affirming the ultimately patriarchal boundaries of her existence, and as such, operates as a display of strength but not necessarily of power.

Does Umm Mahmoud therefore represent one of the 'worn-out idols' that Shaher declares should be smashed? Badr leaves this question open, for although Umm Mahmoud represents a domestic, traditionally feminine version of nationhood, she also challenges Jinan's interpretation of these things as stifling by revealing that the private, domestic realm can also offer forms of political participation, and that traditional femininity is not necessarily submissive, but may also be premised on forms of strength and resilience. This is not necessarily the path towards emancipation that Jinan wishes to take, but it is significant that Badr nevertheless presents it as an alternative direction open to her; for as she stands between the visionary Shaher, committed to the future, and the steadfast Umm Mahmoud, guardian of the past, Jinan becomes a new figure of the Palestinian resistance, poised at the crossroads of past, present and future, of nationalism and feminism, of political and personal concerns.

Jinan's own conflicts and multiple allegiances therefore become emblematic of a postcolonial feminist vision of Palestine, in which nationalist and feminist projects serve to position competing claims, structures and identities alongside one another in ways that might prove productive as well as problematic. In this, Badr's text presents an interesting response to Evelyne Accad's assessment of the relationship between feminism and nationalism in the Middle East:

> To those who believe that it is utopia that feminism and nationalism can ever blend, I would like to first suggest, that it has never been tried [. . .] and second, that if an analysis of sexuality and sexual relations were truly incorporated into revolutionary struggle . . . nationalism could be transformed into a more revolutionary strategy. If women were to demand their rights and a transformation of values and roles in the family at the beginning of national struggles and if national struggles were conceived with different aims that would not perpetuate domination and ownership, we would move toward a different concept of revolution than we have witnessed so far in history.[103]

Badr's text, and indeed the actions of many Palestinian women who have participated in nationalist struggle, refute Accad's claim that blending feminism and nationalism has never been tried. Indeed, both Badr's and Tuqan's texts portray women enacting precisely the demands for rights and transformation

of values of which Accad speaks, and in doing so, they too formulate visions of a more inherently equal social system. Badr's and Tuqan's texts also challenge the idea that blending nationalism and feminism is 'utopian'—far from it. Instead, their fictional and autobiographical accounts both present very realistic assessments of the tensions generated by this process. Yet they also suggest that it is through the tensions between the nationalist and feminist, personal and political that gendered and nationalist discourses begin to interrogate and shape one another into more inclusive, self-aware structures—and in doing so, they imagine how these projects might truly generate the freedom, equality and self-determination for which Palestinian men and women have fought for so long. As Accad suggests, only when feminist and nationalist projects come to operate alongside and even through one another can the resistance struggle be considered truly revolutionary.

Refiguring Resistance

Whatever form it may take, resistance clearly animates both Tuqan's and Badr's creative consciousnesses, affirming it as a key trope of Palestinian cultural expression. Yet their very different and in some ways opposing formulations of this concept show that, as Anne McClintock puts it, 'there is no single narrative of the nation'.[104] Nor, indeed, does a 'single narrative' of female identity or of feminism emerge from their works. Rather, Tuqan and Badr each construct unique narratives of nationalist and feminist commitment that are specific to their own subject-positions, imaginations and identifications. For Tuqan, individual rather than collective struggle facilitates a personal emancipation that will later lead her towards a genuine desire to participate within the political sphere—though the private and public, political and personal retain a fraught relationship within her work. For Badr, political struggle features as the primary route to female and national emancipation—though this may be enacted through a variety of forms of participation, including Badr's own act of writing such a text. While their narratives therefore display important forms of political, ideological and social resistance, they also resist the myth of 'national unity' that has served to fix women in subservient and symbolic roles. Equally, they work against the reductive myth of the 'oppressed Third World woman', who is sometimes presented in a similar manner to Spivak's figure of the 'subaltern' in Western feminist accounts—a figure so radically marginalised by structures of cultural imperialism and of patriarchy that they lack all access to discourse, remaining victims of 'epistemic violence', with no means to make their own histories heard.[105] Both Tuqan and Badr refute their positions as 'subaltern' subjects of history by presenting their own idiosyncratic narratives of nationalist and feminist experience, resisting their discursive relegation to the realms of the symbolic and presenting themselves as active agents of discourse, and of resistance.

Despite the distinctive natures of Tuqan's and Badr's texts, it is nevertheless possible to draw some collective conclusions. Both of these texts reveal that feminisms and nationalisms, realised in their many forms, are closely, even inextricably interlinked in the imaginations of both authors, and indeed in those of many Palestinian women. This is not only because Palestine's colonisation and consequent struggle for nationhood impacts irrevocably on the lives of all Palestinian women, but because women's desires for freedom, equality and agency are often articulated through the fight for broader national liberation. Thus these narratives challenge the distinction drawn in much feminist discourse between the personal and political, public and private, viewing them instead as in a constant state of interplay, albeit one that often produces tensions. In this, both Tuqan and Badr begin to enact what Joseph Massad views as the pressing task of a thorough critique of the gendered structures of the nation. Only then, he suggests, might nationalism reach its fully resistant potential to all forms of inequality, injustice and subjugation:

> In the language of national liberation, one might add that no nation is free with half of its members being secondary and subservient. That this might be considered a specious argument is itself part of the symptom. If the Palestinian struggle does not develop this persistent auto-critique at its most embattled hour, the neglected lessons of history will make a possible victory pyrrhic.[106]

As Tuqan and Badr demonstrate, this 'auto-critique' does not have to necessitate a rejection of nationalist commitment altogether. Rather, it may be enacted through many different forms of participation within the resistance struggle itself. Indeed, it is telling that Tuqan remains unfeeling towards the nationalist cause until she has freed herself from the restraints of patriarchal influence, while Badr's character Jinan suggests that the processes of self-scrutiny and internal critique are integral to locating the right direction forwards for the resistance movement. Both of these authors therefore make the decision to 'subvert from within', rather than to move beyond, structures of national and gendered power.

Tuqan's and Badr's narratives present significant versions of the female-authored resistance narrative, but there are many other ways in which women have figured resistant sentiments in their work. So prevalent is resistance as a theme that it is almost impossible to find a female Palestinian author or filmmaker in whose work it does *not* figure, in one way or another. Gender-conscious accounts of nationalist resistance recur in the poems of Mai Sayigh, for example, a Gaza-born poet, whose poem 'Elegy for Imm 'Ali' mourns the death of a Palestinian woman killed during her work in the Resistance.[107] A more recent work, Najwa Najjar's film *Pomegranates and Myrrh* (2008),[108] presents its own subtle forms of resistance through its portrayal of a young bride left to defend the family's land when her husband is imprisoned.

Torn between a deep love of her land and family, and a potential romance with a new dance troupe teacher who enables her to express her personal, free-spirited desires, the central character presents the complex relationship between female identity, cultural values, land, desire and resistance. Though ultimately a loving and affirmative portrait of Palestine, it also resists clear-cut symbolic formulations of female identity in favour of a portrait of creative female subjectivity.[109] A number of films by emergent female directors also explore the relationship between female identity and resistance from a number of angles. Mahasen Nasser-Eldin's *Samia*, for example, tells the story of a seventy-one-year-old woman who has dedicated her life to the simultaneous struggles for women's rights to education, and Palestinians' rights to live in Jerusalem,[110] while Alia Arasoughly's *This Is Not Living* presents interviews with eight Palestinian women from a range of social backgrounds in order to explore their many different experiences of military occupation, their senses of marginalisation within the struggle and the different ways in which they imagine peace.[111] While many of these texts display social realist tendencies, the fictional work of the prize-winning author Adania Shibli makes a highly distinctive shift away from linear narrative towards a more experimental structure through its intimate, sensory, impressionistic account of female experience that seems to reject all but the most subtle of connections to the national narrative. In her novella *Touch*, for example, political shadows such as the death of the young female protagonist's brother, or finding out at school that Palestine is a forbidden word, are but a backdrop for the vivid perceptions of the little girl, which serve to structure the fragmented narrative of this work.[112] While Shibli may have broken from the traditional structures and tropes of women's resistance narratives, she nevertheless speaks to a creative tradition whereby women have sought to shift their gazes away from the male figures who occupy the foreground of classic portraits of the nation, in order to bring the lives of women into focus, their struggles, feelings and experiences offering astonishing and often unexpected insights into national, feminist and human experience.

Tuqan's and Badr's portrayals of resistance therefore offer powerful prototypes of postcolonial feminist narrative, which are extended and reworked from a number of angles by the female creative practitioners examined in Chapters 4 and 5. Yet as Badr's novel suggests, a gender-conscious critique of nationhood has implications not only for women, but also for men—as the 'crises of masculinity' explored in the next chapter will reveal further.

3 Masculinity in Crisis
From Patriarchy to (Post)Colonial Performativity

Somewhere on the border between Iraq and Kuwait, three Palestinian men huddle inside the metal drum of a water tanker beneath the blazing sun, while the driver seeks the relevant documents to continue his journey and deliver his illicit cargo to their destinations. These men are being smuggled into a new country and so, they hope, to new lives, where they will be able to support themselves and their families, to have a home, and to possess a security that eludes them within a post-*Nakba*, post-partition Palestine. While the driver banters with the border officials, though, these three men slowly suffocate to death inside the tanker. When he finds them, the driver—a fellow Palestinian—will strip the bodies of their possessions and dump the men in the municipal rubbish tip, but as he performs this final act of betrayal, the driver will reflect not on his own actions, but on theirs, asking himself: 'Why didn't they knock on the sides of the tank [. . .] Why? Why? Why?'[1]

This macabre vignette of post-*Nakba* existence appears in the celebrated Palestinian writer Ghassan Kanafani's novella, *Men in the Sun*, and raises many questions about agency and belonging for the newly fragmented Palestinian community. From a postcolonial feminist perspective, though, the men's actions (or lack of action) holds a particular significance, especially when read in light of Judith Butler's theory of 'gender performativity'. For Butler, gender is not innate to our bodies or selves, but something that is socially constructed in relation to our environments, and *performed* through the body. As she puts it:

> Gender ought not to be construed as a stable identity or locus of agency from which various acts follow; rather, gender is an identity tenuously constituted in time, instituted in an exterior space through a *stylized repetition of acts*.[2]

While we perform such 'acts' to the extent that we experience them as quite natural (producing what Butler terms 'the illusion of an abiding gendered

self'),³ and thus cannot simply stop 'performing' our genders, Butler suggests that we may nevertheless become conscious of the performative nature of gender at moments when a 'failure to repeat, a de-formity, or a parodic repetition [of a gendered 'act']' occurs, which 'exposes the phantasmic effect of abiding identity as a politically tenuous construction'.⁴ Thus it is not so much the driver's actions (which can, after all, be read as those of a necessary self-preservation in a time of political turmoil), but the men's *failure* to perform the acts expected of them (that is, to knock on the sides of the tank) that reveals something about the relationship between Palestine's colonial condition and gendered identity in this episode. Torn between their desire for escape and fear of discovery, between the need for silence and speech, self-assertion and disguise, the men find themselves rendered entirely inert, unable to 'act' in any way. It is also at this moment, though, that their very identities as Palestinians, and as men, are exposed as constructs of Palestine's colonial situation. No longer 'masters' of their own environments, identities or destinies, the men find themselves suspended in a 'no-man's land' strongly reminiscent of Palestine itself,⁵ in which they are unable to perform even a basic 'masculine' mastery of their own bodies or situations. Reading this episode in light of Butler's theory of performativity, the men's failure to perform basic acts of masculine agency makes it clear not only that Palestinian and gendered identity are closely entwined for Kanafani's characters, but that *Palestinian masculinity is in crisis.*

As Joe Cleary notes in *Literature, Partition and the Nation State*, creative portrayals of Palestinian masculinity 'in crisis' are in fact a fairly well-worn feature of post-1948 literature.⁶ Such portrayals, however, have tended to present any disruption to the patriarchal order as symbolic of a weakened and 'emasculated' nation: a state of aberration requiring remedy, and a source of sorrow, even trauma. At first glance, the shared generational identities of all of the creative practitioners examined in this chapter—the directors Elia Suleiman (born 1960) and Hany Abu-Assad (1961), and the author Samir El-Youssef (1965)—seem to connect their creative interests in crisis-ridden masculinities to the experience of national trauma. All were born shortly before the *Naksa* of 1967 and experienced two further periods of major societal unrest at key stages of their personal and creative maturation: from 1987 to 1993, during the first *Intifada*, and again during the second Al-Aqsa *Intifada*, meaning that El-Youssef's, Suleiman's and Abu-Assad's personal experiences have been shaped in various ways by key events in the national narrative. Yet all three of the works examined in this chapter—Samir El-Youssef's short story, 'The Day the Beast Got Thirsty', included in the collection *Gaza Blues*,⁷ Elia Suleiman's film *Divine Intervention* (*Yadun Ilahiyya*)⁸ and Hany Abu-Assad's film *Paradise Now* (*Al-Janna Al-A'an*)⁹—present very different visions of what it means to be 'Palestinian', 'male' and 'masculine', and in doing so, appear to interrogate the very fabric of Palestinian patriarchal relations. The question posed by these works, then, is whether the crises in paternal and fraternal identification

presented within them denote a nostalgia for the trappings of pre-colonial patriarchal power—or whether they might also express a desire to reimagine and reconstruct Palestinian masculinity, and hence, society. This chapter therefore explores a variety of different 'performances' of masculinity—from 'honourable' to 'shameful' behaviours, and from male inertia to martyrdom—in order to consider the ways in which masculinity and (post)coloniality might be constructed creatively in relation to one another, and to surmise whether the disruptions, 'de-formities' and 'parodic repetitions' that occur in these performances of masculinity might bear a postcolonial feminist potential.

How, then, might we theorise a 'Palestinian masculinity crisis'? The concept of a contemporary crisis in masculinity has been popular in the North American and European academies since the 1990s, when the emergent field of masculinity studies (which drew on the insights of feminist and gender studies more broadly, including theories of 'gender performativity')[10] began to identify a sense of uncertainty surrounding the roles and identities available to men in the wake of feminism's ideological and social advances, and so to explore the construction of patriarchal power and hegemonic (that is, culturally normative) masculinity.[11] Although some gender-conscious scholars have begun to turn their attention to masculinity within the context of the Middle East,[12] patriarchy often tends to be viewed as prevalent and secure in many Arab societies.[13] There are, however, a handful of scholars who have begun to interrogate the construction of masculinity within the specific sociopolitical landscape of Israeli-Palestinian relations. One such study is that of the cultural anthropologist Amalia Sa'ar and political sociologist Taghreed Yahia-Younis, whose research offers a gendered reading of the 'discourse on crisis' that has emerged in the Arabic press, through which Palestinians living in the State of Israel have attempted to articulate their predicament.[14] They argue that the 'political economic location' of Palestinian Israeli men 'does not allow the realization of militaristic masculinities [. . .] while alternative scripts of less violent masculinities' (founded on traditional patriarchal qualities of strength, honour and community standing) are also unavailable to them.[15] Thus their socio-political location makes it difficult for these men to perform what they understand to be 'masculine' identities, leading to a sense of emasculating crisis. Joseph Massad, meanwhile, has produced an insightful study of the masculine codification of Palestinian nationalism, and of the way in which Israeli colonialism has brought about a number of crises within this discourse (the object of further scrutiny within this chapter).[16] It is clear, therefore, that the discourse of Palestinian masculinity has begun to be understood as something that is performed and constructed not only through the framework of gender relations, but also in relation to the structures of power that underpin Palestinian nationhood and colonial relations. In doing so, such theorists appear to affirm Judith Butler's own assertion that 'performativity' might be usefully translated beyond its immediate application to gender. As she writes in the preface to the 1999 edition of *Gender Trouble*:

> The question of whether or not the theory of performativity can be transposed onto matters of race has been explored by several scholars [...] My view is that no single account of construction will do, and that these categories always work as background for one another, and they often find their most powerful articulation through one another. Thus, the sexualization of racial gender norms calls to be read through multiple lenses at once, and the analysis surely illuminates the limits of gender as an exclusive category of analysis.[17]

Similarly, it also seems possible to transpose questions of race with those of national, socio-political and (post)colonial identities, and to consider how they, too, might be 'performatively' implicated in the construction of Palestinian masculinity. How, then, do these multiple discourses play into the construction of what it means 'to be a man' in Palestinian society?

Like any form of identity, the 'ritual social drama'[18] of hegemonic Palestinian masculinity must be understood as multiply and fluidly constructed through a number of discourses. As Butler reminds us, gender is 'at once a reenactment and a reexperiencing of a set of meanings already socially established . . . [and] the mundane and ritualized form of their legitimation'.[19] Although it is possible to identify many different influences underpinning the 'socially established meanings' of Palestinian masculinity, three intersecting discourses are particularly influential when it comes to its 'reenactment' and 'legitimation': those of nationhood, of Arab cultural identity and of colonial oppression. Between them, these discourses produce a spectrum of ideals, behaviours, roles, identities and relations through which men are able to find various paths leading them towards the performance of hegemonic masculinity.

As we saw in Chapter 1, unified Palestinian nationhood has often tended to be imagined through discourses of idealised femininity, where Palestine is represented as a mother or beloved. Yet as Cynthia Enloe writes, 'nationalism typically has sprung from masculinized memory, masculinized humiliation and masculinized hope. Anger at being "emasculated" [. . .] has been presumed to be the natural fuel for igniting a nationalist movement'.[20] If a beautiful, nurturing, feminised Palestine is the *object* of national desire, then the desiring *subject* of Palestinian nationalism is certainly male, seeking to affirm his territorial position as master of his land. As Rashid Khalidi reveals, though, the identity of the nationalist subject is far from straightforward. In his important work *Palestinian Identity: The Construction of Modern National Consciousness*, Khalidi traces the origins of contemporary nationalist consciousness and finds that 'it is so difficult to perceive the specificity of Palestinian nationalism . . . partly because of the way in which identity for the Palestinians is and has always been intermingled with a sense of identity on so many other levels, whether Islamic or Christian, Ottoman or Arab, local or universal, or family and tribal'.[21] Here, Khalidi suggests that Palestinian

identity is itself comprised of multiple discourses of belonging, rendering the quest for a coherent vision of national community somewhat complex. Yet this quest for a unified national identity has nevertheless been an essential response to the shifting territorial claims and power dynamics within the region, which have threatened to erase its Palestinian inhabitants and their claims to territory.[22] Nationalism therefore emerges as a necessary but constructed rather than innate feature of Palestinian identity. As Massad puts it: 'Nationalist agency, like sexual and gender identities, is performatively produced and compelled by the regulatory practices of [. . .] the category of nationalist agency itself'.[23]

The 'regulatory' qualities of nationalist discourse are perhaps particularly visible within a discourse that has been characterised as 'Palestinianism', which denotes a transcendent desire for Palestinian national independence and a distinctive identification as Palestinian that underpins the ethos of all branches of the nationalist movement.[24] 'Palestinianism' appears to operate according to what Benedict Anderson has described as the 'deep, horizontal comradeship . . . [based on] fraternity' that binds the loyalties of those within the nation as an 'imagined community',[25] and indeed the distinctively masculine qualities of 'fraternal' relations also feature heavily within Palestinian nationalist discourse. The idea of 'fraternity' or brotherhood is particularly evident in the Palestinian National Charter of 1968, for example: a document through which the PLO sought to assert itself as the sole representative of Palestinians. In this document, Palestinian identity is defined as 'a genuine, inherent and eternal trait that is transmitted from *fathers to sons*', a definition that disrupts the traditional gendered symbolism of the nation represented as a mother.[26] Massad explains this gendered shift as a product of the colonial environment, in which a 'maternal' Palestine is considered to have been 'tainted' by the violations of Israeli colonialism, rendering her unable to produce legitimate 'children of the nation'.[27] Thus, as Massad puts it, 'it is now fathers who reproduce the nation'.[28] Nationalism therefore emerges as a discourse of specifically masculinised resistance, and this is evident in the rhetoric of the UNLU (Unified National Leadership of the Uprising), for example, which addresses its male students as 'the stronger body . . . the continually pulsing artery among our people' who should 'rise as one man'.[29] A potent combination of virility, resistance, unity and strength therefore affirms Palestinian nationalist politics as vehemently and hierarchically masculine/ist.

Two further discourses are also integral to this masculinist conception of Palestinian nationalism: colonialism, and specifically Arab conceptualisations of gender. In *The Nation and Its Fragments: Colonial and Postcolonial Histories*, Partha Chatterjee points towards the complex processes of identity construction that formerly colonised nations must undergo as they seek to redefine themselves in a way that rejects colonial influence.[30] This process often involves pinpointing what is deemed to be 'authentic' about a particular national culture, beneath its layers of colonial construction. In the case of

Palestine, nationalist discourse constructs its idea of 'authenticity' by aligning itself with Arab identity. It seeks to reconnect Palestinian identity to the broader cultural attributes of the Arab world, looking to a pre- and implicitly postcolonial model of the Middle East that transcends European and Israeli influence. Gender plays a crucial role in this construction of authenticity. Upholding traditional concepts of Arab masculinity (*rujulah*), which rests on social attributes of honour, kin and community, for example, presents a distinctive vision of social relations deemed to be 'authentic', and hence in defiance of external cultural influence.[31] These social structures demand stereotypically 'masculine' behaviours of men (courage, bravery, strength, protection of the nation and of women), which justify male privilege and dominance within the hierarchical social structures such as the family, the clan and the religious or political group, which are all founded on the patriarch's authority and domination, and on the dependency of others.[32]

In his study of 'neo-patriarchy', Hisham Sharabi is keen to point out that patriarchy is not simply the anathema of Arab cultural tradition, but a discourse that is constantly reshaping itself in response to its environment: a thesis that echoes Butler's own understanding of gender as 'an identity tenuously constituted in time', whose performance is dependent on contextual social norms.[33] This 'reshaping' of patriarchal relations has been central to the formulation of anti-colonial masculinities, and emerges in men's responses to conditions previously assumed to be 'emasculating' under Israeli occupation, such as imprisonment or beatings, common occurrences for men living in the West Bank in particular.[34] Rather than such events being viewed as forms of victimisation, beatings and imprisonment have instead become 'rites of passage . . . central in the construction of an adult, gendered (male) self',[35] whereby paternal sacrifice and endurance become ways of participating in the struggle and of attaining honour. Indeed, in *Wild Thorns*, a novel by Sahar Khalifeh, the character Basil is interred by the Israelis, and the marks he bears from beatings are described as 'badges of honour',[36] while the other prisoners tell him that 'those who don't go for prison, even for a day, will never become real men, even if they grow two moustaches rather than one'.[37] Thus, the very conditions of male oppression are here appropriated as a form of masculine anti-colonial resistance.

While, at one level, this reveals the Palestinian commitment to *sumud*— steadfastness, or resilience—it also suggests something of Butler's theorisation of 'gender performativity' as a discourse that cannot simply be overturned, but that is open to subversion through 'parodic' or 'discontinuitous' performances of gendered identity, in ways that reveal it to be a 'politically tenuous construction'.[38] Similarly, Palestinian men's creative appropriation of their imprisonment as a discourse of resilience rather than victimisation could be said to constitute a 'parodic' or 'discontinuitous' appropriation of Israeli colonial discourse, in a way that also reveals its 'politically tenuous' nature. Palestinian masculinity therefore emerges as

a complex construction predicated on multiple simultaneous affirmations, rejections and appropriations of nationalist, Arab, anti-colonial and gendered identities. The Palestinian male must 'create' the nation, but through masculine resistance and patriarchal authority rather than feminine nurturing. He must embody 'Arab' gender norms—but as they are conceived within the *Palestinian* rather than Zionist or Orientalist imagination. And even when faced with suffering and victimisation, he must reconstruct this as an opportunity to demonstrate his strength of will and character. For Palestinian men, the task of 'being a man' therefore mirrors the uncertainty of Palestine's own condition, suspended in a state of continuous desire and struggle for a securely defined identity. How, then, might creative practitioners respond to this profound uncertainty, even crisis, in Palestinian masculinity? To what extent do they remain defined by colonial constructions of gender and nation, and how far are they willing to deconstruct these paradigms in order to arrive at what might be described as alternative *post*colonial performances of masculinity? These are the central questions asked of each of the texts examined in this chapter.

The first section, 'The Shebab Get Stoned: Samir El-Youssef's "The Day the Beast Got Thirsty"', turns to a short story about the highly disaffected male youth of a Lebanese refugee camp in order to explore the relationship between national disenfranchisement and the performance of masculinity. El-Youssef's disarmingly irreverent portrayal of masculine relations and national politics offers a radical debunking of the 'official' discourse of masculinity by constructing an alternative vision of the male 'drop-out'—yet even this apparently negative portrayal of Palestinian masculinity poses some transgressive possibilities. The second section, 'From Stasis to Sumud: Elia Suleiman's "Chronicle of Love and Pain"', turns to the film *Divine Intervention* by one of the most innovative Palestinian directors to date: Elia Suleiman. While the film is often interpreted as an artistic representation of the Palestinian national condition, it is also a study of the distinctive relationship between a father and son, and of the fraught fraternal relationships within the Palestinian community. In this film, Suleiman radically reconstructs visions of masculine resistance and resilience within the (post)colonial landscape. The final section, 'Masculinity in the Margins: The Subterranean States of Hany Abu-Assad's *Paradise Now*', turns to one of the most controversial discourses of Palestinian resistance, and arguably of masculinity: that of martyrdom, or 'suicide bombing'. This section analyses the relationship between violence, self-destruction and colonial power, as they are inscribed through the male body. Collectively, these analyses reveal a variety of masculine performances that each present a different form of crisis. Traumatic as these crises may be, though, they also offer intensely creative opportunities to reflect upon the performance of Palestinian masculinity, and to consider how its scripts might perhaps be written anew.

The Shebab Get Stoned: Samir El-Youssef's 'The Day the Beast Got Thirsty'

As a young man in his early twenties, El-Youssef would no doubt have been familiar with the images of the 'Children of the Stones' during the first *Intifada* that so captured the stark power imbalances of colonialism, as Palestinian children sought their own role in the resistance by hurling stones at fully armed members of the IDF.[39] Yet in his own portrayal of life in a Lebanese refugee camp during the first *Intifada*, El-Youssef would portray not 'Children of the Stones' but young men who preferred to 'get stoned' in a very different way, turning to drugs as a form of refuge from their surroundings. This off-beat, tangential take on the Palestinian situation is in fact typical of El-Youssef, who has acquired a reputation as a controversial critic of the second *Intifada* and of the Palestinian 'Right of Return', though his commitment to literary and political expression—even at the cost of nationalist solidarity—has earned him the 2005 PEN Tucholsky award for promoting peace and freedom of speech in the Middle East.[40] In the same way, the distinctive angle that he adopts on the lives of marginalised young Palestinian men in 'The Day the Beast Got Thirsty' can be read not only as El-Youssef thumbing his nose at the dominant narratives of national solidarity, but as an important, if irreverent, deconstruction of Palestinian masculinity itself.

Samir El-Youssef was born in 1965 in the Rashida refugee camp in Lebanon, to which his parents had fled following their expulsion from their Palestinian village during the *Nakba*. He moved from the refugee camp at the age of ten, first to a village and then to the city of Sidon in southern Lebanon, where he lived until immigrating to Cyprus in 1989 during the first *Intifada*. He subsequently moved to London in 1990, where he studied philosophy and began to write for the international media, and still lives today. El-Youssef displays a consciousness of the fragmented and disparate nature of Palestinian nationhood at personal and literary levels alike. He states in interview that his birth into a Palestinian family with a Sunni father and, very unusually, a Shi'ite mother 'has contributed to the diversity of my understanding of things—from the beginning you are aware of yourself as someone different'.[41] This consciousness of the disparate nature of Palestinian identity also perhaps stems from El-Youssef's own marginal position in relation to the Palestinian nation through his location in the Rashida refugee camp. During the 1980s, Lebanese refugee camps became sites of extreme depravation and persecution, most notably through the massacres of Palestinians in the Sabra and Shatila camps in 1982, conducted by Christian Phalangists who operated under the supervision of the Israeli General Ariel Sharon.[42] While Lebanon's refugee camps had been placed under PLO control through the Cairo Agreement signed between Nasser and Arafat in 1969, the authority of the PLO had begun to disintegrate by the time of the first *Intifada*, and

various local and international factions were competing for power on the ground in Lebanon.[43] Consequently, El-Youssef reports 'a terrible anti-Palestinian attitude in the country' and the array of 'militias, armed factions and political organizations with ridiculous or bankrupt agendas' as key factors that influenced his decision to leave.[44]

His 2007 novel, *The Illusion of Return* (his first work in English),[45] reflects upon the fragmented nature of the Palestinian community through the voice of an exiled narrator, who recalls the stories of variously marginalised characters within Lebanese society. From the tale of the narrator's friend Ali, forced into collaborating with the Israelis, to that of the narrator's beloved sister driven to suicide by her older brother's bullying, to the story of a young man murdered for being homosexual, an oppressively heteronormative and patriarchal masculinity surfaces in ways that seem to erase the possibility of communal cohesion or of national liberation. Faced with such accounts, the narrator comes to understand 'the idea of return [as] actually an attempt to escape the inhospitability of the present state of the world' and to perceive Palestine as a utopian concept that cannot be located in reality.[46] This portrayal of Palestinian space and identity as illusory is extremely controversial, but the justification for El-Youssef's profound sense of national alienation is expressed only too clearly by the narrator of his earlier short story, 'The Day the Beast Got Thirsty'. Written in the first person from the perspective of a young man enduring life in Lebanon during the first *Intifada*, this story offers an at once disturbing and darkly comic insight into the marginal and dissociated experiences of Palestine's *shebab* (young 'revolutionary' men), who contest any sense of the nation and its diaspora as a 'fraternity'.

'The Day the Beast Got Thirsty' is El-Youssef's contribution (originally written in Arabic but published in the author's own English translation) to the short story collection *Gaza Blues*, which he co-authored with the controversial Israeli writer, Etgar Keret. The very juxtaposition of El-Youssef's and Keret's works can be read as a subtle disaffiliation from the expected bonds of male Palestinian fraternity. Keret's works, such as *Missing Kissinger* and *The Nimrod Flipout*, are known for their quirky surrealism and occasionally tasteless humour.[47] As portraits of a disgruntled Israeli 'generation X', they are neither patriotic nor ostensibly engaged with politics, and El-Youssef's intension in collaborating with Keret therefore remains ambiguous, appearing neither wholly oppositional nor reconciliatory. Rather, the positioning of their stories alongside one another remains awkward and inconclusive: an apt reflection, perhaps, of the contemporary Palestinian condition, which shares an equally uneasy intimacy with its Israeli neighbour and occupier. The fraternal ties conjured in El-Youssef's work therefore seem to be predicated on a sense of political disaffiliation and national disconnection, sentiments that are echoed in the voice of the story's first-person narrator, a young man named Bassem, who is stuck in a Lebanese refugee camp during the first *Intifada*. Bassem's existence revolves around his futile and increasingly

absurd attempts to secure an exit visa from the country, and around his recreational drug taking. It is telling that the opening lines to the story, while ostensibly establishing fraternal bonds between Bassem and his politically active best friend Ahmed, also reveal the artificially induced nature of these brotherly feelings, and evoke a simultaneous sense of spatial and psychological entrapment:

> I liked listening to Ahmed. I liked listening to Ahmed especially after I had a couple of joints. But sometimes Ahmed used to say things that made me realize that unless I leave the country I shall go mad. (111)

Bassem's blunt and bleakly comic narrative tone—typified by his qualifying admission that Ahmed's stories become infinitely better 'after a couple of joints'—jars the reader out of any illusion of nationalist sentiment. Life seems bearable only when viewed through a lens of hazy disconnection for Bassem. Yet Bassem's psychological disconnection also reveals him as 'on the edge', in danger of 'cracking up' if he cannot escape his political and national confines. Fraternal and psychological fragmentation emerges as more than simply a threat over the course of the story, however. Rather, it is the central characteristic of life for the *shebab*, the young men typically charged with the communal task of political resistance, in the marginal space of the Lebanese refugee camp.

The fraternal disconnection that marks this story can be taken as a broader representation of the state of nationalist politics at this point in Palestinian history. The first *Intifada* was, at one level, a spontaneous uprising of the Palestinian people that initially occurred in protest at the killing of four Palestinians in Gaza. This event was the catalyst for a much broader outpouring of anger by the Palestinian people at the daily indignities, attacks and land seizures that they endured under Israeli occupation—but it was also, in part, an expression of exasperation at the Palestinian leadership.[48] In Lebanon, a further result of the *Intifada* was that the focus of resistance was transferred from Lebanese refugee camps to the West Bank and Gaza. Coupled with waning support for the PLO among the younger generation, this led to the emergence of factions and competing causes on the ground, including those of the Islamists, of the PLO, and of various Lebanese, Syrian and Kurdish political factions.[49] Set against this backdrop, it is hardly surprising that El-Youssef's short story should express an extreme sense of nationalist disillusionment as he reveals the schisms among the male population of the refugee camp to darkly comic effect.

A running joke throughout the story is the common distrust of Yasser Arafat among members of Fatah, the party that Arafat founded and led before becoming head of the PLO.[50] Labelled the 'Walking Disaster' by Bassem's friend Ahmed, who is himself a Fatah member, Arafat is a figure of distrust and a focus of contempt for his collaboration with the PLO: 'Arafat cannot be

trusted for a moment', he tells Bassem. 'What do you expect from someone whose uncle was Hajj Amin al-Hussainy?' (115–116).[51] Ahmed does not confine his distrust to the leader of his own party, however. Bassem tells of how Ahmed 'started swearing about Abu Shivan, the Kurds, the Palestinians' (156): no one is immune from Ahmed's contempt in his extended community. Indeed, Ahmed's political and personal relationships with Abu Shivan, the leader of the Kurdistan Liberation Party (KLP), traditionally the 'sister party' of the Palestinian resistance, are equally lacking in fraternal solidarity. The KLP members only seem concerned at being scammed of 40,000 liras by Ahmed, who has promised to produce a newsletter for them. The project is of little interest to Ahmed beyond its immediate financial promises, since this young Fatah member 'knew from experience that political newsletters and leaflets were rarely read, and at best they were used for no better purpose than to wrap up falafel sandwiches' (122). As Bassem's 'brother-in-arms', Ahmed therefore represents a highly cynical and unfraternal comrade.

Bassem's response to the fragmentation of fraternal sentiment is to opt out of any political affiliation by removing himself to the margins of society and striking up friendships with junkies, misfits and liars. When his drug dealer, an Iraqi man named Salim, is arrested, Bassem articulates one of the few moments of emotional connection within the story: 'All of a sudden I noticed that I kept saying I must save Salim' (143), he tells us. Yet conditions of powerlessness have become *de rigueur* for Bassem to the extent that he is swiftly struck by the absurdity of his heroic intentions: 'Who the hell was I? I asked myself, the Scarlet Pimpernel? The brave knight who saved members of the French nobility from the guillotine of the French revolution?' (143). Bassem's shock at his 'masculine' response undercuts the nationalist rhetoric of Palestine's young male community as a strong, unified and committed entity. Instead, they appear so deeply disempowered that any expression of solidarity appears laughably unrealistic. Indeed, Bassem experiences difficulty in connecting with anyone around him at an emotional level and this emerges to the extreme in his loveless relationship with a girl named Dalal. His sense of entrapment manifests itself in grotesquely self-defeatist and emasculating fantasies of getting married to this woman who he finds physically repulsive and of having ten children destined to be killed, before, as he puts it in hyperbolic and near-hysterical terms, 'Israel . . . invade[s] Lebanon again, destroy[s] the Camp and fuck[s] us all up, so we die and get the hell out of this fucking life' (170). For Bassem, even the prospects of marriage and fatherhood—which are strongly affirmed in the Palestinian National Charter as important ways to further the bloodline of the nation, passed from father to son—pose an ultimately futile prospect. Bassem's disconnected relationship with Dalal can be read as a manifestation of the emasculation that he experiences through his inability to perform a virile and powerful version of masculinity within these conditions of profound social depravation and fragmentation. Crises of intimacy, impotence and self-worth therefore plague

both the interior and exterior existences of Bassem, and are revealed to be just as much a projection of the Palestinian condition as they are of the individual male subject.

Instead of throwing stones at Israeli soldiers, then, Bassem's response to this unbearable situation is quite simply to get stoned. His drug taking can be read as deeply symbolic of the communicative and emotional difficulties that are often seen to characterise the 'masculinity crisis'. According to Roger Horrocks, 'a state of being cut off from natural feelings and expressiveness and contact with others' typifies this 'male malaise', a condition for which he has loosely coined the term 'male autism'.[52] Communicative crisis certainly plagues Bassem at the final moments to the story, which suggest the poignant possibility that he may not be as comfortable with his state of disconnected marginality as he at first appears to be. As Bassem watches the students at the elementary school being trained as 'Cubs' (children linked to the activities of the PLO, who were taught to take an oppositional stance to the Israeli occupation), he is prompted to remember how he once tried to join the Cubs during his own childhood, against his father's wishes. Bassem recalls how his father discovered him during training—but his response was not to reprimand his son but to buy him a huge ice cream. His father's subtly considered act of generosity of course won Bassem over at the time—but now, watching them in his adulthood, he finds that he has an unexpected response:

> There were two rows of Cubs parading in a military fashion, while the trainer was walking up and down, and asking them in a strident voice, 'Are you hungry?'
>
> 'Beasts!' the Cubs responded in voices no less loud and strident.
>
> 'Are you thirsty?' the trainer asked again [. . .]
>
> 'Beasts! Beasts!' I heard the Cubs crying out loud, and I was still looking over the wall of the school.
>
> I felt thirsty. I felt thirsty and hungry. I nearly cried out, 'I wish I were a Cub!'
>
> But instead, I cried, 'I wish I could leave this country!' (172)

Bassem's raging senses of hunger and thirst are, perhaps, no more than the result of him being stoned. Yet as he mentally allies himself with the communal cry of the Cubs, his hunger and thirst seem to express a longing for a sense of national belonging, and with it the forms of militarised aggression, resistance, unity and communal identity that the children are being taught to perform: all traditionally masculine gender roles, of the kind that he is now deprived. Yet Bassem undergoes an extreme internal crisis at this moment. Watching the young children being trained to serve a cause that he has long given up on, he also seems to despair at the masculine and nationalist identities that these children are being taught to perform. Conscious of his simultaneous desire and repulsion at such a performance,

his contradictory feelings are too much to express. His final spontaneous utterance (the most active performance of agency that he has managed throughout the entire story), which is so nearly to join the cause, is finally a cry of total impotence: a desire for escape from the Palestinian refugee camp and diasporic community, and an inability to undertake even this form of negating action. His final cry suggests an immense sense of stasis and frustration, torn as he is between a desire for a regression to a state of innocence, connection and *jouissance* embodied in the youthful nationalist fervour of the Cubs but now only obtainable through his drug use—and for an impossible exit from his country.

El-Youssef's short story might seem to offer an uncompromisingly bleak vision of Palestine's fraternal community. Not only is political fraternity conveyed as internally consumed by pettiness and schism, but its male subjects project hatred towards themselves as much as towards one another. Disempowering as this vision may seem, it also in fact poses a transgressive potential. In his refusal to conjure simplistic discourses of masculinity and nationhood that strive blindly to fulfil the ideals of nationalist rhetoric, El-Youssef recognises the contradictory and conflicted pressures that underpin these ideals, which ultimately render them no more than discursive constructs. Rather than positing this as a source of unequivocal pathos, however, El-Youssef expresses this Palestinian masculinity crisis with a level of dark and irreverent humour that reveals a strong sense of self-awareness and a propensity for self-critique within his central character, traits that offer him forms of mental resistance. This resistance can be seen towards the end of the story, when every one of the protagonist's hopes of escape has been frustrated. Bassem's final response is neither despair nor anger but to begin laughing hysterically. Bassem stands firm against the onslaught of reality by retaining a consciousness of the simultaneously absurd and surreal nature of Palestinian existence. As he tells Ahmed, 'didn't I tell you that our cause has grown out of the phase of realism and has become surrealist? [. . .] Everything has become surrealist now!' (168–169). Though Bassem's response may appear irrational, even insane (a stereotypically 'feminine' rather than 'masculine' condition),[53] it is paradoxically a strategy that facilitates his mental endurance; for Bassem recognises that basic notions of reality, logic and rationality are rendered impossible in his environment. Instead, an altogether more subversive understanding of the 'manly' qualities of strength, endurance and rationality is required, one that rests on a self-awareness of the surreal and absurd as powerful modes of self-representation. Fraternity, then, is an impossibility within the world of El-Youssef's short story; but the freethinking and independent, albeit marginal male subject may nevertheless retain a level of imaginative agency. It is this consciousness of the absurd and imaginative as strategies of resistance that brings us to Elia Suleiman's filmmaking: work with which El-Youssef might, after all, find himself able to connect.

From Stasis to Sumud: Elia Suleiman's 'Chronicle of Love and Pain'

Elia Suleiman has come to be recognised as one of the most experimental and challenging Palestinian filmmakers working today. Not only do his films demonstrate a willingness to confront contemporary political issues and to break from traditional nationalist sentiment, but they are also characterised by a distinctive filmic aesthetic that resists traditional linear narrative and instead employs filmic fragments and vignettes that are sometimes highly surrealist or magic realist in tone. This readiness to contest traditional filmic structure reflects his desire to challenge accepted narratives of nationhood, and indeed, as this analysis will argue, to deconstruct the 'scripts' of masculinity upon which this discourse is premised. Focusing on the distinctive range of masculinities displayed in Suleiman's film *Divine Intervention* therefore reveals Suleiman's vision of Palestine as a nation in crisis. Rather than this simply operating as a form of tragedy, though, it seems that this crisis might ultimately facilitate a certain renewal of the structures of both nation and masculine identity in Suleiman's imagination.

Suleiman was born in 1960 and raised in Nazareth—a location within Israel itself that appears in several of his films, including *Chronicle of a Disappearance* and *Divine Intervention*.[54] He left to develop his filmmaking practice in Europe and in New York in the 1980s before returning to Palestine in 1994, where he established the Film and Media Centre at Birzeit University with funding support from the European Commission.[55] Despite this strong commitment to the development of Palestinian cinema, though, Suleiman holds an altogether more fluid understanding of national identity, stating in interview that 'I don't want to tell the story of Palestine; I want to open the way to multiple spaces that lend themselves to different readings [. . .] My challenge is to avoid a centralized, unified image that allows only a single narrative perspective'.[56] The postcolonial potential of this fluid, 'decentralised' vision of Palestine is particularly interesting in the context of Suleiman's 2002 film, *Divine Intervention*, which inadvertently demonstrated the negation of Palestinian national identity when the Academy of Motion Picture Arts and Sciences refused it for Oscar nomination on the grounds that Palestine was not a nation recognised by the Academy.[57] While ostensibly a portrait of the turbulent conditions within Palestine, though, the film, subtitled *A Chronicle of Love and Pain*, is also Suleiman's own account of the illness and death of his father, and this establishes strong links between Suleiman's personal tragedy and that of the nation. Structures of paternity, fraternity, family and community therefore lie at the heart of this film (as indeed they do within his most recent film, *The Time That Remains*, which portrays his father's own role in the Palestinian resistance).[58] Turning to the construction of masculinity within this film therefore reveals the complex

forms of crisis within both national and gendered discourse that generate Suleiman's radical vision of Palestine.

Divine Intervention's subtitle, *A Chronicle of Love and Pain*, is in fact more representative of the dynamics that underpin paternal and fraternal relations within this film, and as such, is the title used throughout this discussion. Like many of his earlier works, this film rejects linear narrative in favour of a sequence of filmic vignettes, which range from bathetic realism to the pyrotechnics of *Matrix*-style action sequences. In this film more than any other, though, Suleiman's filmmaking style becomes a reflection of the psychological state of its central protagonist, the enigmatically titled and silent 'ES', played by Suleiman himself (suggesting a strong autobiographical dimension to the character). Plunged into familial and implicitly patriarchal crisis at his father's demise, the fragmentations and lamentations of ES's grief-stricken mind are projected through the formal characteristics of the film, and this focus on Suleiman's interior world seems to locate the film firmly in the realms of subjective, wayward creativity, rather than external reality. Yet the disjunctive nature of these filmic fragments can also be seen to reflect the essential heterogeneity of Palestinian experience and the sense of crisis that accompanies any attempt to 'make sense' of the Palestinian condition. As such, the interplay of style and symbolic subject matter establish a deeply internalised sense of representational crisis in both the male central character's self-perception and in the director's own vision.

The intrinsically gendered nature of this fragmentation emerges most clearly in vignettes that portray familial, communal and even psychological breakdown. The opening sequence to the film is a striking example of the surreal and somewhat macabre humour that accompanies such visions. In this sequence, a man dressed as that most benevolent of paternal figures, 'Father Christmas', runs in fear of his life through the hills of Nazareth, pursued by a group of young boys from whom he tries to defend himself by hurling presents at them. Finally, he can run no more, halted, we see, by a huge knife with which he has been stabbed in the torso. The political subtext that circulates around this image is complex: is this an image of apparent ingratitude for the 'gifts' offered by other paternal figures in the form of the Oslo Agreement, for example—or could it be a religious motif, in which Christ's sacred origins in the region are violated through violence? Suleiman playfully allows these ideas to circulate while an altogether more banal possibility surfaces: that for young men who have grown up accustomed to disenfranchisement, aggression and hostility, this is no more than a natural expression of male 'pack' mentality; a way to alleviate boredom, when more innocent childhood pursuits have been denied to them. Later, we see a similar group of young men engaged in what looks like extreme revolutionary violence, as they beat, shoot at and finally set fire to another intruder into their territory—which turns out to be no more than a snake. Meanwhile, Father Christmas recovers in hospital, where the wards are lined

with patients smoking endless cigarettes with such determination that they seem intent on their own demise. These vignettes of fragmented community and self-destructive propensities employ a deadpan, off-beat humour that not only subtly subverts our expectations of Palestine (where has the idyllic pastoral Palestine of Khleifi's *Wedding in Galilee* gone?) but which also captures the odd contortions in communal and particularly male relations perceived by Suleiman.

The strangeness of male relations portrayed here can be related to the disruptions to the patriarchal order that followed the major defeats suffered by Palestine in 1948 and 1967, when a younger generation of Palestinian men sought to overturn the values and structures of an older generation of nationalists in order to bring about national progress. This move was described in highly patriarchal terms as the 'overthrow of the fathers', and such a usurpation of power by the 'sons' of the nation must have created a deeply unnerving uncertainty over the hierarchical and indeed emotional structures of the community.[59] Arguably, ES allegorises the sense of trauma that accompanies this crisis in patriarchal power in his role as the grieving son in *A Chronicle of Love and Pain*, and this appears in one particularly poignant episode in the film. Set shortly before his father's death, we see ES sitting at his father's hospital bedside, apparently arm-wrestling with him. It is not until his father is levered up to a sitting position that we realise the image is not one of struggle but of love: ES is helping his aged and infirm father to sit up in his bed. Patriarchal frailty is accompanied by what might initially appear as conflict in this scene—but it in fact reveals a poignant reversal of roles that inspires not so much empowerment on ES's part as a deep sense of melancholy.

Indeed, ES's silence and relative stasis throughout the film points towards a sense of emasculation rather than masculine rejuvenation. In this, the relationship between the nation's fathers and sons can be read as a traumatised one. Julie Peteet connects such a crisis specifically to the occupation:

> The occupation has seriously diminished those realms of practice that allow men to engage in, display and affirm masculinity by means of autonomous actions. Frequent witnesses to their fathers' beatings by soldiers and settlers, children are acutely aware of their fathers' inability to protect themselves and their children.[60]

The disruption of patriarchal hierarchies therefore produces a sense of emasculation among the nation's male subjects. Indeed, the final scene of *A Chronicle of Love and Pain* appears to evoke this emasculation through an image of male impotence that bears interesting parallels with Bassem's frustrated virility in El-Youssef's short story. In this scene, we see ES sitting alongside his mother, rendered inert as he watches the temperature of a pressure cooker swiftly rising and surely about to blow its top. While deeply symbolic of the containment imposed upon Palestinian space and national aspirations, there

is also something of the masculine erotic about this image as the steam rises and its screeching prepares us for an almost orgasmic moment of release and explosion. The political implications of this image, though—Palestine as pressure cooker, a space of confinement that brings its inhabitants to the boil—are also suggestive of both a frustrated and potentially self-destructive male virility; for the release will surely be a violent one, and perhaps a literal as well as metaphorical 'petite mort'.

Faced with such deeply internalised senses of crisis, fragmentation and frustration, how might it be possible for Suleiman to imagine forms of agency for the male inhabitants of the Palestinian nation? Like El-Youssef, Suleiman also refuses to validate traditional ideals of 'manliness' in his work. Rather, he can be seen to undertake subtle and subversive reconfigurations of what characterises Palestinian masculinity, and by extension, of what can be considered 'manly'. One such reconfiguration is staged in *A Chronicle of Love and Pain* at what might be considered a particularly potent site of emasculation for the male Palestinian subject: at the border-checkpoint (a highly gendered space explored in further detail in the next chapter).

Suleiman portrays the checkpoint as a space at which the power dynamics between the Israeli occupier and Palestinian subject are rendered intensely visible and tangible, and this in turn leads to similar intensifications of the performances of masculinity that take place at them. This was evident during

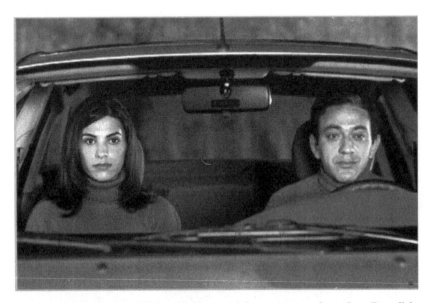

Figure 3.1 The deadpan ES (pictured here with his anonymous lover from Ramallah, who he must meet at the checkpoint due to her inability to cross into Jerusalem): a silent witness to the emasculating injustices of the Israeli occupation. *Divine Intervention* (2002), dir. Elia Suleiman. Image courtesy of Elia Suleiman.

the second *Intifada*, for example, when checkpoints became prominent sites of confrontation between Palestinian male youths and Israeli forces. Protests, stone throwing and confrontations all became increasingly common, and led to a considerable increase in injury among young male Palestinian youths in particular.[61] As well as sites that demand the performance of violent virility, though, the checkpoint is also a space of emasculation. The deadpan ES both bears witness to and embodies such emasculation, as he watches at the checkpoint as an Israeli guard armed with a loudspeaker parades along the line of waiting cars, intent on belittling their occupants during Ramadan by forcing them to swap vehicles arbitrarily, sometimes making them dance and sing along the way. Reduced to interchangeable bodies malleable to the guard's boorish whim, the border-crossers are unable to assert agency and must endure their abuse, carried out through emasculating humiliation and cultural degradation rather than physical violence. ES watches from a similar point of powerlessness in his car. The checkpoint emerges as a space of emasculation and national inertia here, offering few possibilities of fulfilling masculine codes of honour.

Or does it? Suleiman's own behaviour, and indeed that of the border-crossers, can also be read according to alternative codes of masculinity which suggest how Palestinian nationalism might subvert the gendered codes inscribed by dominant Israeli discourse. Julie Peteet states that during the first *Intifada*, the valorisation of Palestinian masculinity shifted from the assertion of active and autonomous behaviours to qualities of endurance, sacrifice and dignity, which came to be understood as alternative means of fulfilling honour (*sharaf*). Acts used to humiliate Palestinian subjects by way of their inability to resist, such as torture and beatings, have become rites of passage which attest to the male subject's commitment to the national 'cause' (*qadiyyah*), and this is reflected in the open display of marks of violence upon the male body, which are appropriated less as marks of subordination than as testament to his endurance, imbuing him with communal standing.[62] Such an understanding of masculinity recognises and addresses the powerlessness of the Palestinian subject while suggesting this has become the condition of resistance in itself—a subversion of the gendered power structures of Israeli authority. This has been extended to Palestinian readings of Israeli military behaviour. Military responses to unarmed Palestinian youths are read as 'cowardly and immoral', 'lacking in the emotional ... qualities of manhood' or as 'rude and boorish'.[63] This facilitates a 'poetics of contrast' between Palestinian and Israeli subjects, which enables Palestinians to reclassify their own behaviour not as passivity but as dignity, politeness and the ability to empathise with others—important ethical qualities that reposition the Palestinian collectivity on the moral high ground.

In this light, ES's actions at the border-checkpoint and indeed his characterisation in general—his stone-faced silence, lack of response and inertia—can be reread as markers of his enduring dignity as well as emotional and

moral strength, and thus as a manifestation of *sumud*. This quality is most usually understood as a non-violent form of resistance that is carried out simply by standing firm in the face of threat or danger, and it circulates widely as a valuable Palestinian characteristic in the cultural imagination.[64] ES's endurance of the marginalising conditions of occupation—and indeed the 'real' ES's creation of a film that testifies so eloquently to the psychological and social fragmentation that it produces—therefore constitute assertions of physical, mental and visual agency. These assertions of agency transform our vision of Palestine from one of marginal stasis and paternal inertia to a subtler conceptualisation of the nation as a space constituted through an altogether more self-aware, enduring and cerebral masculinity. Suleiman's *Chronicle of Love and Pain* therefore suggests the overhaul of patriarchal and traditional concepts of masculinity as a traumatic and painful but nevertheless regenerative process for the nation.

Suleiman's revalorisation of masculinity appears transgressive in postcolonial feminist terms as it seems to break free of the traditional patriarchal orders that characterise both nationalist and colonial power structures. Yet Suleiman's film nevertheless portrays the male subject as somewhat isolated, the bonds of fraternity replaced with a process of self-scrutiny that he must ultimately undergo alone. This wilful rejection of national fraternity might be said to retain a level of elitist and artistic privilege, however, that very same charge which has been levelled against some postcolonial theorists, who bear what Patricia Price-Chalita describes as 'the rather playful luxury of *choosing* to be marginal'.[65] For those who do not bear ES's powers of creative representation, altogether more radical forms of 'speech act' might seem the only way of valorising masculinity—acts that may be performed through the destruction of the male body itself, as Hany Abu-Assad's film *Paradise Now* explores.

Masculinity in the Margins: The Subterranean States of Hany Abu-Assad's *Paradise Now*

Hany Abu-Assad has emerged as one of the most prominent Palestinian directors on the world stage in the twenty-first century, particularly in the wake of his critically acclaimed 2005 release, *Paradise Now*, which not only won a Golden Globe, but was also the first Palestinian film to be nominated for an Academy Award for Best Foreign Language Film. Like Suleiman, Abu-Assad grew up in Nazareth in the 1960s. Born in 1961 into a relatively prosperous family involved in the transport business, he describes himself as a 'privileged Palestinian' who enjoyed comforts not always afforded to others: the balcony seats in the local cinema as a young boy, for example, and later, a relatively smooth transition to life in Amsterdam in the 1980s, where he first studied to be an engineer, then later trained as a filmmaker.[66] Despite his own transcultural location, many of his films, including the works *Ford*

Transit[67] and *Rana's Wedding*,[68] remain focused on the creative exploration of aspects of Palestinian experience, and indeed, *Paradise Now* confronts one of the most controversial and traumatic aspects of Palestinian existence: the practice of 'suicide bombing' or 'martyrdom' (*shahadah*).[69] The film focuses on two best friends who are struggling to get by, financially and emotionally, in the present-day (post-al Aqsa *Intifada*) West Bank. This is no straightforward 'buddy movie', however, for the young men are quickly recruited into militancy by the paternal figure of Jamal, the local schoolteacher, and dispatched on a 'martyrdom' exercise over the border in Israel. The film charts their contrasting responses to their impending mission. While critical attention to the film has often focused on the question of whether or not Abu-Assad seeks to justify violent resistance, *Paradise Now* in fact reveals less about the act of suicide bombing than it does about the interpersonal, specifically masculine bonds that structure and inform such acts within the context of the occupation.[70] The following discussion therefore explores the various constructions of paternal and fraternal relations that emerge in Abu-Assad's film, which present an ambivalent vision of a Palestinian masculinity torn between heroism and dehumanisation, resistance and futility. In particular, the analysis focuses on motifs of the 'subterranean' that circulate at a number of visual and symbolic levels in the film, which tell us much about the complex relationships between male marginalisation, militancy and ultimately (post)coloniality imagined by Abu-Assad.

Paradise Now portrays the recruitment of two young men, Said (played by Kais Nashif) and Khaled (Ali Suliman), into the militant 'underground' of Palestinian resistance. While they also experience the socially marginalising and emasculating effects of the occupation, they are portrayed in very different ways from the aloof and isolated male characters of El-Youssef's and Suleiman's works, however. For Said and Khaled, a genuine sense of fraternity binds them to each other, and we first see them working together on clapped-out cars in an old car yard, before they finish the day by sitting in the hillsides overlooking the city, smoking a water pipe and drinking tea. In their jeans and worn tee shirts, sporting slightly scruffy hair and a little stubble, they appear completely average and entirely likable young men whose friendship is close and genuine.

The two appear a little unmotivated—but that's to be expected when, as Said tells us, work permits to Israel are impossible to come by and day-to-day life consists of menial work and boredom. As the film unfolds, however, the extraordinary backdrop to their 'mundane' lives becomes apparent. Said reveals that he grew up in a refugee camp and has only left the West Bank once, at the age of six, before his father was executed for collaborating with the Israelis. Khaled, meanwhile, casually lets slip that his father's limp was acquired when Israeli soldiers broke into their house during the first *Intifada* and asked his father which leg he'd rather keep. 'I'd rather they'd broken both of them than left him so dishonoured', is Khaled's verdict on the story.

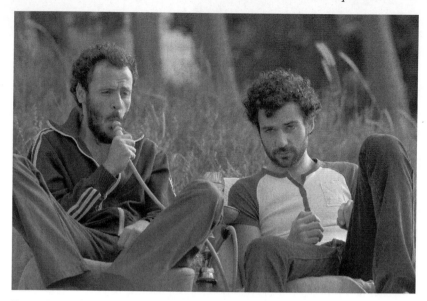

Figure 3.2 Khaled (left) and Said (right), figures of a close and genuine 'fraternal' friendship (portrayed by Ali Suliman and Kais Nashef). *Paradise Now* (2005), dir. Hany Abu-Assad. Image courtesy of Bero Beyer, Augustus Film.

A culture of patriarchal disempowerment and masculine humiliation therefore underpins both Said's and Khaled's experiences.

While this affront to patriarchal authority leads to an off-beat, aloof and cerebral masculine mentality in El-Youssef's and Suleiman's works, Abu-Assad's characters initially adopt an altogether different logic, centred on the rationalisation of violence. Such rationalisation is often cited as a psychological response to severe conditions of depravation, and to the fusion of social and personal trauma. Eyad El Sarraj, a psychiatrist and founder of the Gaza Community Mental Health Programme, states that 'the people who are committing the suicide bombings in this [second] *Intifada* are the children of the first *Intifada*–people who witnessed so much trauma as children. So as they grew up, their own identity merged with the national identity of humiliation and defeat'.[71] The apparent normality of violence within Said's existence, and the link between the self-defensive and self-destructive, becomes apparent in an episode when we see Suha, a young Palestinian woman born in France and newly returned to Nablus, chatting (and perhaps flirting a little) with Said. 'Do you ever go to the cinema?' she asks Said. 'Yes, once, ten years ago when we burned [it] down', Said replies, 'a demonstration ended there'. From her vantage-point as partial outsider, Suha is astonished at his casual attitude towards this violent act. 'Why the cinema?' she asks. 'Why us?' Said replies. Here, Said reveals the way in which the seemingly irrational oppression of

the Palestinian people also engenders a skewed logic of protest and counter-violence in response. The schoolteacher and militant figure Jamal also presents the idea to Said and Khaled that violence is morally justified and indeed unavoidable in chaotic social conditions such as theirs, in his attempts to recruit them into the militant 'underworld'. We see him philosophising with the young men in an intimate and brotherly style: 'What can you do when there is no justice or freedom?' he asks Said. 'If we give in to the law that the strong devours the weak, then we reduce ourselves to the level of animals. That's intolerable . . . Whoever fights for freedom can also die for it. You are the one who can change things'. Rather than pointing towards their inevitable self-destruction, Jamal's logic of violence promises the young men the reclamation of their humanity, predicated on masculine qualities of strength, resistance, will and agency.

Said and Khaled's indoctrination according to this logic offers an insight both into the alternative terms in which 'suicide bombing' is perceived within segments of Palestinian culture, and into the highly gendered terms of its discourse. While 'suicide bombing' is classified as terrorist activity in the Western imagination, it is understood neither as 'terrorism' nor as 'suicide' (an act forbidden within the Qur'an) within a Palestinian context. As Brunner notes, the term *istish-hadi* has emerged as an Arabic neologism for 'suicide bomber' but the term *shaheed*, meaning 'martyr', is the most common term for such acts in Palestine. This term retains connotations of self-sacrifice, honour and struggle against the occupation and is applied to many different kinds of suffering and victimhood.[72] Within a radical Islamic context, the preconditions for *shahadah* (martyrdom) include not only a 'commitment to Islam' but also 'maleness', 'sanity' and 'freedom of choice'.[73] In this sense, the act of martyrdom comes to be perceived as both an assertion of agency and as a sacrifice of selfhood which affirm the typically 'masculine' traits of heroism, strength and defence of one's community. Recent social research has also emphasised the importance of personal or communal losses of male relatives or figureheads as motivations for attacks.[74] This emerges in the film when Jamal tells Said that his mission will 'answer the assassination of Abu Hazem and Umm Jaber's son' who died in a recent bombing, and in the way that Khaled wants to avenge the maiming of his father, while Said wishes to atone for his father's collaboration with the Israelis. *Shahadah* therefore emerges as a discourse through which the male subject's masculinity, and hence the authority of the patriarchal community, might be reinstated. Yet Abu-Assad does not allow this rationale to go untroubled. Rather, he reveals its tenuous masculinist authority by exposing the performativity of martyrdom as a discourse.

The 'performative' nature of martyrdom emerges in the film both at the level of a literally dramatic performance screened through visual media, and in the terms outlined by Butler in her theory of 'gender performativity'. For Butler, gender is not an innate quality of our being but something constructed through the repetition of gendered 'acts' that come to appear 'natural'. As

she puts it: 'What we take to be an "internal" feature of ourselves [that is, gender] is one that we anticipate and produce through certain bodily acts, at an extreme, an hallucinatory effect of naturalized gestures'.[75] In *Paradise Now*, one scene in particular exposes the ways in which the masculine aura afforded the martyr is in fact a ritualised fetishisation of the male body and 'a performative accomplishment which the mundane social audience, including the actors themselves, come to believe and perform in the mode of belief'.[76] This scene portrays Said and Khaled deep in the subterranean world of Palestinian militancy, in a darkened and ramshackle building where they are recording their martyrdom videos. These scenes appear uncanny to a Western viewer more accustomed to encountering such images as news footage in the wake of an attack. Yet Abu-Assad complicates the identity and authority of the militant, masculine martyr within this scene. We first see Khaled in a guise that appears distressingly familiar: that of the armed militant, posing in front of banners sporting militant slogans. He hoists a heavy gun aloft and, with a deep breath signalling the gravity of his words, begins his final official goodbyes to friends, family and nation, before declaring the fatalistic justifications for his mission. By the end of his speech, Khaled is drained and Said appears moved by his friend's words. Yet Abu-Assad deftly debunks the authority of this performance: 'The sound didn't record', the cameraman announces. 'We'll have to do it again'. Jamal, meanwhile, starts munching on a pita bread as Khaled begins reading from the top of his script once more. Khaled's assertion of masculine agency is rendered absurd and even parodic in this scene, offering the very 'failure of repetition' that Butler views as such a productive means to expose the performative nature of gender and, here, of masculine martyrdom. This scene therefore offers a poignant reminder that these men are not entirely free-acting agents; rather, they occupy a subordinate position within the very patriarchal structures that they seek to affirm, and their value within this order exists primarily at a corporeal and symbolic level that could be read as a form of exploitation and dehumanisation. Indeed, this scene can be read as a broader comment on the illusory nature of fraternal relations in contemporary Palestine. While, as Johnson and Kuttab note, the first *Intifada* was characterised by communal activity in which the *shebab* would be supported by the physical presence of others, community in the second *Intifada* now functions primarily as an 'audience' rather than a protective environment, which bears witness to the martyr's sacrifices at a distance, through visual media.[77] Abu-Assad reveals the fallibility of the martyr's masculine authority by disrupting the authority of the sympathetic (implicitly fraternal) cinematic gaze in this scene and revealing an alternative, distancing visual engagement that is just as ready to render the male body no more than a disposable commodity as it is to immortalise it.

If Said and Khaled initially display a naïve belief in the potential of martyrdom to affirm their masculine and nationalist agency, then they also arrive at a more self-aware understanding of this discourse over the course of the

film. This ultimately leads to a division of their brotherly bond, as Khaled decides that his violent self-sacrifice will only perpetuate further conflict, while Said's initial misgivings evolve into eventual certainty at the necessity of this act. Interestingly, though, Said's final conceptualisation of martyrdom encompasses a recognition of its fallibility, and of the conflicted status of the male body within it. He articulates the paradoxical and problematic nature of *shahadah* when he states that 'if they [Israel] take on the role of oppressor and victim then I have no choice but to also become a victim, and a murderer as well'. Indeed, he does not conceive of martyrdom as a primarily spiritual act but as something primitively corporeal: 'Our bodies are all we have left to fight with', he tells Khaled. 'Not our death, but the continuance of resistance will change something. I have no other option'. Here, Said articulates a view of martyrdom that presents it as a form of 'speech act' for the male subject who otherwise lacks a political voice, while also recognising the inherent partiality and fallibility of this discourse. This leads to an interesting alternative gendering of *shahadah*–for as Brunner writes, martyrdom can therefore be interpreted, in some senses, as a 'feminine' act: 'Suicide bombings are highly emotive and refer to the weakness of the enemy as well as to the weakness of the society they pretend to defend [. . .] Corresponding to the inevitable thinking in dichotomies, [they] can be located on the *feminine* side of the scale'.[78] While Said is not straightforwardly feminised through his self-sacrifice, he nevertheless expresses an understanding of martyrdom as an act that does not simply affirm masculinity but which attests to the contradictions and flaws that are entailed within both masculinity and resistance as discourses.

Abu-Assad suggests the ambivalent status of the male martyr's body still further through a series of images that associate the would-be bombers with the (literally subterranean) state of death. Said's own statement that 'under the occupation we're already dead' points towards his limbo-like existence under occupation, but Suha's reference to him as 'her guest of the night' is more strongly suggestive of haunting and ghostliness. A sense of the uncanny also emerges in a highly disconcerting moment during the film when we see Said and Khaled being prepared for martyrdom. In this scene, the men undergo their Muslim funeral rites while still alive. We see them being washed and shaved in an act that simultaneously prepares them to carry explosives while mirroring the practice of washing the body after death, before they are wrapped in white sheets that are perhaps no more than towels, but which resemble the *kafan*, or clean white cloth, in which bodies should be buried. Through this image, Abu-Assad appears to be inviting the viewer to mourn both the men's premature deaths and the states of obliteration that they have already endured in life. An altogether more poignant and ambiguous image of the would-be martyr's liminal state occurs when Said returns to his home after the failure of his initial mission. As Said steals up to his house in the soft afternoon light, he catches one last glimpse of his mother through the window, before pressing his back to the wall so that he cannot be seen. As

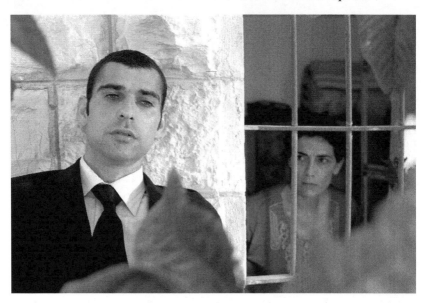

Figure 3.3 A haunting presence: Said's mother senses her son, already lost to the subterranean world of self-destruction. Portrayed by Kais Nashef and Hiam Abbas. *Paradise Now* (2005), dir. Hany Abu-Assad. Image courtesy of Bero Beyer, Augustus Film.

though sensing his presence, his mother comes to the window and the camera dwells for a moment on the juxtaposed images of the mother and the child who is already lost to her. Each figure unseeing of the other, Said is a ghostly presence in this scene, poised on the brink of slipping not only into the night but into a more complete self-erasure.

The lyrical yet ambivalent pathos of this scene resonates with Mahmoud Darwish's attitude towards martyrdom in his well-known poem, 'A State of Siege'. In this poem, Darwish contrasts the perspectives of the martyr before and after death. Initially, the martyr perceives his death as a route to 'freedom' and 'rebirth':

> On the brink of death he says:
> I have no foothold in me left to lose,
> I am free near my freedom
> and my tomorrow is in my hand . . .
> I will enter, in a little while, my life
> and become born free and parentless,
> and choose for my name letters of lapis[79]

Darwish's evocation of martyrdom remains ambivalent, though, for the martyr's search for freedom through death is far from glorified. Instead, both

desperation ('I have no foothold . . . left to lose') and a certain naïve romanticism (that his tombstone should be written in 'letters of lapis') underpin his painfully idealised suicidal 'speech act'. This is an act that breaks the structures of family, community and love, inflicting grief on the father who will no longer 'walk ahead' of his son to death and on the parents that remain on the earth while the martyr ascends after death, 'parentless':

> The martyr cautions me: Don't believe the women's zaghareed
> and believe my father when he looks into my picture tearfully:
> How did you swap our roles, my son,
> and walk ahead of me?
> Me first
> and me first![80]

Darwish's poem appears both a lamentation for the martyr's loss of life, and a warning that the official rhetoric of sacrifice and heroism, evoked in the image of 'the women's zaghareed' (their ululations, expressions of celebration), must not obscure an awareness of the personal and familial suffering also caused through such an act.

It is important to note that Darwish's poem, like Abu-Assad's film, retains a focus on the discourse of Palestinian national solidarity. It does not mourn others killed through the martyr's actions; rather, the pathos of such an act emerges through the disruption that it causes to structures of family and paternity, and through the crisis evoked by the male subject's willingness to erase himself. As such, Abu-Assad seems not so much to contest the necessity of resistance, but to refigure the terms on which it must take place. Significantly, these alternative terms are articulated by Suha, whose position as a woman, as an international subject and crucially, as the daughter of a famous martyr, appears to mobilise a radical postcolonial feminist potential within the film. Speaking of her father, she debunks the values of 'pride' and 'honour' associated with martyrdom: 'I'd rather he were still alive today than be proud of him', she tells Said. Indeed, she points towards the counter-productivity of martyrdom in a later conversation with Khaled: 'You give Israel an excuse to carry on', she tells him; 'We have to turn it into a moral war'. Suha reveals the alternative ways in which Said's martyred body will be inscribed: as that of the violent, irrational terrorist who must be suppressed by Israel, and crucially, this awareness stems from her 'contrapuntal consciousness' as a subject who is aware both of how such acts will be perceived beyond the boundaries of the nation, and of how Palestinians will perceive them from within. Her status as *daughter* to a Palestinian martyr is also highly significant. As 'other' to the structures of paternity, fraternity and patriarchy, Suha does not appear to feel any obligation to perpetuate them; rather, she bears witness to the human loss entailed in her father's sacrifice. Her contrasting solution to Palestine's marginalisation is not conceived in

corporeal terms, but rather in cerebral ones, for it transpires that she has been working as a foreign journalist, reporting overseas on the conditions of life in Palestine. As such, Suha's marginal position as woman and as exile seems to offer the most productive articulation of agency within the film. Yet Suha's 'postcolonial feminist' agency also reveals these margins to be sites of relative privilege. Denied access beyond the borders of the West Bank, Said is unable to move beyond the radical margins at either the physical or psychological levels that Suha can.

Abu-Assad's location of Palestinian masculinity in the radical margins, conceived as sites of the political 'underground' and of a more permanently subterranean existence, therefore testifies to the extreme ambivalence of *shahadah* as a form of national and gendered agency. This ambivalence is symbolised by the final frames of the film, which appear to evoke the instant at which Said detonates his bomb. Said's act of martyrdom is not portrayed as a moment of chaos, destruction or heroism, however. Rather, is it represented quite simply through a whitening of the screen and a silence. This image (or lack of image) allows a number of connotations to circulate: from light and transcendence to total negation. Crucially, it also suggests an absence of signification, pointing towards the sense in which such an act cannot be easily deciphered or transcribed; it exceeds the boundaries of that which can be represented or imagined. Yet this white blankness also appears to conjure a blank inscriptive surface. In this, Abu-Assad perhaps suggests that while the radical margins of Khaled and Said's world may not facilitate 'speech acts' beyond the corporeal, the privileged margins occupied by the filmmaker and implicitly the postcolonial feminist theorist pose other possibilities of articulation, and more productive and connective acts of representation remain to be written. These are possibilities that must surely be embraced, in the hope of arriving at a more connective understanding of the radically marginalising conditions that incite such radical acts of (self-)destruction.

Performing Postcolonial Masculinity

While El-Youssef, Suleiman and Abu-Assad all present highly distinctive visions of Palestinian masculinity, their works all have one thing in common: they do not present masculinity as an innate, pre-given identity, but rather something constructed in relation to the colonial environment. For all of these creative practitioners, Israeli colonial power engenders significant forms of crisis for the male subject, and this crisis is manifested variously as the experience of impotence or emasculation, as a social inertia and lack of voice or as destructive tendencies towards oneself, and others. At one level, these performances of masculinity in crisis therefore evoke the broader national crisis of Palestine, and suggest the colonised status of both the male body and the body politic. Yet there is also an important sense in which all of these creative practitioners move beyond the straightforward equation of

masculine and national crisis—for instead of portraying the crisis in patriarchal power as a situation to be remedied in the transition to postcoloniality, El-Youssef, Suleiman and Abu-Assad locate creative postcolonial possibilities in the very denaturalisation of this discourse.

We see these creative postcolonial possibilities emerge out of various crises experienced by all of the male characters within each of these works. In 'The Day the Beast Got Thirsty', for example, Bassem presents an initially challenging portrait of emasculation, disaffection and disengagement. Yet this character also reveals the unachievable nature of the models of male nationalist heroism demanded of him, and presents instead a fallible but self-aware masculinity that breaks from the scripts of nationalist identity. While Bassem does not necessarily locate a viable alternative to models of nationalist masculinity, his denaturalisation of this discourse nevertheless presents a creative and independent alternative to the dogmas of patriarchal nationalism. Similarly, Suleiman's character 'ES' offers a poignant portrait of the pain that accompanies filial and fraternal love in the crisis-ridden patriarchal structures of contemporary Palestinian society. Although Suleiman's character is unable to perform traditional models of nationalist masculinity, a new form of cerebral, stoical manliness emerges from these conditions of crisis. In the process, Suleiman seems to suggest that idealised models of 'authentic' pre-colonial patriarchy must be dispensed with, in favour of new understandings of post-patriarchal identity befitting the postcolonial future. Abu-Assad's portrayal of Said and Khaled, meanwhile, suggests that the patriarchal structures of both colonial and nationalist militancy perpetuate cycles of self-destructive violence that can be broken only by challenging the 'scripts' of hegemonic masculinity through which these discourses are performed. While Said finds himself unable to achieve this reconfiguration of masculinity, we see its possibility in the figure of Suha, who calls for an ethical and moral reconfiguration of Palestinian resistance, and so of social (including gender) relations. In all of these works, then, performances of masculinity are disrupted in ways that not only portray a crisis in patriarchal power, but which also figure this crisis as a moment of potential transformation: an opportunity, perhaps, to challenge the binary structures of oppressor and oppressed, masculine and feminine, that have long characterised colonial domination.

The radical potential that emerges from these works, though, is far from utopian. Indeed, while they display a willingness to challenge the scripts of nationalist masculinity, this is in some ways a highly introspective masculine self-reflexivity that does not necessarily extend to the reexamination of the relationships between masculinity and femininity, or between men and women. Nevertheless, we might say that these works establish the *potential* for these processes to occur, through the shift from an allegiance to centralised power structures to what we might describe as a more tangential, even 'marginal' perspective. Suleiman himself describes this shift in perspective as central to his work:

> I want to create a 'decentred' image [. . .] My challenge is to avoid a centralized, unified image that allows only a single narrative perspective and, on the contrary, to try to produce a kind of decentralization of viewpoint, perception, and narration.[81]

In this model of the 'decentred' gaze, Suleiman describes a commitment to plural dialogues that can be more readily achieved by turning to the margins. Here, he evokes something of the postcolonial feminist potential identified by bell hooks in her own description of the margins as a meeting-place for all oppressed, excluded and colonised peoples that bears a radical creativity. As she puts it:

> That space in the margin . . . is a site of creativity and power, [an] inclusive space where we recover ourselves, where we meet in solidarity to erase the category colonized/colonizer. Marginality is the space of resistance. Enter that space. Let us meet there. Enter that space. We greet you as liberators.[82]

Consequently, the postcolonial feminist potential of El-Youssef's, Suleiman's and Abu-Assad's works is to be found in the way that they relocate their portrayals of masculinity firmly in the margins, and in doing so, conjure this space not simply as a source of crisis but also of a creative potential—a location where the dialogues and new solidarities described by hooks might be achieved. In order for this postcolonial feminist potential of the margins to be fully realised, though, such self-aware performances of maleness and masculinity must surely be placed in dialogue with those of other genders, identities and subject-positions. This is the intriguing possibility that the creative practitioners examined in the next chapter explore by turning to the difficult encounters that occur in Palestine's literal margins: its borderlands.

4 Bodies Beyond Boundaries?
Transitional Spaces and Liminal Selves

There is perhaps no other space that has captured the imagination of postcolonial feminist theorists quite like that of the border. Many strands of postcolonial feminist theory turn towards the margins, edges or boundaries of social and representational structures in order to challenge the dominant and centralised paradigms of various power/knowledge systems, including those of postcolonialism and feminism as disciplines. Consequently, for some theorists, the border has come to represent the disciplinary location of postcolonial feminism itself, symbolising both '[the theorist's] own estrangement from the centre of her discipline',[1] and the 'liminal' nature of postcolonial feminist discourse, poised as it is on the threshold or 'limen' of competing critical spheres and intellectual worlds. Borders therefore signify 'a place of politically exciting hybridity, intellectual creativity, and moral possibility'[2] for many theorists, who emphasise the inherent ambivalence of the border as a site that not only separates but also forges connections between two or more spaces, cultures or subject-positions. Hence, as Michaelsen and Johnson put it, borders are frequently imagined as a 'privileged locus of hope for a better world' in the realms of critical theory.[3] Yet for Palestine, a nation much in need of 'a better world', borders also represent traumatic sites of spatial and psychological experience and it is for their oppressive permeation of everyday existence that they have taken hold in the imaginations of many Palestinian directors and writers. To what extent might it be possible to create productive critical exchanges between these two vastly different visions of the border? This chapter turns to recent 'border-narratives' by the authors Randa Jarrar, Liana Badr and Raeda Taha, and by the contemporary directors Tawfik Abu Wael and Annemarie Jacir, in order to explore the alternative politics of gendered experience, identification and (post)coloniality that circulate around borders in the Palestinian imagination. Collectively, these narratives not only break down some of the securely utopian assumptions of postcolonial feminist theory, but also reveal a politics of gendered representation that is boundary-breaking in its own right.

It is hardly surprising that borders should have emerged as such prominent tropes in Palestinian creative consciousness, given the way in which

shifting claims to the land have been reflected in the constant redrawing of territorial boundaries. The territory comprised today of the State of Israel, Gaza and the West Bank has been held by various regional and imperial powers throughout its contested history, and the region has, to an extent, always been defined by territorial flux and shifts in power.[4] As the poet Tawfiq Zayyad puts it in his poem, 'What Next?': 'on this land of mine / conquerors never lasted'.[5] Yet the period that has been most influential in building a contemporary Palestinian consciousness of borders has been that of European political intervention in the early twentieth century. During this period, European powers carved nation-states out of the former territory of the Ottoman Empire, leading to the establishment of Palestine as a British mandate in 1922. Despite initial promises from the British that Palestine would eventually be established as an independent Arab nation, Lord Balfour's 1917 statement of commitment to the creation of a home for Jews in Palestine later resulted in the passing of the United Nations' Resolution 181 in 1947, which established a plan for partition of Palestinian territory into independent Israeli and Palestinian states in which 56% of land would be ceded to the Jewish minority and 43% to the Arab majority.[6] This divisive imposition of boundaries reflects Joe Cleary's observation that 'most of the major partitions in the twentieth century have occurred in territories previously subject to colonial rule',[7] and Palestine appears no exception. The borders imposed on Palestine by external forces have tended to operate as colonial usurpations of self-determination rather than as markers of independent nationhood, and this trend has continued throughout the twentieth century, firstly with the *Nakba* of 1948, which extended Israeli territory beyond the initial UN plans for partition, and subsequently during the *Naksa* of 1967, through which Israel gained control of all remaining Palestinian territory.[8] Rather than integrating these areas into the State of Israel, however, Gaza and the West Bank have been maintained as clearly distinctive territories. In 1993, the border with Gaza was sealed and, though granted 'self-rule', it is still unable to control its own boundaries, while the West Bank has been designated as 'occupied territory', never having been formally annexed to Israel or Jordan. As such, its 'jurisdiction is yet to be decided'.[9] The result of this is that Palestine's borders occupy a paradoxical status: they are at once entirely absent, since there is no self-determined Palestinian nation-state; yet Palestinians remain subject to Israeli-enforced boundaries that are controlled according to some of the most rigorously divisive mechanisms operating anywhere in the world today. Consequently, it can be said that Palestinian borders testify both to the colonial control and settlement of formerly Palestinian land, and to Palestine's oddly postmodern (some might say 'post-national', or even in this case 'pre-national') condition of stateless liminality. As the director Elia Suleiman puts it, 'Palestine does not exist. It has no borders. It has all the chaotic elements that lead you to question space, borders, and

crossings . . . The Palestinian people is partitioned into various segments, but there is no real border'.[10]

While Palestinian borders are, at one level, entirely absent, a mentality of boundaries has nevertheless come to define Palestinian existence. Indeed, Rashid Khalidi has suggested that ironically, borders have come to stand as sites of 'quintessential Palestinian experience', for whether at 'a border, an airport, a checkpoint', 'what happens to Palestinians at these crossings brings home to them how much they share as a people'.[11] The shared condition experienced by Palestinians is that of having their right to movement, to freedom and to belonging called into question. Since the first *Intifada* of 1987–1993, a policy of 'internal closure' has been implemented in the West Bank, where hundreds of barbed wire fences, roadblocks and checkpoints have sprung up, and since 1993, all Palestinians living in the West Bank have required an Israeli-issued permit in order to visit Jerusalem, during which they are required to pass through militarily controlled checkpoints at which such documentation is verified or rejected. Those living in Gaza, meanwhile, require three documents in order to pass into Israel or elsewhere, documents that are only held by 5% of the population.[12] In recent years, borders have become increasingly restrictive in material terms, affirming their function as elements of what the architect and theorist Eyal Weizman has termed Israel's 'architecture of occupation': the use of spatial mechanisms to assert Israeli control of every element of Palestinian space, from surveillance strategies implemented through its airspace, to the construction of segregated road systems, to the control of subterranean water supplies in the West Bank.[13] In 2007, for example, following the democratic election of Hamas, an air, land and sea blockade was imposed on Gaza by Israel and Egypt.[14] Perhaps the starkest visual reminder of the borders imposed by the occupation, though, takes the form of the 26-foot-high 'Separation Fence', or 'Apartheid Wall', which began construction in 2002 (in violation of the Green Line outlined in 1949, and declared illegal by the International Court of Justice in 2004)[15] and runs along the entire northwest face of the West Bank, not only dividing the West Bank from Israel but West from East Jerusalem, carving out numerous enclosures within the West Bank itself. As Islah Jad writes, the path of the Apartheid Wall within the West Bank has 'resulted in the creation of localized identities which acted to destroy the social fabric and undermine Palestinian unity'.[16] This very distinctive type of border, then, has served to fragment rather than to affirm Palestinian national boundaries.

This 'Apartheid Wall' eerily echoes the commitment to spatial, cultural and ideological segregation outlined by Jabotinsky, the founder of revisionist Zionism, in an article entitled 'The Iron Wall':

> Zionist colonization, even the most restricted, must either be terminated or carried out in defiance of the will of the native population. This colonization can, therefore, continue and develop only under the protection

104 *Palestinian Literature and Film in Postcolonial Feminist Perspective*

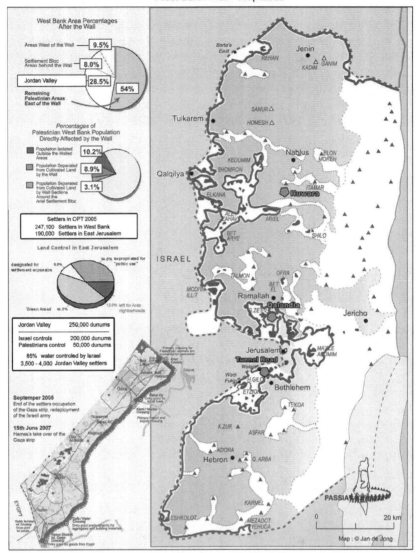

Figure 4.1 Map of the West Bank Wall, 2006. The Wall is indicated by the thick solid line, while the Green Line of 1949 is indicated by the dashed line. Israeli settlements are denoted by triangle shapes. Map courtesy of PASSIA (Palestinian Academic Society for the Study of International Affairs).

of a force independent of the local population—an iron wall which the native population cannot break through. This is, in toto, our policy towards the Arabs.[17]

Following Said, A.H. Sa'di points out the clearly colonial, even Orientalist mentality of this policy, which seeks to establish its difference and superiority to a 'native population' that must be controlled and expelled to the margins of both the Israeli State and Israeli consciousness. This mentality is not unique to colonial Palestine. Indeed, the postcolonialist Avtar Brah has drawn attention to the segregationist and indeed constructivist tendencies of all borders in her description of them as

> arbitrary dividing lines that are simultaneously social, cultural and psychic; territories to be patrolled against those who they construct as outsiders, aliens, the Others; forms of demarcation where the very act of prohibition inscribes transgression; zones where the fear of the Other is the fear of the Self; places where ownership—claims to 'mine', 'yours' and 'theirs'—are staked out, contested, fought over.[18]

This vivid description draws attention to the way in which borders must be understood not only as sites where space and nationhood are delineated, but as intimate sites at which identity and selfhood are also produced. This interplay of the political and personal, spatial and subjective emerges as a major theme within many of the recent literary and filmic works that have focused their sites on borders as a theme or motif.

While borders and border-regions hold a longstanding presence in Palestinian creative consciousness,[19] they have surfaced most extensively following the proliferation of material boundaries set up in the wake of the first *Intifada* in the form of roadblocks, checkpoints and concrete barriers, which serve as highly visible surfaces onto which a director or author may project their creative vision or interpretation.[20] Indeed, this has taken place to such an extent in film that the critic George Khleifi has identified a whole genre of 'roadblock movies' which focus their plot and setting at the checkpoint, with its emergent dramas.[21] Yet a broader cross-genre examination of both literature and film suggests that borders have come to signify more than simply division and oppression, and instead, have begun to represent sites where the politics of identity and selfhood are played out in complex ways. Particularly fascinating within these narratives is the emphasis on the body itself as a bounded, self-contained entity that is forced into confrontation or even contact with the border. Hence the border emerges as more than a straightforward manifestation of the 'architecture of occupation': it also delineates the social, ideological and personal boundaries that circulate around the gendered body and intersect with physical borders in a variety of ways.

In this recognition of the border as a site that reveals multiple cartographies of power and identity, Palestinian border-narratives seem to resemble postcolonial feminist theorisations of the border which view it as a space that constructs 'membership in divergent, even antagonistic, historical and national identities',[22] and thus transcends binarised identity politics. As Naficy contends,

> as a result, border-consciousness, like exilic liminality, is theoretically against binarism and duality and for a third critique, which is multiperspectival and tolerant of ambiguity, ambivalence and chaos.[23]

To what extent, however, does the interplay of bodily and spatial boundaries, of national and gender politics, and of competing structures of power result in this radically postcolonial, even post-patriarchal state when it comes to the Palestinian border? Over the course of this chapter, I turn to some of the more unusual narratives that evoke the interplay between borders and bodies as their subject matter in order to suggest the variety of restrictive and transgressive scenarios imagined through them.

In the first section of the chapter, I explore the figure of the 'checkpoint heroine' who appears in the work of several contemporary female authors, including Randa Jarrar, Liana Badr and Raeda Taha, whose 'border-narratives' are anthologised in the collection *Qissat*.[24] In the second part of the chapter, I turn to more radically deconstructive explorations of Palestine's liminal spaces and subjectivities through Tawfik Abu Wael's film *'Atash*[25] and Annemarie Jacir's short film *like twenty impossibles*,[26] both of which conjure the 'borderland' as a site at which the politics of bodies and identity are thrown into disarray. Throughout these analyses, I employ tools drawn from postcolonial feminist theorisations of the border such as the work of Gloria Anzaldúa and D. Emily Hicks, and from Palestinian cultural concepts of gender, in order to suggest the forms of interplay and discrepancy that are opened up when Palestinian and postcolonial feminist visions of the border are placed alongside one another. Where might this act of border-crossing lead us, as theorists and as readers? In order to answer this question, we must first confront one of the most traumatic but imaginatively productive spaces within the Palestinian imagination: the checkpoint.

Narratives of the 'Checkpoint Heroine'

Checkpoints have become a familiar if unwelcome part of the landscape for any Palestinian seeking to travel into, out of or within the West Bank. According to Eyal Weizman, 'between 1994 and 1999, Israel installed 230 checkpoints and imposed 499 days of closures',[27] but in the wake of the second *Intifada*, Israel expanded its use of checkpoints to 'isolate and fragment Palestinian resistance' by employing 'an extensive network of barriers that included

permanent and partially manned checkpoints, roadblocks, metal gates, earth dykes, trenches [and] "flying" or mobile checkpoints' which, by September 2006, 'comprised a system of 528 physical obstacles'.[28] In the present day, IDF-manned checkpoints exist at every possible point of crossing out of the West Bank, but they also frequently spring up between towns and villages within the West Bank itself, creating unpredictable and often torturously lengthy conditions for travel. So extensive has Israel's use of checkpoints become that the writer and activist Azmi Bishara has described Palestine as the 'land of checkpoints'. Thus checkpoints result in chaotic and ambivalent experiences of travel and indeed existence for Palestinians: 'The checkpoint takes all that man has, all his efforts, all his time, all his nerves . . . The checkpoint is the chaos and the order, it is within the law and outside of it, operating by rationality and idiosyncrasy, through both order and disorder'.[29]

Checkpoints are therefore more than simply border-controls where identity documents are checked (and frequently refused) by Israeli forces. They are also sites of inherent psychological and physical trauma, where the vulnerable human body is forced to endure indignities such as queuing for hours in cramped conditions or body searches, and to surrender itself to the possibility of violence erupting at these traumatic sites, either through the actions of the armed IDF or at the hands of Palestinians themselves, who may seek to protest or attack Israeli forces at what has become a common site of confrontation. Consequently, checkpoints present peculiarly intimate and embodied experiences of the border, and from a Palestinian perspective, this confrontation between militarised border and individual body draws attention to the vast discrepancies in power between the Israeli occupation and Palestinian subject. Despite its vehemently oppressive traits, however, the checkpoint has also surfaced in the creative imagination as a site that Palestinians remain determined to cross—whether out of necessity, as an act of *sumud* or as a deliberate act of transgression. In this, they reflect Baud and Van Schendel's observation that 'no matter how clearly borders are drawn on official maps, how many customs officials are appointed, or how many watchtowers are built . . . people . . . take advantage of borders in ways that are not intended or anticipated by their creators'.[30] Borders, then, are sites that produce a subversive desire within those who are limited by them most. It is therefore significant that this transgressive potential has often been realised in the Palestinian imagination by figures who are specifically *female*. What might these female figures, who might be described as 'checkpoint heroines', reveal about the ways in which power, identity and gender politics are imagined in Palestine's liminal landscape? Before answering this question, we must become a little more acquainted with the 'checkpoint heroines' themselves.

It is, in some ways, unsurprising that the border-crossers of so many checkpoint narratives should be women. As Nira Yuval-Davis and Marcel Stoetzler point out, 'women both embody and cross collectivity boundaries and territorial borders'.[31] As figures celebrated within nationalist discourse

for their roles as wives, mothers and care-givers, women have come to function as 'border-guards' according to John Armstrong, since they serve the symbolic function of regulating members of the collectivity by maintaining traditionally 'feminine' behaviours that, in turn, cement the cultural boundaries of the community and, ultimately, of the nation.[32] Yet this symbolic status also positions women in what many feminist theorists have read as marginal or subservient social roles, locating them as 'others' to the patriarchal national order, in which they are typically deemed to belong in less powerful, even disenfranchised positions on what Shirley Ardener has termed the 'social map'.[33] Indeed, in her postcolonial feminist work *Borderlands / La Frontera*, Gloria Anzaldúa, writing from her own context of the U.S.-Mexico borderlands, constructs an inherent alliance between women and all of those relegated to the 'margins' of society. For Anzaldúa, borders are socially and metaphorically populated by 'those who do not feel psychologically or physically safe in the world . . . those who are pounced on . . . the females, the homosexuals of all races, the darkskinned, the outcast, the persecuted, the marginalized, the foreign'.[34] Thus women are symbolically located as simultaneous guardians of communal boundaries and as inhabitants of the social margins, and at a crossroads between national empowerment and gendered disempowerment: a situation that casts them as both 'self' and 'other'. While this might appear a tenuous position to occupy, Anzaldúa goes on to suggest that this situation at the cusp of multiple spatial and social, national and gendered boundaries can in fact be negotiated in a way that allows women to claim it as a psychological and literal space of their own:

> *La mestiza* [woman of mixed racial heritage, but also woman of the 'in-between', or border-region] undergoes . . . a struggle of borders, an inner war [. . .] [She] copes by developing a tolerance for contradictions . . . To juggle cultures . . . she operates in a pluralistic mode . . . Not only does she sustain contradictions, she turns the ambivalence into something else.[35]

For Anzaldúa, the female subject situated at the intersection of cultural, gendered and social boundaries finds her own way to cross the multiple borders that confront her on the 'social map'. The condition of border-crossing is, according to Anzaldúa, therefore inherent to the existence of any woman who feels herself to belong to more than one cultural sphere or affiliation—a condition that the Palestinian woman, confronted with simultaneous struggles for national and gendered agency, also faces. How, then, are women's statuses as 'border-guards' and 'border-crossers' mobilised in the figure of the 'checkpoint heroine'?

It would be tempting to imagine the 'checkpoint heroine' as a glamorous, larger-than-life figure, and indeed, in Elia Suleiman's film *Divine Intervention* (examined in the previous chapter), this is exactly how she appears: as a bold, sexy young woman who marches defiantly across the border and, with

the magic realism typical of Suleiman's films, brings the checkpoint control tower crashing to the ground in the process.[36] In the border-narratives presented by several female authors in the short story collection *Qissat*, however, the acts of border-crossing accomplished by their female protagonists are of a much more everyday nature. Nevertheless, the forms of resilience, courage and even heroism they display render them 'checkpoint heroines' in ways with which Palestinian women might be more readily able to identify. *Qissat*, edited by Jo Glanville, brings together sixteen short stories by Palestinian women of many different generations and locations. Despite the variety of subject-positions and geographical locations from which these women write, however, the act of border-crossing recurs in several of the stories, and indeed forms the focus of three narratives within the collection: Randa Jarrar's 'Barefoot Bridge', Raeda Taha's 'A Single Metre' and Liana Badr's 'Other Cities'. The border therefore acts as a connective site of imaginative and experiential empathy for these female authors. Yet the women in their stories are faced with numerous spatial and social boundaries, many of them linked to the communal expectations mapped onto the female body. In each of these stories, though, the woman's act of border-crossing brings different social boundaries into focus, and maps out the potential for alternative models of strength, heroism and transgression through her actions.

Raeda Taha's short story, 'A Single Metre', focuses on the final moments of one woman's journey to the border. This focus seems to echo Homi Bhabha's poignant observation that 'the globe shrinks for those who own it . . . but for the displaced or dispossessed, the migrant or refugee, no distance is more awesome than the few feet across borders or frontiers';[37] for in this story, 'a single metre' is the distance between the protagonist and the Qalandiya checkpoint, between imprisonment and freedom and potentially even between life and death, as the female protagonist finds herself inadvertently drawn into a potential act of violent resistance. Taha, a Ramallah-based writer, constructs a third-person narrative that intimately explores a single nameless woman's thoughts and observations as she tries to cross the border. The story opens by conjuring the woman's sense of weariness at the inevitable discourtesies and humiliations that she has come to expect in crossing the Qalandiya checkpoint to Jerusalem in her attempt to meet with relatives there: 'She's tried several times to avoid that arduous trip to Jerusalem; she can no longer stand that close-by far-away city' (128). Central to this weariness, we learn, is the material and bodily experience of crossing the border:

> She decided, without any hesitation, that she wouldn't squeeze herself into a circle of sweat mixed with hatred, malice and perversion. For a moment she imagined her body sandwiched between two young men thirsty for a piece of flesh. She didn't want to allow herself to be an object of masturbation, or for a moment to lie of a filthy bed, under a yellow blanket, in one of their fantasies. (128)

The protagonist's sense of repulsion at the border not only stems from the ways in which her personal freedoms are curtailed by Israeli controls on space, but also at the way in which this space collapses respectful and humane social conditions between those forced to cross it. Such an observation is supported by Eyal Weizman's research into checkpoint mechanisms, in which he finds that although they are designed to create total physical separation between the Palestinian border-crosser and Israeli regulator, they encroach in deliberately tangible and spatially limiting ways upon the body of the border-crosser, evident in the design of turnstiles which can be halted at the touch of a button, trapping several people inside them at once, and which have deliberately shortened arms so that they press against the body in order to 'ensure there is nothing under their clothes',[38] making the experience claustrophobic, intrusive and distressing.

For these reasons, the firm-minded heroine makes a bold and in some ways 'unfeminine' move at the checkpoint. Determined to avoid the queues and crowds, she marches up to a vehicle waiting at the crossing and, after 'pointing at the back seat questioningly', gets in and demands a lift from the driver. Such an act of defiance might seem to cast the protagonist as a 'checkpoint heroine' for the way in which she sidesteps the intimidating atmosphere of the checkpoint through a subversion of gender norms; as Monterescu notes, this somewhat impertinent though assertive act is untypical of women's social expectations, and may lead to her being labelled '*mdakara* or . . . *mara mzambara*–[a] virile, impertinent woman'.[39] The protagonist, though, considers her behaviour an accomplishment, for she is 'proud of herself, as though she'd won an historic victory' (129). Yet as she looks around her, other anxieties emerge.

> The driver was a bearded young man . . . and his friend seemed equally well behaved. She noticed a small Qur'an in the driver's hand. He was reading it intensely, in a voice like a secret delight. (129)

From these observations, a concern emerges in her mind: 'What if he's planning to blow himself up?'(129). Given the protagonist's earlier harsh judgments of her imaginary male border-crossers as 'thirsty for a piece of flesh' (128), we might dismiss her analysis as no more than an overly cynical, even paranoid interpretation of these men. Yet the tense uncertainty of her situation (and its bleak irony—that having avoided the crush of disrespectful young men at the checkpoint, she has possibly rendered her body supremely vulnerable by demanding this proximity to her polite and respectful male drivers) also vividly evokes the unpredictability and inherently traumatic nature of the border-crossing experience, which is never guaranteed to be successful or safe.

Whether or not the protagonist has in fact located herself alongside would-be 'suicide bombers', her response to this hypothetical situation is

interesting; for while her immediate thought is that 'I want to get out, I want to cry', her next is that 'maybe I want to be the heroine' (129). Although only a metre away from the checkpoint by this stage, the protagonist still has the opportunity to flee, as the driver's glance at her in the rear-view mirror might imply; yet instead, 'she gave him a quiet look, and a smile of surrender' (129). In this act, the checkpoint heroine becomes an altogether more ambivalent, even poignant figure. Is her act of courage, her willingness for self-sacrifice, coerced or voluntary? Is it to be interpreted in radical Fanonian terms, as an act of necessarily violent resistance, the protagonist assuming the controversial role of the female martyr typifying societal crisis—or is it symbolically indicative of the denial of female agency and the dominant circuits of male power that condition, control and constrain female bodies at every level?[40] However we interpret the protagonist's situation, it is deeply symbolic of the immense corporeal and psychological pressures placed on the Palestinian subject, which crystallise at the site of the border in terms of the multiple threats posed to bodily integrity. Thus Taha's protagonist offers a radical and controversial recognition of borders as sites of violent confrontation not only with the limits imposed by the occupation, but with the pressures and power structures that emerge within Palestinian society itself. Though she approaches the border bravely, Taha's protagonist does not cross communal, gendered or ideological boundaries entirely on her own terms. Instead, her journey displays the limbo-like uncertainties and conflicted loyalties of the female border-crosser, and the ways in which she might suffer as a result.

While Taha's story casts her protagonist as a somewhat unwitting 'checkpoint heroine' caught up in external forces, Randa Jarrar's story 'Barefoot Bridge' offers a different take on border-crossing as a process that may also entail liberating possibilities. Told in the first person from the perspective of a young girl raised in the Palestinian diaspora in Egypt and hence poised at the cusp of cultures and worldviews, the story offers a poignant portrait of the subtle resistance of the female border-crossers around the young girl, and of the other traumatic border-crossings that have also liberated her from the restrictions on women in the West Bank. 'Barefoot Bridge' is the name given to the Allenby Bridge border-crossing between Jordan and the West Bank by the narrator, and through the girl's young eyes, we see how her journey across this bridge comes to symbolise her transition from privileged naïvety to a gathering realisation of the restrictions that demarcate many elements of Palestinian existence.

The story opens with the child explaining that this is her first trip 'to Palestine, which Baba calls the bank—*el daffa*—to bury my Baba's baba' (19), and it is through her inexperienced eyes that the complex and seemingly absurd restraints on Palestinian space become apparent: 'We have to fly to Jordan and then . . . cross a bridge . . . so I ask Baba, "Why can't we just drive there, or take a plane straight there?" He tells me to be quiet' (19). When they reach the Allenby Bridge (a crossing also vividly described at the start of Mourid

Barghouti's *I Saw Ramallah*), the experience of border-crossing emerges as an intrinsic element of Palestinian experience, and indeed, it seems to conjure an eclectic female community among women otherwise distinguished by religious and cultural differences: 'There are women in pretty dresses, women in jeans, women in veils . . . women in traditional dresses . . . women in khaki shorts' (21), the little girl observes with wonder. Regardless of what they are wearing, however, all are stripped of their identities and dignity in the same way at the border. The little girl describes her sense of humiliation at watching her mother being searched: 'Mama takes off her skirt and blouse and is left in tight underwear that is meant to tuck her tummy in, and a see-through bra . . . I feel embarrassed for her, who's naked in front of this rough-handed stranger' (22). Jarrar intervenes at this distressing moment by employing humour as a subversive strategy, for the mother's response is to 'fart a huge silent fart that stinks up the fitting room and forces the soldier to leave for a few seconds. We giggle and Mama says *"Kaffik"*, and I give her five' (22). Though far from an act of serious resistance, this moment of shared childish silliness with her daughter sees the mother regaining some kind of control over their dehumanising situation. The child's enduring impressions of the border are of people collectively forced to endure exhaustion, heat and discomfort. In contrast to this, the boundaries of her father's family seem much safer and more welcoming—but as the child finds out, these also have their own restrictions.

These restrictions emerge through the figure of Sitto, the father's sister. Sitto is conjured as an enchanting figure of traditional Palestine, a guardian of folktales and family recipes who 'doesn't care she can't write, because she tells tales and winks and makes cheese' (26). Sitto is the female 'border-guard' charged with preserving the boundaries of communal identity through her affirmation of gender norms, but it is in fact the figure of the patriarch, the girl's father, who draws attention to the boundaries that also exist within this close-knit, family-oriented community. Standing outside his old family home, he shows his daughter the whitewashed wall in front of which all of his sisters were married before seventeen, 'like prisoners awaiting execution' (28). The father reveals how the experience of being forced beyond the borders of one's own home might be both traumatic and liberating. He tells his daughter that 'I was sad [to leave because of the war] but going to Egypt, going to university, gave me my freedom. Your aunts never received such an opportunity. I want more than anything else in the world for you to have that opportunity' (28). Jarrar's story reflects Edward Said's observation in his essay 'Reflections on Exile', in which he suggests that while exile is a painful condition entailing loss of one's home, 'there are things to be learned [from it] [. . .] Exiles cross borders, break barriers of thought and experience', resulting in a 'plurality of vision' that allows them to negotiate their exilic existence.[41] This 'plurality of vision' can arguably be applied in gendered terms to this story, in which the father's exilic consciousness allows him to

perceive the multiple structures of power, privilege and oppression entailed in both communal belonging and in exile for the female subject; indeed, it is perhaps his status as 'border-crosser' which allows him to challenge the patriarchal assumptions of the community into which he was born. In this story, then, the young girl bears witness to the traumatic border-crossings that have shaped her family's lives, and senses the comforting closeness and romance of a culture that she can never quite access, but she comes to understand how her father's border-crossing has placed her in a privileged position beyond the restraints of a traditional rural patriarchal community. That the father's diasporic liberation should take place when exiled in Egypt rather than the West problematises the notion that women's rights to education are inherently Western, neo-colonial influences;[42] rather, they are revealed as elements of a modernising Arab world that, like the political landscape and the 'nomadic, decentred, contrapuntal'[43] life of the exile, is subject to shifting spatial, societal and gendered boundaries. While the little girl of Jarrar's story endures her border-crossings bravely, she is therefore a 'checkpoint heroine' by proxy, for her own ability to break free from boundaries is a product of her father's own painful passage across borders.

Can the restrictions on women's freedoms and ambitions only be overcome by moving beyond Palestine's borders altogether, then? The protagonist of Liana Badr's story 'Other Cities' would suggest otherwise. The protagonist, Umm Hasan, expresses a desire to break free from the spatial and patriarchal restraints imposed upon her very early in the story, as she draws parallels between the restrictions enforced by her husband, by her community in *Khuzq al-Far*, the 'mouse-hole neighbourhood of Hebron' (40) in which she lives, and by the occupation. Umm Hasan's existence appears a subordinate and limited one, particularly in her dependence on her husband—a man who is portrayed as lazy, unemployed and patronising towards her. This portrait can be read as a brave feminist affront on Badr's part to the notion of kinship loyalty that is often seen to define Palestinian familial relations, and indeed to provide support networks for women.[44] Yet her life within this insular community is also subject to rigorous restraints on identity and space imposed by the occupation. We're told of how 'the number of security patrols . . . in the streets of Hebron kept growing'; of how 'the settlers often clashed with residents, spitting on them, pelting them with stones, beating them' (40); and of how 'the trip to Ramallah [that] had once been a forty-minute drive . . . now required an entire day of meandering from village to village along rocky, hilly roads' (42) due to the roadblocks and checkpoints imposed by the occupation. Umm Hasan finds herself enclosed by literal borders and social boundaries on all sides.

Against this oppressive backdrop, Umm Hasan develops a daring plan: to take her children to Ramallah with ID cards borrowed from a neighbour and money secretly saved from her housekeeping allowance. Summoning up all her courage, Umm Hasan puts her plan into action, achieving a

transgression of patriarchal and colonial boundaries, and a longed-for independence—until her money runs out and she is forced to return home. Yet her most subversive act of border-crossing in fact takes place during this return journey. Stuck in a queue of traffic in the sweltering heat with a bawling baby, Umm Hasan steps out of her taxi and marches up to the border, where she confronts the guard by telling him that her child is sick and he must let the cars go. At this moment, Umm Hasan asserts her position as mother: a highly traditional role, though one that here assumes a transgressive potential. Her simple assertion of motherly authority facilitates a radical border-crossing within the narrative, as we see when Badr suddenly shifts to the third-person perspective of the Israeli soldier:

> The captain . . . didn't quite understand what had happened . . . It seemed as though her voice echoed to him out of a deep and cavernous ravine [. . .] He suddenly found himself contemplating all the things he felt he couldn't bear to lose on account of this accursed prison [. . .] He had to escape from the dangerous assault of emotions he didn't want to face. As the soldiers looked on in disbelief, he held out his arm and signalled to the cars to move. (57)

This face-to-face confrontation with the disenfranchised Palestinian 'other' instigates a collapse in binary subject-positions in the final moments of the narrative. We, as reader, are briefly transported to the 'other side' of the border-control as we hear the soldier's thoughts, but he too begins to identify with the sense of vulnerability, constraint and isolation experienced by the Palestinian border-crossers. Though the soldier focuses on his own pain, rather than that of Umm Hasan or her baby, he nevertheless experiences a moment of connective humanity due to Umm Hasan's transgression of her role as silent, oppressed 'other'. Her act of courage establishes her as a 'checkpoint heroine' who not only stands up to patriarchal, colonial and material boundaries, but also instigates shifts in the power structures that govern them.

Collectively, these narratives of the 'checkpoint heroine' reveal her to be a complex figure who challenges the 'social maps' of colonial and patriarchal authority in a number of ways. At one level, the 'checkpoint heroine' presents a stark affront to the narratives of 'self-defence' and classically colonial 'paternalism' that Israel often employs in order to justify its military presence and use of checkpoints.[45] These narratives instead portray the majority of border-crossers as ordinary, vulnerable people, many of them women and children, whose own physical and psychological integrity comes under threat at these sites of stringent colonial authority. In this sense, the 'ordinary' rather than 'extraordinary' nature of these women's acts of heroism (which often simply consist of a determination to cross the border) serves an important political function, affirming what Laleh Khalili describes as a 'politics of sympathy, pity and intimacy' that presents a 'feminised' alternative to the 'masculine'

'muscular politics of collective violence'.[46] Yet the 'checkpoint heroine's' acts of bravery do not necessarily affirm her as 'border-guard' of a unified Palestinian nation. Instead, she may also reveal the sources of gender inequality and marginality embedded in her own community, which she must find ways to negotiate. In doing so, she evokes the border as a powerful site of alterity (radical 'otherness') from which those relegated to the margins might undermine and even deconstruct the authority of the 'centre'.[47]

The 'checkpoint heroine' therefore seems to affirm Homi Bhabha's assertions in his essay, 'DissemiNation: Time, Narrative and the Margins of the Modern Nation', in which he suggests that the alternative histories, identities and experiences that emerge from the margins disrupt the authority of national discourse in a way that might be potentially liberating. Bhabha writes that by turning to the margins,

> we are confronted with the nation split within itself, articulating the heterogeneity of its population. The barred Nation *It/Self*, alienated from its eternal self-generation, becomes a liminal signifying space that is *internally* marked by the discourse of minorities, the heterogeneous histories of contending peoples, antagonistic authorities and tense locations of cultural difference.[48]

This 'heterogeneity' of nationhood emerges from the alternative spatial, national and gendered experiences articulated within the border-narratives of the 'checkpoint heroine', who similarly disrupts dominant narratives of both colonial power and of national belonging. For Bhabha, these disruptions are far from negative, signifying a break from the monolithic, essentialist confines of a securely mapped nation, and offering instead a liminal and plural model of postcolonial space that deconstructs colonial and patriarchal binaries or hierarchies. For the 'checkpoint heroine', though, this 'liminal' territory proves a more ambivalent state of being—for while she may therefore initially appear a subversive figure of the radical margins, she is also shown to inhabit a territory in flux, in which boundaries must be continually renegotiated and certainties dispensed with. While such conditions might be liberating in the realms of the imagination, their spatial reality presents far less enticing prospects for everyday existence. Through this realisation the 'checkpoint heroine' leads us into another territory of the Palestinian imagination defined by liminality and uncertainty, which bears its own forms of postcolonial feminist potential: the 'borderland'.

Liminal States: Into the Borderlands in Abu Wael's *'Atash* and Jacir's *like twenty impossibles*

When Shimon Peres responded to criticism over the land ceded by his government to the Palestinians by asking whether his critics 'expected the

Palestinians to live suspended between earth and sky, like the figures in a Marc Chagall painting',[49] he offered a compelling image of Palestinians' liminal existence. As inhabitants of a stateless nation lacking self-determination over its own boundaries, Palestinians are poised in a 'no-man's land' in which they nevertheless remain subject to the shifting regulations, boundaries and territorial claims cast upon them, and for critics such as Kamal Abdel-Malek, this condition leads to a profound consciousness of the liminal not only in socio-political and spatial terms, but also within the creative imagination.[50] While, for Abdel-Malek, this liminal consciousness appears in the work of authors including Fawaz Turki and Mahmoud Darwish, it has also emerged in several recent films that conjure a vivid sense of liminality through their portrayals of what might be described as the landscape of the 'borderland'. Turning to two particularly evocative filmic renderings of borderland space, in Tawfik Abu Wael's 2004 feature film *'Atash (Thirst)* and Annemarie Jacir's 2003 short film *like twenty impossibles*, the following analysis explores the deconstructive aesthetics of (dis)identification which seems to surface through the realm of the liminal, and considers its postcolonial feminist potential.

The term 'liminality' means, literally, 'of the limen, or threshold'[51] and while it defines a state of suspension or of the 'in-between', it is also suggestive of a non-static condition in which boundaries are being constantly tested and destabilised: a state of 'becoming' rather than 'being', to use the Deleuzian term.[52] Such a state could be said to characterise Palestine in itself—a nation defined by, as Edward Said puts it, the condition of 'a protracted not yet, which is not always a very hopeful one',[53] and this is a condition that is in many ways affirmed by the simultaneously present and absent nature of national boundaries. As Gertz and Khleifi note, 'borders have ... become a sign of oppression characterised by an Israeli definition of Palestine as a non-existent, split or broken identity'[54] in recent Palestinian cinema, pointing towards the absence of self-determination but also to the enduring presence of a traumatised Palestinian national identity. Yet Said has made the radical suggestion that Palestine's liminal state need not necessarily be defined solely as one of oppression. Instead, he has suggested that it might be embraced as the very character of Palestinian experience, and employed as a mode of representation in itself. He writes that 'since the main features of our present existence are dispossession, dispersion, and yet also a kind of power incommensurate with our stateless exile, I believe that essentially unconventional, hybrid, and fragmentary forms of expression should represent us'.[55] For Said, the possibilities of Palestinian self-representation lie in the very qualities of liminality, transition and placelessness that also deny its existence as a nation-state.

This appropriation of a radically marginal condition as one of potential transgression is characteristic of postcolonial and indeed feminist theorisations of the border, and here, the motif of the 'borderland' emerges with

a particular force. In its literal sense, the borderland refers either to 'the region in one nation that is significantly affected by an international border', or 'the region on *both* sides of the border'.[56] The latter approach emphasises the sense of cultural interaction engendered by the border, affirming its status as a space with a cultural character of its own. As an 'in-between' space, the borderland is characterised not so much by the specificity of its cultural codes as by a multiplicity of languages, cultures and identities. Its distinctive character therefore stems from its identity as a space where the authority of all cultural and social constructs is called into question. Unsurprisingly, postcolonial theorists have adopted the borderland as a potent metaphor for cultural hybridity akin to Homi Bhabha's 'Third Space', which he describes as a space of the 'in-between' and 'of translation: a place of hybridity, figuratively speaking, where the construction of a political object that is new, *neither the one nor the other*, properly alienates our political expectations, and changes, as it must, the very forms of our recognition of the moment of politics'.[57] As a space in which the boundaries of space, power and identity are called into question, the borderland has also proven attractive to deconstructivist strands of feminist and 'queer' theory, in which the possibility of a radically 'nonunified subject',[58] liberated not only from patriarchal boundaries but from the restraints of identification altogether, might emerge. Indeed, for some theorists, the borderlands constitute an alternative representational space in which 'all forms come undone, as do all the significations, signifiers and signifieds to the benefit of an unformed matter of deterritorialized flux, of nonsignifying signs'[59]— forms that might be represented through highly experimental modes of 'border-writing' or other expressions of 'border-consciousness'.

The postcolonial feminist potentials embedded in the borderland make it an incredibly exciting site from which to consider the politics of representation in Palestinian cultural consciousness. Yet the very specific nature of Palestine's borderland status means that these theoretical potentials must be approached with caution. In the following analyses, I therefore attempt to tease out the distinctive nuances of Palestine's liminal states in two recent portrayals of Palestinian borderlands as locations where both space and self are radically destabilised, and alternative creative possibilities of representation begin to emerge.

One of the most visually evocative representations of the Palestinian borderland appears in Tawfik Abu Wael's 2004 film, *'Atash (Thirst)*. Abu Wael, like Annemarie Jacir (whose work is discussed later in this chapter), is of a younger generation of filmmakers whose work has risen to prominence in the twenty-first century,[60] and his work displays an interest in the interplay, and the tensions, between the personal and the political.[61] Despite the fact that *'Atash* is a rare collaboration between a Palestinian director and Israeli producer (Avi Kleinberger), its political stance remains ambivalent and Abu Wael focuses instead on the evocation of atmosphere, symbolism and place

in ways that allow a number of interpretive possibilities to surface. Indeed, the film establishes a close link between exterior and interior worlds through its strong reliance on pathetic fallacy. Set in a wasteland that appears bereft of all the basics for survival, the film portrays the attempts of the Abu Shukri family to create a life and home for themselves there. The setting therefore mirrors the conflicted and yearning psychologies of its characters, all possessed by their own thirsts and hungers—whether these are for water, for education, for independence or simply for love. While 'Atash is at one level an existential drama evoking the liminal psychology of Palestinian existence, it is also an intimate portrayal of personal as well as political longings, which are played out through the specifically gendered and generational conflicts within the family itself. Bodies and selves as well as spaces therefore undergo forms of transition within the borderland realms of 'Atash, and between them, these borderland bodies present some astonishing and transformational possibilities of self-representation.

'Atash immediately evokes the qualities of the borderland through its elemental setting. Though filmed in Umm el-Fahim, a Palestinian town right next to the Green Line in Israel where Abu Wael was born, the setting in fact takes on a more allegorical status as its identity is described only through the anonymous empty shells of an abandoned settlement, possibly a military outpost or deserted village, that we learn is on land confiscated by the Israeli State. Consequently, the Abu Shukri family live there illicitly, remaining unseen by the local authorities as they go about carving out a meagre existence from the land by trapping birds and stealing wood for their charcoal business. Much of the film's lyrical and understated symbolism derives from these activities, which invoke the elements of earth, air, fire and water through shots of the wood being chopped and burned, and of pluming smoke, flames and embers being raked. 'Atash therefore subverts the Palestinian pastoral tradition which portrays the landscape as lush and fertile, with the peasant as its deeply rooted custodian.[62] Instead, this rocky, barren realm is better described by the Arabic term *jarda'* which, according to Parmenter, 'means bleak, barren, without vegetation but can also refer to open, unprotected borders'.[63] This kind of landscape often appears in Palestinian and indeed Arabic literature more broadly, where it symbolises 'existential alienation' in the way that 'while providing nearly limitless space, [it] cannot provide a place, a home', coming to stand as a representation of literal and psychological exile, homelessness and even 'unreality in the world'.[64] This 'no-man's land' can therefore be read as an allegory of colonial Palestine more broadly: an indeterminate realm in which its inhabitants must live without sanction or a true sense of belonging, embodying the 'prohibited and forbidden' inhabitants of the borderland described by Anzaldúa.

The Abu Shukri family's struggle against this sense of estrangement from the land is dramatised through a quest for something that concerns many Palestinians: water. Following the *Naksa* of 1967, Israel seized control of the

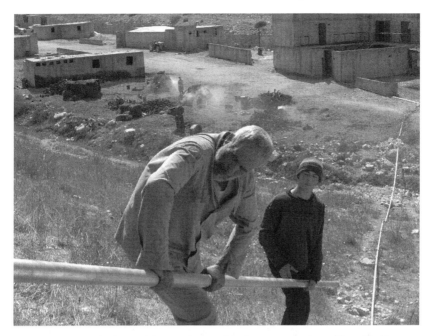

Figure 4.2 Abu Shukri and his son lay an illegal water pipe that will enable them to settle in the barren borderland. *'Atash* (2004), dir. Tawfik Abu Wael. Image courtesy of Axiom Films.

water supplies within the West Bank, and their appropriation of this resource is a source of outrage for many Palestinians, who struggle to obtain water even within the territories from which it is originally derived.[65] Abu Shukri, the father of the family, engages in an act of affront to this appropriation of natural resources by building an illegal pipe that diverts a constant supply of water to their home.

The fervour with which he protects this pipe indicates Abu Shukri's thirst not only for water but also for ownership of the land, and perhaps even for his own patriarchal status within it. Consequently, the borderland emerges not simply as a site of oppression but as one of potential subversion; for here, the panoptic gaze of the state seems to peter out, presenting a wild and socially marginal zone open for appropriation by its illicit inhabitants. Indeed, as Salma Khadra Jayyusi points out, the similarly wild, barren and liminal space of the desert also features in classical Arabic poetry as a symbol for 'man's torturous journey through life' that 'determin[es] the fate of [the] protagonist',[66] meaning that it may operate not only as a site of struggle but also of transformation. The barren borderlands of *'Atash* prove similarly integral to determining the Abu Shukri family's fate, as they too undergo dynamic and momentous shifts within them.

These shifts emerge around the relationship between the father of the family (played by Hussein Yassin Mahajne) and his eldest daughter, Gamila (Ruba Blal). Though *'Atash* retains a level of deliberate ambiguity in its plot details, encouraging the viewer to 'read' the characters at multiple levels, it is hinted that Gamila has carried out some act of sexual 'indiscretion', most probably a love affair, which has damaged the family's honour to such an extent that the father has moved them away from their village.[67] This social exile indicates the rigorous imposition of patriarchal boundaries and social expectations upon the female body, and the film's indeterminate landscape therefore acts as a projection of the family's marginalisation within the Palestinian community: a marginality that is gendered and sexualised in nature. Over the course of the film, Abu Shukri's quest to master the resources of the borderland mirrors his attempts to control his family, and thus redeem himself from his emasculating status as a *tartur*: a man who has failed to control the women in his family and who is therefore considered to be weak and humiliated.[68] As a result, Abu Shukri imposes strict patriarchal boundaries on his family, keeping his own rooms and belongings under lock and key, denying education to his children, particularly his two daughters, and reprimanding Gamila for any expression of will, emotion or pleasure. The symbolic relationship between patriarchal mastery of the land and control of the family is established further through the motif of the water pipe, which will allow the family to settle permanently in this liminal environment. Yet the eldest daughter realises that permanent settlement in the borderland will see her condemned to a life in which the women's only functions are to make charcoal and look after the family, and in which the education and human contact that she so longs for will become impossibilities. The borderland therefore gives rise to competing but similarly overwhelming 'thirsts' for both father and daughter.

'Atash conveys Gamila's thirst for freedom through a distinctively female and feminine aesthetic that stands in stark contrast to the barren landscape, which we might read as the patriarchal realm. In one scene, in the interior of the house (similar in tone to the interior sequences in *Wedding in Galilee*), we see the sisters sharing perfume, their loose wet hair illuminated in the gentle glow of the indoor light. At other points in the film, a distinctively 'feminine' mode of expression also emerges in the music played by the younger sister, which she not only produces on an old, out-of-tune *qanun* (a traditional stringed musical instrument), but which she also creates from the artefacts of violence and conflict around her. In one scene, for example, we see her stringing wires with landmine pins that she plays like a harp; in another, she tosses used bullet cartridges in a metal pan, delighting in the sharp, sparkling clatter that they produce. Significantly, we rarely hear the youngest daughter speak. Instead, she finds her voice through this transformation of all that is threatening and violent around her into gentle and beautiful sounds. A similar appropriation of the language of 'masculine' oppression

also appears in a scene in which Gamila teaches her illiterate mother to trace her name in Arabic on the wall, using the charcoal produced by the family. Here, the very substance of their father's livelihood, and of their servitude, is transformed into something with creative, self-expressive potential.

Language, music, creativity and expression are all therefore celebrated as transgressive and feminocentric forces within this film, which might be likened to D. Emily Hicks' theorisation of 'border-writing' as a transgressive textual practice in which systems of meaning are similarly 'resignified'. For Hicks, border-writing is a 'mode of operation rather than a definition . . . a strategy of translation rather than representation',[69] typified by writing that draws on the multiple cultural codes available in the borderlands—whether these are languages, symbols or other reference points. Gamila and her sister's ability to conjure new modes of self-expression from the borderland, whether through music, charcoal or water, can perhaps also therefore be interpreted as a form of 'border-writing' that bears a postcolonial and post-patriarchal potential in its break from singular, static modes of expression, becoming instead a mode of textual representation that expresses the fragmented mentality of the border itself. It is significant in postcolonial feminist terms that the authors of these 'border-writing' processes are women; for it appears that the daughters in 'Atash pose a redemptive or transformational alternative to the rigorous patriarchal connection to the land established by their father, and indeed, in one highly significant scene, Gamila herself is established as the quintessential borderland subject.

In this scene, Gamila flees from her homestead and wanders out into the surrounding environment. In shots that pull and push her face in and out of focus with the sun (the typical guiding force in the 'desert narrative'), we see the bright blue sky and what appear to be new settlements built on the land. As though sensing her own estrangement from such a landscape, Gamila seeks refuge in the natural environment and, in the most sustained shot of water in the film, she is shown washing her hair, cleansing her face and quenching her thirst from the rain that cascades in front of the open mouth of the womb-like cave in which she shelters. This highly gendered imagery conjures a naturally feminised landscape with which Gamila has an unforced connection: a stark point of contrast from her father's tenuous appropriation of natural resources. Though Gamila is therefore a figure who finds herself torn between competing social pressures—between modern values and traditional duties, between desire and repression, between family loyalty and betrayal—'Atash appears to celebrate her liminal potential, and casts Gamila as at home within the Palestinian borderland, though estranged from its patriarchal confines: a transgressive vision of a postcolonial feminist Palestine.

For a moment, it seems that this postcolonial feminist potential might triumph within the film as Abu Shukri appears to undergo a process of traumatic soul-searching, and finally attempts to destroy the water pipe—perhaps

in order to free his family from the confines he has created, or by way of admitting to his own relative powerlessness. This moment of transformation is violently short-circuited by an unexpected turn of events. The son, who has been taught to guard the water pipe at all costs, catches his father in the act of destroying the pipe and, whether out of hatred for his cruelly oppressive father or out of a deep internalisation of masculinist authority, he attacks and kills him. The end of the film sees the son assuming the role and appearance of the father, but it nevertheless retains a level of ambiguity; for in the final scene, we see Gamila turning suspiciously towards her younger brother and, though they continue to rake over the charcoal, the water pipe still in place, we sense that neither her defiance, nor her thirst for freedom, will lessen. While *'Atash* may not therefore dramatise a total overhaul of patriarchal or colonial power structures, it nevertheless holds a radically postcolonial feminist potential in its ability to acknowledge the competing languages, experiences and desires that exist within Palestine's liminal space. Thus, while the borderland is a zone ruled by the father, its true inhabitant, though 'prohibited and forbidden', is the daughter: a 'queer' figure who moves fluidly among boundaries, troubling and testing them as she goes, casting a transgressive claim upon Palestine's liminal boundaries as spaces that she will continue to try to make her own.

If an 'aesthetics of liminality' offers transgressive possibilities in *'Atash* then it operates in very different ways in Annemarie Jacir's 17-minute film, *like twenty impossibles* (2003). This film also ventures into Palestine's borderlands by charting the journey of a small film crew led by a Palestinian director with U.S. citizenship called 'Annemarie' (who we might assume bears strong parallels with Jacir herself), which is attempting to cross from the West Bank into Jerusalem in order to make a film there. Presented as documentary film footage taken by the crew, this work is playfully postmodern and self-referential, and displays a direct desire to engage with the politics of Palestinian self-representation—for as the film crew deviates from official borders and ventures further into Palestine's liminal realms, their hold on identity and representation begins to disintegrate in ways that reveal a great deal about the boundaries imposed on both Palestinian space and the Palestinian subject. The following analysis therefore examines the radical shift beyond the specific politics of the gendered body to the more complete 'queering'[70] of identity that takes place within the borderlands of this film, and considers its unique relationship to concepts of the postcolonial and feminist.

As a filmmaker, author, poet, festival curator, lecturer and co-director of the film project *Dreams of a Nation*, Jacir displays a profound commitment to creativity and imagination as essential facets of Palestinian identity, and as enduring features of Palestine's struggle for self-determination. This commitment also emerges in the film's title, *like twenty impossibles*: a phrase taken from a line in the famous poem 'Here We Shall Stay' by Tawfiq Zayyad, a 'resistance poet' whose works have become classics of Palestinian cultural

expression in their commitment to unending struggle and dignity even in oppression.[71] In 'Here We Shall Stay', Zayyad evokes a resilient vision of Palestinian existence by contrasting the 'impossibilities' of Palestinian experience—the erasure of land and identity, the restrictions on movement and agency—with the enduring cultural traditions of the Palestinian people, such as singing and dancing, living within and caring for the land and even discussing and debating ideas. Such acts establish impenetrable, if invisible barriers to Israeli domination, which lie like 'a hard wall on [the oppressor's] breast': a constant reminder of the Palestinian subject's enduring connection to the land.[72] Thus cultural expression itself, including freedom of thought, becomes a form of resistance that renders the Palestinian subject similarly 'impossible' to erase. Yet in this film (as in her more recent feature-length film, *Salt of This Sea*),[73] Jacir also explores the challenges and traumas entailed in this constant struggle against 'impossibility', which she dramatises through the film crew's journey into increasingly 'impossible' circumstances within the borderlands.

like twenty impossibles establishes a link between mobility, freedom and self-representation right from the opening sequence, in which we see a hand extended from the window of a moving car delighting in the breeze that caresses its fingertips, and hear a woman's voice recalling her happy childhood memories of driving with her father: moments at which she experienced a sense of freedom so immense that it was 'like we were flying and no one could stop us'.

This focus on intimate, sensuous experience immediately imbues the concept of mobility with personal, metaphorical resonances and suggests that for the Palestinian subject, the ability to cross borders resonates with a broader sense of political agency. It soon becomes apparent as to why this might be the case—for the film crew swiftly draw up to a checkpoint, which they are told has closed. Here, a subtle aesthetic shift takes place from the smooth, meditative portrayal of movement in the opening frames to jolty, disrupted camerawork suggestive of 'authentic' documentary recording. Similarly, the lyrical interior monologue of the opening frames gives way to the background noise of the crew grumbling about the ever-increasing restrictions on their mobility. In particular, we hear the actor, who is from Ramallah in the West Bank, grimly advising the others that 'this isn't a checkpoint . . . Another year or two and it'll be a border'. This crew is comprised of creative, freethinking individuals, though, and when the driver declares that he knows a side road, they do not hesitate to head away from the official checkpoint and into the borderlands of the West Bank.

This assertion of agency incites another representational shift. As the crew moves further away from the authoritarian stasis of the border-control, the scenery gradually changes from a militarised urban landscape into a soothing pastoral setting of green hills and rocky paths: an image of the Palestinian homeland much more familiar to the literary and filmic

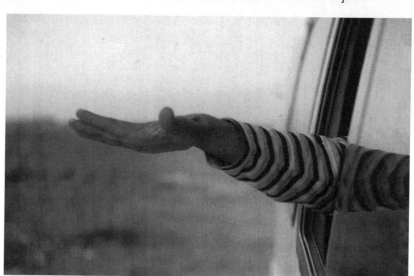

Figure 4.3 An image of freedom, mobility and connection: an outstretched hand caresses the breeze at the start of the film crew's journey. *like twenty impossibles* (2003), dir. Annemarie Jacir. Image courtesy of Annemarie Jacir.

imagination. The crew therefore appear to be engaging in what Michel de Certeau terms 'tactical' traversals of space, whereby unsanctioned and unexpected appropriations of official topographies demonstrate the possibility of human agency, will, resistance and opportunism, constituting 'a proliferating illegitimacy [whereby they have] developed and insinuated themselves into the networks of surveillance'.[74] Though the crew engages in subversively fluid movement here, a consciousness of spatial boundaries nevertheless remains with them, as we hear from the intimate conversation inadvertently recorded between the director and actor. We hear the actor asking why she has been away so long, to which she replies that it is expensive and difficult to 'come and go': it is easier to stay put within boundaries than to be forced into constant confrontation with them, even within the diaspora. In this, the director presents a subtle challenge to some of the more utopian theorisations of diaspora that have emerged from postcolonialists keen to celebrate models of the 'borderless' world, reminding us instead that, as Janet Wolff puts it,

> the problem with terms like 'nomad', 'maps' and 'travel' is that they are not usually located, and hence (and purposely) they suggest ungrounded and unbounded movement—since the whole point is to resist selves/viewers/subjects. But the consequent suggestion of free and equal mobility is itself a deception, since we don't all have the same access to the road.[75]

In this film, mobility appears as anything but 'free and equal', for while Annemarie may occupy something of an 'ungrounded and unbounded' position as a diasporic subject, her specifically located identity as a diasporic *Palestinian* denies her a basic 'access to the roads' that should bring her back to Palestine. Instead, like many millions of Palestinians, she is denied this basic 'right of return', representing her diasporic existence as an oppressive rather than liberating transcendence of (or estrangement from) national boundaries.

The disjunctive maps of identity, space and agency to which Palestinians are subjected come into even sharper focus when the crew is confronted by an ad-hoc checkpoint that has been established by a small group of Israeli soldiers working in the 'buffer-zone' of the borderland. The confrontation begins with the soldiers interrogating each crewmember in turn and in doing so, they reveal the array of disenfranchising, 'impossible' subject-positions occupied by Palestinians. First, the soundman is told that he is forbidden from entering the West Bank because he is from Jaffa, and therefore an Israeli citizen. This 'official' identity appears entirely at odds with the man's own identification as Arab, which he views as naturally aligned with Palestinian space. His disbelieving response to the soldiers—'Are you kidding? I'm Arab!'—also suggests the impossible irony of his exclusion when rigorous Israeli border-controls usually function in order to prevent the Arab Palestinian population from crossing into Israel, confining them to the West Bank or Gaza. While the actor from Ramallah *is* in fact from the West Bank, the soldiers nevertheless remove him from the vehicle and take him aside, claiming that he is on a list of people wanted for questioning. This vague explanation may or may not be true and suggests the 'impossible' sense of belonging experienced by the West Bank inhabitant who finds himself estranged even within his home, but it also implies that his involvement in the cultural sphere may itself be deemed subversive. Finally, Annemarie is interrogated. Asked where she's from, she replies (with factual accuracy) 'Palestine': a retort denied by the soldiers, who point out that her passport is American, and that if she doesn't like the way things are here, she should 'go home'—an act that Annemarie is in fact trying to achieve at some level by travelling into Palestine, though the soldiers render it impossible. Despite their very different identities, then, each and every Palestinian finds the legitimacy of both self and space called into question within the borderland, and as they are separated from one another, they find their representational agency disintegrates still further.

This disintegration of identity could be seen to reflect D. Emily Hicks' theorisation of the borderland as a space in which a 'nonunified subject' emerges, for whom language is 'dismembered' so that there is 'no longer . . . a clearly defined "subjective" or "objective" meaning'.[76] According to Hicks, this collapse of signifying boundaries presents a radically 'queer' transgression of subject/object relationships, and of the boundaries between 'self' and 'other'. Yet for Jacir's characters, this dismemberment of language offers

altogether less liberating possibilities. We see this in the way that the fragmentation of the team is mirrored by the gradual breakdown of the representational process. Despite the crew's protestations that they carry press cards and have permission to film, they are ordered to turn the camera off, though they manage to carry on filming illicitly, at a skewed angle. As the soundman is taken aside, the sound recording becomes oddly disjointed from the visuals before it is finally switched off altogether. With both the actor and soundman detained by the soldiers, the director is forced to leave with only the cameraman and driver still in tow, and as they drive away, the film is soundless and the visuals are shaky and partial. The final disconnected shots try desperately to keep their focus on the soundman being guarded in a tent and on the actor, his hands on his head, who had earlier expressed fear of being beaten by the soldiers—but this proves impossible, and they are left to dissolve into the liminal rural landscape in which spatial, social and political boundaries, though invisible, are shown to fracture the possibility of self-representation for the Palestinian subject.

Consequently, we see that the Palestinian borderland does indeed emerge as a space in which systems of representation and identification are 'dismembered', but not in the culturally exciting or 'queer' ways envisaged by Hicks, whereby the confrontation of dual cultural codes and power structures might lead to 'the ability to see not just from one side of a border, but from the other side as well'.[77] Instead, the act of border-crossing reveals the divisive boundaries of colonial power that endure within the Palestinian borderlands, and shows that the attempt to transgress them may instigate a total dissolution of political and indeed artistic agency. Jacir's representation of the borderland therefore dramatises the boundaries imposed on Palestinian self-representation more broadly. Indeed, as Jacir observes elsewhere in her writing, violent opposition to Palestinian cultural self-representation has been a strategy of Israeli oppression for many years and is evident in many forms—from the destruction of the Palestinian film archives in Beirut during the invasion of 1982, to attacks on the Khalil Sakakini Cultural Centre in Ramallah, to the assassination of Palestinian creative practitioners such as Ghassan Kanafani and Kamal Nasser. It is against this backdrop that the act of filmmaking acquires a deep political significance for Jacir, since it offers a means to 'resist the systematic destruction of the cultural infrastructure of Palestinian cultural life and the further fragmentation of our society'.[78]

What, then, does *like twenty impossibles* reveal about the postcolonial feminist potential of the borderland as a representational space? At one level, Jacir's lyrical work could be said to echo Elia Suleiman's provocative comment that 'Palestine's chaotic status quo gives you a kind of freedom. It's the best place to reflect on space',[79] or even to evoke Anzaldúa's idea that 'living in a state of psychic unrest, in a Borderland, is what makes poets write and artists create'.[80] Yet Jacir's film also radically contests this view by insisting upon the representational disenfranchisement that accompanies the

disintegration of space and selfhood. While the film certainly challenges simplistic binary oppositions between oppressor and oppressed, male and female, 'insider' and 'outsider' in its presentation of Palestinian identity (the diasporic Palestinian woman with U.S. citizenship and film-school training, the Israeli-Arab soundman who is the 'ward' of the Israeli State and the male Palestinian actor who cannot leave Ramallah each occupy different subject-positions of simultaneous oppression and privilege that transcend straightforwardly gendered or national identifications), the radical 'queering' of identity and self-representation that takes place within the borderland does not appear to lead to what Naficy describes as 'border-consciousness': a perspective that is 'multiperspectival and tolerant of ambiguity, ambivalence and chaos'.[81] Instead, Jacir portrays the disenfranchising effects of the political and discursive 'chaos' that beset Palestinians at the boundaries of space, colonial control and identification. As we emerge from the borderlands, then, a question emerges: what might a uniquely *Palestinian* border-theory look like?

Towards a Palestinian Border-Theory

Borders clearly occupy a significant status within Palestinian creative consciousness, just as they do in Palestinian existence. While physical borders attest primarily to the enduring occupation of Palestinian land and so to its colonial status, creatively imagined boundaries also present an array of complex postcolonial feminist possibilities. In postcolonial terms, borders frequently operate as vital sites of witnessing, where the production of narratives enables the individual to testify to the oppressive and traumatic experiences that are so often entailed in encounters with the border. We see these acts of witnessing occur in Taha's, Badr's and Jarrar's short stories, for example, and in Jacir's short film, which each present vividly rendered accounts of the border-crossing experiences common to so many Palestinians. Consequently, many border-narratives can be understood as acts of 'writing back' to the Israeli-enforced discourse of borders as fairly policed security measures. In other works, though, the socio-spatial characteristics of the borderland itself offer a distinctive aesthetic through which creative practitioners are able to construct the liminal insecurity of Palestinian space as a source of self-representation rather than negation. Here, Abu Wael's and Jacir's films seem to echo Said's calls for the use of 'unconventional, hybrid and fragmented' forms as a means to represent Palestine. Border-narratives therefore expose the unique and ambivalent nature of Palestine's colonial condition: one that is at once premised on stringent material restrictions, and on a deconstructive liminality that threatens to negate Palestine's national identity, while revealing the many different ways in which it might be possible to negotiate these very different kinds of spatial oppression.

Borders also acquire a further significance in their interaction with gendered bodies, however. In all of the narratives examined in this chapter, borders do more than simply reveal Israel's enduring colonial presence; they also expose the less immediately visible social boundaries structured around the gendered body, which intersect with the 'social maps' of the Israeli occupation and of Palestinian community in multiple ways. At these boundaries, the interplay between the colonial and patriarchal becomes visible, and we see how socio-spatial restrictions may emerge through both official and unofficial boundaries instated by the occupation, and according to gender norms constructed within the Palestinian community itself. As a result, in narratives such as Badr's 'Other Cities' and Jarrar's 'Barefoot Bridge', or even in *'Atash*, physical borders become sites that dramatise other forms of social marginality circulating around the gendered body within a patriarchal society. Significantly, though, borders also emerge as sites of postcolonial feminist potential. Indeed, when confronted with a border or boundary, most of the characters within the border-narratives examined in this chapter attempt to cross it. Narratives such as Badr's 'Other Cities' and Abu Wael's *'Atash* even appear to suggest that women's attempts to challenge and transgress social boundaries may play an important role in establishing a postcolonial Palestine, by challenging the structures of patriarchy that seems to mirror the binary terms of colonialism itself. Thus border-narratives do not simply seek to present women as 'victims' of the 'social map', but as agents who are able to navigate the intricate interplay of national and gendered subject-positions in order to produce new, creative delineations of selfhood and space for themselves.

Borders therefore appear as loci of creative potential as well as oppression within the Palestinian imagination. They act as important sites of witnessing and testimony, but they are also places that produce forms of simultaneously postcolonial and feminist agency. These creative potentials emerge from very different understandings of space, identity and representation to those held within more traditional postcolonial feminist theorisations of the border, however. While theorists such as Anzaldúa, Hicks, Bhabha and Naficy all celebrate the potential deconstructions of self, space and identity that can be theorised within the 'hybrid' realms of the borderland, Palestinian border-narratives tend to represent the liminal dissolution of subject-position as a source of disenfranchisement rather than liberation. In doing so, they suggest that tendencies towards poststructuralist border-theory prevalent in the postcolonial feminist academy to date do not readily translate into the very specific conditions of Palestinian colonialism and gender relations. Instead, the emphasis placed on bodily agency and political positionality within Palestinian border-narratives seems to demand a return to more materially grounded understandings of both borders and bodies. This, according to Ian McLean, might in fact incite an important recognition in postcolonial and indeed cultural theory more broadly: that despite the claims of some postmodernists, 'we don't live in a post-national landscape, but in an

inter-national and transnational one in which the nation-state remains all-powerful'.[82] Within this context, it remains clear why the construction rather than deconstruction of self-determined borders remains key to postcoloniality for Palestine. Within a materialist feminist context, Kathleen Kirby also recognises the importance of boundaries to the realisation of specifically gendered agency. She writes that

> in political terms, entirely sacrificing boundaries—such as that between 'man' and 'woman'—makes impossible the usual political tasks of identifying group interests and seeking them through to realisation. Conventional though they may be, it may prove necessary to preserve the bounds of the subject in order to make political action imaginable.[83]

While Kirby's calls for a bounded gender-consciousness might seem limited when contrasted with the radically deconstructive tendencies of 'queer' theory, Kirby suggests here that this very recognition of gender boundaries is in fact a premise of agency. As Spivak reminds us, turning to apparently 'essentialist' subject-positions does not have to be a restrictive end-point for the individual but can be enacted 'strategically', so that gendered or national identity, for example, might be mobilised in order to respond to a specific set of political circumstances.[84] Instances of 'strategic essentialism' are integral to the postcolonial feminist potential of many border-narratives examined in this chapter. In Raeda Taha's 'A Single Metre', for example, an insistence on the materiality and vulnerability of the body as a bounded entity proves essential to her critique of the border as a site of patriarchal violence, pain and all too physical suffering, while in Liana Badr's 'Other Cities', Umm Hasan's assertion of her identity as a mother is integral to her successful transgression of colonial power. Both Gamila in *'Atash* and Annemarie in *like twenty impossibles*, meanwhile, testify to the loss of political agency that emerges within an indeterminate socio-spatial landscape bereft of boundaries with which to ally oneself.

A uniquely Palestinian border-theory therefore reveals significant points of tension as well as overlap with existing postcolonial feminist theorisations of the border. Palestinian borders appear to incite a return to concepts of political agency, opposition and materiality, and to inherently 'bounded' models of space and selfhood within postcolonial feminist discourse. In doing so, they invite theorists to reconsider the role of borders in the contemporary postcolonial landscape, which seems to be increasingly defined by border-control mechanisms. This is, after all, the age of the biometric passport, of the Border Agency and the Immigration Detention Centre: perhaps now more than ever before, borders regulate, define and produce our identities and our movements. Yet against this backdrop, Palestinian border-narratives also offer us a source of hope. Through them, we see the creative and courageous ways in which individuals stand up to and transgress even

the most rigorously enforced and unjust of boundaries within real and imagined worlds alike.

For the millions of Palestinians displaced from Palestine's boundaries altogether, though, the distance that separates them from their homeland is much greater than the few traumatic metres of the checkpoint or border-crossing. In the next (and final) chapter, we therefore venture beyond national boundaries altogether in order to explore the creative identifications and postcolonial feminist affiliations of those within the diasporic community.

5 Imagining the Transnational Feminist Community

Diasporic space haunts the (post)colonial Palestinian imagination. Millions of Palestinians have endured conditions of displacement, refugeeism, migration and exile as a result of Palestine's traumatic colonial history, and those within the Palestinian diaspora testify to the simultaneously spatial and political dispossession of their nation. Despite the uprootings and dislocations experienced by those within the diaspora, though, diasporic space has also emerged as a site of creative energy from which many authors and filmmakers have sought both to affirm structures of belonging, and to engender new, imaginative forms of community. This final chapter therefore explores some of the ways in which creative practitioners within the diaspora have imagined forms of community according to variously feminist, anti-colonial, postcolonial, ethical and transnational identifications. While these communal identifications present vital forms of solidarity with Palestine, they may also pose a powerful potential within the transnational landscapes of inequality, injustice and communicative breakdown that have surfaced at the boundaries of 'West' and 'Middle East' in a post-September 11th environment. As such, these works draw us towards the tantalizing possibility of a distinctively transnational postcolonial feminist community.

Experiences of displacement and dispersal are integral to Palestinian national identity itself. The specific nature of the Palestinian experience, though, means that the notion of 'diaspora' has very different resonances to Palestinians than it does to many postcolonial theorists. The term 'diaspora' derives from the Greek, where *dia* (through, across) and *speirein* (to sow, scatter) are conjoined in the word *diaspeirein* (to disperse).[1] Broadly speaking, it refers to communities of people who have been dislocated from their original homeland, either through voluntary processes of migration or through the forced experience of exile, displacement or refugeeism.[2] This 'scattering' of people has certainly taken place for many Palestinians, but in a much more traumatic way than the original Greek term seems to imply. The *Nakba* of 1948 created some 750,000 Palestinian refugees consisting of Palestinians internally displaced within the new State of Israel and those forced beyond the boundaries of historic Palestine altogether.[3]

Most of these people were barred from ever returning to their homes. A subsequent major wave of displacement occurred following the *Naksa* of 1967, but instances of traumatic dispossession have recurred throughout the history of Palestine's conflict with Israel and thus are an inherent feature of Palestine's colonial condition. In 2001, the number of registered Palestinian refugees stood at 3.9 million according to the United Nations Relief and Works Agency (UNRWA) for Palestine refugees in the near East, the majority of whom live in the Arab world, with a substantial proportion based in refugee camps in Jordan, Lebanon, the West Bank and Gaza. Figures from 1991 place the number of Palestinians living in 'non-Arab states' at 325,000, most of whom live in the U.S.[4] Despite the passing of Resolution 194 by the United Nations in 1948, which guaranteed the 'right of return' to Palestinian refugees displaced from their homes, this right has not been recognised by Israel and remains a central debate within Palestinian political discourse.[5] While a substantial proportion of Palestinians live within diasporic communities, displacement therefore permeates national consciousness and indeed, Muhammad Siddiq describes Palestine itself as a 'refugee nation'.[6] This idiosyncratic state of affairs also leads to a distinctive understanding of Palestinian belonging and identity, however—for while many diasporic communities tend to be understood as separate from the homeland, Palestinian diasporic subjects are still considered to be very much a part of the Palestinian population. Indeed, to many Palestinians, the diasporic community is a symbol not only of the enduring injustices of colonial rule but of the ongoing struggle to achieve a unified postcolonial nation to which those in the diaspora should have the right to return, if they should wish to do so.

The political context surrounding the creation of the Palestinian diaspora therefore raises certain problems relating to terminology. While the term 'diaspora' has, as Clifford writes, been 'widely appropriated' and applied to a number of victimised communities defined by 'a shared, on-going history of displacement, suffering, adaptation, or resistance',[7] it was originally associated with, and remains strongly related to, the Jewish experience of displacement. This bears a certain irony for many within the diasporic Palestinian community, who read their own displacement as premised on Israel's attempts to territorialise the Jewish diasporic population. For this reason, Edward Said states that 'I do not like to call it a Palestinian *diaspora*: there is only an apparent symmetry between our exile and theirs [. . .] Our *ghurba* or *manfa* is a much different thing'.[8] The term *manfa* is derived from the verb *nafa*, which means 'to banish or expel', hence it refers to a literal or technical sense of exile. A comparative term is *al-shatat*, which denotes being scattered, dispersed or separated, which might be seen as most closely akin to the connotations of scattering implicit in 'diaspora'.[9] The term *ghurba* has a richer and more symbolic resonance, however, and is used widely by authors and scholars. *Al-ghurba* is translated literally as banishment, estrangement or

separation from one's country, but in Qur'anic Arabic, it is linked to the verb *gharaba*, the opposite of *sharaqa*: a verb that denotes being oriented towards the rising sun, and hence to the East or Orient. As Juliane Hammer explains: 'The West, as the opposite, implies being away from the sun, in the darkness. Thus, the term *ghurba* means religiously and philosophically barred from the light'.[10] *Ghurba* is therefore a highly emotive term which implies a psychological as well as literal sense of alienation or exile, and it gestures towards a sense of loss and longing for return (*al-'awda*) to the homeland (*al-watan*).

The psychological implications of *ghurba* are very different to the associations attached to diaspora in the postcolonial imagination. Theorists such as James Clifford and Arjun Appadurai have tended to view diaspora as an inherently open, egalitarian and deterritorialised process of spatial interaction which reveals the ways in which well-worn configurations of space and self as 'form[s] of closed interiority encapsulated in a boundary'[11] no longer seem adequate within our increasingly 'borderless world'.[12] The Deleuzian 'nomad' typifies this image of diaspora: a figure whose rootlessness is often equated with the 'deterritorialised' liberation offered by postmodern, globalised space.[13] Yet for many Palestinians, the flux and fluidity of diasporic existence is not liberating but deeply oppressive (as we also saw in Chapter 4). The poet 'Abdallah Radwan, for example, describes exile as akin to a 'deformed birth': an existence in which his very sense of being and identity is distorted and 'abnormal'.[14] The prominent Palestinian writer and intellectual Fawaz Turki, meanwhile, describes the Palestinian diaspora as 'a reality scorched by alienation . . . a ceremony of shadows that was to become our homeland in exile'.[15] The painful, involuntary nature of Palestinian diasporic experience therefore stands at odds with its postmodern celebration. This leads Smadar Lavie and Ted Swedenburg to conclude that 'hybridity . . . does not appear to be a viable strategy in the struggle for Palestine'; it is instead 'a case of an exilic identity demanding return to its historic territory' in which 'essentialism is a political necessity, particularly when the group or culture is threatened with radical effacement'.[16] Palestinian diasporic experience therefore affirms rather than destabilises the value of borders and locatedness in the transnational landscape.

Just as Palestinian creativity proves resilient under the conditions of occupation though, so has a significant body of creative expression emerged from within the context of *ghurba*. Edward Said is the most prominent diasporic Palestinian theorist to have considered the nature of exile. In one particularly famous discussion of the topic, he draws on a phrase by Wallace Stevens in order to characterise exile as the condition of '"a mind of winter" in which the pathos of summer and autumn as much as the potential of spring are nearby but unobtainable'.[17] Said formulates his understanding of exile specifically in relation to intellectual and creative activity, which he views as 'compensating for disorienting loss by creating a new world to rule'.[18] While exile is therefore an inherently painful state for Said,

seeing 'the entire world as a foreign land' enables originality [. . .] and . . . plurality of vision [which] gives rise to an awareness of simultaneous dimensions, an awareness that—to borrow a phrase from music—is *contrapuntal*.[19]

Exile facilitates a certain creativity of vision for Said; hence, as he writes, 'exiles cross, break barriers of thought and experience'.[20] Said is not alone in recognising the creative possibilities that may be mobilised by the exile. In her overview of 'Palestinian Identity in Literature', the esteemed writer, scholar and translator of Palestinian literature Salma Khadra Jayyusi states that a blossoming of literary talent among Palestinian authors emerged partly from their exilic conditions:

> A fantastic change in the cultural identity of the Palestinian poet and writer of fiction has indeed taken place since 1948. This, however, was due not to cultural encounter with Israelis, but to the fact that Palestinians living in the Diaspora . . . came into direct contact with the vibrant literary currents blowing over the Arab world . . . and acquired new ambitions that the pre-1948 generations did not experience.[21]

Over the course of this chapter, it will become apparent that this statement might be extended beyond the Arab world to encompass the tremendous outpouring of literary and filmic talent from diasporic Palestinians in the U.S. and other Western contexts. For these authors and filmmakers, the 'pathos of autumn' and 'potential of spring' are also to be found through the enduring potentials of their creative imaginations within even the wintriest conditions of diasporic alienation.

Said's model of the 'exilic intellectual' also presents its own problems to postcolonial feminist understandings of diasporic expression and identity though. As Eva Karpinski writes, Said's model of exile is distinctly individualistic and 'comes very close to the fulfilment of a male fantasy of the free, unencumbered, independent self'.[22] By way of contrast, we might turn instead to the alternative tradition of interpretation which seeks to 'feminise' the condition of exile, and so presents the female collective rather than the male individual as emblematic of the exilic condition. While it was Virginia Woolf who first declared that 'as a woman, I have no country. As a woman I want no country. As a woman my country is the whole world',[23] feminist thinkers from a broad range of disciplinary and cultural backgrounds have since recognised the symbolic resonances between the condition of women and that of the exile. Julia Kristeva writes that 'a woman is trapped within the frontiers of her body . . . and consequently always feels exiled':[24] a powerfully spatialised vision of the power-based and representational boundaries that locate women in socially and psychologically marginal positions. For Kristeva, then, the construction of gender boundaries themselves exile women from their own potentials for human agency. Feminist theorists have

often sought to reveal these cartographies in their work (as have Palestinian authors such as those examined in Chapter 4, who also explore gendered boundaries), but more thorough mappings of the relationship between gendered and geographical exile have emerged from the field of transnational feminism. This critical approach

> acknowledges both the specific local and national forms of patriarchy, as well as the ways in which global economic restructuring and transnational cultural influences shape and link the material and cultural lives of women around the world.[25]

Thus transnational feminism recognises the multiple structures of gendered, economic, political and social power that intersect within the diasporic landscape, forming a complex mesh of solidarities and differences among women. A transnational feminist approach therefore reveals what Grewal and Kaplan term 'scattered hegemonies':[26] structures of power and authority that arise fluidly within diasporic space. Thus diasporic movement does not simply enable the gendered subject to transcend oppressively patriarchal, colonial or national boundaries: new hegemonic relations may resurface within diasporic space itself. For diasporic Palestinians, these 'scattered hegemonies' might appear around official discourses of national belonging within their host nation, for example, or through communal gender norms that are resurrected within migrant communities. Indeed, for Palestinian Americans, these 'scattered hegemonies' have assumed a particularly troubling form following the events of September 11th 2001, as prejudice, harassment and hostility towards those associated with the Arab world have increased, at the same time as military policy towards the Middle East has become increasingly aggressive: conditions that evoke the hegemonic relations of imperialism.[27] Against this backdrop of simultaneously spatial, social, gendered and political power dynamics, the quest for postcolonial feminist agency within diasporic space appears all the more challenging.

How might creative practitioners negotiate the 'scattered hegemonies' of diasporic space, and the senses of loss and fragmentation as well as potential that emerge out of the experience of displacement and rehoming? For all of the creative practitioners examined in this chapter, one particular concept emerges as a vital touchstone: community. In each of the works examined, this concept is premised on distinctive understandings of affiliation, 'togetherness' and agency. The first half of the chapter, entitled 'Cartographic Bodies and Textual Intimacies in Masri's *Frontiers of Dreams and Fears* and Hatoum's *Measures of Distance*', turns to two very different forms of filmic work. Yet in both Mai Masri's documentary film *Frontiers of Dreams and Fears*[28] and Mona Hatoum's work of video art, *Measures of Distance*,[29] distinctive visions of connection between women separated within diasporic space emerge through the conditions of female embodiment and textual communication. These

themes inspire connections with a variety of feminist theories of embodiment and location, but particularly interesting links emerge with Sara Ahmed's work on embodiment, skin and intimacy within a diasporic context. In this opening section, then, concepts of feminocentric community appear at a microcosmic level, borne out of the deeply personal ties conjured between women through the realms of the body and the textual imagination. The second part of the chapter, '"Not Everything Is Lost": The Creative Solidarities of Palestinian American Poetry', turns to the work of two female poets born into the Palestinian diaspora in the U.S.: Naomi Shihab Nye and Suheir Hammad. For both Nye and Hammad, diaspora emerges as a space that facilitates multiple forms of connection and solidarity with many different geographical, political, ethical and gendered communities. Within their work, both feminist and postcolonial commitments emerge as part of broader ethical and creative struggles for justice, equality and representation that speak not only to Palestine, but also to the interrelated landscape of U.S. imperialism. Consequently, these poets present the opportunity to explore the postcolonial feminist potential of theoretical models such as Avtar Brah's 'diaspora space', and indeed enable us to consider the ways in which postcolonial feminism may come to play an increasingly important transnational function within a post-September 11th world.

Cartographic Bodies and Textual Intimacies in Masri's *Frontiers of Dreams and Fears* and Hatoum's *Measures of Distance*

How might the visual and emotional potentials that circulate around the female body help diasporic filmmakers to imagine forms of transnational connection and even community in their work? This is just one of the questions that emerges from two distinctive portraits of feminocentric Palestinian diasporic experience: Mai Masri's documentary film *Frontiers of Dreams and Fears* (2001), and Mona Hatoum's 15-minute work of video art, *Measures of Distance* (1988). While very different in terms of style, content and context, both of these visual works place female bodies and relationships at the heart of their explorations of diasporic experience. Within both films, visuality and textuality are placed in interplay with one another through the use of epistolary communication as a device that forges an emotional, experiential and even embodied intimacy between women separated from one another within diasporic space. The following analysis therefore explores the competing forces of separation and distance, of embodiment and absence, and of the visual and textual that surface in both Masri's and Hatoum's works, in order to consider how new forms of connection and community might come to be mapped out in feminocentric terms.

Diasporic experience has been central to both Masri's and Hatoum's lives. Masri was born in 1952 in Jordan to a Palestinian father and an American

mother, and spent her early years between Amman and Nablus, before moving to Beirut in 1966. She relocated to Berkeley, California in 1976, the year after the Lebanese Civil War broke out, where she studied film theory. After meeting her husband, the Lebanese filmmaker Jean Chamoun, she lived in Paris and London but finally moved back to Beirut when the Civil War ended.[30] Hatoum was also born in 1952, to Palestinian parents who had been forced to flee from Haifa in 1948 and to relocate to Beirut. Hatoum herself was forced to relocate to London when, during her stay there, civil war broke out in Lebanon, preventing her from returning to Beirut. While living in London, she studied at the Byam Shaw School of Art and then the Slade, before going on to make video productions in Canada, and working as a guest professor across Europe.[31] While neither Hatoum nor Masri therefore experienced the *Nakba* directly, its traumatic legacy no doubt has a place within the collective memories of both of their families. Masri's and Hatoum's own diasporic movements, though, are distinctive in many respects from the straightforwardly traumatic experience of the *Nakba*. Their time studying in Europe, and Masri's chosen return to Lebanon, points towards a level of transnational mobility that may have also facilitated access to a number of different artistic worlds. Equally, the filmmakers' own creative relationships to diasporic experience appear very different from one another. Hatoum—unable to return to Lebanon at the time of making *Measures of Distance*—reflects upon her own traumatic separation from her family and home, in particular from her mother, from within the diasporic space while Masri—able to return to Lebanon, and indeed to travel into parts of Palestine—instead chooses to explore the traumatic separations endured by others within the Palestinian diaspora. Thus the autobiographical backdrop of each filmmaker's diasporic experience resonates in a quite different way in each work. It is interesting to note that there is nevertheless a common spatial orientation towards the Middle East in both of their films, even though they retain access to non-Arab cultural frameworks through their travel, and that despite what some critics might describe as the 'masculine' possibilities of mobility and agency afforded them by their travels, their gazes remain inexorably drawn towards feminocentric experience. What, then, do these distinctive orientations of the gaze reveal about the dynamics of belonging, identification and space in each of the works?

Both *Frontiers of Dreams and Fears* and *Measures of Distance* explore relationships between female figures who occupy different locations within the Palestinian diaspora. Masri's *Frontiers of Dreams and Fears* focuses on the experience of two girls, who were each born into a different Palestinian refugee camp. Mona Zaaroura, aged 13, lives in the Shatila refugee camp in Beirut: the site of the notorious massacres of Palestinians carried out in 1982.[32] Manar Majed Faraj, aged 14, lives in the Dheisha refugee camp in Bethlehem, a territory officially within the West Bank and under the governance of the Palestinian Authority.[33] While there are many male inhabitants of these camps, including

older figures who perhaps possess a greater 'authority', Masri chooses instead to focus her gaze on the friendship that emerges between Mona and Manar when they are placed in contact via organisations within each of their camps that seek to improve life for young Palestinians. Masri's portrait of the girls also explores the female-dominated communal structures that envelop their lives. Mona in Shatila records that her father died in 1989 when she was two years old, and that many of the teenagers in the camp are without fathers because of the 1982 massacre. Indeed, her closest friend Samar has neither a mother nor a father, and Mona identifies very closely with Samar, to the extent that their relationship assumes a 'sisterly' dimension: 'As soon as I laid eyes on her, I felt she was like me', Mona says of Samar; 'everyone thought we were sisters'. Women, not only mothers but also female friends and neighbours, therefore play a central role in Mona's life. This is also the case for Manar in Dheisha. She records that her father was imprisoned when she was born, and remained absent for much of her childhood. Her main communal structures have been her own family, which includes her mother, three brothers and two sisters, and the Ibdaaʻ cultural centre (*ibdaaʻ* translates as 'creation' or 'creative ability'), which provides cultural activities, particularly dance, through which Manar connects with her mainly female friends and is also put in touch with Mona. This feminocentric experience reflects the gender structures that typify Palestinian diasporic communities, particularly within refugee camps, where communal trauma has often led to a depleted male population due either to their imprisonment or death.[34] Female relationships therefore present maternal and sisterly support networks for the girls. Indeed, Masri's own directorial gaze might also be aligned with this commitment to supportive female community, for while she has access to the 'male', 'public' realms of the Palestinian refugee community as a diasporic filmmaker, she instead chooses to focus on the private worlds and desires of these two young girls, offering an intimate and even maternal insight into the 'dreams and fears' of the film's subjects at a formative point in their lives. As such, Masri's own filmic gaze can be read as feminocentric and even feminist.

Mona Hatoum's *Measures of Distance*, meanwhile, offers an intimately autobiographical but equally feminocentric exploration of diasporic space. Originally displayed as a video installation, this 15-minute work of video art consists of a layering of visual imagery and voice-over, in which a woman—presumably Mona—reads extracts in English from letters that her mother has sent to her from Beirut. These letters reveal the diasporic context to the film: Mona is in London, while her mother is in Beirut (also a diasporic location since her mother was forced to flee from Palestine in 1948). While the visual imagery is initially abstract, consisting of blurred hues of dark blue, crimson and black, the camera gradually pans out from what is revealed as a close-up detail of a photograph of her mother in the shower taken by Mona during a visit to Beirut. This image is, in turn, layered with handwritten Arabic text from the mother's letters to Mona.

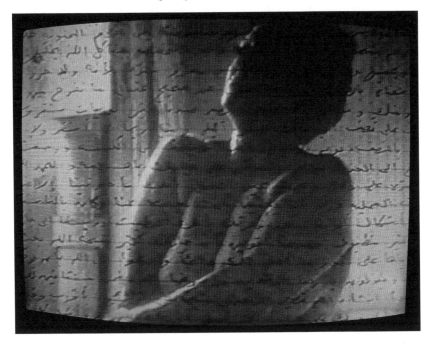

Figure 5.1 Palimpsestic layers of image, text and voice create a portrait of mother-daughter intimacy that transcends diasporic distance. *Measures of Distance* (1988), dir. Mona Hatoum. Colour video with sound. Duration: 15 minutes. A Western Front Video Production, Vancouver, 1988. Courtesy of White Cube.

These layered narratives evoke a portrait of tremendous emotional closeness between mother and daughter. While the letters initially establish a somewhat conventional mother-daughter relationship founded in the mother's desire for her daughter to return to her (described as a physical intimacy by the mother, who states that 'I long to hold you in my arms'), the letters soon reveal other forms of intimacy between them based around gender rather than diasporic location. The mother speaks of the episode during which Mona took the photographs of her in the shower and tells of how they were discovered by her father, who appeared deeply shocked. The mother describes how, although they laughed off the episode, she was left with a clear sense that her husband felt as though Mona had 'trespassed on his property'. Despite the fact that he speaks dismissively of the 'women's nonsense' that Mona and her mother discuss—what the mother terms 'intimate conversations about women's things'—the mother retains a clear sense that he feels somehow excluded, even hurt that Mona does not discuss personal matters with him. Nevertheless, the mother reveals the strong bond she feels is forged between them through such conversations, not only in terms of their mother-daughter relationship, but also at a 'sisterly' level: 'I felt we were like

sisters—close together with nothing to hide . . . I enjoyed the feeling of intimacy', she writes. Mona's diasporic location therefore evokes a simultaneous distance from and closeness to her mother, which are mediated through the realms of both body and text, image and voice.

The interplay between body and text also proves central to the connections forged between Mona and Manar in *Measures of Distance*, but so too does the relationship between 'self' and 'other'. While the discursive relationship between 'self' and 'other' most usually refers to the binary distinction constructed between 'man' and woman', 'masculine' and 'feminine' in patriarchal discourse, the feminocentric space of exile posits the 'other' as an/other female figure, who is at once closely connected to the female subject's sense of 'self'. In *Frontiers of Dreams and Fears*, Mona and Manar are one another's 'other', but this 'otherness' is constructed as an almost uncanny doubling, evident not only in the similarity of their names (Mona/Manar), ages (13/14), situations (both born as refugees in Palestinian camps, with absent fathers) and temperaments (thoughtful, bright, creative and kind) but also in the way in which they construct their own self-awareness through their correspondence with each 'other'. This 'doubling' or 'mirroring' of experience can be read in psychoanalytic, specifically Lacanian terms, as Elizabeth Grosz describes:

> Lacan maintains that the infant's earliest identity comes from its identification with its own image in a mirror. The specular or virtual space of mirror-doubles is constitutive of whatever imaginary hold the ego has on identity and corporeal autonomy [. . .]
>
> He stresses that the mirror *Gestalt* not only presents the subject with an image of its body in a visualized exteriority, but also duplicates the environment, placing real and virtual space in contiguous relations.[35]

While Lacan refers to the early childhood stages of development, the sense in which Mona and Manar's mirroring relationship helps them to form an understanding of themselves can also be related to their status as pubescent girls, on the cusp of womanhood, and hence at a crucial stage of self-development. Yet this development of self-awareness does not only take place in relation to gendered identity, but also through their specifically diasporic location. As Sara Ahmed writes, the construction of a 'home' within the space of diaspora itself entails the encounter with 'strange bodies' 'other' than your own:

> There is always an encounter with strangeness at stake, even within the home: the home does not secure identity by expelling strangers, but requires those strangers to establish relations of proximity and distance within the home [. . .] There is already strangeness and movement within the home itself.[36]

In *Frontiers of Dreams and Fears*, it certainly seems true that the girls establish a sense of diasporic 'home' through one another. Crucially, though, this reconstruction of 'home' takes place through a specifically textual medium: written correspondence.

Within the film, we learn that the girls are initially placed in contact through a 'pen friend' scheme set up by the cultural groups in each of their camps, and further research into the context of the film by Helena Schultz reveals that this initially occurred through a project set up by the Information Technology Unit at Birzeit University, called the Across Borders project, which aimed to act as a 'virtual space' in which refugees could communicate without the restrictions of borders or separation of distance.[37] It is tempting to theorise 'cyberspace' as a connective, transnational realm where identities, including gendered and national affiliations, can be reinscribed at will[38]—but it is interesting to note that the physically written word, transmitted from hand to pen to paper—becomes the chosen medium of correspondence for the girls. Their letters soon become deeply personal, and over the course of a year, which includes the outbreak of the second *Intifada* in Palestine, the girls strike up an epistolary connection through which they support and comfort one another.

Interestingly, many of their letters discuss their sense of longing for Palestine, and for home: a (be)longing that, in some ways, they come to fulfil through one another. We see this, for example, when Mona asks Manar, as a West Bank resident, to find and visit her family's former village of Saffouria from which they were exiled. Manar fulfils this request and constructs a narrative of return, which she sends to Mona. Though the houses have been erased and many trees planted to obscure the site of destruction, Manar attempts to find traces of Mona's family history. She tells Mona that she found a cactus which seemed to mark the entrance to the village, and tells her that 'your village is beautiful. It takes your breath away'. Most significantly, though, Manar collects and sends soil from the village to Mona, and Masri films Mona allowing the earth to run slowly through her fingers. Manar's body, given free(er) access to areas of the West Bank, therefore enables Mona to complete her diasporic quest for return at some level. In this way, loss of the homeland emerges as both a shared source of pain and collective memory, but also as a ground for connection between the girls. Mona and Manar's written correspondence could therefore be seen to affirm Ahmed's view that

> stories of dislocation help to relocate: they give a shape, a contour, a skin to the past itself. The past becomes presentable through a history of lost homes (unhousings), as a history which hesitates between the particular and the general, and between the local and the transnational. The telling of stories is bound up with—touched by—the forming of new communities. Memory is a collective act which produces its object (the 'we'), rather than reflects on it.[39]

Here, Ahmed's description of the narrative as a 'skin' that 'fleshes out' an absent or erased space evokes the heavily embodied dynamic to the girls' diasporic experience. Not only is Mona's reconnection to her former home instigated through Manar's bodily travel to her family home, which in turn enables her to touch its soil, but the culmination of their story sees Mona and Manar managing to meet at the Israeli-Lebanese border and to hold hands.

This encounter is made possible by Israel's withdrawal from South Lebanon, and Masri films hundreds of people flocking to the border in order to catch a glimpse of, communicate with or even reach out their hands to friends and relatives from whom they have been separated for many years.[40] This marks a significant moment in the traumatic collective memory of Palestinian refugeeism, then, and it is appropriate that Mona and Manar, two young representatives of the legacy of this trauma, are brought together at this point. Meeting at the border, the girls speak to one another and share narratives about the difficulties that they face in the camps, finding many similarities—the lack of water and electricity, for example. Only later, though, do they reveal the poignancy of this moment for them. Mona speaks of how 'when I held Mona's hands and we sang, it felt very special', while Manar says that 'I felt something was calling me to hold onto their hands and to tear down the barbed wire'. Yet Mona and Manar's touch evokes not only closeness, but also irreconcilable distance. As Jackie Stacey and Sara Ahmed

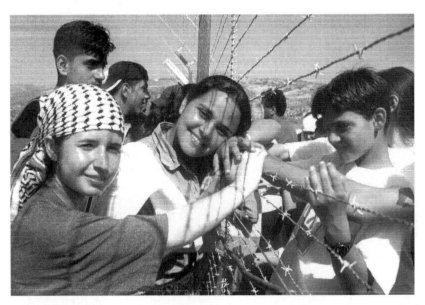

Figure 5.2 Children from the Dheisha refugee camp in the West Bank and from Shatila refugee camp in Beirut come to meet and hold hands at the Israeli-Lebanese border. *Frontiers of Dreams and Fears* (2001), dir. Mai Masri. Image courtesy of Arab Film Distribution.

write, the skin is but an 'interface between bodies and worlds';[41] the act of touching is not one that conjoins or undoes distance but instead, as Sara Ahmed writes, 'touching, as a temporary encounter with another, involves a movement closer . . . which does not grasp that other . . . The movement towards, in touch, is always already *a movement away*'.[42] The contact between hand and soil, hand and hand therefore reveals not only intimacy but loss, not just proximity but distance, as inscribed on each girl's body.

Despite the incomplete nature of the 'home' that Mona and Manar find in one another, they nevertheless seem to affirm Ahmed's hypothesis that exile may also create a 'community of strangers'. This kind of community does not simply seek to replace the one that is lost, but rather, forges shared connections through that very experience of loss. Ahmed writes:

> We need to recognise the link between the suspension of a sense of having a home with the formation of new communities. The forming of a new community provides a sense of fixity through the language of heritage—a sense of inheriting a collective past *by sharing the lack of a home rather than sharing a home*. In this sense, the movement of global nomads allows the fixing rather than unfixing of the boundaries implicated in community and identity formation.[43]

In postcolonial feminist terms, it is highly significant that this 'community of strangers' should also emerge from the specific parameters of feminocentric experience and female identity. For Mona and Manar, heritage, collective memory and the loss of home provide an important sense of connection to their past, but it is through their identities and emotions as girls shortly to become women that they also construct visions of community that connect them to the future, remapping the boundaries of community on their own terms.

Bodily and textual correspondence with an 'other' also proves integral to the construction of selfhood and belonging in *Measures of Distance*. For Mona (Hatoum), this 'other' is literally her m/other, with whom a certain doubling or mirroring of experience also takes place in the film, just as it does for Mona and Manar in *Frontiers*. Here, the Lacanian parallels are more direct. As Lindsey Moore writes, the film portrays, at one level, 'a universal gendered experience: a daughter's self-differentiation from, but ongoing identification with, her mother'.[44] Laura U. Marks is also keen to emphasise the film's psychoanalytic possibilities in her reading of it as a dramatisation of 'an erotic relationship that is organised less by a phallic economy than by the relationship between mother and infant'.[45] This resistance to the 'phallic economy' appears particularly in the presentation of the mother's body. As the photograph of her in the shower slowly comes into focus, her nakedness is revealed to the viewer but the effect of this image, shot in indistinct hues of indigo and maroon and semi-veiled by her words, is not that of a sexualised striptease but of a closeness and connection to the voluptuous, maternal

female body. This celebratory sense of maternal intimacy recalls Lacan's theorisation of feminine *jouissance*: a pleasure that recalls the sense of bliss experienced by the child when still at a stage of total unity with the mother.[46] In this way, Hatoum resists the 'phallocentric' voyeurism of the male gaze in favour of an affirmative vision of female intimacy, identity and embodiment. Indeed, the mother's letter reveals that although she has found Mona's questions about her sexuality 'probing', they have also 'ma[de] me think about myself in a way I hadn't . . . before'. Consequently, the film's visual engagement with the 'other' becomes a representation of a dual process of self-exploration on the parts of both Mona and her mother.

Connective though Mona's visualisation of her mother might appear, though, loss remains indelibly inscribed upon her mother's body. Here, it is useful to turn to Verónica Schild's evocative critique of the classic postcolonial model of the 'liberated' diasporic subject, or 'nomad', as formulated by Rosi Braidotti. Schild writes:

> Rosi Braidotti has characterised the nomad's identity 'as a map of where s/he has already been; s/he can always reconstruct it a posteriori [. . .].' Braidotti forgot to mention, however, that this identity has hegemonic pretensions; it is a map wilfully written and traced over that other one penned through the senses and fleshed out by powerful emotions. It is hard to describe this map as anything but stones and cracks that keep springing up as if from nowhere, jolting one back, however momentarily—through hurt and pain—to that initial point, to the fault line [. . .] thus nomads' identities are anchored to bodies that will not forget.[47]

Measures of Distance similarly presents the sensuous and emotive female body as a 'vessel' of collective memory inscribed with the scars of traumatic diasporic experience. Within the film, this traumatic inscription of the female body takes place quite literally through the superimposition of lines from the mother's letter onto the image of her body, as we hear the mother speak of her own move from Palestine to Lebanon in 1948. She describes how she 'had to separate from all her loved ones' who were 'scattered all over the world', many of them never to be seen again. It 'felt as though I had been stripped naked of my very soul . . . our identity and pride in who we are went out the window', she confides. Yet this traumatic narrative also functions in a way that is connective. It enables the mother to identify with her daughter's own feelings: 'When you talk about a feeling of fragmentation, of not knowing where you belong—this has been the reality of all our people', she tells Mona. Mother, daughter and Palestinian collective experience therefore find themselves connected through the narratives that surface through the female body.

The feminocentric visions of both *Frontiers of Dreams and Fears* and *Measures of Distance* reveal a distinctive postcolonial feminist potential. While some feminists are resistant to the way in which 'many identity narratives

position "Woman" . . . as the pure space of "home"' and hence 'repeatedly appropriate [the female body] as a marker of national, racial, religious and ethnic communities',[48] both of these films indicate that women themselves may author these connections between the female body, nation and home in order to construct new, imaginative maps of community and connection within diasporic space. In this, they support the critic Irene Gedalof's recognition that

> when women of a given community are targeted by racism, ethnic absolutism, religious hatred or other forms of intolerance or violence because of their membership in that community, it makes no sense to claim that these women's sense of themselves as women is not intimately bound up with their sense of belonging to that community.[49]

Hence, the drive towards feminocentric connection and community can be read as a postcolonial response to the traumatic colonial legacies of Palestinian diasporic experience. Yet these feminocentric communities do not simply seek to recuperate traditional gender norms or social structures. Instead, they place women's bodies and subjectivities at the generative heart of communal structures, producing what Elizabeth Grosz describes as 'the possibility of occupying, dwelling or living in new spaces, which in their turn help generate new perspectives, new bodies, new ways of inhabiting'.[50] Despite the very different diasporic experiences and relationships between women visualised by Masri and Hatoum, their films nevertheless display a common commitment to this search for 'new perspectives, new bodies, new ways of inhabiting' diasporic space that resist women's disconnection not only from Palestine, but from one another. In this, their films look beyond the divisive 'frontiers' of colonial and patriarchal authority to 'dreams' of a connective postcolonial feminist future.

'Not Everything Is Lost': The Creative Solidarities of Palestinian American Poetry

The Palestinian diaspora stretches across the world, creating many different communities that must each find their own creative ways to mediate their relationship to Palestine through the transnational location and socio-political landscape in which they find themselves. Over the past few decades, particularly distinctive creative explorations of transnational Palestinian identity and community have emerged from the Palestinian American poets Naomi Shihab Nye and Suheir Hammad, who share a preoccupation with the many different possibilities of belonging and solidarity that may be mobilised through the medium of poetry. For both Nye and Hammad, though, the contemporary U.S. landscape also presents a particularly challenging environment in which to locate these possibilities. While Nye and Hammad each employ very

different poetic strategies in order to negotiate the transnational and U.S. landscapes in which they find themselves, it is nevertheless possible to identify a common humanitarian commitment in their work that is often expressed in either explicitly or implicitly gendered terms—whether in the form of familial relationships between daughters, mothers, fathers and grandmothers, as in Nye, or through strident expressions of opposition to the masculinist rhetoric of violence perpetuated against Palestinians and against women, as in Hammad's poetry. While the gendered undertones of their work must be situated within a much broader matrix of political commitments and concerns, the structures of family, solidarity and alliance that circulate around gendered identities and bodies in their work nevertheless prove integral to their search for imaginative and connective relationships to, and indeed between, Palestinian and U.S. communities within the diasporic landscape.

Naomi Shihab Nye and Suheir Hammad are two of the most prominent contemporary Palestinian American poets writing in English today, and each of them shines as a leading light in different poetic 'scenes'. Nye is the author of more than twenty-five books, which include poetry anthologies, novels and collections of poetry and prose written for both adults and younger readers. She has received many literary awards and fellowships, has had work presented on radio and television, and has even read at the White House.[51] She was born in 1952 in St Louis, Missouri, to a Palestinian father, the author Aziz Shihab, who came to settle in the U.S. following his displacement from Palestine by the *Nakba*, and to an American mother of European descent. Nye has subsequently lived in St Louis, Jerusalem and San Antonio, Texas and has travelled across Asia, Europe, Canada, Mexico, Central and South America and the Middle East. She continues to travel widely in order to read and take writing workshops. Her poetry is taught in schools in the U.S., and she cites the American poet and pacifist, William Stafford, as one of her greatest inspirations.[52] Despite her inauguration into U.S. literary culture, though, Palestine remains a touchstone in much of her work. Indeed, writing of Nye's work in light of his interview with her, the Palestinian American poet and environmental scholar Sharif S. Elmusa writes: 'Perhaps I would not be off the mark to say that the Palestinian plight is constitutive of the poet's sensibility: empathy with the vulnerable, aversion to loss, and abhorrence of aggression and violence'.[53] Nye's work therefore displays a deep commitment to the connective and healing powers of creative expression, and to its social potentials to educate, inspire and forge dialogue within and across many different kinds of community.

Suheir Hammad, meanwhile, has risen to prominence as a cultural educator, activist and actress (she starred in Annemarie Jacir's 2008 film *Salt of This Sea*), but as a poet, she is known for an altogether different style of poetry that draws on the rawness, spontaneity and self-assertion of the U.S. musical traditions of hip hop and rap, and on the contemporary tradition of the poetry slam.[54] Hammad sprung to public prominence for her poem 'first

writing since',[55] which was circulated widely on the Internet as one of the first poetic responses to the terrorist attacks of September 11th 2001. Already an acclaimed poet (the recipient of the Audre Lorde Writing Award, among other accolades and fellowships) and author of two works (the poetry collection *Born Palestinian, Born Black*[56] and prose reflections *Drops of This Story*[57]), Hammad was invited to perform on the HBO series *Def Poetry Jam* and on the Broadway show that later emerged from it, establishing her as one of the freshest and most politically strident voices in Palestinian American and indeed Arab American poetry.[58] The diverse cultural influences in Hammad's work stem from her upbringing in a multi-ethnic Brooklyn neighbourhood from the age of five, where she grew up listening to music by the likes of Public Enemy and came to be inspired by the stridently feminist and political voices of African American writers including Audre Lorde and June Jordan. Indeed, in her author's preface to *Born Palestinian, Born Black*, Hammad attaches particular importance to Jordan's poem 'Moving Towards Home', written in response to the Sabra and Shatila massacres. The poem includes the lines: 'I was born a Black woman / and now / I am become a Palestinian / against the relentless laughter of evil / there is less and less living room'.[59] Here, Jordan articulates a certain fluidity of communal identification as integral to the expression of her political solidarities, and this intercommunal identification also proves important within Hammad's own work, evident in her multi-ethnic identification as 'born Palestinian, born Black'.[60] For Hammad, then, communal identification does not signal a straightforward desire to assimilate or to exclude, nor to arrive at a fixed sense of belonging. Rather, it presents her with the conditions for political agency and social visibility: a way of viewing community that has proven integral to struggles for equality and justice throughout U.S. history, notably during the campaigns for racial equality undertaken by the Civil Rights movement.[61] For Hammad, then, it is possible to belong to many communities, and different potentials for agency, opposition and solidarity are to be found in each.

For both Nye and Hammad, their identity as specifically *Palestinian* Americans nevertheless remains at the heart of their imaginative explorations of diasporic belonging and community. As the children of 1948 Palestinian refugees who sought sanctuary in the U.S., they are members of a U.S.-based diasporic community of over 200,000 Palestinians of various generations.[62] Traces of their parents' traumatic experiences surface in many of Nye's and Hammad's poems, and inflect the ways in which they understand the concepts of 'home' and 'community'. As Nye puts it in her poem 'Jerusalem', 'each carries a tender spot: / something our lives forgot to give us',[63] and in Nye's case, this tender spot could be said to relate to the traumatic legacy of her father's displacement from Palestine during the *Nakba*: an event that has, in turn, shaped Nye's own consciousness of her identity. In interview, she speaks of how her father carried the memory of the *Nakba* with him in a way that meant

[his] entire life was shadowed by grief over loss of his home [. . .] [He] never stopped describing what he saw as the terribly unfair situation in his homeland, supported mightily by the U.S. government [and so] issues of identity and empathy, or lack thereof, became a big part of my awareness.[64]

So it is that many of Nye's poetic explorations of her own diasporic situation connect to her father's sense of loss, which engenders an acute awareness of the fragility of 'home' in Nye. In her poem 'Brushing Lives', for example, she conjures the silent legacy of collective loss that underpins her own and, to an extent, all diasporic people's existences: 'Who else? They're out there . . . / the ones we're lonely for . . . / the ones who know the story before / our own story starts'.[65] Here, the loss of the homeland is something that produces an inherent sense of absence and negation, but it also forges a community of its own kind: what Sara Ahmed terms a 'community of strangers'. Nye suggests that the diasporic landscape is inevitably inscribed with a sense of loss, and that the search for a way to return to or reconnect with the lost home endures within the diasporic environment. In her tender poem 'My Father and the Fig Tree', for example, her father's sense of longing for his homeland appears through his vivid descriptions of the delicious, fragrant figs that used to grow in Palestine. The poem subtly suggests his inability to reconcile himself to his diasporic existence through his poignant refusal to try to grow figs; thus 'home' remains intangible, absent, a perfect memory that can never be lived up to in the reality of his new environment. In the final stanza of the poem, though, Nye reveals how, within the last home in which he lives, her father finally finds himself able to nurture his memories of home while allowing himself to 'root' in his new location. She describes how

> He took me out to the new yard.
> There, in the middle of Dallas, Texas,
> a tree with the largest, fattest,
> sweetest figs in the world
> [. . .] fruits like ripe tokens,
> emblems, assurance
> of a world that was always his own.[66]

Here, Nye reveals a sensitive awareness of her father's desire to find some way to reconnect to his homeland, and for a 'rootedness' in his new home: a desire that is at once specifically connected to Palestine, but that is also deeply human. As both a living plant and a symbolic entity, the fig tree therefore suggests the way in which new senses of belonging may blossom from new soil, even as its meaning and memory remains inextricably tied to the losses of the past.

An awareness of her parents' traumatic displacement also infuses many of Hammad's poems. Both of Hammad's parents were 1948 Palestinian refugees originally from Lydd and Ramleh (now in the Tel Aviv area) who initially fled to Jordan, where Hammad was born in 1973, then moved to Beirut, and on to New York in 1978. In interview, Hammad recalls how she was exposed to many different cultural influences during her childhood in New York. While she grew up listening to 'very nationalist PLO chants' and poetry by 'Fadwa Tuqan and her brother [Ibrahim]', which her parents would 'chant in that oral tradition of Arabic poetry',[67] her poem 'daddy's song' also reveals the presence of jazz and blues music in her home. In this poem, she describes how she hears echoes of her father's flight from Palestine in the lyrics of Sam Cooke's Civil Rights anthem 'Change Is Gonna Come':

> that was you
> daddy born by a river
> in a little tent and i swear
> you been running
> running ever since[68]

Here, then, Hammad displays the ability to connect experiences of ethnic and political disenfranchisement across cultures and communities, while conjuring the diasporic landscape as a palimpsest of spaces, times and experiences that come to be layered upon one another. As such, Hammad's work constructs an interplay between personal and communal narratives of identity and belonging.

The construct of the family therefore proves integral to both Nye's and Hammad's personal relationships to diasporic space. While families transmit burdens of trauma and loss, though, they also become the medium through which both poets construct affirmative and connective relationships with Palestine. Significantly, these connective potentials appear particularly through the figures of resilient and maternal Palestinian women in their poetry. In Hammad's poem 'mama sweet baklava', for example, the 'sticky', 'sweet', 'layered' Middle Eastern delicacy baklava comes to represent not only a link to Hammad's Palestinian heritage, as it is a 'recipe old and passed / down through word / of hand creating and sustaining', but it also evokes woman herself as the bearer of Palestinian identity, her 'backbone strong foundation / layers thousand layers / [. . .] pressed / into steel children marriage / nation woman'.[69] Woman, in this poem, is the bearer of history and nation, yet rather than functioning simply as a cipher or symbol, she is also a figure who is complex and 'layered'—just as the rhythmic, stream-of-consciousness movement of Hammad's lines invoke her own 'layered' connection to Palestine, her style conjuring the lilts and leaps of jazz as much as it does the fragrance and intimacy of a Palestinian kitchen.[70] In Nye's poem 'My Grandmother in

the Stars', meanwhile, her relationship with her grandmother also conjures her simultaneous closeness to and distance from Palestine, as she describes how they sit together, 'our two languages adrift, / heart saying, Take this home with you'.[71] In 'The Words under the Words', her grandmother is also a vessel of memory, place and wisdom,[72] while in 'Voices', she describes how she experiences her grandmother's dispossession from her land 'like a debt', which makes her 'want to walk among silent women / scattering light'.[73] Her grandmother's trauma therefore lives on in Nye, but assumes a regenerative potential, her poetry the 'light' that she scatters: a means, perhaps, to give voice to Palestinian women's silenced histories.

Imaginative identification with maternal female figures therefore enables both Nye and Hammad to construct a sense of connection to Palestine. Yet this connection is not simply nostalgic; it is also the basis of a powerful ethical commitment to justice, equality and freedom for those within and beyond Palestine, which often takes the form of anti-colonial sentiment. Here, we find echoes of Chandra Talpade Mohanty's subversive feminist theorisation of diasporic space as a landscape in which the movement of people deconstructs spatial and ideological distinctions between 'East' and 'West', 'North' and 'South'. Through the relocation of 'Third World' women into the 'First World', Mohanty suggests that they carry with them an insurgent political opposition to conditions of exploitation, imperialism and neo-colonialism. Thus, diaspora creates 'imagined communities of women with divergent histories and social locations, woven together by the *political* threads of opposition to forms of domination that are not only pervasive but also systemic'.[74] These 'threads of opposition' emerge in many of Hammad's and Nye's poems, where the intersecting structures of Israeli colonialism and U.S. imperial domination are placed under scrutiny and actively resisted, often through specifically feminocentric communities. In Hammad's poem 'rice haikus', for example, we hear the imagined voices of Palestinian women who have given food to resistance fighters describing how the occupying forces have punished them by ruining their food supplies, pouring sugar into their rice. Now, though, it is the women themselves who engage in their own oppositional activity, by 'eat[ing] sweet rice . . . / meals of resistance'.[75] In 'blood stitched time', meanwhile, the voice of a mother, perhaps the embodiment of Palestine itself, declares herself 'no longer willing to sacrifice sons / to wars of men and / gods of war [. . .] / to sons gone crazy'.[76] Here, cycles of violence are portrayed as inherently masculinist, and while women are often the victims of such cycles, they may also be the ones imbued with the power to break them.

A strong sense of feminist pacifism also emerges in Hammad's poem 'What I Will': a work that can be read as an expression of opposition to the U.S.'s many forms of imperialist intervention in the Middle East. In this poem, Hammad engages in playful linguistic dances around the motif of the 'war drum', which morphs into a metaphorical representation of a 'drummed

up war' to which all citizens of the U.S. are supposed to 'dance', a likely reference to the rhetoric of the 'war on terror' and subsequent invasions of Iraq and Afghanistan which were contemporaneous to the writing of this poem. Yet Hammad refuses to 'dance to your / beating' because, the poem reveals, she identifies intimately with 'that skin / you are hitting . . . / alive once / hunted stolen / stretched'.[77] Through this extended metaphor, Hammad displays an array of anti-imperialist sentiments. By not only standing in solidarity but also identifying with the victimised populations of the Middle East, Hammad draws attention to the long history of imperialistic intervention in the region, evident in the potently colonial image of the drum-skin as a 'spoil of war' or hunting trophy. Hammad's opposition to the war also implicitly challenges the paternalistic rhetoric employed by the U.S. government in the run-up to the invasions of Iraq and Afghanistan, through which the invasion was presented as an opportunity to 'rescue' Afghan women from Taliban oppression:[78] an eerie reincarnation of the 'colonial rescue fantasy'.[79] By allying herself with the ethnic and gendered 'other' in this poem, Hammad projects a powerfully postcolonial feminist voice, with which she vows to construct a community of her own founded not in a masculinist logic of destruction but in a generative (arguably maternal) faith in creativity. In 'What I Will', Hammad states that she will 'gather my beloved / near and our chanting will be dancing. Our / humming will be drumming'. This, Hammad suggests, is a music that stands in strident opposition to the 'lifeless' beat of the 'war drum', because it is founded in a deep-seated belief in life, affirmation and collective ethical responsibility that amounts to the palpitations of love: a 'heartbeat . . . louder than death'. In this poem, the rich and varied cadences of her language, drawn from hip hop, the Brooklyn streets, from Arabic oral poetry and from her allegiances as a Palestinian, an American, a woman and a lover of peace, all harmonise in a way that is, to use Said's appropriately musical term, truly 'contrapuntal'. In this poem, then, Hammad's diasporic consciousness connects her to communities and vantage-points both within and outside of the U.S., enabling her to fulfil what Said views as the resistant potential of the exile: the ability to perform 'elucidating and critical tasks' through their 'cross-cultural and transnational visions'.[80]

Like Hammad, Nye also displays an anti-colonial sentiment founded heavily in pacifism. The feminist commitment underpinning this stance is subtler in Nye's case, however, and takes the form of a vocabulary of the domestic and 'feminine', which stands in opposition to the 'masculinist' rhetoric of colonialism, violence and warfare. While many of her earlier poems from the 1990s are concerned with possibilities of travel and connection, Nye's 2005 collection *You & Yours* addresses a more heavily divided and fragmented global landscape. The influence of U.S. imperialist policy in the Middle East forms an undeniable backdrop here, but Nye does not situate herself in straightforward antagonism with the U.S. Rather, she travels back and forth across subject-positions within this fraught global landscape in order to

invoke a variety of powerfully dissenting voices. In her poem 'He Said Eye-Rack', for example, the anonymity of official military language employed by, we assume, George Bush—'He said, "We are not dealing with peaceful men." [. . .] He said, "reckless aggression"'—is rendered absurd by its juxtaposition with the language of the vital and quotidian: 'Tell that to . . . the bride, / . . . the peanut-seller, / the librarian careful with her shelves . . . / the ants tunnelling through the dirt'.[81] Here, Nye employs an arguably feminised language of 'smallness' which, Samina Najmi argues, subverts the 'binary gendering patterns that cast emotional realities as feminine and reason as masculine', by revealing that '*not* focusing on the small, the particular, and the concrete results in forfeiting rational thought processes'; thus, she 'makes visible what the gendered discourse of war conceals'.[82] This is the irrational, unthinking cruelty of war and destruction, epitomised by the cultural ignorance and hostility evident in the sinister dismembering of 'Iraq' into what sounds like an instrument of torture on George Bush's tongue: 'EYE-RACK'.

Like Hammad, then, Nye's own personal connection to, and experience of, Middle Eastern culture demands that she intervene in the dehumanising discourse of violence, and this desire to resist through the humanisation and individualisation of the 'other' emerges strongly in several poems which memorialise Palestinian children who have died through the violence of the occupation. All of these poems reveal the colossal scale of injustice for Palestinians through their focus on 'smallness': the 'small' life of a child, once with 'secret happy hopes . . . singing . . . with eyes closed / under the bridge', killed by a 'stray' bullet, as in 'For Mohammed Zeid of Gaza, Age 15';[83] or the 'small' 'kidneys . . . liver . . . heart' of Ahmed Ismail Khatib which, donated to an Israeli boy, remind Nye that 'we must—simply must—be bigger too'.[84] While Nye's focus on the loss of young life invokes an obvious sense of humanitarian and ethical outrage, it also perhaps suggests an implicitly maternal dimension. Writing from a diasporic location, Nye's focus here may also enable her to establish wider bonds of subversive maternal connection beyond the victimised Palestinian community itself.

Hammad's similar commitment to cross-cultural ethical solidarity assumes an altogether more visceral feminist dimension in her poem 'of woman torn'. This poem presents a harrowing account of an 'honour killing', but within it, Hammad not only condemns the violently patriarchal ethos of this social phenomenon but seeks to honour and connect with its victims. In this poem, Hammad's voice resonates with a sisterly intimacy as she shows how female bodies, desires and rights may be constructed as illicit and subversive within the patriarchal system. Drawing upon the imagery of resistance and combat, she writes of how, for 'palestine's daughter love / making can be as dangerous / as curfews broken / guerrillas hidden'.[85] Here, Hammad conjures an analogy between the abuses of the occupation and the violence of patriarchal power: just as Palestine is dispossessed of its own self-determination, so is the woman dispossessed of her own body. In its critique of patriarchal 'honour/

shame' codes, though, this poem also displays a willingness to condemn structures of oppression and violence wherever they may occur, including within the Palestinian community itself. Here, then, Hammad displays an ethical commitment to the view that women's rights are ultimately human rights and must be defended across all cultural boundaries: a task in which her own transnational location may be of assistance. In the final lines of the poem, Hammad evokes a deeply connective love that may be founded in feminocentricity, but that is ultimately committed to wider qualities of justice and equality: 'this is a love poem / cause i love / you now woman [. . .] / under my skin / i carry your bones'.[86] Hammad therefore stands in solidarity with this woman as a Palestinian, a woman and a supporter of human rights, and she reveals that ethical solidarities construct communities every bit as intimate as those based around more traditional notions of geographical belonging. While her commitments in this poem appear specifically feminist, they are also inherently postcolonial since they can be seen to enact what Robert J.C. Young terms the 'radical agenda' of postcolonial studies,

> to shift the dominant ways in which the relations between western and non-western people and their worlds are viewed [and hence . . . to disturb] the order of the world . . . [to] threaten privilege and power [. . .] to demand equality and well-being for all human beings on this earth.[87]

Lyrical as Nye's and Hammad's poems may be, they also constitute powerful demands for equality and well-being through their own renegotiation of the relationships between West and non-West, and through the 'disruptions to the order of the world' performed through their diasporic locations and imaginations.

Both Nye and Hammad therefore mobilise their positions as diasporic Palestinian women as a means to engage in the task of what Edward Said termed 'speaking truth to power':[88] something perceived by Said to be an obligation of the exilic author. The forms of 'truth' and 'power' voiced by these poets are multiple rather than singular, though, and stem from a number of different geographical, cultural, political, ideological and gendered subject-positions. Consequently, these poets seem to affirm Avtar Brah's theorisation of diaspora space as 'embedded within a multi-axial understanding of power; one that problematizes the notion of "minority/majority" [. . . and] signals . . . *multi-locationality across geographical, cultural and psychic boundaries*'.[89] Similarly, both Nye and Hammad traverse 'geographical, cultural and psychic boundaries' in their work, revealing the multiple axes of power, privilege and disenfranchisement that circulate within and across diasporic space. In doing so, they reveal a distinctive vision of the postcolonial feminist potentials embedded within diasporic space, whereby gender-conscious, feminist and postcolonial commitments are contained within their broader ethical and creative concerns with justice, equality, dignity and self-representation.

Perhaps the most powerful element of Nye's and Hammad's poetry, though, remains its mobilisation of transnational commitments to ethics and creativity *within* the diasporic landscape of the contemporary U.S. In doing so, they arguably enact what Brah reads as the radical potential of diasporic space to destabilise the 'boundaries of inclusion and exclusion, of belonging and otherness, "us" and "them"' in a way that 'seriously problematizes the subject-position of the native'.[90] By situating themselves in carefully considered positions of simultaneous tension and solidarity with different aspects of the U.S. landscape, their work encourages its readers, whether Palestinian or American, male or female, to reflect carefully on where *they* stand, as individuals and as members of a community, and to consider what kind of world they wish to live in. In Nye's prose-poem or flash-fiction piece, 'Gate 4-A', we catch a glimpse of what this kind of self-reflexive world might look like. Writing of her encounter with an elderly Palestinian woman at the Albuquerque airport (an environment that has become synonymous with state surveillance, cultural antagonism and fear in a post-September 11th world), Nye unexpectedly finds 'the world I want to live in', as the woman offers 'a sack of home-made mamool cookies . . . to all the women at the gate' and finds that 'not a single woman declined one'. Looking around her, she notices, to her amazement, that 'not a single person . . . seemed apprehensive about any other person'.[91] In this poem, the act of reaching out across cultures and subject-positions, perhaps simply by connecting one hand to another, overcomes distance and difference, fear and unknowing. In this instant, each and every 'lost and weary traveller' becomes connected to this Palestinian woman, the member of a 'lost and weary' community of 'travellers' herself, and the diasporic landscape of travel and transition becomes one in which things are not only lost but also found, connections not only broken but made anew.

While both Nye and Hammad therefore remain connected to their heritage as Palestinians, the diasporic landscape also presents the possibility of forging many other communal connections based in variously postcolonial, feminist, ethical and creative solidarities. Fraught as the divisions and injustices permeating both U.S. and Palestinian landscapes may be, their work ultimately retains a faith in the potential for transnational connection. As Nye concludes in 'Gate 4-A': 'This can still happen anywhere. Not everything is lost'.

Expanding the Postcolonial Feminist Community

Over the course of this chapter, we have seen the variety of imaginative means by which female creative practitioners have begun to expand the parameters of the Palestinian postcolonial feminist community. While estranged from the physical space of historic Palestine itself, many diasporic filmmakers, artists and poets have nevertheless found creative means to forge

communal identities founded variously on Palestinian, gendered and ethical identifications that mobilise different forms of postcolonial feminist potential. In Masri's and Hatoum's filmic works, for example, we saw how the site of the female body itself might operate both as a textual surface that enables the female subject to testify to individual and collective trauma, and as a vehicle that enables them to reach out and 'touch' others across spatial and communal boundaries. The communities forged by Masri and Hatoum are highly feminocentric, yet women's bonds, bodies and identities are shown to inscribe a sense of national as well as gendered identity, through which they may formulate politicised senses of belonging that connect them directly to Palestine, and to one another. In Nye's and Hammad's poetry, meanwhile, feminist dynamics are implicit rather than explicit, but are nevertheless integral to the formulation of anti-colonial, ethical alliances with both U.S.-based and Palestinian communities. While diasporic space is far from utopian for either of these poets, given the sense in which it remains deeply connected to the loss of homeland experienced by the personal and national family, it nevertheless emerges as a space of creative interventionist possibilities within the contemporary landscapes of colonial, imperialist and patriarchal oppression that resonate within and between Palestine and the U.S.

Collectively, these works radiate a powerful postcolonial feminist potential. The enduring connections to Palestine constructed by those within the diaspora can be read as inherently postcolonial: not only does their refusal to renounce their Palestinian affiliations present an important form of solidarity with Palestine's political claims to self-determined national status, but it also displays a commitment to basic human rights and equality within the global landscape. This global landscape, though, remains tied to the politics of the human body, as well as to the body politic. Hence the diasporic landscape constructed within these works seems to emerge out of what Avtar Brah describes as a transnational feminist awareness of the 'politics of location'. Brah writes that

> feminist politics have constituted an important site where issues of home, location, displacement and dislocation have long been a subject of contention and debate. Out of these debates emerges the notion of a 'politics of location' as *locationality in contradiction*—that is, a positionality of dispersal; of simultaneous situatedness within gendered spaces of class, race and ethnicity, sexuality and age.[92]

Rather than privileging gender as the primary category of identification, then, the kind of transnational feminist awareness described by Brah maps out a more complex yet complete understanding of the different subject-positions, situations and spaces that both distinguish and connect women within the global landscape. All of the creative practitioners examined within this chapter display an awareness of their 'simultaneous situatedness' within

different, often contradictory locations, yet rather than this leading to a sense of fragmentation and political incoherence, their attentiveness to 'historical, geographical, cultural, psychic and imaginative boundaries' might also, according to Mohanty, provide 'the ground for political . . . self-definition'.[93] Through the maps of experience, identification and creativity demarcated by the women in this chapter, then, we see how neither postcolonial nor feminist allegiances can be extricated from, nor privileged over, one another. Instead, they appear as absolutely integral to one another's existence.

Perhaps the most radical feature of the postcolonial feminist communities that emerge in this chapter, though, is their potential to operate at a transnational level, and to construct forms of solidarity and identification with Palestine that extend beyond the boundaries of national or ethnic identity. As Hammad and Nye demonstrate, their positions within and between U.S. and Middle Eastern cultures enable them to project dissenting voices within the imperialist landscape of the U.S. itself, while destabilising the very structures of cultural 'otherness' on which imperialist intervention in the Middle East is premised. While Palestinian diasporic experience remains inexorably tied to the space of the homeland, these creative practitioners demonstrate that the ethical, emotional and personal debates inspired by their work possess a transnational potential that may generate new networks and connections beyond the Palestinian body politic: a task of vital importance in the increasingly fraught landscape of cultural dialogue between the 'West' and 'Middle East'. In Hammad's poem 'some of my best friends', this transnational connectivity finds particularly potent expression as a celebration of those who transcend cultural, religious and national differences in order to stand together for peace, for equality, and for Palestine:

> our solidarity
> angers others who would always rather war [. . .]
> [but] love is larger than our details
> these are my people
> and we are chosen
> family eating darkness
> hiccupping light
> little by little by light by little by light together[94]

The community with which Hammad connects here is at once Palestinian and transnational, at once political and inspired by a raw commitment to humanity—and in its desire for equality between and rights for all human beings, alongside its respect for cultural identity, it is also, of course, postcolonial feminist.

Conclusion
Postcolonial Feminist Futures

A country on the verge of dawn . . .
In a little while, we will bid this long road farewell
and ask: Where do we begin?
- Mahmoud Darwish, 'A State of Siege'[1]

In his classic work of anti-colonialism, *The Wretched of the Earth*, Frantz Fanon describes the traumatic silencing of historical and cultural narratives that takes place at the hands of the colonial power: 'Colonialism is not satisfied merely with holding a people in its grip', he writes; 'it [also] turns to the past of the oppressed people, and distorts, disfigures and destroys it'.[2] Many journeys towards postcoloniality have therefore involved turning to the past as a source of cultural memory, historical identity and political legitimacy, and the Palestinian anti-colonial struggle has been no exception. It, too, has often turned to narratives that recover moments of colonial and communal trauma such as the *Nakba* of 1948, or that describe a historical rootedness in the 'motherland'; that commemorate the sacrifices of martyrs for the struggle, or that celebrate and affirm traditional forms of resistance such as *sumud*. Yet as Laleh Khalili observes, central as narratives of the past may be to Palestinian consciousness, 'none of [the] icons [of nationalism] are stable, historically unchanging or uncontested. National(ist) narratives—and the crucial symbols at their core—are challenged from within and without'.[3] This book has explored one particular set of 'challenges' posed to traditional nationalist narratives of Palestinian historical and cultural identity: those of the 'postcolonial feminist perspectives' mobilised by creative practitioners and theorists both 'within and without' Palestine, to use Khalili's phrase. These postcolonial feminist perspectives have destabilised, contested and reformulated the representation of Palestine through their simultaneous awareness of colonial and gendered power structures. In doing so, they have revealed a crucial shift in the directions in which Palestinian creative consciousness is moving, for a postcolonial *feminist* perspective looks not only to the past, but also to the future, and imagines how the integrity, equality and liberation of both the 'body politic' *and* the politics of the body might be realised in a postcolonial Palestine. The narrative journey promised to you at the outset of this book, then—through that fraught territory of the postcolonial feminist imagination—leads us, finally, to the crossroads described by Darwish in the

epigraph to this conclusion: a point at which Palestinian creative practitioners no longer simply ask themselves, 'where have we been', but 'where do we begin'? What, in other words, are the future directions for Palestinian self-representation and its study that have been revealed through these postcolonial feminist perspectives?

Over the course of the preceding chapters, we have seen many different directions in postcolonial feminist enquiry opening up within the literary and filmic landscape. A number of authors and filmmakers have revealed how constructs of sexed, gendered and sexual power are deeply embedded in representations of nationhood, which in themselves respond to gendered and sexualised narratives of colonial power—but exploring this 'gendering' of nationhood also reveals the extraordinary willingness of some Palestinian creative practitioners such as Khleifi and Darwish to scrutinise and interrogate these gender paradigms in ways that reimagine the national image. The complex and at times troubled interplay between feminist and nationalist commitments in the creative imagination also presents a significant direction in postcolonial feminist enquiry, as it reveals the multiple forms of personal and political, national and gendered identification that surface within the Palestinian struggle, and suggests the plurality rather than singularity of the 'national resistance narrative'. Postcolonial feminist enquiry also directs us towards scrutiny of those oft-unquestioned discourses of patriarchy and masculinity. A performative understanding of these discourses reveals the intersecting crises in national and gendered identification brought about by colonial power—yet creative explorations of these crises reveal highly self-aware, self-reflexive and subversive reformulations of gendered and national agency taking place in the visions of filmmakers such as Suleiman and Abu-Assad, and of writers such as El-Youssef. These works direct us towards a new understanding of what it might mean 'to be a man' in Palestinian society.

The creative attention directed towards the site of the border in the Palestinian imagination has also indicated how colonial and patriarchal power may be enacted through space in ways that inscribe boundaries upon the gendered Palestinian body, as in narratives of the 'checkpoint heroine'; but the forms of crisis and destabilisation produced at these boundaries have also presented possibilities of liminality and dis-identification that prove variously liberating (as in Tawfik Abu Wael's *'Atash*) and oppressive (as in Annemarie Jacir's *like twenty impossibles*). A postcolonial feminist perspective also proves illuminating when directed towards the gazes of diasporic Palestinian authors and filmmakers, who demonstrate how vital bonds of transnational feminist community and solidarity may be forged through a variety of gender-conscious, transnational, postcolonial and ethical identifications imagined through creative mediums. The images of transnational feminist community revealed by these works present expansive future possibilities for cross-cultural postcolonial feminist enquiry. Each of the creative works examined over the course of the preceding chapters therefore realises a form

of postcolonial feminist potential that is unique and specific to the imagination of its author or filmmaker, but taken collectively, they reveal a significant consciousness of gender inflecting their understanding of the politics of (post)coloniality, and identify a distinctive tendency towards self-scrutiny and self-reflexivity at the heart of Palestinian creative consciousness. Above all, then, the postcolonial feminist perspectives examined over the course of this book present Palestinian creative expression as a space of *polyphony*, in which multiple voices and perspectives are able to circulate.

The rich polyphony that emerges from these postcolonial feminist perspectives serves many important functions. Firstly, it reveals that the national narrative is not singular but plural, and composed of many different experiences and perspectives of both a political and personal nature. While these may, at times, compete with or even contradict one another, they collectively comprise a discursive territory in which, to use Bakhtin's description, 'a plurality of independent and unmerged voices and consciousnesses, a genuine polyphony of fully valid voices'[4] converge. By presenting a powerful discursive alternative to the reductive, binarised and exclusionary politics of both colonial and patriarchal discourses, this polyphony therefore establishes a postcolonial feminist commitment to equality, authority and multiplicity of voice at the very heart of Palestinian creative consciousness. It suggests that the task of imagining a liberated, just and equal Palestine must necessarily entail attention to the multiple sites of inequality, oppression and power within the nation itself, thus revealing the importance of postcolonialism and feminism working hand in hand. As well as revealing the multiplicity of the Palestinian narrative, though, this polyphony also establishes space for divergent perspectives on and approaches to questions of Palestinian identity and politics: a move that might prove liberating not only to Palestinian creative practitioners, but also to scholars.

In the introduction to this book, I gestured towards some of the 'roadblocks' that have traditionally hampered scholars' abilities to address questions of Palestinian self-representation, political identity and (post)colonial status. Those 'roadblocks' include benign but often negotiable limitations such as those surrounding questions of language and translation, which may limit the disciplines in which Palestinian literature and film are traditionally taught. They also, however, include altogether more malignant limits imposed by the Manichean and antagonistic discourse that has sometimes surfaced against academics whose work is open to the various perspectives and voices of Palestinians.[5] Although there are now a number of academic arenas that seek to generate serious, nuanced and diverse discussion of issues relating to Palestine,[6] the threat of this kind of very public opposition to the exercise of academic freedom is no doubt one of the reasons that attention to Palestinian creative expression and cultural discourse has remained confined to a select number of disciplines, such as Middle Eastern studies and international relations: disciplines accustomed to tackling

the dense political issues generated by these oppositional discourses. One of the aims of this book, however, has been to identify alternative routes into the discussion of Palestinian culture and self-representation that might enable scholars to move beyond the reductive political polemics that have so often limited debate on Palestine, and to appreciate instead the richness, complexity and diversity of cultural identity and expression that is to be found within Palestinian narratives themselves. This book has attempted to bring this richness to the fore by re-narrating Palestinian cultural expression in a way that reveals its complex relevance to a number of critical approaches and disciplines including comparative literary and postcolonial studies, cultural studies and gender studies. The polyphonic perspectives established by the creative practitioners over the course of this work therefore open up numerous entry-points into Palestinian cultural expression and invite interdisciplinary investigation. This kind of interdisciplinary and ultimately transnational attention to Palestinian culture might begin to create a discursive territory that is connective rather than restrictive, and that reflects more accurately the commitments of the Palestinian authors and filmmakers examined in this study to political, personal and creative freedoms alike. So, too, may it begin to establish forms of dialogue with Palestinian scholars, creative practitioners and individuals that move beyond a conflict-driven narrative, and that circulate instead around that most connective and, ultimately, most human(e) of mediums: creativity.

While the postcolonial feminist perspectives examined in this book point towards exciting future opportunities for interdisciplinary and intercultural dialogue, they also, however, invite us to reflect critically upon the nature and remit of the 'postcolonial feminist' itself. As I explored in the introduction to this work, postcolonial discourse has been somewhat reticent when it comes to the discussion of Palestine for reasons that are both institutional and conceptual in nature. Discouraged by the ambivalence of its (post)colonial status and its resistance to core postcolonial paradigms such as 'hybridity', as well as its somewhat unfashionable adherence to discourses of nationalism and nationhood, postcolonial attention to Palestine has tended to remain largely focused on Said's distinctive contribution to the field. While Said's work remains extremely important to the postcolonial study of Palestine, the postcolonial feminist analyses performed in each of the preceding chapters also suggest that the remit of postcolonial attention to Palestine can be considerably expanded beyond a Saidian approach to incorporate concepts and theories drawn from many other facets of postcolonial and feminist studies—from Fanonian theory to 'border-theory', and from theories of diasporic embodiment to those of gender performativity. Expanding the remit of postcolonial attention to Palestine in this way performs a vital function, as it reveals the pressing relevance of Palestine to many sites of concern within the contemporary postcolonial agenda, while also inviting postcolonialists to reassess the very nature of that agenda, not least by recognising the sites of

colonial oppression that endure within what many see as a primarily *post*colonial global landscape.

Just as these theories tell us much about the complex colonial and gendered power dynamics embedded within Palestinian self-representation, so does their application to the Palestinian context also challenge and nuance our understanding of those theories themselves. While Palestinian authors and filmmakers engage in highly creative and imaginative explorations of their interior worlds, the material pressures of the exterior world are never far from their thoughts. This constant awareness of the material effects of colonial power upon the embodied individual—effects such as violence, hunger, thirst, cold, suffering, uncertainty, insecurity, humiliation, even death—acts as a stark reminder to the postcolonial feminist theorist that acts of representation, while creative, also stem from locations in reality that must not be elided through critical obscurantism or total abstraction. Palestinian creative representation remains, to use Said's phrase, inextricably tied to a 'worldliness' that asks the academic to remember that 'the realities of power and authority—as well as the resistances offered by men, women and social movements to institutions, authorities, and orthodoxies—are the realities that make texts possible, that deliver them to their readers, that solicit the attention of critics'.[7] This 'worldliness' presents something of a challenge to highly deconstructivist and poststructuralist strands of postcolonial feminist theory that are keen to celebrate the demise of boundaries, whether of the self or of the nation; for these entities, restrictive as they may be, nevertheless remain the conditions of political agency and self-representation for many Palestinians.

The Palestinian context therefore invites postcolonial feminist theory to 'ground' itself in relation to the specific manifestations of power and identification that appear within the colonial and gendered landscape. While this 'grounding' does not have to entail statements of political allegiance, it may nevertheless reenergise the political potentials that have always been embedded in postcolonial feminist studies by inviting the scholar to engage in precisely the forms of careful contextualisation that might, according to Shohat, produce a 'flexible yet critical usage [of 'the postcolonial'] that can [not only identify] historical and geographical contradictions and differences, but also [reaffirm] historical and geographical links, structural analogies, and openings for agency and resistance'.[8] Working with postcolonial feminist theory in the context of Palestine, then, alerts the scholar to the ways in which the form and meaning of the 'postcolonial feminist' alters according to its cultural, temporal and geographical location—but despite the divergences and differences that may appear en route, important forms of solidarity and alliance might also come into focus.

During the summer of 2011, precisely this form of 'grounded' postcolonial feminist solidarity appeared in the form of a delegation of eleven 'indigenous and women of colour feminists'[9] who travelled to Palestine in order to observe the effects of the occupation for themselves. This delegation

included high-profile activists, academics and creative practitioners such as Chandra Talpade Mohanty, Angela Davis and Ayoka Chenzira, all with their own experiences of combating racial and gendered social injustice— whether in the U.S., or other contexts such as apartheid South Africa. The statement issued upon their return articulates the absolute necessity of a carefully located feminist awareness to their solidarity with the Palestinian anti-colonial struggle:

> As feminists, we deplore the Israeli practice of 'pink-washing,' the state's use of ostensible support for gender and sexual equality to dress-up its occupation. In Palestine, we consistently found evidence and analyses of a more substantive approach to an indivisible justice. We met the President and the leadership of the Arab Feminist Union and several other women's groups in Nablus who spoke about the role and struggles of Palestinian women on several fronts. We visited one of the oldest women's empowerment centres in Palestine, In'ash al-Usra, and learned about various income-generating cultural projects. We also spoke with Palestinian Queers for BDS [Boycott, Divestment, and Sanctions], young organizers who frame the struggle for gender and sexual justice as part and parcel of a comprehensive framework for self-determination and liberation. Feminist colleagues at Birzeit University, An-Najah University, and Mada al-Carmel spoke to us about the organic linkage of anti-colonial resistance with gender and sexual equality, as well as about the transformative role Palestinian institutions of higher education play in these struggles.[10]

The many expressions of commitment to 'an indivisible justice' identified by the delegation can be understood as postcolonial feminist in nature, for they too view the struggle for gender equality and anti-colonial resistance as 'organically' linked, and recognise that a liberated Palestine will only emerge when external opposition is combined with internal self-scrutiny. Yet the delegation also identifies the fraught power politics that surrounds acts of feminist solidarity, and reminds us of the importance of locating feminist aspirations in relation to the broader politics of (post)coloniality and indeed social injustice, both within and beyond Palestine. While the postcolonial feminist perspectives of Palestinian creative practitioners therefore enable us to scrutinise the complex dynamics of colonial and gendered power that circulate within the Palestinian landscape, they also alert us to the necessity of turning this postcolonial feminist gaze beyond Palestine itself, to the international landscapes through which representation of, antagonism towards and indeed support for Palestine are mediated. As the delegation of 'indigenous and women of colour feminists' demonstrated, a postcolonial feminist understanding of the power dynamics at stake within our own environment may ultimately enable us to forge more productive,

creative and nuanced forms of dialogue and alliance across geographical, cultural and discursive boundaries.

Palestine's journey towards self-determination has indeed been arduous and painful, and this book cannot foresee when that 'long road' will end. Yet the astonishing visions of the authors and filmmakers explored over the course of this work testify to the creative resilience with which the women and men of Palestine continue to seek new directions forward in this journey. While the postcolonial feminist perspectives that surface through Palestinian literature and film reveal the many intersecting injustices, inequalities and struggles that have marked Palestine's history so far, they also gesture towards the intensely creative possibilities that lie in Palestine's future, and invite us to consider how the paths of postcolonial, feminist and cultural enquiry might cross on Palestine's journey towards liberation.

Notes

Notes to the Introduction

1. Naomi Shihab Nye, 'The Words under the Words,' in *19 Varieties of Gazelle: Poems of the Middle East* (New York: HarperTempest, 2005), 15. Text copyright © 2002 Naomi Shihab Nye. Used by permission of HarperCollins Publishers.
2. I place the term 'Western' in inverted commas here in order to recognize its reductive homogenisation of various cultures and nations. This is of course paralleled in the term 'Middle East,' which is similarly problematic and indeed Eurocentric in its formulation of global geography (insofar as it is defined in relation to, and by, the 'West'). I use these terms, however, to indicate the powerful 'imagined geographies' of ideological and cultural identification that circulate around these broadly defined spaces.
3. See Edward Said, 'Permission to Narrate,' *Journal of Palestine Studies* 13, no. 3 (1984): 27–48. In this essay, Said discusses what he perceives as a general resistance, particularly within North America, to the publication of academic or journalistic writings that either seek to critique Israeli policies, or to express support for the Palestinian right to self-determination. See also the special edition of *Arab Studies Quarterly* 33, nos. 3–4 (2011), guest edited by Tareq Ismael on 'Academic Freedom, Ideological Boundaries, and the Teaching of the Middle East,' which presents a number of important discussions of some of the boundaries that scholars have encountered in their own teaching and research on Palestine.
4. Norman G. Finkelstein's book *Image and Reality of the Israel-Palestine Conflict* (London: Verso, 1995) sets out to challenge what the author reads as the many instances of Palestine's reductive representation at the hands of the media and indeed academics, including Israeli 'revisionist' historians.
5. In 'Culture and Resistance,' for example, Said describes Palestinians as an 'invisible' people. Edward Said, *Culture and Resistance: Conversations with Edward Said*, interviews by David Barsamian (Cambridge, MA: South End Press, 2003), 20–21. A number of other critics have also revealed the ways in which Palestinian narratives of experience and memory have been 'colonized' and 'silenced' by the dominant Israeli narrative. See for example Issam Nassar, 'Reflections on Writing the History of Palestinian Identity,' *Palestine-Israel Journal* 8, no. 1 (2001): 24–37.
6. Nurith Gertz and George Khleifi, *Palestinian Cinema: Landscape, Trauma, Memory* (Edinburgh: University of Edinburgh Press, 2008), 1–3.

7. In the late 1970s, Palestinian filmmakers began to collate an archive of work that would act as a form of collective memory and cultural consciousness for Palestinians: a 'people's cinema,' but it was lost almost in its entirety during the Israeli efforts to oust the PLO from Lebanon during the Siege of Beirut in 1982. The archive is the subject of a short experimental film made by Sarah Wood, entitled *For Cultural Purposes Only* (2009), which can be viewed online at www.animateprojects.org. Accessed 14th May 2012.
8. The Palestinian Festival of Literature, or 'PalFest,' currently runs on an annual basis in collaboration with a number of partner organisations in Palestine. See www.palfest.org. Accessed 14th May 2012.
9. Frantz Fanon, 'On National Culture,' in *Colonial Discourse and Post-colonial Theory: A Reader*, ed. Patrick Williams and Laura Chrisman (Harlow: Pearson Education Limited, 1994), 36–52.
10. See Mohammed Ayoob, *Middle East in World Politics* (Abingdon: Croom Helm, 1981), 83. Fanon's writings in *The Wretched of the Earth* regarding the necessity of armed struggle were particularly influential to the PLO. See Frantz Fanon, *The Wretched of the Earth*, trans. Constance Farrington (1961, in French; London: Penguin, 1969).
11. Patrick Williams, '"Outlines of a Better World": Rerouting Postcolonialism,' in *Rerouting the Postcolonial: New Directions for the New Millennium*, ed. Janet Wilson, Cristina Sandru and Sarah Lawson Welsh (Abingdon: Routledge, 2010), 91.
12. This is according to Kaylin Goldstein in 'Reading Palestine-Israel: On Coloniality and Other Paradigms,' *Middle East Report* 225 (2002): 50–52. This view seems to be supported in the work of scholars such as Basem L. Ra'ad in *Hidden Histories: Palestine and the Eastern Mediterranean* (London: Pluto, 2010).
13. Gershon Shafir provides a carefully nuanced exploration of the relationship between colonialism and Zionism in his work *Land, Labor and the Origins of the Israeli-Palestinian Conflict, 1882–1914* (Berkeley: University of California Press, 1996), xiii, in which he concludes that although Zionism differs from other colonial projects in some respects, there are nevertheless points of 'fundamental similarity' to models of 'settler colonialism' which make it appropriate to understand Zionism within this context. Ilan Pappé also notes these similarities to settler colonialism and provides an interesting overview of Israeli sociologists' use of the colonial paradigm in his article 'Zionism as Colonialism: A Comparative View of Diluted Colonialism in Asia and Africa,' *South Atlantic Quarterly* 107, no. 4 (2008): 611–633.
14. There are many historical accounts of the long and complex history of the region, many of which bear their own marks of political bias, and as such, it is advisable to read a selection of texts on the subject. Good starting points include Gudrun Krämer, *A History of Palestine: From the Ottoman Conquest to the Founding of the State of Israel*, trans. Graham Harmer and Gudrun Krämer (Princeton: Princeton University Press, 2008); Moshe Gil, *A History of Palestine, 634–1099*, trans. Ethel Broido (Cambridge: Cambridge University Press, 2002); Ra'ad, *Hidden Histories*; Ilan Pappé, *A History of Modern Palestine: One Land, Two Peoples* (Cambridge: Cambridge University Press, 2006).
15. In a series of documents known as the Husayn-McMahon Correspondence (1915–1916), British officials in Cairo offered their support to Arab officials in Palestine who wished to establish independence from Ottoman rule and

promised to help them to establish an independent Arab state, in the hope that this would destabilise the Ottoman Empire (which was allied to Germany, Britain's enemy during the First World War). Neither the Arab rebellion nor British promises materialised, however. They were actively undermined by the Sykes-Picot Agreement of 1916, in which the British and French outlined the forms of direct and indirect control to be exercised by each of them over the region, and in the Balfour Declaration of 1917, in which the British foreign secretary, Arthur Balfour, promised the Jews a national home in Palestine: moves in direct contravention of earlier promises for an Arab state. See Charles D. Smith, *Palestine and the Arab-Israeli Conflict: A History with Documents*, sixth edition (Boston: Bedford/St Martin's, 2007), 63–73.
16. Joseph Massad, 'The "Post-colonial" Colony: Time, Space, and Bodies in Palestine/Israel,' in *The Pre-occupation of Postcolonial Studies*, ed. Fawzia Afzal-Khan and Kalpana Seshadri-Crooks (Durham: Duke University Press, 2000), 313.
17. Ra'ad, *Hidden Histories*, 123.
18. Shafir, *Land, Labour and the Origins of the Israeli-Palestinian Conflict*, xiii.
19. These forms of stringent control and appropriation of resources are discussed in Eyal Weizman's fascinating study of the use of architecture by the Israeli state, *Hollow Land: Israel's Architecture of Occupation* (London: Verso, 2007).
20. See Derek Gregory, *The Colonial Present: Afghanistan, Palestine, Iraq* (Oxford: Blackwell, 2004) and Rashid Khalidi, *Resurrecting Empire: Western Footprints and America's Perilous Path in the Middle East* (London: I.B.Tauris, 2004).
21. Joseph Massad, 'The "Post-colonial" Colony,' 312.
22. Ra'ad, *Hidden Histories*, 10.
23. Ella Shohat, 'The "Postcolonial" in Translation: Reading Edward Said between English and Hebrew,' in *Taboo Memories, Diasporic Voices* (Durham: Duke University Press, 2006), 369.
24. See for example Ran Aaronsohn, 'Baron Rothschild and the Initial Stage of Jewish Settlement in Palestine (1882–1890),' *Journal of Historical Geography* 19, no. 2 (1993): 142–156.
25. Benita Parry, *Postcolonial Studies: A Materialist Critique* (London: Routledge, 2004), 81.
26. Shohat, 'The "Postcolonial" in Translation,' 369.
27. Nur Masalha, *The Politics of Denial: Israel and the Palestinian Refugee Problem* (London: Pluto Press, 2003), 26. Other accounts place this figure as higher. Subsequent waves of refugeeism and displacement have occurred at various points, including after 1967.
28. See Martin Gilbert, *Israel: A History* (London: Black Swan, 2008), 45–116, for a discussion of Jewish resistance to the British mandate.
29. See for example Gideon Shamoni's statement that 'whatever value inheres in postcolonial theory for comprehending the history of Zionism relates to explanation of its genesis as a nationalist movement emerging out of the emancipation and post-emancipation situation of the Jews,' in his essay 'Postcolonial Theory and the History of Zionism,' in *Postcolonial Theory and the Arab-Israel Conflict*, ed. Philip Carl Salzman and Donna Robinson Divine (Abingdon: Routledge, 2008), 192.
30. Massad, 'The "Post-colonial" Colony,' 312.
31. Massad, 'The "Post-colonial" Colony,' 312.

32. Donna Robinson Divine, 'Introduction,' in *Postcolonial Theory and the Arab-Israel Conflict*, 5.
33. Anna Bernard, 'Palestine and Postcolonial Studies,' unpublished paper, University of York (2010), accessed June 2011. http://www.sas.ac.uk/fileadmin/documents/postgraduate/Papers_London_Debates_2010/Bernard__Palestine_and_postcolonial_studies.pdf.
34. See particularly Divine, 'Introduction,' 5, 8.
35. Philip Carl Salzman, 'Arab Culture and Postcolonial Theory,' in Salzman and Divine, *Postcolonial Theory and the Arab-Israeli Conflict*, 165.
36. See Bernard, 'Palestine and Postcolonial Studies,' 3, 6.
37. Ella Shohat, 'Notes on the "Post-colonial",' in *Taboo Memories, Diasporic Voices*, 232–249.
38. Anne McClintock, 'The Angel of Progress: Pitfalls of the Term "Post-colonialism",' in Williams and Chrisman, *Colonial Discourse and Postcolonial Theory: A Reader*, 293.
39. Williams, 'Outlines of a Better World,' 93.
40. McClintock, 'The Angel of Progress,' 293.
41. Shohat, 'Notes on the "Post-colonial",' 247–248.
42. Shohat, 'Notes on the "Post-colonial",' 242.
43. Miriam Cooke, 'Feminist Transgressions in the Postcolonial Arab World,' *Critique: Critical Middle Eastern Studies* 8, no. 14 (1999): 93.
44. Lindsey Moore, *Arab, Muslim, Woman: Voice and Vision in Postcolonial Literature and Film* (London: Routledge, 2008), 2. See also Mona Fayad, 'Cartographies of Identity: Writing Maghribi Women and Postcolonial Subjects,' in *Beyond Colonialism and Nationalism in the Maghrib: History, Culture, and Politics*, ed. Ali Abdullatif Ahmida (New York: Palgrave, 2000), 85.
45. Reina Lewis and Sara Mills, 'Introduction,' in *Postcolonial Feminist Theory: A Reader*, ed. Reina Lewis and Sara Mills (Edinburgh: Edinburgh University Press, 2010), 1.
46. Lewis and Mills, 'Introduction,' 3.
47. Anastasia Valassopoulos, *Contemporary Arab Women Writers: Cultural Expression in Context* (Abingdon: Routledge, 2007), 20.
48. Audre Lorde, 'The Master's Tools Will Never Dismantle the Master's House,' in Lewis and Mills, *Feminist Postcolonial Theory: A Reader*, 25–28.
49. Margot Badran and Miriam Cooke, 'Introduction,' in *Opening the Gates: A Century of Arab Feminist Writing*, ed. Margot Badran and Miriam Cooke (London: Virago, 1992), xvii.
50. See Therese Saliba and Jeanne Kattan, 'Palestinian Women and the Politics of Reception,' in *Going Global: The Transnational Reception of Third World Women Writers*, ed. Amal Amireh and Lisa Suhair Majaj (New York: Garland Publishing, 2000), 86.
51. Rita Giacaman, 'Palestinian Women, the *Intifada* and the State of Independence: An Interview,' *Race and Class* 34 (1993): 37.
52. Giacaman, 'Palestinian Women, the *Intifada* and the State of Independence,' 35.
53. Chandra Talpade Mohanty, 'Under Western Eyes: Feminist Scholarship and Colonial Discourses,' *Feminist Review* 30, no. 30 (1988): 61–88.
54. Valassopoulos, *Contemporary Arab Women Writers*, 30.

55. François Lionnet provides an interesting discussion of the limits of 'cultural relativism' in relation to feminism. See Françoise Lionnet, *Postcolonial Representations: Women, Literature, Identity* (Ithaca: Cornell University Press, 1995), 2.
56. Edward Said, 'Travelling Theory,' in *The World, The Text, and the Critic* (Cambridge, MA: Harvard University Press, 1983), 230.
57. See for example Miriam Cooke, *Women Claim Islam: Creating Islamic Feminism through Literature* (New York: Routledge, 2000); Evelyne Accad, *Sexuality and War: Literary Masks of the Middle East* (New York: New York University Press, 1990); Fedwa Malti-Douglas, *Men, Women and Gods: Nawal El Saadawi and Arab Feminist Poetics* (Berkeley: University of California Press, 1995); Leila Ahmed, *Women and Gender in Islam: Historical Roots of a Modern Debate* (New Haven, CT: Yale University Press, 1992); Fatima Mernissi, *The Veil and the Male Elite: A Feminist Interpretation of Women's Rights in Islam* (New York: Perseus Books, 1992).
58. Lisa Suhair Majaj, Paula W. Sunderman and Therese Saliba, eds., *Intersections: Gender, Nation, and Community in Arab Women's Novels* (New York: Syracuse University Press, 2002); Valassopoulos, *Contemporary Arab Women Writers*; Moore, *Arab, Muslim, Woman*.
59. It is important to note that there are a number of different ways in which the terms 'Palestine' and 'Palestinian' might be understood. The term 'Palestine' (particularly when used in the phrase 'historic Palestine') generally refers to the pre-partition territory that today comprises Israel, the West Bank and Gaza. It may, however, also refer to the concept of a future Palestinian state, or to the current 'Palestinian Territories,' the West Bank and Gaza. The term 'Palestinian' can be used as a marker of identity for those who live within any part of historic Palestine, but it also refers to the substantial population of refugees and members of the Palestinian diaspora who live outside of Palestine, with family origins in historic Palestine. Thus a film directed by someone of Palestinian origin, even if made outside of historic Palestine with foreign funding, can be identified as 'Palestinian': the term is not wholly reliant on geographical location.
60. *Al-Nakba*, or simply the *Nakba* as it is commonly referred to in English, translates from Arabic as 'the catastrophe' and refers to the foundation of the State of Israel in 1948: an event that was perceived as a catastrophic dispossession of land, identity, security and dignity for Palestinians, and created over 750,000 Palestinian refugees. See Nur Masalha, *The Palestinian Nakba: Decolonising History, Narrating the Subaltern, Reclaiming Memory* (London: Zed Books, 2012).
61. The term *Intifada* means, literally, 'shaking off' but is usually translated as 'uprising.' It refers to the two sustained periods of resistance to occupation: the first *Intifada*, from 1987 to 1993, and the second (sometimes termed the al-Aqsa) *Intifada*, which began in 2000 and ended in around 2005 or 2006 (the exact date is disputed). See Smith, *Palestine and the Arab-Israeli Conflict*, 563. See also Laetitia Bucaille, *Growing Up Palestinian: Israeli Occupation and the Intifada Generation*, trans. Anthony Roberts (Princeton: Princeton University Press, 2004).
62. I readily acknowledge that my comparative approach to Palestinian literature in particular does not bear the same level of historical knowledge of either field as would be brought to it by scholars of Arabic literature. For scholars and students in a similar position to myself who wish to learn more about the history of Arabic literature, an excellent introductory work is Roger Allen's *An Introduction to Arabic Literature* (Cambridge: Cambridge University Press, 2000).

63. Waïl S. Hassan and Rebecca Saunders, 'Introduction to Special Edition on Comparative (Post)Colonialisms,' *Comparative Studies of South Asia, Africa and the Middle East* 23, no. 1 (2003): 20.
64. See Bernard, 'Palestine and Postcolonial Studies,' 6, in which she discusses some of the critiques of comparative literary studies put forward by Spivak and Huggan, and offers her own solutions to the problems that they outline.
65. Waïl S. Hassan, 'Postcolonial Theory and Modern Arabic Literature: Horizons of Application,' *Journal of Arabic Literature* 33, no. 1 (2002): 60.
66. See for example Rashid Khalidi, *The Iron Cage: The Palestinian Struggle for Statehood* (Oxford: Oneworld, 2007); Hisham Sharabi, *Embers and Ashes: Memoirs of an Arab Intellectual* (New York: Interlink, 2007); Faisal Darraj, 'Transformations in Palestinian Literature,' trans. Michael K. Scott, in *Words without Borders* (November 2006), accessed 20th December 2011. http://wordswithoutborders.org/issue/november-2006.
67. Salma Khadra Jayyusi, ed., *Anthology of Modern Palestinian Literature* (New York: Columbia University Press, 1992). Due to the variety of texts included in this volume, I make frequent reference to it and it is therefore a useful companion volume to consult while reading this book. It is also important to note the specific sociopolitical context to this work, though, which arguably shapes the narrative of Palestinian culture presented by Jayyusi. See Salah D. Hassan, '*Modern Palestinian Literature* and the Politics of Appeasement,' *Social Text* 21, no.2 (2003): 7–23, in which Hassan argues that the anthology can be read as 'part of a broader agenda that sought to rehabilitate and domesticate the Palestinian cause . . . within the framework of the U.S.-sponsored peace process', 9. My discussion of extracts from this anthology may therefore be read as a reframing of this material within an alternative postcolonial feminist narrative that, to an extent, resists this 'domestication' of the Palestinian cause.
68. Nathalie Handal, ed., *The Poetry of Arab Women: A Contemporary Anthology* (New York: Interlink, 2001); Nur and Abdelwahab Elmessiri, eds., *A Land of Stone and Thyme: An Anthology of Palestinian Short Stories* (London: Quartet, 1996); A.M. Elmessiri, ed. and trans., *The Palestinian Wedding: A Bilingual Anthology of Contemporary Palestinian Resistance Poetry* (Washington, DC: Three Continents Press, 1982).
69. Hamid Dabashi, ed., *Dreams of a Nation: On Palestinian Cinema* (London: Verso, 2006); Gertz and Khleifi, *Palestinian Cinema*.
70. Kamal Abdel-Malek and David C. Jacobson, eds., *Israeli and Palestinian Identities in History and Literature* (Basingstoke: Palgrave Macmillan, 1999).
71. Ami Elad-Bouskila, *Modern Palestinian Literature and Culture* (London: Routledge, 1999).
72. Kamal Abdel-Malek, *The Rhetoric of Violence: Arab-Jewish Encounters in Contemporary Palestinian Literature and Film* (Basingstoke: Palgrave Macmillan, 2006).
73. Rebecca L. Stein and Ted Swedenburg, eds., *Palestine, Israel, and the Politics of Popular Culture* (Durham: Duke University Press, 2005).
74. Annemarie Jacir, '"For Cultural Purposes Only": Curating a Palestinian Film Festival,' in Dabashi, *Dreams of a Nation*, 29.
75. Fedwa Malti-Douglas, 'Dangerous Crossings: Gender and Criticism in Arabic Literary Studies,' in *Borderwork: Feminist Engagements in Comparative Literature*, ed. Margaret R. Higgonet (Ithaca: Cornell University Press, 1994), 229.

76. Adrienne Rich, 'Notes towards a Politics of Location,' in *Blood, Bread, and Poetry: Selected Prose 1979–1985* (New York: W.W. Norton and Company, 1986), 219.
77. Edward Said, with photographs by Jean Mohr, *After the Last Sky: Palestinian Lives* (New York: Pantheon Books, 1986), 166.
78. Nye, 'The Words Under the Words,' 15.

Notes to Chapter 1

1. This concept emerges in Edward Said, *Culture and Imperialism* (London: Vintage, 1994), xiii and Homi Bhabha, 'DissemiNation: Time, Narrative and the Margins of the Modern Nation,' in *The Location of Culture* (London: Routledge, 1994), in which he describes the nation as an 'ambivalent . . . narrative strategy,' 140. This concept also informs his edited collection of essays, *Nation and Narration* (London: Routledge, 1990). However, it is worth noting that the 'narrative' construction of hegemonic national, particularly imperialist identity finds even earlier expression in Said's *Orientalism* (1978; London: Penguin, 2003). This discourse is the subject of more extensive discussion within the chapter.
2. This insight has informed much feminist scholarship on nationhood, but key texts include Nira Yuval-Davis, *Gender and Nation* (London: Sage, 1997); Nira Yuval-Davis and Floya Anthias, *Woman-Nation-State* (London: Macmillan, 1989); and essays collected in Anne McClintock, Aamir Mufti and Ella Shohat, eds., *Dangerous Liasons: Gender, Nation, and Postcolonial Perspectives* (Minneapolis: University of Minnesota Press, 1998).
3. See Frances S. Hasso, 'Review of Rhoda Ann Kanaaneh's *Birthing the Nation: Strategies of Palestinian Women in Israel*,' *Gender and Society* 17, no. 3 (2003): 482.
4. Edward Said has described Palestine as a perennial 'question' 'for anyone writing and living in the West,' as any consideration of it is framed as a 'contest between an affirmation and a denial,' a 'presence and an interpretation' of claims to the territory. Said, *The Question of Palestine* (New York: Vintage, 1992), 8–9. In his recognition of Palestine as a 'question,' he also presents it, significantly, as a site of *discursive* as much as spatial contestation. Joseph Massad extends this motif of Palestine as 'question' in his important work, *The Persistence of the Palestinian Question: Essays on Zionism and the Palestinians* (Abingdon: Routledge, 2006).
5. Benedict Anderson, *Imagined Communities: Reflections on the Origins and Spread of Nationalism*, revised edition (London: Verso, 1991), 6.
6. Anderson, *Imagined Communities*, 6.
7. Said, *Culture and Imperialism*, xiii.
8. See the introduction to this book and Michael J. Cohen, *The Origins and Evolution of the Arab-Zionist Conflict* (Berkley: University of California Press, 1987) for some of the many accounts of the foundation of the State of Israel, and the Palestinian response.
9. Edward Said, *Humanism and Democratic Criticism* (New York: Columbia University Press, 2004), 48–49.
10. Said, *Orientalism*, 12.
11. Michel Foucault, 'Interview on the Prison: The Book and Its Method,' cited in Colin Gordon, 'Introduction,' in Michel Foucault, *Power: Essential Works of*

Michel Foucault 1954–1984, volume 3, ed. James D. Faubion, trans. Robert Hurley and others (London: Penguin, 2002), xvi.
12. Tom Nairn, *Faces of Nationalism: Janus Revisited* (London: Verso, 1997), 168.
13. The term 'ethno-nation' describes a nation without state status, but with a unified ethnic grouping. Katherine Verdery, 'Beyond the Nation in Eastern Europe,' *Social Text* 38 (1994): 4.
14. Though Said's *Orientalism* makes a number of references to the implicitly gendered and sexualised paradigms of the Orientalist imagination, it does not engage in substantial analysis of the significance of such tropes. As a result, it has generated a significant quantity of feminist scholarship scrutinising Orientalism from a gender-conscious standpoint, including Reina Lewis, *Gendering Orientalism: Race, Femininity and Representation* (London: Routledge, 1996) and Meyda Yegenoglu, *Colonial Fantasies: Towards a Feminist Reading of Orientalism* (Cambridge: Cambridge University Press, 1992). See also Lila Abu-Lughod, 'Orientalism and Middle East Feminist Studies,' *Feminist Studies* 27, no. 1 (2001): 101–113 for an assessment of the impact of Said's discourse within Middle Eastern feminism itself.
15. Anne McClintock, '"No Longer in a Future Heaven": Gender, Race, and Nationalism,' in McClintock, *Dangerous Liaisons*, 90.
16. Beth Baron, *Egypt as a Woman: Nationalism, Gender, and Politics* (Berkeley: University of California Press, 2005), 64.
17. Nira Yuval-Davis and Marcel Stoetzler, 'Imagined Boundaries and Borders: A Gendered Gaze,' *The European Journal of Women's Studies* 9, no. 3 (2002): 334.
18. Yuval-Davis, *Gender and Nation*, 47.
19. The term patriarchy means, literally, 'rule of the fathers.' There are many analyses of patriarchy, but within the context of this book, the term should be understood as a form of sexual asymmetry in which men are deemed to hold 'natural' authority within all spheres of society, from political institutions to the family, and are positioned as hierarchically superior in ways that are often understood as oppressive for women. For introductory accounts of patriarchy, see Gerda Lerner, *The Creation of Patriarchy: The History of Women's Subordination* (Oxford: Oxford Paperbacks, 1988) and Fedwa Malti-Douglas, *Encyclopedia of Sex and Gender* (Detroit: Macmillan, 2007); for a discussion of patriarchy within the Arab world, see Deniz Kandiyoti, 'Bargaining with Patriarchy,' *Gender and Society* 2, no. 3 (1988): 274–290.
20. Bhabha, 'DissemiNation,' 140.
21. Michel Khleifi, dir., *Wedding in Galilee* (Palestine/Belgium/France, 1987).
22. Raja Shehadeh, *Palestinian Walks: Notes on a Vanishing Landscape* (London: Profile Books, 2008), xii, xv.
23. The paradoxical term 'present absentee' emerged under the Absentee Property Laws passed by the Knesset in 1950, to describe those Palestinians who were absent from their properties within what came to be Israel during 1948 (due variously to their participation in fighting, their flight or their expulsion) and thus had their properties confiscated, but who nevertheless remained in the newly formed territory of Israel. See David Schechla, 'The Invisible People Come to Light: Israel's "Internally Displaced" and the "Unrecognized Villages",' *Journal of Palestine Studies* 31, no. 1 (2001): 21–22. The poet Mahmoud Darwish was a 'present absentee,' a condition on which he meditates in his work of prose/

poetry/autobiography, *Absent Presence*, trans. Mohammad Shaheen (London: Hesperus Press, 2010).
24. Ted Swedenburg, 'The Palestinian Peasant as National Signifier,' *Anthropological Quarterly* 63, no. 1 (1990): 19.
25. For further discussion of the ways in which the Zionist movement imagined the land as empty, see Uri Eisenzweig, 'An Imaginary Territory? The Problematic of Space in Zionist Discourse,' *Dialectical Anthropology* 5 (1981): 261–285.
26. Said, *Question of Palestine*, 17.
27. Golda Meir, *Sunday Times*, 15th June 1969.
28. Haim Gerber, 'Zionism, Orientalism, and the Palestinians,' *Journal of Palestine Studies* 33, no. 1 (2003): 23–41.
29. Anne McClintock, *Imperial Leather: Race, Gender and Sexuality in the Colonial Contest* (London: Routledge, 1995), 22–26.
30. Theodor Herzl, *Old-New-Land*, first edition (Minneapolis: Filiquarian Publishing LLC, 2007), 151, 57.
31. McClintock, *Imperial Leather*, 30.
32. Herzl describes Zionism as an attempt to 'transform the desert into a garden' in *The Jewish State* (Minneapolis: Filiquarian Publishing LLC, 2006), 28.
33. Massad, 'The "Post-colonial" Colony,' 332.
34. Said, *Question of Palestine*, 75.
35. Ella Shohat, 'Gender and Culture of Empire: Toward a Feminist Ethnography of the Cinema,' in *Otherness and the Media: The Ethnography of the Imagined and the Imaged*, ed. Hamid Naficy and Teshome H. Gabriel (Poststrasse, Switzerland: Harwood, 1993), 77.
36. Said, *Question of Palestine*, 81.
37. Said, *Question of Palestine*, 81–82.
38. Lewis, *Gendering Orientalism*.
39. Said, *Orientalism*, 207.
40. Said, *Orientalism*, 207.
41. Shohat, 'Gender and Culture of Empire,' 56–57.
42. Barbara McKean Parmenter, *Giving Voice to Stones: Place and Identity in Palestinian Literature* (Austin: University of Texas Press, 1994), 19.
43. Sigmund Freud, 'The Question of Lay Analysis, pt. 4,' in *The Complete Psychological Works of Sigmund Freud*, volume 20, ed. James Strachey (London: Vintage, 2001), 212.
44. Said, *Orientalism*, 188.
45. As David Newman puts it, Israel was envisaged as 'an exclusive territory in which the "Other" simply did not exist, or at the very least would be "allowed" to reside providing they accepted the rule of the majority.' David Newman, 'From National to Post-national Territorial Identities in Israel-Palestine,' *Geojournal* 53 (2001): 238.
46. Amos Oz, *My Michael*, trans. Nicholas de Lange (1968; London: Vintage, 1991), 202–203.
47. Oz, *My Michael*, 89.
48. Shohat, 'Gender and Culture of Empire,' 63.
49. Oz is often viewed as a left-leaning figure in his role as a prominent member of the Peace Now organisation, which defines itself as 'an Israeli pacifist organisation for Palestinian self-determination within 1967 borders.' See http://www.

peacenow.org.il/Site/en/homepage.asp for an outline of the organisation and its further aims. Accessed 16th May 2012.
50. Yosefa Loshitzky, *Identity Politics on the Israeli Screen* (Austin: University of Texas Press, 2001), 110.
51. All cited in Said, *Question of Palestine*, 79–81.
52. Said, *Question of Palestine*, 87.
53. Massad, 'The "Post-colonial" Colony,' 332.
54. Daniel Monterescu, 'The Bridled Bride of Palestine: Orientalism, Zionism, and the Troubled Urban Imagination,' *Identities: Global Studies in Culture and Power* 16 (2009): 646.
55. Parmenter, *Giving Voice to Stones*, 32.
56. Mahmoud Darwish, 'Identity Card,' in *The Music of Human Flesh*, trans. Denys Johnson-Davies (London: Heinemann, 1980), 10–11; stanzas 1, 3 and 6.
57. Said, *Question of Palestine*, 155. Darwish has come to be hailed as the most important Palestinian poet of his age, and while his early poetry bears many of the classic gendered traits of 'resistance poetry,' such as its characterisation of the land as a 'mother,' his later poetry moves beyond this symbolism into highly sophisticated meditations upon questions of loss, death, beauty, love and human relationships, which transcend the political sphere. Reference to his work also appears in Chapter 4 of this book. For an interesting comparative study of Darwish's poetry informed by postcolonial theorisations of 'home,' see Najat Rahman, *Literary Disinheritance: The Writing of Home in the Work of Mahmoud Darwish and Assia Djebar* (Lanham, MD: Lexington Books, 2008).
58. Darwish, 'Identity Card,' stanzas 3–4.
59. Susan Slymovics, 'The Gender of Transposed Space,' *Palestine-Israel Journal of Politics, Economics and Culture* 9, no. 4 (2002): 114.
60. Parmenter, *Giving Voice to Stones*, 19.
61. 'Abd al-Raheem Mahmoud, 'Call of the Motherland,' in Jayyusi, *Anthology of Modern Palestinian Literature*, 210–211.
62. Tawfiq Zayyad, 'A Million Suns in My Blood,' in Jayyusi, *Anthology of Modern Palestinian Literature*, 329.
63. Joseph Massad, 'Conceiving the Masculine: Gender and Palestinian Nationalism,' *Middle East Journal* 49, no. 3 (1995): 471.
64. Terms from 'Communiqué 5' of *The Unified National Leadership of the Uprising*, cited in Massad, 'Conceiving the Masculine,' 474.
65. 'Abdallah Radwan, 'You Are Everything,' in Jayyusi, *Anthology of Modern Palestinian Literature*, 264.
66. Tina Sherwell, 'Imaging the Homeland: Gender and Palestinian National Discourses,' in *After Orientalism: Critical Entanglements, Productive Looks*, ed. Inge E. Boer (New York: Rodopi, 2003), 133.
67. Jabra Ibrahim Jabra, 'In the Deserts of Exile,' in *An Anthology of Modern Arabic Poetry*, ed. and trans. Mounah Khouri and Hamid Algar (Berkeley: University of California Press, 1974), 225.
68. Slymovics, 'Gender of Transposed Space,' 113.
69. Swedenburg, 'The Palestinian Peasant as National Signifier,' 19, 26.
70. Sherwell, 'Imaging the Homeland,' 133.
71. Hanna Elias, dir., *The Olive Harvest* (Palestine, 2004).
72. Lina Khatib, *Filming the Modern Middle East: Politics in the Cinemas of Hollywood and the Arab World* (London: I.B.Tauris, 2006), 58.

73. Laila 'Allush, 'The Path of Affection,' in Jayyusi, *Anthology of Modern Palestinian Literature*, 106–107.
74. Hanan Mikhail Ashrawi, 'The Contemporary Palestinian Poetry of Occupation,' *Journal of Palestine Studies* 7, no. 3 (1978): 77–101.
75. 'Allush, 'The Path of Affection,' 106.
76. 'Allush, 'The Path of Affection,' 106–107.
77. Honour is a crucial element of Palestinian culture and has traditionally been defined according to the 'honour/shame' system, whereby men maintain honour for themselves by regulating women's behaviours and identities, thereby avoiding 'shame' being brought upon the family. While concepts of honour and shame circulate in both Muslim and Christian religious discourses, it is such a prevalent social discourse that even secular families may adhere to it. For a discussion of the complex circuits of gendered and sexual power that operate in relation to family honour, see Diane Baxter, 'Honour Thy Sister: Selfhood, Gender, and Agency in Palestinian Culture,' A*nthropological Quarterly* 80, no. 3 (2007): 737–775. For a more general discussion of honour and associated 'honour crimes' (whereby women are punished or killed in order to regain familial honour) in Arabo-Muslim culture, see Lama Abu-Odeh, 'Crimes of Honour and the Construction of Gender in Arab Societies,' in *Feminism and Islam: Legal and Literary Perspectives*, ed. Mai Yamani (Reading: Ithaca Press, 1996), 141–196.
78. Sheila Hannah Katz, '*Adam* and *Adama*, '*Ird* and *Ard*: En-gendering Political Conflict and Identity in Early Jewish and Palestinian Nationalisms,' in *Gendering the Middle East: Emerging Perspectives*, ed. Deniz Kandiyoti (London: I.B.Tauris, 1996), 88.
79. These tropes appear in the writing of Aimé Césaire and Frantz Fanon, for example.
80. Rosemary Sayigh, *Palestinians: From Peasants to Revolutionaries* (London: Zed, 1979), 79.
81. See, for example, Mahmoud Shaheen's short story 'The Sacred River,' a story about Palestinian refugeeism, in Jayyusi, *Anthology of Modern Palestinian Literature*, 525–545.
82. Arafat quoted in Massad, 'Conceiving the Masculine,' 473.
83. Harum Hashim Rasheed, 'Poem to Jerusalem,' in Jayyusi, A*nthology of Modern Palestinian Literature*, 265–266.
84. 'Umar Shabana, 'From: The Book of Songs and Stones,' in Jayyusi, *Anthology of Modern Palestinian Literature*, 295.
85. Abu Salma, 'We Shall Return,' in Jayyusi, *Anthology of Modern Palestinian Literature*, 96.
86. Ashrawi, 'Contemporary Palestinian Poetry of Occupation,' 96, 100.
87. Rashid Husain, 'First,' in Jayyusi, *Anthology of Modern Palestinian Literature*, 175.
88. Raja Shehadeh, *The Third Way: A Journal of Life in the West Bank* (London: Quartet, 1992), 86–89. See Parmenter, *Giving Voice to Stones*, 86–87, for further discussion of Shehadeh's comments here.
89. For collections of Darwish's work translated into English, see *The Butterfly's Burden*, trans. Fady Joudah (Tarset: Bloodaxe, 2000) and *Unfortunately, It Was Paradise: Selected Poems*, ed. and trans. Munir Akash and Carolyn Forché with Sinan Antoon and Amira El-Zein (Berkeley: University of California Press, 2003).
90. Darwish, 'No More and No Less,' *The Butterfly's Burden*, 49.

91. Michel Khleifi, 'From Reality to Fiction—from Poverty to Expression,' trans. Omar al-Qattan, in Dabashi, *Dreams of a Nation*, 57.
92. Michel Khleifi, dir., *Zindeeq* (Palestine/UK/Belgium/UAE, 2009).
93. Gertz and Khleifi, *Palestinian Cinema*, 4–5.
94. Michel Khleifi, dir., *Fertile Memory* (Palestine/Netherlands/Belgium, 1980).
95. See Jeff Halper, 'A Strategy within a Non-strategy: Sumud, Resistance, Attrition, and Advocacy,' *Journal of Palestine Studies* 35, no. 3 (2006): 46 for further discussion of this term.
96. Viola Shafik, *Arab Cinema: History and Cultural Identity*, revised edition (Cairo: American University in Cairo Press, 2007), 187.
97. Mary N. Layoun, 'A Guest at the Wedding: Honour, Memory, and (National) Desire in Michel Khleife's *Wedding in Galilee*,' in *Between Women and Nation: Nationalisms, Transnational Feminisms, and the State*, ed. Caren Kaplan, Norma Alarcón and Minoo Moallem (Durham: Duke University Press, 1999), 93.
98. See Gertz and Khleifi, *Palestinian Cinema*, 30, 40.
99. Massad, 'Conceiving the Masculine,' 476. The resistant undertones of the trope of 'the Palestinian wedding' also appear in the title of a key poetry collection comprised of Palestinian resistance poetry collected and translated by A.M. Elmessiri, *The Palestinian Wedding*.
100. This was reportedly Meir's response to a Polish Jewish man who had returned from Palestine in 1920 to assess its suitability for settlement. Benjamin Beit-Hallahmi, *Original Sins: Reflections on the History of Zionism and Israel* (New York: Olive Branch Press, 1993), 78.
101. Laura Mulvey, 'Visual Pleasure and Narrative Cinema,' *Screen* 16, no. 3 (1975): 54–64.
102. Said, *Orientalism*, 103.
103. Yegenoglu, *Colonial Fantasies*, 72.
104. Said, *Orientalism*, 6.
105. 'Crisis heterotopias' include, according to Foucault, spaces such as the boarding school, military service or the 'honeymoon trip,' which are all locations where individuals undergoing forms of transitional crisis (such as adolescence, menstruation, loss of virginity, development of virility) can complete these processes without disrupting social norms. Michel Foucault, 'Of Other Spaces,' trans. Jay Miskowiec, *Diacritics* 16 (Spring 1986): 24.
106. Samih al-Qasim, 'You Pretend to Die,' in Jayyusi, *Anthology of Modern Palestinian Literature*, 258.
107. Layoun, 'A Guest at the Wedding,' 97.
108. Edward Said, 'Review of *Wedding in Galilee* and *Friendship's Death*,' in *The Politics of Dispossession: The Struggle for Palestinian Self-Determination 1969–1994* (London: Chatto and Windus, 1994), 136.
109. Khleifi, 'From Reality to Fiction,' 48.
110. Carol Delaney, cited in Khatib, *Filming the Modern Middle East*, 83.

Notes to Chapter 2

1. Abu Salma was one of Palestine's best-known poets during the period of the British mandate and following the *Nakba*, and came to be known as 'The

Olive Tree of Palestine' for his firm commitment to his country, even when later writing from exile. 'Abd al-Raheem Mahmoud, meanwhile, was a poet-martyr who wrote highly patriotic poetry that rallied the Palestinian people and continues to be memorised by some of them today. He fell while fighting for Palestine following the partition of 1947. Jayyusi, *Anthology of Modern Palestinian Literature*, 95, 209.
2. Some of Suleiman's films are analysed in detail in Chapter 3.
3. Amilcar Cabral, 'National Liberation and Culture,' in *Unity and Struggle, Speeches and Writings*, trans. Michael Wolfers (New York: Monthly Review Press, 1979), 140, 143.
4. Yuval-Davis, *Gender and Nation*, 45.
5. Elise G. Young, *Keepers of the History: Women and the Israeli-Palestinian Conflict* (New York: Teachers College Press, 1992), 8.
6. Geraldine Heng, '"A Great Way to Fly": Nationalism, the State, and the Varieties of Third-World Feminism,' in *Feminist Genealogies, Colonial Legacies, Democratic Futures*, ed. M. Jacqui Alexander and Chandra Talpade Mohanty (New York: Routledge, 1997), 34.
7. Ahmed, *Women and Gender in Islam*, 167.
8. Gayatri Chakravorty Spivak, 'French Feminism in an International Frame,' *Yale French Studies* 62 (1981): 184.
9. Kumari Jayawardena, *Feminism and Nationalism in the Third World* (London: Zed, 1992), 10.
10. Cooke, 'Feminist Transgressions in the Postcolonial Arab World,' 93–105.
11. Nawar Al-Hassan Golley, *Reading Arab Women's Autobiographies: Shahrazad Tells Her Story* (Austin: University of Texas Press, 2003), 27.
12. Golley, *Reading Arab Women's Autobiographies*, 27.
13. Lila Abu-Lughod, 'The Marriage of Feminism and Islamism in Egypt: Selective Repudiation as a Dynamic of Postcolonial Cultural Politics,' in *Remaking Women: Feminism and Modernity in the Middle East*, ed. Lila Abu-Lughod (Princeton: Princeton University Press, 1988), 248.
14. Abu-Lughod, 'The Marriage of Feminism and Islamism in Egypt,' 234.
15. For a pertinent discussion of Islamic feminism, see Cooke, *Women Claim Islam*.
16. Recently, women proved integral to the overthrow of Mubarak in Egypt in February 2011, and to the overthrow of Gaddafi in Libya, where they have subsequently demanded their rights in the post-revolutionary climate. See Leana Hosea, 'A Woman's Place in the New Egypt,' *BBC News: Middle East*, 23rd March 2011, accessed 18th September 2011, http://www.bbc.co.uk/news/world-middle-east-12819919.
17. Frantz Fanon, *Studies in a Dying Colonialism*, trans. Haakon Chevalier (1958; New York: Monthly Review Press, 1965). See also Carolyn Fluehr-Lobhan, 'The Political Mobilisation of Women in the Arab World,' in *Women in Contemporary Muslim Societies*, ed. Jane Smith (Lewisburg: Bucknell University Press, 1980), 235–252.
18. Indeed, this was the case in the Algerian struggle, where women participated widely in order to bring about both feminist and national reforms in society, only to find that patriarchal order was widely reinstated and they were returned to domestic roles upon Algeria's 'liberation.' See Mounria M. Charrad, *States and Women's Rights: The Making of Postcolonial Tunisia, Algeria and Morocco* (Berkeley,

CA: University of California Press, 2001), particularly Chapter 8: 'Elite Divisions and the Law in Gridlock: Algeria,' 169–200.
19. Suha Sabbagh, 'Palestinian Women Writers and the Intifada,' *Social Text* 22 (1989): 65.
20. See the introduction to this book, and Saliba and Kattan, 'Palestinian Women and the Politics of Reception,' 86, for a discussion of many women's decisions to reject the label of 'feminist' to describe their struggles for women's rights.
21. Ellen L. Fleischmann, 'The Emergence of the Palestinian Women's Movement, 1929–39,' *Journal of Palestine Studies* 29, no. 3 (2000): 17.
22. Fleischmann, 'The Emergence of the Palestinian Women's Movement,' 25.
23. Fleischmann, 'The Emergence of the Palestinian Women's Movement,' 25–27.
24. Constantine K. Zurayak, *The Meaning of the Disaster*, trans. R. Bayly Winder (Beirut: Khayat's College Book Cooperative, 1956), 36.
25. For a fascinating and more extensive discussion of this early commitment to modernisation, see Frances S. Hasso, 'Modernity and Gender in Arab Accounts of the 1949 and 1967 Defeats,' *International Journal of Middle East Studies* 32, no. 4 (2000): 491–510.
26. Frances S. Hasso, 'The "Women's Front": Nationalism, Feminism, and Modernity in Palestine,' *Gender and Society* 12, no. 4 (1998): 449.
27. Massad, *The Persistence of the Palestinian Question*, 52. As one of the most prominent female political figures in Palestine, Hanan Ashrawi has been written about extensively and indeed has produced her own autobiography: Hanan Ashrawi, *This Side of Peace: A Personal Account* (New York: Simon and Schuster, 1995). See also Ashrawi's poetry in English, much of which displays a level of gender-consciousness, in Jayyusi, *Anthology of Modern Palestinian Literature*, 335–341.
28. F. al-Labadi, *Memories of a Palestinian Daughter*, MA dissertation 1993, cited in Hasso, '"The Women's Front",' 449–450.
29. Rita Giacaman, 'Palestinian Women, the *Intifada* and the State of Independence,' 40.
30. Simona Sharoni, *Gender and the Israeli-Palestinian Conflict: The Politics of Women's Resistance* (New York: Syracuse University Press, 1995), 38.
31. See Chapter 1 for further discussion of the honour/shame discourse.
32. Nahla Abdo, 'Women of the Intifada: Gender, Class and National Liberation,' *Race and Class* 32, no. 4 (1991): 30.
33. Buthina Canaan Khoury, dir., *Women in Struggle* (New York: Women Make Movies, 2004). DVD.
34. Islah Jad, 'The Conundrums of Post-Oslo Palestine: Gendering Palestinian Citizenship,' *Feminist Theory* 11, no. 2 (2010), 157.
35. Jad, 'The Conundrums of Post-Oslo Palestine,' 160.
36. Nahla Abdo, 'Gender and Politics under the Palestinian Authority,' *Journal of Palestine Studies* 28, no. 2 (1999): 42.
37. Maria Holt, 'Palestinian Women, Violence, and the Peace Process,' *Development in Practice* 13, no. 2 (2003): 233.
38. 'Declaration of Principles on Interim Self-Government Arrangements and Draft Basic Law for the National Authority of the Transitional Period,' cited in Barbara Harlow, 'Partitions and Precedents: Sahar Khalifeh and Palestinian Political

Geography,' in Majaj, Sunderman and Saliba, *Intersections: Gender, Nation, and Community in Arab Women's Novels*, 131.

39. Poetry is the most deeply rooted and highly revered literary tradition in Palestinian and indeed in Arab culture, and it has often played a highly public and political role as a mode of response to historical events. See Allen, *An Introduction to Arabic Literature*, 66.
40. Penny Johnson, 'From Seclusion to Creation,' *The Women's Review of Books* 8, no. 4 (1991): 11.
41. Golley, *Reading Arab Women's Autobiographies*, 114. Tuqan has been the recipient of several literary prizes, including the International Poetry Award in Palmero, Italy, the Jerusalem Award for Culture and the Arts in 1990 and the Honorary Palestine prize for poetry in 1996.
42. Jayyusi, *Anthology of Modern Palestinian Literature*, 10.
43. Omar Karmi, '"Enough for Me to Die on Her Earth": An Obituary of Palestinian Poetess Fadwa Touqan,' *Palestine-Israel Journal* 11, no. 1 (2004): 97.
44. Magda M. Al-Nowaihi, 'Resisting Silence in Arab Women's Autobiographies,' *International Journal of Middle East Studies* 33, no. 4 (2001): 480.
45. Fadwa Tuqan, *A Mountainous Journey: A Poet's Autobiography*, trans. Olive Kenny (London: The Women's Press, 1990), 11. All subsequent page references to this text will be cited in brackets directly after the quotation.
46. After its initial serialisation in the Palestinian press, it was subsequently serialised for the broader Arab public in the magazine *al-Doha* in 1984, and printed in book form in 1985, with subsequent reprints. See Al-Nowaihi, 'Resisting Silence in Arab Women's Autobiographies,' 480; Salma Khadra Jayyusi, 'Foreword,' in Tuqan, *A Mountainous Journey*, viii; Golley, *Reading Arab Women's Autobiographies*, 114.
47. Leila Khaled with George Hajjar, *My People Shall Live: Autobiography of a Revolutionary* (Toronto: NC Press Ltd., 1975); Raymonda Tawil, *My Home, My Prison* (1979; New York: Holt, Rinehart and Winston, 1980). The text was initially published in Hebrew, but is published in this edition in the author's own English translation.
48. While a traditionally male-dominated genre, many autobiographies by Arab women emerged in the twentieth century, including those of prominent feminists such as Huda Sha'rawi. Fedwa Malti-Douglas, 'Introduction: A Palestinian Female Voice against Tradition,' in Tuqan, *A Mountainous Journey*, 2.
49. Al-Nowaihi, 'Resisting Silence in Arab Women's Autobiographies,' 478.
50. This is the view expressed by some female Palestinian students interviewed in the West Bank by Saliba and Kattan. See Saliba and Kattan, 'Palestinian Women and the Politics of Reception,' 89.
51. A powerful example of 'personal account literature' by a female author is Ghada Karmi's *In Search of Fatima: A Palestinian Story* (London: Verso, 2002), in which Karmi tells the story (in English) of her family's own violent displacement in 1948.
52. Samih Al-Qasim is a highly political poet who was born to a Druze family in the Galilee region in 1939. He is of the same poetic generation as Mahmoud Darwish, with whom he published poems in the 1984 collection *Victims of a Map*. See Adonis, Mahmoud Darwish and Samih al-Qasim, *Victims of a Map: A Bilingual Anthology of Arabic Poetry*, trans. Abdullah al-Udhari (London: Saqi, 1984).
53. Badran and Cooke, 'Introduction,' xviii.

54. Jayawardena, *Feminism and Nationalism in the Third World*, 8.
55. Carol Hanisch, 'The Personal Is the Political,' February 1969, accessed 12th September 2011. http://www.carolhanisch.org/CHwritings/PIP.html.
56. Samih K. Farsoun, *Culture and Customs of the Palestinians* (Westport: Greenwood Press, 2004), 32. For a gender-conscious account of the way in which the 'self' is understood in relation to the family construct, see 'Introduction,' in *Intimate Selving in Arab Families: Gender, Self, and Identity*, ed. Suad Joseph (New York: Syracuse University Press, 1999).
57. See for example Ibrahim Wade Ata, *The West Bank Palestinian Family* (London: KPI Limited, 1986).
58. Fatima Mernissi, *Beyond the Veil: Male-Female Dynamics in a Modern Muslim Society* (Cambridge, MA: Schenkman Publishing, 1975), 4.
59. See Mernissi, *Beyond the Veil*, 81–87.
60. Western feminist geographers, for example, have questioned the idea that private space is a realm of female power, stating that 'it is men who decide which "women's space" other men may enter, and it could be argued, therefore, that this is to be understood as part of men's space also.' Shirley Ardener, *Women and Space: Ground Rules and Social Maps* (Oxford: Berg, 1993), 21.
61. Mernissi, *Beyond the Veil*, 84.
62. See Chapter 1 for further discussion of the honour/shame discourse.
63. Jayyusi, 'Introduction,' in *Anthology of Modern Palestinian Literature*, 20.
64. Jean-Paul Sartre, 'Preface,' in Fanon, *The Wretched of the Earth*, 15–16.
65. Mohanty, 'Under Western Eyes,' 70.
66. Mohanty, 'Under Western Eyes,' 61–78.
67. Golley, *Reading Arab Women's Autobiographies*, 121, 125.
68. Though Tuqan does not claim this to be the condition of all Palestinian women, it is nevertheless interesting to note a number of features of her autobiography, such as the tyrannical father, the overbearing older brother and the 'single error' in conduct that brings about punishment, that recur as common tropes in a number of autobiographies by both Arab men and women. These narratives do not necessarily critique such behaviours; rather, they operate partly in the service of drama. See Hartmuch Fähndrich, 'Fathers and Husbands: Tyrants and Victims in Some Autobiographical and Semi-autobiographical Works from the Arab World,' in *Love and Sexuality in Modern Arab Literature*, ed. Roger Allen, Hilary Kilpatrick and Ed de Moor (London: Saqi, 1995), 106–115.
69. Moore, *Arab, Muslim, Woman*, 109.
70. Ibrahim Tuqan (1905–1941) was a well-known poet, scholar, activist and broadcaster of the 1920s, 30s and 40s. Fadwa was devastated at her brother's death from an illness that he developed while teaching in Iraq. She would later write several elegies for her brother, echoing the voice of Al-Khansa: the female elegiac poet with whose poetry Ibrahim had first sought to inspire her. See Terri DeYoung, '"Love, Death and the Ghost of al-Khansa": The Modern Female Poetic Voice in Fadwa Tuqan's Elegies for Her Brother Ibrahim,' in *Tradition, Modernity and Postmodernity in Arabic Literature*, ed. Kamal Abdel-Malek and Wael Hallaq (Leiden, Netherlands: Brill, 2000), 45–75.
71. Malti-Douglas, 'Introduction: A Palestinian Female Voice against Tradition,' 7. It should be noted that *ritha'* was also composed and recited by male poets.
72. Malti-Douglas, 'Introduction: A Female Voice against Tradition,' 7.

73. Ahmed Badrakhan, dir., *Dananeer* (Egypt, 1940).
74. All poems cited here are translated by Naomi Shihab Nye and included as appendices to *A Mountainous Journey*. For further English translations of poems by Tuqan, see Handal, *The Poetry of Arab Women*.
75. Therese Saliba, 'A Country beyond Reach: Liana Badr's Writings of the Palestinian Diaspora,' in Majaj, Sunderman and Saliba, *Intersections: Gender, Nation, and Community in Arab Women's Novels*, 132–133.
76. Other works by Badr available in translation include her collection of three novellas, *A Balcony over the Fakihani*, trans. Peter Clark and Christopher Tingley (1983, in Arabic; Northampton, MA: Interlink Books, 1995) and *The Eye of the Mirror*, trans. Samira Kawar (1991, in Arabic; Reading: Garnet, 2008), both of which are set during the Lebanese Civil War. Her films include *Fadwa* (Palestine, 1999) and *Zeitounat* (Palestine, 2000), a film about the relationship between women and their ancestral olive trees.
77. Liana Badr, *A Compass for the Sunflower*, trans. Catherine Cobham (1979; London: The Women's Press, 1989), 69. All subsequent page numbers from this text will be cited in brackets directly after the quotation.
78. For further information on Kanafani, see Chapter 3. Harlow draws on Ghassan Kanafani's work, *Literature of Resistance in Occupied Palestine: 1948–1966* (Beirut: Institute for Arab Research, 1981), in her formulation of this term. As Kanafani's work is not available in English translation, I work primarily with Harlow's subsequent translations of his work and theorisation of this term.
79. Indeed, a cross-cultural example of this appears within the text. The female character Shahd presents her friend Samar with a book of poetry by Pablo Neruda, the Chilean poet and activist, which she describes as works 'for hunted people everywhere' (96). Elsewhere in the novel, the character Jinan also cites the Vietnamese struggle against the U.S. as a source of inspiration for the Palestinian resistance (76).
80. Barbara Harlow, *Resistance Literature* (New York: Methuen, 1987), 3, 11. Harlow engages in some interesting discussions of examples of Palestinian 'resistance literature' in this work, as she does in her later text, *After Lives: Legacies of Revolutionary Writing* (London: Verso, 1996).
81. Liana Badr in personal interview with Saliba and Kattan, 'Palestinian Women and the Politics of Reception,' 100.
82. See Helena Lindholm Schultz with Juliane Hammer, *The Palestinian Diaspora: Formation of Identities and Politics of Homeland* (London: Routledge, 2003), particularly Chapter 3, in which the authors provide an account of the various diasporic populations living in Jordan and Lebanon, and the political trajectories that brought many of them there.
83. Frances S. Hasso, 'Feminist Generations: The Long-Term Impact of Social Movement Involvement on Palestinian Women's Lives,' *American Journal of Sociology* 107, no. 3 (2001): 589.
84. See Harlow, *Resistance Literature*, 12.
85. Philippa Strum, *The Women Are Marching: The Second Sex and the Palestinian Revolution* (New York: Lawrence Hill Books, 1992), 32, 39.
86. Leila Hudson, 'Coming of Age in Occupied Palestine: Engendering the Intifada,' *Reconstructing Gender in the Middle East: Tradition, Identity, and Power*, ed.

Fatma Müge Göçek and Shiva Balaghi (New York: Columbia University Press, 1994), 133.
87. Bouthaina Shaaban, *Both Right and Left Handed: Arab Women Talk about Their Lives* (London: The Women's Press, 1988), 164.
88. Fanon, *The Wretched of the Earth*, 73–74.
89. Frantz Fanon, 'Algeria Unveiled,' in *Studies in a Dying Colonialism*, 35–67. See Nigel C. Gibson, 'The "Absolute Originality" of Women's Actions,' in *Fanon: The Postcolonial Imagination* (Cambridge: Polity, 2003), 139–148 for further discussion of Fanon's views on women's significance to the resistance struggle.
90. Julie Peteet, 'Male Gender and Rituals of Resistance in the Palestinian Intifada: A Cultural Politics of Violence,' in *Imagined Masculinities: Male Identity and Culture in the Modern Middle East*, ed. Mai Ghoussoub and Emma Sinclair-Webb (London: Saqi Books, 2000), 154.
91. Khaled, *My People Shall Live*, 122.
92. Rajeswari Mohan, 'Loving Palestine: Nationalist Activism and Feminist Agency in Leila Khaled's Subversive Bodily Acts,' *Interventions* 1, no. 1 (1998): 68–69.
93. Mohan, 'Loving Palestine,' 69.
94. Accad, *Sexuality and War*, 73–74.
95. Hasso, 'Modernity and Gender in Arab Accounts of the 1948 and 1967 Defeats,' 495.
96. Sharoni, *Gender and the Israeli-Palestinian Conflict*, 39.
97. See Katz, '*Adam* and *Adama*, '*Ird* and *Ard*,' 91, and Rhoda Ann Kanaaneh, *Birthing the Nation: Strategies of Palestinian Women in Israel* (Berkeley: University of California Press, 2005).
98. Julie Peteet, 'Icons and Militants: Mothering in the Danger Zone,' *Signs* 23, no. 1 (1997): 114.
99. Abdo, 'Women of the Intifada,' 25.
100. Julie Peteet, *Gender in Crisis: Women and the Palestinian Resistance Movement* (New York: Columbia University Press, 1991), 153.
101. Amalia Sa'ar, 'Feminine Strength: Reflections on Power and Gender in Israeli-Palestinian Culture,' *Anthropological Quarterly* 79, no. 3 (2006): 408.
102. Sa'ar, 'Feminine Strength,' 408.
103. Accad, *Sexuality and War*, 18.
104. Anne McClintock, '"No Longer in a Future Heaven",' 93.
105. Gayatri Chakravorty Spivak, 'Can the Subaltern Speak?,' in *Colonial Discourse and Postcolonial Theory: A Reader*, ed. Patrick Williams and Laura Chrisman (Harlow: Pearson Education Ltd., 1994), 83.
106. Massad, *The Persistence of the Palestinian Question*, 54.
107. Mai Sayigh, 'Elegy for Imm 'Ali,' in Jayyusi, *Anthology of Modern Palestinian Literature*, 280–281.
108. Najwa Najjar, dir., *Pomegranates and Myrrh* (Palestine, 2008).
109. Despite the highly affirmative portrayal of Palestine in this film, Najwa Najjar states in interview that there was public outcry when her film was first screened in Ramallah, for what was deemed its 'unpatriotic' portrayal of an untrustworthy wife of a political prisoner (an iconic trope of masculinity in nationalist consciousness). The subversive potential of even the subtlest of gender-conscious disruptions to the national narrative is clear from this account. Najwa Najjar in

Q&A Session, *London Palestine Film Festival*, Barbican Centre, London, 2nd May 2010.
110. Mahasen Nasser-Eldin, dir., *Samia* (Palestine, 2009); a Shashat Production with support from the European Union.
111. Alia Arasoughly, dir., *This Is Not Living* (Palestine, 2001).
112. Adania Shibli, *Touch*, trans. Paula Haydar (Northampton, MA: Clockroot Publishing, 2010), first published in Arabic under the title *Masas*. Shibli, born in Palestine in 1974, has twice been awarded the A.M. Qattan Foundation Young Writer's Award, and was described as 'the most talked about writer on the West Bank' by Ahdaf Soueif (front cover of *Touch*).

Notes to Chapter 3

1. Ghassan Kanafani, *Men in the Sun and Other Palestinian Stories*, trans. Hilary Kilpatrick (London: Lynne Rienner Publishers, 1999), 74. For a much more detailed interpretation of Kanafani's *Men in the Sun* as a novella portraying 'masculinity in crisis,' see Joe Cleary, *Literature, Partition and the Nation-State: Culture and Conflict in Ireland, Israel and Palestine* (Cambridge: Cambridge University Press, 2002), 186–225.
2. Judith Butler, *Gender Trouble: Feminism and the Subversion of Identity* (New York: Routledge Classics, 2006), 179.
3. Butler, *Gender Trouble*, 179.
4. Butler, *Gender Trouble*, 179.
5. Here, my reading follows that of Joe Cleary, who writes that 'the tragedy that brings the narrative to conclusion occurs in a space which is quite literally a "no-place" since the men die in a juridical "no-man's land" between states [. . .] [that] must ultimately be read as a figure in the text for Palestine itself—a land that officially disappeared from the map in 1948.' *Literature, Partition and the Nation State*, 198.
6. Cleary, *Literature, Partition and the Nation State*, 212. There are many works that can be read as portrayals of a Palestinian 'masculinity crisis,' including Emile Habiby's *The Secret Life of Saeed the Pessoptimist*, trans. Salma Khadra Jayyusi and Trevor Le Gassick (London: Arabia Books, 2010), a tragicomic novel about a Palestinian citizen of Israel named Saeed who becomes a collaborator with the Israelis, but whose incompetence sees him fail at every turn.
7. Samir El-Youssef, 'The Day the Beast Got Thirsty,' in *Gaza Blues: Different Stories*, Samir El-Youssef and Etgar Keret (London: David Paul, 2004), 111–173. All subsequent references to this work will be cited as page references in brackets directly after the quotation.
8. Elia Suleiman, dir., *Divine Intervention* (France/Morocco/Germany/Palestine, 2002).
9. Hany Abu-Assad, dir., *Paradise Now* (Palestine/France/Netherlands/Germany/Israel, 2005).
10. See R.W. Connell, *Masculinities* (Cambridge: Polity Press, 1995) and Lynne Segal, *Slow Motion: Changing Masculinities, Changing Men* (London: Virago, 1990) for examples of studies that 'denaturalise' and scrutinise patriarchal power.

11. See for example Roger Horrocks, *Masculinity in Crisis* (Basingstoke: Macmillan Press, 1994) and Ronald F. Levant, 'The Masculinity Crisis,' *The Journal of Men's Studies* 5 (1997): 221–231.
12. See, for example, Evelyne Accad, *Sexuality and War*, particularly 'Part Three: War Unveils Men.'
13. See for example Ghoussoub and Sinclair-Webb, *Imagined Masculinities*, 8–9, and Hisham Sharabi, *Neopatriarchy: A Theory of Distorted Change in Arab Society* (Oxford: Oxford University Press, 1988), in which Sharabi argues that the emergence of 'modernity' in Arab nations has not led to a critique of patriarchy; rather, patriarchy has adapted to and renewed itself within the modern environment.
14. There are around 1.3 million Palestinian Israelis: 20% of Israel's citizens. Although their Israeli citizenship ostensibly grants them equal rights to Israelis, they nevertheless face social discrimination and are overrepresented in unemployment and poverty statistics. Amalia Sa'ar and Taghreed Yahia-Younis, 'Masculinity in Crisis: The Case of Palestinians in Israel,' *British Journal of Middle Eastern Studies* 35, no. 3 (2008): 309.
15. Sa'ar and Yahia-Younis, 'Masculinity in Crisis,' 322.
16. Massad, 'Conceiving the Masculine,' 467–483.
17. Butler, *Gender Trouble*, xvi.
18. Butler, *Gender Trouble*, 178.
19. Butler, *Gender Trouble*, 178.
20. Cynthia Enloe, *Bananas, Beaches and Bases: Making Feminist Sense of International Politics* (Berkeley: University of California Press, 1990), 44.
21. Rashid Khalidi, *Palestinian National Identity: The Construction of Modern National Consciousness* (New York: Columbia University Press, 1997), 6.
22. At various points in its history, Palestine had had to revise its understanding of national identity—in response to the fall of the Ottoman Empire, for example, and to the formation of the State of Israel. Pan-Arabism has also been a significant regional influence. Palestine's national origins are a source of much (often polemical) debate, and so extensive is scholarship in this area that I do not wish to deliver what would inevitably be a reductive account of it here. However, for a considered discussion of 'The Formation of Palestinian Identity: The Critical Years, 1917–1923,' see Khalidi, *Palestinian National Identity*, 145–175.
23. Massad, 'Conceiving the Masculine,' 478.
24. Various branches of Palestinian nationalism include Fateh, the Palestinian Liberation Organization (PLO), Palestine National Front (PNF) and Democratic Front for the Liberation of Palestine (DFLP), all of which have mounted different forms of action at varied points in the nation's turbulent history. For an introduction to Palestinian nationalism, see Helena Lindholm Schulz, *The Reconstruction of Palestinian Nationalism: Between Revolution and Statehood* (Manchester: Manchester University Press, 1999).
25. Anderson, *Imagined Communities*, 16. See Chapter 1 for further discussion of the 'imagined community' and its link to the postcolonial concept of the 'nation as narration.'
26. Massad, 'Conceiving the Masculine,' 472. Significantly, this patriarchal basis to national citizenship was revised in 2003 following pressure from the women's movement to include blood ties to both parents. Jad, 'The Conundrums of Post-Oslo Palestine,' 153.
27. Massad, 'Conceiving the Masculine,' 472.

28. Massad, 'Conceiving the Masculine,' 472. Translation of the Charter is Massad's, as is the emphasis in this quotation. Further discussion of the traditional gendered symbolism of the nation appears in Chapter 1.
29. Massad, 'Conceiving the Masculine,' 479.
30. Partha Chatterjee, *The Nation and Its Fragments: Colonial and Postcolonial Histories* (Princeton: Princeton University Press, 1993), 120.
31. Peteet, 'Male Gender and Rituals of Resistance,' 107.
32. Sharabi, *Neopatriarchy*, 35, 41.
33. Butler, *Gender Trouble*, 179.
34. According to the director of the Trauma Rehabilitation Centre in Ramallah, approximately 40% of men in the Occupied Territories have been detained at some point and 86% of those detained have been tortured. Michael Kennedy, 'Prison Is for Men: Remembering Al-Fara'a,' *Surfacing* 2, no. 1 (2009): 92.
35. Peteet, 'Male Gender and Rituals of Resistance,' 103.
36. Sahar Khalifeh, *Wild Thorns*, trans. Salma Khadra Jayyusi, Osman Nusairi and Jana Gough (1976, in Arabic; London: Saqi, 2005), 116.
37. Khalifeh, *Wild Thorns*, 149.
38. Butler, *Gender Trouble*, 179.
39. For further discussion of this phenomenon, see Marouf Hasian Jr. and Lisa A. Flores, 'Children of the Stones: The Intifada and the Mythic Creation of the Palestinian State,' *Southern Communication Journal* 62, no. 2 (1997): 89–106.
40. Matthew Reisz, 'Samir El-Youssef: At Home with the Heretic,' *The Independent*, 19th January 2007, accessed 27th July 2010. http://www.independent.co.uk/arts-entertainment/books/features/samir-elYoussef-at-home-with-the-heretic-432650.html.
41. Reisz, 'Samir El-Youssef,' online.
42. Katherine Viner, 'Despair As Usual for Palestinians,' *The Guardian*, 7th February 2001, accessed 26th November 2010. http://www.guardian.co.uk/israel/Story/0,2763,434655,00.html. For further discussions of other creative works set in or exploring life in Lebanese refugee camps for Palestinians, see the analyses of Liana Badr's novel *A Compass for the Sunflower* in Chapter 2, and of Mai Masri's film *Frontiers of Dreams and Fears* in Chapter 5.
43. Smith, *Palestine and the Arab-Israeli Conflict*, 435.
44. Reisz, 'Samir El-Youssef,' online.
45. Samir El-Youssef, *The Illusion of Return* (London: Halban, 2007).
46. Mary Fitzgerald, 'A Faraway Country,' *The New Statesman*, 15th January 2007, accessed 20th November 2009. http://www.newstatesman.com/books/2007/01/return-palestinian-Youssef.
47. For example, the narrator of Keret's short story 'Missing Kissinger' in *Gaza Blues* expresses his hatred for his girlfriend in highly misogynistic sexual terms. There are parallels between the disaffected male narrators of both Keret and El-Youssef's stories. See also Etgar Keret, *The Nimrod Flipout* (London: Vintage, 2006) and *Missing Kissenger* (London: Vintage, 2008).
48. Smith, *Palestine and the Arab-Israeli Conflict*, 412. As leader of the PLO, Arafat was, by this stage, exercising control from a state of exile in Tunis, having been expelled from his former seat in Beirut during the Israeli invasion of Lebanon from 1981–1982, and support for him as leader was beginning to wane. Smith, *Palestine and the Arab-Israeli Conflict*, 379.

49. Laleh Khalili, 'A Landscape of Uncertainty: Palestinians in Lebanon,' *Middle East Report* 236 (2005): 35.
50. Arafat did not defect; rather, the PLO absorbed factions such as Fatah into it, leading to Arafat's election as head of the PLO in 1969. Smith, *Palestine and the Arab-Israeli Conflict*, 314.
51. Hajj Amin al-Hussainy is a controversial figure within the history of Palestinian nationalism. He was appointed Grand Mufti of Jerusalem during the British mandate, and was a leading anti-British and anti-Zionist Arab nationalist, but many of his strategies and actions have been criticised from various angles. See Philip Mattar, *The Mufti of Jerusalem: Al-Hajj Amin Al-Husayni and the Palestinian National Movement*, revised edition (New York: Columbia University Press, 1992).
52. Horrocks, *Masculinity in Crisis*, 107.
53. Conditions of irrationality and insanity have traditionally been understood as 'female' conditions—a result, many have argued, of the patriarchal structures that underpin discourses of psychology and medicine. See Elaine Showalter, *The Female Malady: Women, Madness and English Culture, 1830–1980* (London: Virago, 1987).
54. Elia Suleiman, dir., *Chronicle of a Disappearance* (Palestine/Israel/France/Germany, 1997).
55. Hamid Dabashi, 'In Praise of Frivolity: On the Cinema of Elia Suleiman,' in Dabashi, *Dreams of a Nation*, 146.
56. Elia Suleiman, 'A Cinema of Nowhere,' *Journal of Palestine Studies* 29, no. 2 (2000): 98; 97.
57. Dabashi, *Dreams of a Nation*, 8.
58. Elia Suleiman, dir., *The Time that Remains* (UK/Italy/Belgium/France, 2009).
59. Frances S. Hasso, *Resistance, Repression, and Gender Politics in Occupied Palestine and Jordan* (Syracuse, NY: Syracuse University Press, 2005), 18.
60. Peteet, 'Male Gender and Rituals of Resistance,' 107.
61. Penny Johnson and Eileen Kuttab, 'Where Have All the Women (and Men) Gone? Reflections on Gender and the Second Palestinian Intifada,' *Feminist Review* 69 (2001): 31.
62. Peteet, 'Male Gender and Rituals of Resistance,' 109.
63. Peteet, 'Male Gender and Rituals of Resistance,' 114–116.
64. See the discussions of Khleifi's film *Fertile Memory* in Chapter 1, and of Liana Badr's novel *A Compass for a Sunflower* in Chapter 2, for further examples of this trait.
65. Patricia Price-Chalita, 'Spatial Metaphor and the Politics of Empowerment: Mapping a Place for Feminism and Postmodernism in Geography?,' *Antipode* 26, no. 3 (1994): 247.
66. B. Ruby Rich, 'Bomb Culture,' *Sight and Sound* 16 (2006): 28.
67. Hany Abu-Assad, dir. *Ford Transit* (Palestine/Israel, 2002). Film release.
68. Hany Abu-Assad, dir. *Rana's Wedding* (Palestine/Netherlands/UAE, 2002). Film release. This film was co-written by Liana Badr, one of the authors discussed in Chapter 2.
69. Linda Pitcher, '"The Divine Impatience": Ritual, Narrative, and Symbolization in the Practice of Martyrdom in Palestine,' *Medical Anthropology Quarterly* 12, no. 1 (1998): 9.

70. The film received significant critical attention in both the West and Middle East, and while it received an Oscar nomination for Best Foreign Film in 2006 (the category from which *Divine Intervention* was excluded), it was also met with hostility both within the U.S., where it was seen to humanise an ultimately inhumane act, and in Palestine, where some lobbies felt it presented an unfavourable view of an oversimplified national resistance. See Rich, 'Bomb Culture,' and James Bowman, 'Humanized without Honour,' *American Spectator* 39 (2006): 58–59.
71. Eyad El Sarraj and Linda Butler, 'Suicide Bombers: Dignity, Despair, and the Need for Hope; An Interview with Eyad El Sarraj,' *Journal of Palestine Studies* 31, no. 4 (2002): 71.
72. Claudia Brunner, 'Female Suicide Bombers—Male Suicide Bombing? Looking for Gender in Reporting the Suicide Bombings of the Israeli-Palestinian Conflict,' *Global Society* 19, no. 1 (2005): 29.
73. Hilal Khashan, 'Collective Palestinian Frustration and Suicide Bombings,' *Third World Quarterly* 24, no. 6 (2003): 1052.
74. Robert Brym and Bader Araj, 'Suicide Bombing as Strategy and Interaction: The Case of the Second Intifada,' *Social Forces* 84, no. 4 (2006): 1974.
75. Butler, *Gender Trouble*, xv.
76. Butler, *Gender Trouble*, 192.
77. Johnson and Kuttab, 'Where Have All the Women (and Men) Gone?,' 35.
78. Brunner, 'Female Suicide Bombers,' 46.
79. Mahmoud Darwish, 'A State of Siege,' in *The Butterfly's Burden*, trans. Fady Joudah, bilingual edition (Tarset: Bloodaxe, 2007), 123.
80. Darwish, 'A State of Siege,' 163. Note that the term 'martyr' is replaced with 'victim' in alternative translations of this poem.
81. Suleiman, 'A Cinema of Nowhere,' 97.
82. bell hooks, 'Choosing the Margin as a Space of Radical Openness,' in *The Feminist Standpoint Theory Reader: Intellectual and Political Controversies*, ed. Sandra G. Harding (New York: Routledge, 2004), 159.

Notes to Chapter 4

1. Jane Marcus, 'Alibis and Legends: The Ethics of Elsewhereness, Gender and Estrangement,' in *Women's Writing in Exile*, ed. Mary Lynn Broe and Angela Ingram (Chapel Hill: University of North Carolina Press, 1989), 273.
2. Scott Michaelsen and David E. Johnson, eds., *Border Theory: The Limits of Cultural Politics* (Minneapolis: University of Minnesota Press, 1997), 2–3.
3. Michaelsen and Johnson, *Border Theory*, 2–3. According to the authors, 'border-theory' can be identified as a development within 'liberal-to-left' work within the humanities and social sciences that began with developments in 'Chicano' writing and theory concerning the U.S.-Mexico border. Other critics, meanwhile, posit the development of border-theory as a product of 'postmodernism's introduction into geography in the late 1980s,' which led scholars across the disciplines to reflect on 'the textual character of space.' Keith Woodward and John Paul Jones III, 'On the Border with Deleuze and Guattari,' in *B/Ordering Space*,

ed. Henk Van Houtum, Olivier Kramsch and Wolfgang Ziethofer (Aldershot: Ashgate, 2005), 235.
4. See the introduction to this book for further discussion of Palestine's shifting status under various authorities.
5. Tawfiq Zayyad, 'What Next?,' trans. Sharif Elmusa and Jack Collom in Jayyusi, *Anthology of Modern Palestinian Literature*, 330.
6. Robert C. Cottrell, *The Green Line: The Division of Palestine* (Philadelphia: Chelsea House Publishers, 2005), 28, 44–45.
7. Cleary, *Literature, Partition and the Nation-State*, 3.
8. Cottrell, *The Green Line*, 115.
9. Newman, 'From National to Post-national Territorial Identities in Israel-Palestine,' 238.
10. Suleiman, 'A Cinema of Nowhere,' 96.
11. Khalidi, *Palestinian National Identity*, 1.
12. Khalidi, *Palestinian National Identity*, 3.
13. Weizman, *Hollow Land*.
14. See Mehdi Hasan, 'No End to the Strangulation of Gaza,' *New Statesman*, 3rd January 2011, 29 for an account of the enduring impact of the blockade on Gaza.
15. A.H. Sa'di, 'The Borders of Colonial Encounter: The Case of Israel's Wall,' *Asian Journal of Social Science* 38 (2010): 55.
16. Jad, 'The Conundrums of Post-Oslo Palestine,' 150.
17. Vladimir Jabotinsky, 'The Iron Wall (We and the Arabs),' 1923/1937, cited in Sa'di, 'The Borders of Colonial Encounter,' 47.
18. Avtar Brah, *Cartographies of Diaspora: Contesting Identities* (New York: Routledge, 2002), 198.
19. See, for example, Ghassan Kanafani's novella, *Men in the Sun*, which casts the frontier or border-crossing as the site at which the Palestinians' powerlessness comes into sharpest focus. Joe Cleary discusses the politics of borders in this novella in some detail in *Literature, Partition and the Nation State*.
20. For further discussion of the visual status and representation of borders in the Palestinian imagination, see Anna Ball, 'Impossible Intimacies: Towards a Politics of "Touch" at the Israeli-Palestinian Border,' *Cultural Research* 16, nos. 2–3 (2012): 175–195.
21. Nurith Gertz and George Khleifi, 'Palestinian "Roadblock Movies",' *Geopolitics* 10 (2005): 320. Examples include films ranging from *Rana's Wedding*, dir. Hany Abu-Assad (Palestine, 2002), a film about a young woman determined to marry her lover whose marriage eventually takes place at the border due to restrictions on their travel, to Rashid Mashrawi's *Ticket to Jerusalem* (Netherlands/Palestine/France/Australia, 2002), which tells the story of a film projectionist who travels among Palestinian refugee camps to screen films for children. He encounters severe restrictions on travel (and also, by implication of his profession, on creativity, self-expression and imagination) in the form of checkpoints, permit systems and the presence of the occupation.
22. Hamid Naficy, *An Accented Cinema: Exilic and Diasporic Filmmaking* (Princeton: Princeton University Press, 2001), 31.
23. Naficy, *An Accented Cinema*, 31.

24. Jo Glanville, ed., *Qissat: Short Stories by Palestinian Women* (London: Telegram, 2006). All subsequent page references to this text will be cited in brackets, directly after the quotation within the body of the text.
25. Tawfik Abu Wael, dir., *'Atash* (Palestine/Israel, 2004).
26. Annemarie Jacir, dir., *like twenty impossibles* (Palestine, 2003).
27. Weizman, *Hollow Land*, 143.
28. Weizman, *Hollow Land*, 146.
29. Azmi Bishari, quoted in Weizman, *Hollow Land*, 147–148.
30. Michiel Baud and Willem Van Schendel, 'Towards a Comparative History of the Borderlands,' *Journal of World History* 8, no. 2 (1997): 211.
31. Yuval-Davis and Stoetzler, 'Imagined Boundaries and Borders,' 329.
32. John Armstrong, *Nations before Nationalism* (Chapel Hill: University of North Carolina Press, 1982), 6, 242.
33. Shirley Ardener, 'Ground Rules and Social Maps: An Introduction,' in *Women and Space: Ground Rules and Social Maps* (Oxford: Berg, 1993), 5.
34. Gloria Anzaldúa, *Borderlands / La Frontera: The New Mestiza* (San Francisco: Aunt Lute Books, 1987), 60.
35. Anzaldúa, *Borderlands*, 100–101.
36. For a discussion of the female border-crossers who appear in Suleiman's films, and of the conflicted gender politics that accompany them, see Anna Ball, 'Between a Postcolonial Nation and Fantasies of the Feminine: The Contested Visions of Palestinian Cinema,' *Camera Obscura: Feminism, Culture and Media Studies* 23, no. 3 (2008): 1–35.
37. Homi Bhabha, 'Double Visions,' *Artforum* 30, no. 5 (1992): 88.
38. Weizman, *Hollow Land*, 151.
39. Daniel Monterescu, 'Masculinity as a Relational Mode: Palestinian Gender Ideologies and Working-Class Boundaries in an Ethnically Mixed Town,' in *Reapproaching Borders: New Perspectives on the Study of Israel-Palestine*, ed. Sandy Sufian and Mark LeVine (Lanham: Rowman and Littlefield Publishers, 2007), 191.
40. For a discussion of the emergence of the figure of the female 'martyr' or 'suicide bomber,' see Brunner, 'Female Suicide Bombers.'
41. Edward Said, 'Reflections on Exile,' in *Reflections on Exile and Other Literary and Cultural Essays* (London: Granta, 2000), 184–186.
42. See Abu-Lughod, *Remaking Women* for further discussion of this, particularly in the context of Egypt.
43. Said, 'Reflections on Exile,' 186.
44. See, for example, Samira Haj, 'Palestinian Women and Patriarchal Relations,' *Signs* 17, no. 4 (1992), in which Haj writes that 'some debates that have so occupied Western feminism [. . .] for example, the family as the principal site of women's oppression—have no resonance among women whose families and communities are under assault by an occupying power,' 778. While it is important to note that gender is a socially nuanced construct and that forms of power and solidarity may in fact be carved out between women within an extended family, the perspective that emerges in this short story is at odds with such an idea, and represents an important assertion of individualism. See Chapter 2 for further analysis of work by Liana Badr.

45. See Sean D. Murphy, 'Self-Defence and the Israeli Wall Advisory Opinion: An *Ipse Dixit* from the ICJ?,' *The American Journal of International Law* 99, no. 1 (2005): 62–76 for a discussion of the International Court of Justice's rejection in 2004 of Israel's legal claims that the Wall was justified on the grounds of self-defence.
46. Laleh Khalili, *Heroes and Martyrs of Palestine: The Politics of National Commemoration* (Cambridge: Cambridge University Press, 2007), 37.
47. Bill Ashcroft, Gareth Griffiths and Helen Tiffin, *The Empire Writes Back: Theory and Practice in Post-colonial Literatures*, second edition (London: Routledge, 2003), 40.
48. Bhabha, 'DissemiNation,' 148.
49. Peter Lagerquist, 'Fencing the Last Sky: Excavating Palestine after Israel's "Separation Wall",' *Journal of Palestine Studies* 33, no. 2 (2004): 30.
50. Kamal Abdel-Malek, 'Living on Borderlines: War and Exile in Selected Works by Ghassan Kanafani, Fawaz Turki, and Mahmud Darwish,' in *Israeli and Palestinian Identities in History and Literature*, ed. Kamal Abdel-Malek and David C. Jacobson (London: Macmillan, 1999), 179–193.
51. The term 'liminal' is defined as 'of or pertaining to the threshold ("limen") or initial stage in a process,' or in psychological terms, as the point of definition or deviation from a standard. Like the border, it is therefore a simultaneously spatial and psychological construct. J.A. Simpson and E.S.C. Weiner, *Oxford English Dictionary*, volume 8, second edition (Oxford: Clarendon Press, 1989), 964. The idea of the 'liminal' has been extensively evoked in critical theory as the place where a boundary is crossed and the normal regulations on identity, society and thought are relaxed. See Victor Turner, 'Betwixt and Between: The Liminal Period in *Rites de Passage*,' in *The Forest of Symbols: Aspects of Ndembu Ritual* (Ithaca: Cornell University Press, 1967), 93–111.
52. 'Becoming' implies constant process, as opposed to the static nature of simply 'being.' Gilles Deleuze and Félix Guattari, *A Thousand Plateaus: Capitalism and Schizophrenia* (London: Continuum, 2004), 270. See Plateau 10, 'Becoming-Intense, Becoming-Animal, Becoming-Imperceptible' for a fuller explanation of 'becoming' as oppose to simply 'being,' *A Thousand Plateaus*, 256–341.
53. Said, *After the Last Sky*, 155.
54. Gertz and Khleifi, 'Palestinian "Roadblock Movies",' 320.
55. Said, *After the Last Sky*, 6.
56. Baud and Van Schendel, 'A Comparative History of the Borderlands,' 216.
57. Bhabha, *Location*, 25.
58. D. Emily Hicks, *Border Writing: The Multidimensional Text* (Minneapolis: University of Minnesota Press, 1991), xxiv.
59. Gilles Deleuze and Felix Guattari, *Kafka: Towards a Minor Literature*, trans. Dora Polan (Minneapolis: University of Minnesota Press, 1986), 13.
60. Abu Wael was born in the Palestinian town (situated in Israel) of Umm el-Fahim in 1976 and graduated in film studies from Tel Aviv University in 1996. He now lives in Tel Aviv. Other films include *Waiting for Salah Addin* (Palestine, 2001), a documentary depicting the everyday life of eight residents of East Jerusalem. See Gertz and Khleifi, *Palestinian Cinema*, 197.
61. This interplay between the personal and political is also evident in Abu Wael's short film *Diary of a Male Whore* (Palestine, 2001), which depicts a young man named Esam, whose physical exploitation bears symbolic parallels to the

everyday humiliations, forms of domination and violations that he must endure as a Palestinian.
62. See Swedenburg, 'The Palestinian Peasant as National Signifier,' 18–30.
63. Parmenter, *Giving Voice to Stones*, 53.
64. Parmenter, *Giving Voice to Stones*, 53, 67–68.
65. See Jan Selby, *Water, Power and Politics in the Middle East: The Other Israel-Palestine Conflict* (London: I.B.Tauris, 2004).
66. Jayyusi, *Anthology of Modern Palestinian Literature*, 31.
67. See Chapter 2 for further discussion of the honour/shame discourse that is often portrayed as a feature of Palestinian familial and social relations.
68. Monterescu, 'Masculinity as a Relational Mode,' 191.
69. Hicks, *Border Writing*, xxiii.
70. My use of the term 'queer' here refers to its manifestation in the field of 'queer theory' that has evolved in gender studies, where its archaic usage as a derogatory term for homosexuality is subverted by returning to its original meaning as something that incites instability or strangeness. Hence 'queer theory' describes a deconstructivist approach to gendered, sexual and indeed all forms of identity as it seeks to 'estrange' identities from secure or essentialist boundaries. Both Judith Butler (examined in Chapter 3) and Gloria Anzaldúa (examined in this chapter) are often defined as 'queer theorists.' For a basic introduction to queer theory, see Nikki Sullivan, *A Critical Introduction to Queer Theory* (Edinburgh: Edinburgh University Press, 2003).
71. Many of Zayyad's songs have been put to music and are popular songs in Palestine. Jayyusi, *Anthology of Modern Palestinian Literature*, 65.
72. Tawfiq Zayyad, 'Here We Shall Stay,' in Jayyusi, *Anthology of Modern Palestinian Literature*, 328.
73. Jacir's *Salt of This Sea* (Palestine, 2008) tells the story of a young woman (played by Suheir Hammad) born to Palestinian refugees in Brooklyn who longs to return to the West Bank—where she meets a young man who longs to emigrate. Rather than offering a straightforwardly romanticised vision of 'return,' however, the film explores the complexities of the search for belonging and identity for Palestinians both within and beyond Palestine.
74. Michel de Certeau, 'Walking in the City,' in *The Practice of Everyday Life*, trans. Steven Rendall (Berkley: University of California Press, 1988), 96.
75. Janet Wolff, 'On the Road Again: Metaphors of Travel in Cultural Criticism,' *Cultural Studies* 7, no. 2 (May 1993): 253.
76. Hicks, *Border Writing*, xxiv–xxv.
77. Hicks, *Border Writing*, xxiii.
78. Jacir, '"For Cultural Purposes Only",' 26.
79. Suleiman, 'A Cinema of Nowhere,' 96.
80. Anzaldúa, *Borderlands*, 95.
81. Naficy, *An Accented Cinema*, 31.
82. Ian McLean, 'Back to the Future: Nations, Borders and Cultural Theory,' *Third Text* 57 (2001–2002): 27.
83. Kathleen M. Kirby, *Indifferent Boundaries: Spatial Concepts of Human Subjectivity* (London and New York: Guilford press, 1996), 119.
84. Spivak employs the term 'strategic essentialism' to describe the process whereby subjects may find it necessary to adopt particular essentialist stances

in response to specific political challenges, while retaining multiple other subject-positions at the same time. See Donna Landry and Gerald MacLean, eds., *The Spivak Reader: Selected Works of Gayatri Chakravorty Spivak* (London: Routledge, 1996), 214.

Notes to Chapter 5

1. Oxford English Dictionary Online, 'diaspora, n.,' June 2011, accessed 13th August 2011. http://www.oed.com/view/Entry/52085?redirectedFrom=diaspora.
2. Jana Evans Braziel and Anita Mannur, 'Nation, Migration, Globalization: Points of Contention in Diaspora Studies,' in *Theorizing Diaspora: A Reader*, ed. Jana Evans Braziel and Anita Mannur (Oxford: Blackwell, 2003), 1.
3. Masalha, *The Politics of Denial*, 26. There are, of course, competing accounts of the policies that underpinned this mass exodus of Palestinians. For alternative accounts, see Anita Shapira, *Land and Power* (Oxford: Oxford University Press, 1992) or 'new Israeli historian' Benny Morris, *The Birth of the Palestinian Refugee Problem, 1947–1949* (Cambridge: Cambridge University Press, 1988).
4. It is important to note that figures for refugee populations vary and are problematic because they require refugees to be registered with organisations such as UNRWA. Figures cited in Schulz and Hammer, *The Palestinian Diaspora*, 45.
5. Sari Hanafi, 'Opening the Debate on the Right of Return,' *Middle East Report* 222 (2002): 2–7.
6. Muhammad Siddiq, 'On Ropes of Memory: Narrating the Palestinian Refugees,' in *Mistrusting Refugees*, ed. E. Valentine Daniel and John Chr. Knudsen (Berkeley: University of California Press, 1995), 87.
7. James Clifford, 'Diasporas,' *Cultural Anthropology* 9, no. 3 (1994): 306.
8. Edward Said, *After the Last Sky*, 115.
9. Schultz and Hammer, *The Palestinian Diaspora*, 20.
10. These definitions of *ghurba* and *manfa* are both outlined in more extensive detail in Juliane Hammer's publication, *Palestinians Born in Exile: Diaspora and the Search for a Homeland* (Austin: University of Texas Press, 2005), 60.
11. Kathleen M. Kirby, 'Re-mapping Subjectivity: Cartographic Vision and the Limits of Politics,' in *Body/Space: Destabilising Geographies of Gender and Sexuality*, ed. Nancy Duncan (London: Routledge, 1996), 51.
12. Masao Miyoshi, 'A Borderless World? From Colonialism to Transnationalism and the Decline of the Nation-State,' *Critical Enquiry* 19 (1993): 726–751. Wilson and Dissanayak among others argue that technology, travel and communication have delimited space and subjectivity. See Rob Wilson and Wimal Dissanayak, eds., *Global/Local* (Durham: Duke University Press, 1996).
13. See Rosi Braidotti, *Nomadic Subjects: Embodiment and Sexual Difference in Contemporary Feminist Theory* (New York: Columbia University Press, 1994), 5.
14. 'Abdallah Radwan, 'Deformed,' in Jayyusi, *Anthology of Modern Palestinian Literature*, 263.
15. Fawaz Turki, *Soul in Exile: Lives of a Palestinian Revolutionary* (New York: Monthly Review Press, 1988), 26.

16. Smadar Lavie and Ted Swedenburg, 'Introduction,' in *Displacement, Diaspora, and Geographies of Identity*, ed. Smadar Lavie and Ted Swedenburg (Durham: Duke University Press, 1996), 12.
17. Edward Said, 'The Mind of Winter: Reflections on Life in Exile,' *Harper's* (September 1985): 55.
18. Said, 'The Mind of Winter,' 52.
19. Said, 'The Mind of Winter,' 55.
20. Said, 'The Mind of Winter,' 54.
21. Salma Khadra Jayyusi, 'Palestinian Identity in Literature,' in Abdel-Malek and Jacobson, *Israeli and Palestinian Identities in History and Literature*, 175.
22. Eva C. Karpinski, 'Choosing Feminism, Choosing Exile: Towards the Development of a Transnational Feminist Consciousness,' in *Émigré Feminism: Transnational Perspectives*, ed. Alena Heitlinger (Toronto: University of Toronto Press, 1999), 21.
23. Virginia Woolf, *Three Guineas* (New York: Harcourt Inc., 1938), 109.
24. Julia Kristeva, in *The Kristeva Reader*, ed. Toril Moi (New York: Columbia University Press, 1986), 298.
25. Karpinski, 'Choosing Feminism, Choosing Exile,' 7.
26. Inderpal Grewal and Caren Kaplan, eds., *Scattered Hegemonies: Postmodernity and Transnational Feminist Practices* (St Paul: University of Minnesota Press, 1994), 94.
27. See Maha El Said, 'The Face of the Enemy: Arab-American Poetry Post-9/11,' *Studies in the Humanities* 30, nos. 1–2 (2003): 200–217.
28. Mai Masri, dir., *Frontiers of Dreams and Fears* (2001; Seattle: Arab Film Distribution, 2009). DVD.
29. Mona Hatoum, dir., *Measures of Distance* (Vancouver: A West Front Video Production, 1988). Video recording.
30. Rebecca Hillauer, 'Mai Masri,' in *Encyclopedia of Arab Women Filmmakers*, trans. Allison Brown, Deborah Cohen and Nancy Joyce (Cairo: The American University in Cairo Press, 2005), 223–227.
31. Rebecca Hillauer, 'Mona Hatoum,' in *Encyclopedia of Arab Women Filmmakers*, 212–214.
32. See Bayan Nuwayhed Al-Hout, *Sabra and Shatila: September 1982* (London: Pluto, 2004) for a detailed discussion of the massacres.
33. I concur with the view of Schultz and Hammer here, who write that even those Palestinians living within the Occupied Territories can be considered 'diasporic' Palestinians as they have been alienated from their land, and denied citizenship and statehood, which has 'implications for feelings of meaningful belonging.' Schultz and Hammer, *The Palestinian Diaspora*, 73.
34. Another film portraying the feminocentric nature of community within a Palestinian refugee camp is Dahna Abourahme's documentary *The Kingdom of Women* (Lebanon, 2010), which depicts the women of the Ein El Hilweh refugee camp in South Lebanon, who showed remarkable independence and resilience when all of the men in the community were imprisoned and the women managed to construct a town from scratch.
35. Elizabeth Grosz, *Space, Time, and Perversion: Essays on the Politics of Bodies* (London: Routledge, 1995), 86–87.

36. Sara Ahmed, 'Home and Away: Narratives of Migration and Estrangement,' *International Journal of Cultural Studies* 2, no. 3 (1999): 340.
37. Schultz and Hammer, *The Palestinian Diaspora*, 181.
38. An exciting body of work on the significance of Internet communication to Palestinians within and beyond the Palestinian Territories is starting to emerge. See Miriyam Aouragh, *Palestine Online: Transnationalism, the Internet and the Construction of Identity* (London: I.B.Tauris, 2011) for a contribution to this debate.
39. Ahmed, 'Home and Away,' 343.
40. The withdrawal of Israeli troops from South Lebanon took place in May 2000, after more than twenty years of conflict. See Sune Haugbolle, *War and Memory in Lebanon* (Cambridge: Cambridge University Press, 2010) for insight into the ways in which this and other conflicts have been processed by various communities within Lebanon.
41. Jackie Stacey and Sara Ahmed, 'Introduction: Dermographies,' in *Thinking through the Skin*, ed. Jackie Stacey and Sara Ahmed (London: Routledge, 2001), 1.
42. Sara Ahmed, 'Intimate Touches: Proximity and Distance in International Feminist Dialogues,' *Oxford Literary Review* 19 (1997): 28.
43. Ahmed, 'Home and Away,' 337.
44. Moore, *Arab, Muslim, Woman*, 145.
45. Laura Marks, *The Skin of the Film: Intercultural Cinema, Embodiment, and the Senses* (Durham: Duke University Press, 2000), 188.
46. While *jouissance* is essentially phallic for Lacan, he writes that there is a '*jouissance* of the Other' that is essentially feminine and 'beyond the phallus.' Jacques Lacan, *The Seminar of Jacques Lacan, Book XX. Encore, 1972–73*, ed. Jacques-Allain Miller, trans. Bruce Fink (1975; New York: W.W. Norton and Company, 1999), 74.
47. Verónica Schild, 'Transnational Links in the Making of Latin American Feminisms: A View from the Margins,' in *Émigré Feminisms: Transnational Perspectives*, ed. Alena Heitlinger (Toronto: University of Toronto Press, 1999), 71.
48. Irene Gedalof, 'Taking (a) Place: Female Embodiment and the Re-grounding of Community,' in *Uprootings/Regroundings: Questions of Home and Migration*, ed. Sara Ahmed, Claudia Castañeda, Anne-Marie Fortier and Mimi Sheller (Oxford: Berg, 2003), 95.
49. Gedalof, 'Taking (a) Place,' 92.
50. Elizabeth Grosz, *Volatile Bodies: Towards a Corporeal Feminism* (Bloomington: Indiana, 1994), 124.
51. Nye's awards include the National Poetry Series selection and Pushcart Prize, and fellowships include Lannan, Guggenheim and Witter Bynner fellowships, while other publications not discussed extensively in this chapter include *Never in a Hurry: Essays on People and Places* (Columbia: University of South Carolina Press, 1996) and the edited poetry collection *The Flag of Childhood: Poems from the Middle East* (New York: Aladdin Paperbacks, 2002).
52. See Kate Long, 'Roots: On Language and Heritage. A Conversation with Naomi Shihab Nye,' *World Literature Today* (November–December 2009): 31–34.
53. Sharif S. Elmusa, 'Vital Attitude of the Poet: Interview with Naomi Shihab Nye,' *Alif* 27 (2007): 107.

54. Poetry slams have emerged as a prominent part of the performance poetry scene in the U.S. They are typically competitions where poets read, recite or perform their work. Hammad does not generally perform her work in competitive contexts, but the style of her performance is certainly influenced by the sense of energy, spontaneity and connection with the audience that characterises slam poetry.
55. Suheir Hammad, 'first writing since,' in *ZaatarDiva* (New York: Cypher, 2005), 98–102.
56. Suheir Hammad, *Born Palestinian, Born Black & the Gaza Suite* (1996; New York: UpSet Press, 2010).
57. Suheir Hammad, *Drops of This Story* (New York: Harlem River Press, 1996).
58. See Marcy Jane Knopf-Newman, 'Interview with Suheir Hammad,' *MELUS* 31, no. 4 (2006): 71. For further discussion of both Nye's and Hammad's work within the context of Arab American cultural expression, see Layla Al Maleh, 'From Romantic Mystics to Hyphenated Ethics: Arab-American Writers Negotiating/Shifting Identities,' in *Arab Voices in Diaspora: Critical Perspectives on Anglophone Arab Literature*, ed. Layla Al Maleh (New York: Rodopi, 2009), 424–448.
59. These lines are cited by Suheir Hammad in the author's preface (1996) to *Born Palestinian, Born Black*, 11.
60. Knopf-Newman, 'Interview with Suheir Hammad,' 77.
61. See Keith Feldman, 'The (Il)Legible Arab Body and the Fantasy of National Democracy,' *MELUS* 31, no. 4 (2006): 33–53, for further discussion of the way in which Arab American communities may seek 'racial visibility' in order to assert political agency.
62. Kathleen Christison, *The Wound of Dispossession: Telling the Palestinian Story* (Santa Fe: Sunlit Hills Press, 2002), 74.
63. Naomi Shihab Nye, 'Jerusalem,' in *Tender Spot: Selected Poems* (Tarset: Bloodaxe, 2008), 120.
64. Long, 'Roots: On Language and Heritage,' 32.
65. Naomi Shihab Nye, 'Brushing Lives,' in *Red Suitcase* (New York: BOA Editions, 1994), 91.
66. Naomi Shihab Nye, 'My Father and the Fig Tree,' in *Tender Spot*, 102.
67. Knopf-Newman, 'Interview with Suheir Hammad,' 78–79. Indeed, it is interesting to note the potential overlap between the oral emphasis of poetry slams and musical influences on Hammad's work, with the oral tradition of improvised-sung poetry (*al-sicr al-murtajal*) in Palestinian culture, which is often sung at weddings and other celebrations, and also includes an element of debate between singers and interaction with the audience. See Dirgham H. Sbait, 'Debate in the Improvised-Sung Poetry of the Palestinians,' *Asian Folklore Studies* 52, no. 1 (1993): 93–117.
68. Suheir Hammad, 'daddy's song,' in *ZaatarDiva*, 29.
69. Hammad, 'mama sweet baklava,' *ZaatarDiva*, 36–37.
70. See Michelle Hartman, '"this sweet / sweet music": Jazz, Sam Cooke, and Reading Arab American Literary Identities,' *MELUS* 31, no. 4 (2006): 145–165 for further discussion of the influence of jazz in Hammad's work.
71. Naomi Shihab Nye, 'My Grandmother in the Stars,' in *Red Suitcase*, 41.
72. Naomi Shihab Nye, 'The Words under the Words,' in *19 Varieties of Gazelle*, 14–15.

73. Naomi Shihab Nye, 'Voices,' in *Red Suitcase*, 28.
74. Mohanty, 'Introduction: Cartographies of Struggle,' 4.
75. Suheir Hammad, 'rice haikus,' in Nye, *The Flag of Childhood*, 62.
76. Suheir Hammad, 'blood stitched time,' in *Born Palestinian, Born Black*, 24.
77. Suheir Hammad, 'What I Will,' 60.
78. See Carol A. Stabile and Deepa Kumar, 'Unveiling Imperialism: Media, Gender and the War on Afghanistan,' *Media, Culture and Society* 27, no. 5 (2005): 765–782 for further discussion of this gendered dynamic.
79. Shohat, 'Gender and Culture of Empire,' 63.
80. Said, 'The Mind of Winter,' 49–50.
81. Naomi Shihab Nye, 'He Said EYE-RACK,' in *Tender Spot*, 142.
82. Samina Najmi, 'Naomi Shihab Nye's Aesthetic of Smallness and the Military Sublime,' *MELUS* 35, no. 2 (2010): 162.
83. Naomi Shihab Nye, 'For Mohammed Zeid of Gaza, Age 15,' in *Tender Spot*, 138.
84. Naomi Shihab Nye, 'Parents of Murdered Palestinian Boy Donate His Organs to Israelis,' in *Tender Spot*, 156.
85. Suheir Hammad, 'of woman torn,' in *ZaatarDiva*, 75–76.
86. Hammad, 'of woman torn,' 76. It is significant to note, however, that other of Hammad's poems are equally critical of the gender structures she observes in parts of 'Western' culture. Poems such as 'delicious' and 'exotic,' for example, critique the 'Orientalist,' sexualising gaze of white American men, while 'yo baby yo' critiques the machismo posturing of young African American men in Brooklyn. All poems in *Born Palestinian, Born Black*.
87. Robert J.C. Young, *Postcolonialism: A Very Short Introduction* (Oxford: Oxford University Press, 2003), 2–7.
88. The term 'speaking truth to power' expresses Said's belief in the critic's function as a voice of opposition who must strive for truth and justice through their writing. The term appears as the title of an essay: Edward Said, 'Speaking Truth to Power,' in *Representations of the Intellectual* (New York: Vintage, 1996), 85–102.
89. Avtar Brah, 'Diaspora, Border and Transnational Identities,' in Lewis and Mills, *Postcolonial Feminist Theory*, 622–625.
90. Brah, 'Diaspora, Border and Transnational Identities,' 632.
91. Naomi Shihab Nye, 'Gate 4-A,' in *Tender Spot*, 157.
92. Brah, 'Diaspora, Border and Transnational Identities,' 628.
93. Chandra Talpade Mohanty, 'Feminist Encounters: Locating the Politics of Experience,' *Copyright* 1 (1987): 31.
94. Suheir Hammad, 'some of by best friends,' in *ZaatarDiva*, 89.

Notes to the Conclusion

1. Darwish, 'A State of Siege,' 169.
2. Fanon, *The Wretched of the Earth*, 169.
3. Khalili, *Heroes and Martyrs of Palestine*, 2.
4. Mikhail Bakhtin, *Problems of Dostoevsky's Poetics*, volume 8 of *Theory and History of Literature*, ed. and trans. Caryl Emerson (Minneapolis: University of Minnesota Press, 1984), 6.

5. See the introduction to this book and the 2011 special edition of *Arab Studies Quarterly* for further discussion of the problems encountered by academics wishing to engage with issues relating to Palestine.
6. Since this kind of very public opposition to debate on Palestine tends to emerge most strongly within the U.S. and at times in Europe, I am mainly referring to the work of research centres within these areas, such as the Institute for Palestine Studies based in Washington and Beirut, the Center for Palestine Studies at Columbia University, the European Centre for Palestine Studies at the University of Exeter and the Centre for Palestine Studies at SOAS.
7. Edward Said, 'Introduction: Secular Criticism,' in *The World, the Text and the Critic*, 4–5.
8. Shohat, 'Notes on the "Post-colonial",' 247–248.
9. Ali Abunimah, 'After Witnessing Palestine's Apartheid, Indigenous and Women of Color Feminists Endorse BDS,' *Electronic Intifada*, 7th December 2011, accessed 15th February 2012. http://electronicintifada.net/blog/ali-abunimah/after-witnessing-palestines-apartheid-indigenous-and-women-color-feminists-endorse.
10. 'Justice for Palestine: A Call to Action from Indigenous and Women of Colour Feminists,' cited in Abunimah, http://electronicintifada.net/blog/ali-abunimah/after-witnessing-palestines-apartheid-indigenous-and-women-color-feminists-endorse.

Bibliography

Aaronsohn, Ran. 'Baron Rothschild and the Initial Stage of Jewish Settlement in Palestine (1882–1890).' *Journal of Historical Geography* 19, no. 2 (1993): 142–156.

Abdel-Malek, Kamal. 'Living on Borderlines: War and Exile in Selected Works by Ghassan Kanafani, Fawaz Turki, and Mahmud Darwish.' In *Israeli and Palestinian Identities in History and Literature*, edited by Kamal Abdel-Malek and David Jacobson, 179–193. Basingstoke: Palgrave Macmillan, 1999.

Abdel-Malek, Kamal. *The Rhetoric of Violence: Arab-Jewish Encounters in Contemporary Palestinian Literature and Film.* Basingstoke: Palgrave Macmillan, 2006.

Abdel-Malek, Kamal and David C. Jacobson, eds. *Israeli and Palestinian Identities in History and Literature.* Basingstoke: Palgrave Macmillan, 1999.

Abdo, Nahla. 'Gender and Politics under the Palestinian Authority.' *Journal of Palestine Studies* 28, no. 2 (1999): 38–51.

Abdo, Nahla. 'Women of the Intifada: Gender, Class and National Liberation.' *Race and Class* 32, no. 4 (1991): 19–35.

Abu-Lughod, Lila. 'The Marriage of Feminism and Islamism in Egypt: Selective Repudiation as a Dynamic of Cultural Politics.' In *Remaking Women: Feminism and Modernity in the Middle East*, edited by Lila Abu-Lughod, 243–267. Princeton: Princeton University Press, 1988.

Abu-Lughod, Lila. 'Orientalism and Middle East Feminist Studies.' *Feminist Studies* 27, no. 1 (2001): 101–113.

Abunimah, Ali. 'After Witnessing Palestine's Apartheid, Indigenous and Women of Color Feminists Endorse BDS.' *Electronic Intifada*, 7th December 2011. Accessed 15th February. http://electronicintifada.net/blog/ali-abunimah/after-witnessing-palestines-apartheid-indigenous-and-women-color-feminists-endorse.

Abu-Odeh, Lama. 'Crimes of Honour and the Construction of Gender in Arab Societies.' In *Feminism and Islam: Legal and Literary Perspectives*, edited by Mai Yamani, 141–196. Reading: Ithaca Press, 1996.

Accad, Evelyne. *Sexuality and War: Literary Masks of the Middle East.* New York: New York University Press, 1990.

Adonis, Mahmud Darwish and Samih al-Qasim. *Victims of a Map: A Bilingual Anthology of Arabic Poetry.* Translated by Abdullah al-Udhari. London: Saqi, 1984.

Ahmed, Leila. *Women and Gender in Islam: Historical Roots of a Modern Debate.* New Haven, CT: Yale University Press, 1992.

Ahmed, Sara. 'Home and Away: Narratives of Migration and Estrangement.' *International Journal of Cultural Studies* 2, no. 3 (1999): 329–347.

Ahmed, Sara. 'Intimate Touches: Proximity and Distance in International Feminist Dialogues.' *Oxford Literary Review* 19 (1997): 19–46.

Ahmed, Sara. *Strange Encounters: Embodied Others in Post-coloniality.* London: Routledge, 2000.

Al-Hout, Bayan Nuwayhed. *Sabra and Shatila: September 1982*. London: Pluto, 2004.
Allen, Roger. *An Introduction to Arabic Literature*. Cambridge: Cambridge University Press, 2000.
'Allush, Laila. 'The Path of Affection.' In *Anthology of Modern Palestinian Literature*, edited by Salma Khadra Jayyusi, 106–107. New York: Columbia University Press, 1992.
Al-Nowaihi, Magda M. 'Resisting Silence in Arab Women's Autobiographies.' *International Journal of Middle East Studies* 33, no. 4 (2001): 477–502.
Al-Qasim, Samih. 'You Pretend to Die.' In *Anthology of Modern Palestinian Literature*, edited by Salma Khadra Jayyusi, 258. New York: Columbia University Press, 1992.
Al Maleh, Layla. 'From Romantic Mystics to Hyphenated Ethnics: Arab-American Writers Negotiating/Shifting Identities.' In *Arab Voices in Diaspora: Critical Perspectives on Anglophone Arab Literature*, edited by Layla Al Maleh, 424–448. New York: Rodopi, 2009.
Amery, Hussein A. and Aaron T. Wolf. *Water in the Middle East: A Geography of Peace*. Austin: University of Texas Press, 2000.
Anderson, Benedict. *Imagined Communities: Reflections on the Origins and Spread of Nationalism*. Revised edition. London: Verso, 1991.
Anzaldúa, Gloria. *Borderlands / La Frontera: The New Mestiza*. San Francisco: Aunt Lute Books, 1987.
Aouragh, Miriyam. *Palestine Online: Transnationalism, the Internet and the Construction of Identity*. London: I.B.Tauris, 2011.
Ardener, Shirley. 'Ground Rules and Social Maps: An Introduction.' In *Women and Space: Ground Rules and Social Maps*, 11–32. Oxford: Berg, 1993.
Ardener, Shirley. *Women and Space: Ground Rules and Social Maps*. Oxford: Berg, 1993.
Armstrong, John. *Nations before Nationalism*. Chapel Hill: University of North Carolina Press, 1982.
Ashcroft, Bill, Gareth Griffiths and Helen Tiffin. *The Empire Writes Back: Theory and Practice in Post-colonial Literatures*. Second edition. London: Routledge, 2003.
Ashrawi, Hanan Mikhail. 'The Contemporary Palestinian Poetry of Occupation.' *Journal of Palestine Studies* 7, no. 3 (1978): 77–101.
Ashrawi, Hanan. *This Side of Peace: A Personal Account*. New York: Simon and Schuster, 1995.
Ata, Ibrahim Wade. *The West Bank Palestinian Family*. London: KPI Limited, 1986.
Ayoob, Mohammed. *Middle East in World Politics*. Abingdon: Croom Helm, 1981.
Badr, Liana. *A Balcony over the Fakihani*. Translated by Peter Clark and Christopher Tingley. 1983, in Arabic; Northampton, MA: Interlink Books, 1995.
Badr, Liana. *A Compass for the Sunflower*. Translated by Catherine Cobham. 1979, in Arabic; London: The Women's Press, 1989.
Badr, Liana. *The Eye of the Mirror*. Translated by Samira Kawar. 1991, in Arabic; Reading: Garnet, 2008.
Badran, Margot. *Feminists, Islam, and Nation: Gender and the Making of Modern Egypt*. Princeton: Princeton University Press, 1995.
Badran, Margot and Miriam Cooke, 'Introduction.' In *Opening the Gates: A Century of Arab Feminist Writing*, edited by Margot Badran and Miriam Cooke, xvii–xxxix. London: Virago, 1992.
Bakhtin, Mikhail. *Problems of Dostoevsky's Poetics*. Volume 8 of *Theory and History of Literature*, edited and translated by Caryl Emerson. Minneapolis: University of Minnesota Press, 1984.
Ball, Anna. 'Between a Postcolonial Nation and Fantasies of the Feminine: The Contested Visions of Palestinian Cinema.' *Camera Obscura: Feminism, Culture and Media Studies* 23, no. 3 (2008): 1–35.

Ball, Anna. 'Impossible Intimacies: Towards a Politics of "Touch" at the Israeli-Palestinian Border.' *Cultural Research* 16, nos. 2–3 (2012): 175–195.
Baron, Beth. *Egypt as a Woman: Nationalism, Gender, and Politics.* Berkeley: University of California Press, 2005.
Baud, Michiel and Willem Van Schendel. 'Towards a Comparative History of the Borderlands.' *Journal of World History* 8, no. 2 (1997): 211–242.
Baxter, Diane. 'Honour Thy Sister: Selfhood, Gender, and Agency in Palestinian Culture.' *Anthropological Quarterly* 80, no. 3 (2007): 737–775.
Beit-Hallahmi, Benjamin. *Original Sins: Reflections on the History of Zionism and Israel.* New York: Olive Branch Press, 1993.
Bernard, Anna. 'Palestine and Postcolonial Studies.' Unpublished paper, University of York, 2010. Accessed June 2011. http://www.sas.ac.uk/fileadmin/documents/postgraduate/Papers_London_Debates_2010/Bernard__Palestine_and_postcolonial_studies.pdf.
Bhabha, Homi. 'Dissemination: Time, Narrative and the Margins of the Modern Nation.' In *The Location of Culture*, 139–170. London: Routledge, 1994.
Bhabha, Homi. 'Double Visions.' *Artforum* 30, no. 5 (1992): 82–90.
Bhabha, Homi, ed. *Nation and Narration.* London: Routledge, 1990.
Boullata, Issa J. 'Ibrahim Tuqan's Poem "Red Tuesday".' In *Tradition and Modernity in Arabic Literature*, edited by Issa J. Boullata and Terri DeYoung, 87–100. Fayetteville: University of Arkansas Press, 1997.
Bowman, James. 'Humanized without Honour.' *American Spectator* 39 (2006): 58–59.
Brah, Avtar. *Cartographies of Diaspora: Contesting Identities.* New York: Routledge, 2002.
Brah, Avtar. 'Diaspora, Border and Transnational Identities.' In *Feminist Postcolonial Theory*, edited by Reina Lewis and Sara Mills, 613–634. Edinburgh: Edinburgh University Press, 2010.
Braidotti, Rosi. *Nomadic Subjects: Embodiment and Sexual Difference in Contemporary Feminist Theory.* New York: Columbia University Press, 1994.
Braziel, Jana Evans and Anita Mannur. 'Nation, Migration, Globalization: Points of Contention in Diaspora Studies.' In *Theorizing Diaspora: A Reader*, edited by Jana Evans Braziel and Anita Mannur, 1–22. Oxford: Blackwell, 2003.
Brunner, Claudia. 'Female suicide bombers—Male suicide bombing? Looking for Gender in Reporting the Suicide Bombings of the Israeli-Palestinian Conflict.' *Global Society* 19, no. 1 (2005): 29–48.
Brym, Robert and Bader Araj. 'Suicide Bombing as Strategy and Interaction: The Case of the Second Intifada.' *Social Forces* 84, no. 4 (2006): 1969–1986.
Bucaille, Laetitia. *Growing Up Palestinian: Israeli Occupation and the Intifada Generation.* Translated by Anthony Roberts. Princeton: Princeton University Press, 2004.
Bush, George W. 'Address to a Joint Session of Congress and the American People.' *The Whitehouse.* 20th September 2001. http://www.whitehouse.gov/news/releases/2001/09.
Butler, Judith. *Gender Trouble: Feminism and the Subversion of Identity.* New York: Routledge Classics, 2006.
Cabral, Amilcar. 'National Liberation and Culture.' In *Unity and Struggle, Speeches and Writings.* Translated by Michael Wolfers, 138–154. New York: Monthly Review Press, 1979.
Certeau, Michel de. 'Walking in the City.' In *The Practice of Everyday Life*, translated by Steven Rendall, 91–110. Berkley: University of California Press, 1988.
Charrad, Mounira M. *States and Women's Rights: The Making of Postcolonial Tunisia, Algeria and Morocco.* Berkeley: University of California Press, 2001.
Chatterjee, Partha. 'The Nationalist Resolution of the Women's Question.' In *Recasting Women: Essays in Indian Colonial History*, edited by Kumkum Sangari and Sudesh Vaid, 233–253. New Brunswick, NJ: Rutgers University Press, 1989.

Chatterjee, Partha. *The Nation and Its Fragments: Colonial and Postcolonial Histories.* Princeton: Princeton University Press, 1993.

Christison, Kathleen. *The Wound of Dispossession: Telling the Palestinian Story.* Santa Fe: Sunlit Hills Press, 2002.

Cleary, Joe. *Literature, Partition and the Nation-State: Culture and Conflict in Ireland, Israel and Palestine.* Cambridge: Cambridge University Press, 2002.

Clifford, James. 'Diasporas.' *Cultural Anthropology* 9, no. 3 (1994): 302–338.

Cohen, Michael J. *The Origins and Evolution of the Arab-Zionist Conflict.* Berkley: University of California Press, 1987.

Connell, R.W. *Masculinities.* Cambridge: Polity Press, 1995.

Cooke, Miriam. 'Feminist Transgressions in the Postcolonial Arab World.' *Critique: Critical Middle Eastern Studies* 8, no. 14 (1999): 93–105.

Cooke, Miriam. *Women Claim Islam: Creating Islamic Feminism Through Literature.* New York: Routledge, 2000.

Cottrell, Robert C. *The Green Line: The Division of Palestine.* Philadelphia: Chelsea House Publishers, 2005.

Dabashi, Hamid, ed. *Dreams of a Nation: On Palestinian Cinema.* London: Verso, 2006.

Dabashi, Hamid. 'In Praise of Frivolity: On the Cinema of Elia Suleiman.' In *Dreams of a Nation: On Palestinian Cinema*, edited by Hamid Dabashi, 131–161. London: Verso, 2006.

Dabashi, Hamid. 'Introduction.' In *Dreams of a Nation: On Palestinian Cinema*, 8–22. London: Verso, 2006.

Darraj, Faisal. 'Transformations in Palestinian Literature.' Translated by Michael K. Scott. *Words without Borders.* November 2006. Accessed 20th December 2011. http://wordswithoutborders.org/issue/november-2006.

Darwish, Mahmoud. *Absent Presence.* Translated by Mohammad Shaheen. London: Hesperus Press, 2010.

Darwish, Mahmoud. *The Butterfly's Burden.* Translated by Fady Joudah. Tarset: Bloodaxe, 2000.

Darwish, Mahmoud. 'Identity Card.' In *The Music of Human Flesh*, translated by Denys Johnson-Davies, 10–11. London: Heinemann, 1980.

Darwish, Mahmoud. 'A State of Siege.' In *The Butterfly's Burden*, translated by Fady Joudah, bilingual edition, 119–173. Tarset: Bloodaxe, 2007.

Darwish, Mahmoud. *Unfortunately, It Was Paradise: Selected Poems.* Edited and translated by Munir Akash and Carolyn Forché with Sinan Antoon and Amira El-Zein. Berkeley: University of California Press, 2003.

Deleuze, Gilles and Felix Guattari. *Kafka: Towards a Minor Literature.* Translated by Dora Polan. Minneapolis: University of Minnesota Press, 1986.

Deleuze, Gilles and Félix Guattari. *A Thousand Plateaus: Capitalism and Schizophrenia.* London: Continuum, 2004.

DeYoung, Terri. '"Love, Death and the Ghost of al-Khansa": The Modern Female Poetic Voice in Fadwa Tuqan's Elegies for Her Brother Ibrahim.' In *Tradition, Modernity and Postmodernity in Arabic Literature*, edited by Kamal Abdel-Malek and Wael Hallaq, 45–75. Leiden, Netherlands: Brill, 2000.

Divine, Donna Robinson. 'Introduction.' In *Postcolonial Theory and the Arab-Israel Conflict*, edited by Philip Carl Salzman and Donna Robinson Divine, 1–11. Abingdon: Routledge, 2008.

Eisenzweig, Uri. 'An Imaginary Territory? The Problematic of Space in Zionist Discourse.' *Dialectical Anthropology* 5 (1981): 261–285.

Elad-Bouskila, Ami. *Modern Palestinian Literature and Culture.* London: Routledge, 1999.

Elmessiri, A.M., ed. and trans. *The Palestinian Wedding: A Bilingual Anthology of Contemporary Palestinian Resistance Poetry*. Washington, DC: Three Continents Press, 1982.

Elmessiri, Nur and Abdelwahab, eds. *A Land of Stone and Thyme: An Anthology of Palestinian Short Stories*. London: Quartet, 1996.

Elmusa, Sharif S. 'Vital Attitude of the Poet: Interview with Naomi Shihab Nye.' *Alif* 27 (2007): 107–113.

El Said, Maha. 'The Face of the Enemy: Arab-American Poetry Post-9/11.' *Studies in the Humanities* 30, nos. 1–2 (2003): 200–217.

El Sarraj, Eyad and Linda Butler. 'Suicide Bombers: Dignity, Despair, and the Need for Hope: An Interview with Eyad El Sarraj.' *Journal of Palestine Studies* 31, no. 4 (2002): 71–76.

El-Youssef, Samir. 'The Day the Beast Got Thirsty.' In *Gaza Blues: Different Stories*, Samir El-Youssef and Etgar Keret, 111–173. London: David Paul, 2004.

El-Youssef, Samir. *The Illusion of Return*. London: Halban, 2007.

Enloe, Cynthia. *Bananas, Beaches and Bases: Making Feminist Sense of International Politics*. Berkeley: University of California Press, 1990.

Fähndrich, Hartmuch. 'Fathers and Husbands: Tyrants and Victims in Some Autobiographical and Semi-autobiographical Works from the Arab World.' In *Love and Sexuality in Modern Arab Literature*, edited by Roger Allen, Hilary Kilpatrick and Ed de Moor, 106–115. London: Saqi, 1995.

Fanon, Frantz. 'Algeria Unveiled.' In *Studies in a Dying Colonialism*, 35–67. New York: Monthly Review Press, 1965.

Fanon, Frantz. 'On National Culture.' In *Colonial Discourse and Post-colonial Theory*, edited by Patrick Williams and Laura Chrisman, 36–52. Harlow: Pearson Education Limited, 1994.

Fanon, Frantz. *Studies in a Dying Colonialism*. Translated by Haakon Chevalier. 1958; New York: Monthly Review Press, 1965.

Fanon, Frantz. *The Wretched of the Earth*. Translated by Constance Farrington. 1961, in French; London: Penguin, 1969.

Farsoun, Samih K. *Culture and Customs of the Palestinians*. Westport: Greenwood Press, 2004.

Fayad, Mona. 'Cartographies of Identity: Writing Maghribi Women and Postcolonial Subjects.' In *Beyond Colonialism and Nationalism in the Maghrib: History, Culture, and Politics*, edited by Ali Abdullatif Ahmida. New York: Palgrave, 2000.

Feldman, Keith. 'The (Il)Legible Arab Body and the Fantasy of National Democracy.' *MELUS* 31, no. 4 (2006): 33–53.

Finkelstein, Norman G. *Image and Reality of the Israel-Palestine Conflict*. London: Verso, 1995.

Finkelstein, Norman G. 'A Land without a People: Joan Peters's "Wilderness" Image.' In *Image and Reality of the Israel-Palestine Conflict*, second edition, 21–50. London: Verso, 2003.

Fitzgerald, Mary. 'A Faraway Country.' *The New Statesman*, 15th January 2007. Accessed 20th November 2009. http://www.newstatesman.com/books/2007/01/return-palestinian-youssef.

Fleischmann, Ellen L. 'The Emergence of the Palestinian Women's Movement, 1929–39.' *Journal of Palestine Studies* 29, no. 3 (2000): 16–32.

Fluehr-Lobhan, Carolyn. 'The Political Mobilisation of Women in the Arab World.' In *Women in Contemporary Muslim Societies*, edited by Jane Smith, 235–252. Lewisburg: Bucknell University Press, 1980.

Foucault, Michel. 'Interview on the Prison: The Book and Its Method.' Cited in Colin Gordon, 'Introduction.' In Michel Foucault, *Power: Essential Works of Michel*

Foucault 1954–1984, volume 3, edited by James D. Faubion, translated by Robert Hurley and others, xii–xli. London: Penguin, 2002.
Foucault, Michel. 'Of Other Spaces.' Translated by Jay Miskowiec. *Diacritics* 16 (Spring 1986): 22–27.
France and the United Kingdom. 'Sykes-Picot Agreement.' *United Nations Information System on the Question of Palestine.* 16th May 1916. Accessed 21st December 2011. http://unispal.un.org/UNISPAL.NSF/0/232358BACBEB7B5585257110007 8477C.
Freud, Sigmund. 'The Question of Lay Analysis.' In *The Complete Psychological Works of Sigmund Freud*, volume 20, edited by James Strachey, 177–258. London: Vintage, 2001.
Gedalof, Irene. 'Taking (a) Place: Female Embodiment and the Re-grounding of Community.' In *Uprootings/Regroundings: Questions of Home and Migration*, edited by Sara Ahmed, Claudia Castañeda, Anne-Marie Fortier and Mimi Sheller, 91–107. Oxford: Berg, 2003.
Gerber, Haim. 'Zionism, Orientalism, and the Palestinians.' *Journal of Palestine Studies* 33, no. 1 (2003): 23–41.
Gertz, Nurith and George Khleifi. *Palestinian Cinema: Landscape, Trauma, Memory.* Edinburgh: University of Edinburgh Press, 2008.
Gertz, Nurith and George Khleifi. 'Palestinian "Roadblock Movies".' *Geopolitics* 10 (2005): 316–334.
Ghoussoub, Mai and Emma Sinclair-Webb, eds. *Imagined Masculinities: Male Identity and Culture in the Modern Middle East.* London: Saqi Books, 2000.
Giacaman, Rita. 'Palestinian Women, the *Intifada* and the State of Independence: An Interview.' *Race and Class* 34 (1993): 31–43.
Gibson, Nigel C. 'The "Absolute Originality" of Women's Actions.' In *Fanon: The Postcolonial Imagination*, 139–148. Cambridge: Polity, 2003.
Gil, Moshe. *A History of Palestine, 634–1099.* Translated by Ethel Broido. Cambridge: Cambridge University Press, 2002.
Gilbert, Martin. *Israel: A History.* London: Black Swan, 2008.
Gilman, Sander L. *Freud, Race and Gender.* Princeton: Princeton University Press, 1995.
Glanville, Jo, ed. *Qissat: Short Stories by Palestinian Women.* London: Telegram, 2006.
Goldstein, Kaylin. 'Reading Palestine-Israel: On Coloniality and Other Paradigms.' *Middle East Report* 225 (2002): 50–52.
Golley, Nawar Al-Hassan. *Reading Arab Women's Autobiographies: Shahrazad Tells Her Story.* Austin: University of Texas Press, 2003.
Gregory, Derek. *The Colonial Present: Afghanistan, Palestine, Iraq.* Oxford: Blackwell, 2004.
Grewal, Inderpal and Caren Kaplan, eds. *Scattered Hegemonies: Postmodernity and Transnational Feminist Practices.* St Paul: University of Minnesota Press, 1994.
Grosz, Elizabeth. *Space, Time, and Perversion: Essays on the Politics of Bodies.* London: Routledge, 1995.
Grosz, Elizabeth. *Volatile Bodies: Towards a Corporeal Feminism.* Bloomington: Indiana, 1994.
Habiby, Emile. *The Secret Life of Saeed the Pessoptimist.* Translated by Salma K. Jayyusi and Trevor Le Gassick. London: Arabia Books, 2010.
Haj, Samira. 'Palestinian Women and Patriarchal Relations.' *Signs* 17, no. 4 (1992): 761–778.
Hall, Stuart. 'Cultural Identity and Diaspora.' In *The Postcolonial Studies Reader*, edited by Bill Ashcroft, Gareth Griffiths and Helen Tiffin, 435–438. London: Routledge, 2006.

Halper, Jeff. 'A Strategy within a Non-Strategy: Sumud, Resistance, Attrition, and Advocacy.' *Journal of Palestine Studies* 35, no. 3 (2006): 45–51.
Hammad, Suheir. *Born Palestinian, Born Black & The Gaza Suite*. 1996; New York: UpSet Press, 2010.
Hammad, Suheir. *Drops of This Story*. New York: Harlem River Press, 1996.
Hammad, Suheir. *ZaatarDiva*. New York: Cypher, 2005.
Hammer, Juliane. *Palestinians Born in Exile: Diaspora and the Search for a Homeland*. Austin: University of Texas Press, 2005.
Hanafi, Sari. 'Opening the Debate on the Right of Return.' *Middle East Report* 222 (2002): 2–7.
Handal, Nathalie, ed. *The Poetry of Arab Women: A Contemporary Anthology*. New York: Interlink, 2001.
Hanisch, Carol. 'The Personal Is the Political.' February 1969. Accessed 12th September 2012. http://www.carolhanisch.org/CHwritings/PIP.html.
Harlow, Barbara. *After Lives: Legacies of Revolutionary Writing*. London: Verso, 1996.
Harlow, Barbara. 'Partitions and Precedents: Sahar Khalifeh and Palestinian Political Geography.' In *Intersections: Gender, Nation, and Community in Arab Women's Novels*, edited by Lisa Suhair Majaj, Paula W. Sunderman and Therese Saliba, 113–131. New York: Syracuse University Press, 2002.
Harlow, Barbara. *Resistance Literature*. New York: Methuen, 1987.
Hartman, Michelle. '"this sweet / sweet music": Jazz, Sam Cooke, and Reading Arab American Literary Identities.' *MELUS* 31, no. 4 (2006): 145–165.
Hasan, Mehdi. 'No End to the Strangulation of Gaza.' *New Statesman*, 3rd January 2011, 29.
Hasian Jr., Marouf and Lisa A. Flores. 'Children of the Stones: The Intifada and the Mythic Creation of the Palestinian State.' *Southern Communication Journal* 62, no. 2 (1997): 89–106.
Hassan, Salah D. '*Modern Palestinian Literature* and the Politics of Appeasement.' *Social Text* 21, no.2 (2003): 7–23.
Hassan, Waïl S. 'Postcolonial Theory and Modern Arabic Literature: Horizons of Application.' *Journal of Arabic Literature* 33, no. 1 (2002): 45–60.
Hassan, Waïl S. and Rebecca Saunders. 'Introduction to the Special Edition on Comparative (Post)Colonialisms.' *Comparative Studies of South Asia, Africa and the Middle East* 23, no. 1 (2003): 18–31.
Hasso, Frances S. 'Feminist Generations: The Long-Term Impact of Social Movement Involvement on Palestinian Women's Lives.' *American Journal of Sociology* 107, no. 3 (2001): 586–611.
Hasso, Frances S. 'Modernity and Gender in Arab Accounts of the 1949 and 1967 Defeats.' *International Journal of Middle East Studies* 32, no. 4 (2000): 491–510.
Hasso, Frances S. *Resistance, Repression, and Gender Politics in Occupied Palestine and Jordan*. Syracuse, NY: Syracuse University Press, 2005.
Hasso, Frances S. 'Review of Rhoda Ann Kanaaneh's Birthing the Nation: Strategies of Palestinian Women in Israel.' *Gender and Society* 17, no. 3 (2003): 482–492.
Hasso, Frances S. 'The "Women's Front": Nationalism, Feminism, and Modernity in Palestine." *Gender and Society* 12, no. 4 (1998): 441–465.
Haugbolle, Sune. *War and Memory in Lebanon*. Cambridge: Cambridge University Press, 2010.
Heng, Geraldine. '"A Great Way to Fly": Nationalism, the State, and the Varieties of Third-World Feminism.' In *Feminist Genealogies, Colonial Legacies, Democratic Futures*, edited by M. Jacqui Alexander and Chandra Talpade Mohanty, 30–45. New York: Routledge, 1997.
Herzl, Theodor. *The Jewish State*. Minneapolis: Filiquarian Publishing LLC, 2006.

Herzl, Theodor. *Old-New-Land*. First edition. Minneapolis: Filiquarian Publishing LLC, 2007.
Herzog, Hanna and Taghreed Yahia-Younis. 'Men's Bargaining with Patriarchy: The Case of Primaries within Hamulas in Palestinian Arab Communities in Israel.' *Gender and Society* 21, no. 4 (2007): 579–602.
Hicks, D. Emily. *Border Writing: The Multidimensional Text*. Minneapolis: University of Minnesota Press, 1991.
Hillauer, Rebecca, ed. *The Encyclopedia of Arab Women Filmmakers*. Translated by Allison Brown, Deborah Cohen and Nancy Joyce. Cairo: The American University in Cairo Press, 2005.
Hillauer, Rebecca. 'Mai Masri.' In *The Encyclopedia of Arab Women Filmmakers*, 223–227. Cairo: The American University in Cairo Press, 2005.
Hillauer, Rebecca. 'Mona Hatoum.' In *The Encyclopedia of Arab Women Filmmakers*, 212–214. Cairo: The American University in Cairo Press, 2005.
Holt, Maria. 'Palestinian Women, Violence, and the Peace Process.' *Development in Practice* 13, no. 2 (2003): 223–238.
hooks, bell. 'Choosing the Margin as a Space of Radical Openness.' In *The Feminist Standpoint Theory Reader: Intellectual and Political Controversies*, edited by Sandra G. Harding, 153–160. New York: Routledge, 2004.
Horrocks, Roger. *Masculinity in Crisis*. Basingstoke: Macmillan Press, 1994.
Hosea, Leana. 'A Woman's Place in the New Egypt.' *BBC News: Middle East*, 23rd March 2011. Accessed 18th September 2011. http://www.bbc.co.uk/news/world-middle-east-12819919.
Hudson, Leila. 'Coming of Age in Occupied Palestine: Engendering the Intifada.' In *Reconstructing Gender in the Middle East: Tradition, Identity, and Power*, edited by Fatma Müge Göçek and Shiva Balaghi, 123–138. New York: Columbia University Press, 1994.
Husain, Rashid. 'First.' In *Anthology of Modern Palestinian Literature*, edited by Salma Khadra Jayyusi, 175. New York: Columbia University Press, 1992.
Ismael, Tareq, ed. 'Academic Freedom, Ideological Boundaries, and the Teaching of the Middle East.' Special edition. *Arab Studies Quarterly* 33, nos. 3–4 (2011).
Jabotinsky, Vladimir. 'The Iron Wall (We and the Arabs).' 1923/1937. Cited in Sa'di, 'The Borders of Colonial Encounter: The Case of Israel's Wall.' *Asian Journal of Social Science* 38 (2010): 47.
Jabra, Jabra Ibrahim. 'In the Deserts of Exile.' In *An Anthology of Modern Arabic Poetry*, edited and translated by Mounah Khouri and Hamid Algar, 225. Berkley: University of California Press, 1974.
Jacir, Annemarie. '"For Cultural Purposes Only": Curating a Palestinian Film Festival.' In *Dreams of a Nation: On Palestinian Cinema*, edited by Hamid Dabashi, 23–31. London: Verso, 2006.
Jad, Islah. 'The Conundrums of Post-Oslo Palestine: Gendering Palestinian Citizenship.' *Feminist Theory* 11, no. 2 (2010): 149–169.
Jayawardena, Kumari. *Feminism and Nationalism in the Third World*. London: Zed, 1992.
Jayyusi, Salma Khadra, ed. *Anthology of Modern Palestinian Literature*. New York: Columbia University Press, 1992.
Jayyusi, Salma Khadra. 'Palestinian Identity in Literature.' In *Israeli and Palestinian Identities in History and Literature*, edited by Kamal Abdel-Malek and David Jacobson, 167–177. Basingstoke: Palgrave Macmillan, 1999.
Johnson, Penny. 'From Seclusion to Creation.' *The Women's Review of Books* 8, no. 4 (1991): 11–12.

Johnson, Penny and Eileen Kuttab. 'Where Have All the Women (and Men) Gone? Reflections on Gender and the Second Palestinian Intifada.' *Feminist Review* 69 (2001): 21-43.
Joseph, Suad. *Intimate Selving in Arab Families: Gender, Self, and Identity*. New York: Syracuse University Press, 1999.
Kanaaneh, Rhoda Ann. *Birthing the Nation: Strategies of Palestinian Women in Israel*. Berkeley: University of California Press, 2005.
Kanafani, Ghassan. *Literature of Resistance in Occupied Palestine: 1948-1966*. Beirut: Institute for Arab Research, 1981.
Kanafani, Ghassan. *Men in the Sun and Other Palestinian Stories*. Translated by Hilary Kilpatrick. Boulder: Lynne Rienner, 1999.
Kandiyoti, Deniz. 'Bargaining with Patriarchy.' *Gender and Society* 2, no. 3 (1988): 274-290.
Kandiyoti, Deniz. *Women, Islam and the State*. Philadelphia, PA: Temple University Press, 1991.
Kaplan, Caren. 'The Politics of Location as Transnational Feminist Critical Practice.' In *Hybridity and Its Discontents: Politics, Science, Culture*, edited by Avtar Brah and Annie E. Coombs, 137-152. London: Routledge, 2000.
Kaplan, Caren, Norma Alarcón and Minoo Moallem, eds. *Between Women and Nation: Nationalisms, Transnational Feminisms, and the State*. Durham: Duke University Press, 1999.
Kaplan, Danny. 'The Military as a Second Bar Mitzvah: Combat Service as Initiation to Zionist Masculinity.' In *Imagined Masculinities*, edited by Mai Ghoussoub and Emma Sinclair-Webb, 127-146. London: Saqi Books, 2000.
Karmi, Ghada. *In Search of Fatima: A Palestinian Story*. London: Verso, 2002.
Karmi, Omar. '"Enough for Me to Die on Her Earth": An Obituary of Palestinian Poetess Fadwa Touqan.' *Palestine-Israel Journal* 11, no. 1 (2004): 96-98.
Karpinski, Eva C. 'Choosing Feminism, Choosing Exile: Towards the Development of a Transnational Feminist Consciousness.' In *Émigré Feminism: Transnational Perspectives*, edited by Alena Heitlinger, 17-29. Toronto: University of Toronto Press, 1999.
Katz, Sheila Hannah. '*Adam* and *Adama*, *'Ird* and *Ard*: En-gendering Political Conflict and Identity in Early Jewish and Palestinian Nationalisms.' In *Gendering the Middle East: Emerging Perspectives*, edited by Deniz Kandiyoti, 85-105. London: I.B.Tauris, 1996.
Kennedy, Michael. 'Prison Is for Men: Remembering Al-Fara'a.' *Surfacing* 2, no. 1 (2009): 90-114.
Keret, Etgar. *Missing Kissenger*. London: Vintage, 2008.
Keret, Etgar. *The Nimrod Flipout*. London: Vintage, 2006.
Khaled, Leila with George Hajjar. *My People Shall Live: Autobiography of a Revolutionary*. Toronto: NC Press Ltd., 1975.
Khalidi, Rashid. *The Iron Cage: The Palestinian Struggle for Statehood*. Oxford: Oneworld, 2007.
Khalidi, Rashid. *Palestinian National Identity: The Construction of Modern National Consciousness*. New York: Columbia University Press, 1997.
Khalidi, Rashid. *Resurrecting Empire: Western Footprints and America's Perilous Path in the Middle East*. London: I.B.Tauris, 2004.
Khalifeh, Sahar. *Wild Thorns*. Translated by Salma Khadra Jayyusi, Osman Nusairi and Jana Gough. 1976, in Arabic; London: Saqi, 2005.
Khalili, Laleh. *Heroes and Martyrs of Palestine: The Politics of National Commemoration*. Cambridge: Cambridge University Press, 2007.
Khalili, Laleh. 'A Landscape of Uncertainty: Palestinians in Lebanon.' *Middle East Report* 236 (2005): 34-39.

Khashan, Hilal. 'Collective Palestinian Frustration and Suicide Bombings.' *Third World Quarterly* 24, no. 6 (2003): 1049–1067.
Khatib, Lina. *Filming the Modern Middle East: Politics in the Cinemas of Hollywood and the Arab World*. London: I.B.Tauris, 2006.
Khleifi, Michel. 'From Reality to Fiction—From Poverty to Expression.' Translated by Omar al-Qattan. In *Dreams of a Nation: On Palestinian Cinema*, edited by Hamid Dabashi, 45–57. London: Verso, 2006.
Kirby, Kathleen M. *Indifferent Boundaries: Spatial Concepts of Human Subjectivity*. London: Guilford Press, 1996.
Kirby, Kathleen M. 'Re-mapping Subjectivity: Cartographic Vision and the Limits of Politics.' In *Body/Space: Destabilising Geographies of Gender and Sexuality*, edited by Nancy Duncan, 45–55. London: Routledge, 1996.
Knopf-Newman, Marcy Jane. 'Interview with Suheir Hammad.' *MELUS* 31, no. 4 (2006): 71–91.
Krämer, Gudrun. *A History of Palestine: From the Ottoman Conquest to the Founding of the State of Israel*. Translated by Graham Harmer and Gudrun Krämer. Princeton: Princeton University Press, 2008.
Lacan, Jacques. *The Seminar of Jacques Lacan, Book XX. Encore, 1972–73*. Edited by Jacques-Allain Miller. Translated by Bruce Fink. 1975; New York: W.W. Norton and Company, 1999.
Lagerquist, Peter. 'Fencing the Last Sky: Excavating Palestine after Israel's "Separation Wall".' *Journal of Palestine Studies* 33, no. 2 (2004): 5–35.
Landry, Donna and Gerald MacLean, eds. *The Spivak Reader: Selected Works of Gayatri Chakravorty Spivak*. London: Routledge, 1996.
Lavie, Smadar and Ted Swedenburg. 'Introduction.' In *Displacement, Diaspora, and Geographies of Identity*, edited by Smadar Lavie and Ted Swedenburg, 1–25. Durham: Duke University Press, 1996.
Layoun, Mary N. 'A Guest at the Wedding: Honour, Memory, and (National) Desire in Michel Khleife's *Wedding in Galilee*.' In *Between Women and Nation: Nationalisms, Transnational Feminisms, and the State*, edited by Caren Kaplan, Norma Alarcón and Minoo Moallem, 92–107. Durham: Duke University Press, 1999.
Lerner, Gerda. *The Creation of Patriarchy: The History of Women's Subordination*. Oxford: Oxford Paperbacks, 1988.
Levant, Ronald F. 'The Masculinity Crisis.' *The Journal of Men's Studies* 5 (1997): 221–231.
Lewis, Reina. *Gendering Orientalism: Race, Femininity and Representation*. London: Routledge, 1996.
Lewis, Reina and Sara Mills, eds. *Feminist Postcolonial Theory: A Reader*. Edinburgh: Edinburgh University Press, 2010.
Lewis, Reina and Sara Mills. 'Introduction.' In *Feminist Postcolonial Theory: A Reader*, 1–20. Edinburgh: Edinburgh University Press, 2010.
Lionnet, Françoise. *Postcolonial Representations: Women, Literature, Identity*. Ithaca: Cornell University Press, 1995.
Long, Kate. 'Roots: On Language and Heritage. A Conversation with Naomi Shihab Nye.' *World Literature Today* (November–December 2009): 31–34.
Lorde, Audre. 'The Master's Tools Will Never Dismantle the Master's House.' In *Feminist Postcolonial Theory: A Reader*, edited by Reina Lewis and Sara Mills, 25–28. Edinburgh: Edinburgh University Press, 2010.
Loshitzky, Yosefa. *Identity Politics on the Israeli Screen*. Austin: University of Texas Press, 2001.
Mahmoud, 'Abd al-Raheem. 'Call of the Motherland.' In *Anthology of Modern Palestinian Literature*, edited by Salma Khadra Jayyusi, 210–211. New York: Columbia University Press, 1992.

Majaj, Lisa Suhair, Paula W. Sunderman and Therese Saliba, eds. *Intersections: Gender, Nation, and Community in Arab Women's Novels.* New York: Syracuse University Press, 2002.
Malti-Douglas, Fedwa. 'Dangerous Crossings: Gender and Criticism in Arabic Literary Studies.' In *Borderwork: Feminist Engagements in Comparative Literature*, edited by Margaret R. Higgonet, 224–229. Ithaca: Cornell University Press, 1994.
Malti-Douglas, Fedwa. *Encyclopedia of Sex and Gender.* Detroit: Macmillan, 2007.
Malti-Douglas, Fedwa. 'Introduction: A Palestinian Female Voice against Tradition.' In *A Mountainous Journey*, Fadwa Tuqan, 1–9. Saint Paul: Graywolf Press, 1990.
Malti-Douglas, Fedwa. *Men, Women and Gods: Nawal El Saadawi and Arab Feminist Poetics.* Berkeley: University of California Press, 1995.
Marcus, Jane. 'Alibis and Legends: The Ethics of Elsewhereness, Gender and Estrangement.' In *Women's Writing in Exile*, edited by Mary Lynn Broe and Angela Ingram, 269–294. Chapel Hill: University of North Carolina Press, 1989.
Marks, Laura. *The Skin of the Film: Intercultural Cinema, Embodiment, and the Senses.* Durham: Duke University Press, 2000.
Masalha, Nur. *The Palestinian Nakba: Decolonising History, Narrating the Subtaltern, Reclaiming Memory.* London: Zed Books, 2012.
Masalha, Nur. *The Politics of Denial: Israel and the Palestinian Refugee Problem.* London: Pluto Press, 2003.
Massad, Joseph. 'Conceiving the Masculine: Gender and Palestinian Nationalism.' *Middle East Journal* 49, no. 3 (1995): 467–483.
Massad, Joseph. *The Persistence of the Palestinian Question: Essays on Zionism and the Palestinians.* Abingdon: Routledge, 2006.
Massad, Joseph. 'The "Post-colonial" Colony: Time, Space, and Bodies in Palestine/Israel.' In *The Pre-Occupation of Postcolonial Studies*, edited by Fawzia Afzal-Khan and Kalpana Seshadri-Crooks. Durham: Duke University Press, 2000.
Mattar, Philip. *The Mufti of Jerusalem: Al-Hajj Amin Al-Husayni and the Palestinian National Movement.* Revised edition. New York: Columbia University Press, 1992.
McClintock, Anne. 'The Angel of Progress: Pitfalls of the Term "Post-colonialism".' In *Colonial Discourse and Postcolonial Theory: A Reader*, edited by Patrick Williams and Laura Chrisman, 291–304. Harlow: Pearson Education Limited, 1994.
McClintock, Anne. *Imperial Leather: Race, Gender and Sexuality in the Colonial Contest.* London: Routledge, 1995.
McClintock, Anne. '"No Longer in a Future Heaven": Gender, Race, and Nationalism.' In *Dangerous Liaisons: Gender, Nation, and Postcolonial Perspectives*, edited by Anne McClintock, Aamir Mufti and Ella Shohat, 89–112. Minneapolis: University of Minnesota Press, 1998.
McClintock, Anne, Aamir Mufti and Ella Shohat, eds. *Dangerous Liasons: Gender, Nation, and Postcolonial Perspectives.* Minneapolis: University of Minnesota Press, 1998.
McLean, Ian. 'Back to the Future: Nations, Borders and Cultural Theory.' *Third Text* 57 (2001–2002): 23–30.
Meir, Golda. *Sunday Times*, 15th June 1969.
Mernissi, Fatima. *Beyond the Veil: Male-Female Dynamics in a Modern Muslim Society.* Cambridge, MA: Schenkman Publishing, 1975.
Mernissi, Fatima. *The Veil and the Male Elite: A Feminist Interpretation of Women's Rights in Islam.* New York: Perseus Books, 1992.
Michaelsen, Scott and David E. Johnson, eds. *Border Theory: The Limits of Cultural Politics.* Minneapolis: University of Minnesota Press, 1997.
Miyoshi, Masao. 'A Borderless World? From Colonialism to Transnationalism and the Decline of the Nation-State.' *Critical Enquiry* 19 (1993): 726–751.

Mohan, Rajeswari. 'Loving Palestine: Nationalist Activism and Feminist Agency in Leila Khaled's Subversive Bodily Acts.' *Interventions* 1, no. 1 (1998): 52–80.

Mohanty, Chandra Talpade. 'Feminist Encounters: Locating the Politics of Experience.' *Copyright* 1 (1987): 30–44.

Mohanty, Chandra Talpade. 'Introduction. Cartographies of Struggle: Third World Women and the Politics of Feminism.' In *Third World Women and the Politics of Feminism*, edited by Chandra Talpade Mohanty, Ann Russo and Lourdes Torres, 1–47. Bloomington: Indiana University Press, 1991.

Mohanty, Chandra Talpade. 'Under Western Eyes: Feminist Scholarship and Colonial Discourses.' *Feminist Review* 30 (1988): 61–88.

Moi, Toril, ed. *The Kristeva Reader*. New York: Columbia University Press, 1986.

Monterescu, Daniel. 'The Bridled Bride of Palestine: Orientalism, Zionism, and the Troubled Urban Imagination.' *Identities: Global Studies in Culture and Power* 16 (2009): 643–677.

Monterescu, Daniel. 'Masculinity as a Relational Mode: Palestinian Gender Ideologies and Working-Class Boundaries in an Ethnically Mixed Town.' In *Reapproaching Borders: New Perspectives on the Study of Israel-Palestine*, edited by Sandy Sufian and Mark LeVine, 177–198. Lanham: Rowman and Littlefield Publishers, 2007.

Moore, Lindsey. *Arab, Muslim, Woman: Voice and Vision in Postcolonial Literature and Film*. London: Routledge, 2008.

Morris, Benny. *The Birth of the Palestinian Refugee Problem, 1947–1949*. Cambridge: Cambridge University Press, 1988.

Mulvey, Laura. 'Visual Pleasure and Narrative Cinema.' *Screen* 16, no. 3 (1975): 54–64.

Murphy, Sean D. 'Self-Defence and the Israeli Wall Advisory Opinion: An *Ipse Dixit* from the ICJ?' *The American Journal of International Law* 99, no. 1 (2005): 62–76.

Naficy, Hamid. *An Accented Cinema: Exilic and Diasporic Filmmaking*. Princeton: Princeton University Press, 2001.

Nairn, Tom. *Faces of Nationalism: Janus Revisited*. London: Verso, 1997.

Najjar, Najwa. Q&A session at the London Palestine Film Festival, Barbican Centre, London, 2nd May 2010.

Najmi, Samina. 'Naomi Shihab Nye's Aesthetic of Smallness and the Military Sublime.' *MELUS* 35, no. 2 (2010): 151–171.

Nassar, Issam. 'Reflections on Writing the History of Palestinian Identity.' *Palestine-Israel Journal* 8, no. 1 (2001), 24–37.

Newman, David. 'From National to Post-national Territorial Identities in Israel-Palestine.' *Geojournal* 53 (2001): 235–246.

Nye, Naomi Shihab. *19 Varieties of Gazelle: Poems of the Middle East*. New York: HarperTempest, 2005.

Nye, Naomi Shihab, ed. *The Flag of Childhood: Poems from the Middle East*. New York: Aladdin Paperbacks, 2002.

Nye, Naomi Shihab. *Never in a Hurry: Essays on People and Places*. Columbia: University of South Carolina Press, 1996.

Nye, Naomi Shihab. *Red Suitcase*. New York: BOA Editions, 1994.

Nye, Naomi Shihab. *Tender Spot: Selected Poems*. Tarset: Bloodaxe, 2008.

Oz, Amos. *My Michael*. Translated by Nicholas de Lange. 1968; London: Vintage, 1991.

Palestine National Council. 'Palestinian National Charter: Resolutions of the Palestine National Council.' In *Basic Political Documents of the Armed Palestinian Resistance Movement*, edited by Leila S. Kadi, 137–141. Beirut: Palestine Research Centre, 1969.

Pappé, Ilan. *A History of Modern Palestine: One Land, Two Peoples*. Cambridge: Cambridge University Press, 2006.

Pappé, Ilan. 'Zionism as Colonialism: A Comparative View of Diluted Colonialism in Asia and Africa.' *South Atlantic Quarterly* 107, no. 4 (2008): 611–633.
Parmenter, Barbara McKean. *Giving Voice to Stones: Place and Identity in Palestinian Literature.* Austin: University of Texas Press, 1994.
Parry, Benita. *Postcolonial Studies: A Materialist Critique.* London: Routledge, 2004.
Peteet, Julie. *Gender in Crisis: Women and the Palestinian Resistance Movement.* New York: Columbia University Press, 1991.
Peteet, Julie. 'Icons and Militants: Mothering in the Danger Zone.' *Signs* 23, no. 1 (1997): 103–129.
Peteet, Julie. 'Male Gender and Rituals of Resistance in the Palestinian Intifada: A Cultural Politics of Violence.' In *Imagined Masculinities*, edited by Mai Ghoussoub and Emma Sinclair-Webb, 103–126. London: Saqi Books, 2000.
Peters, Joan. *From Time Immemorial: The Origins of the Arab-Jewish Conflict over Palestine.* New York: Harper and Row, 1984.
Pitcher, Linda. '"The Divine Impatience": Ritual, Narrative, and Symbolization in the Practice of Martyrdom in Palestine.' *Medical Anthropology Quarterly* 12, no. 1 (1998): 8–30.
Price-Chalita, Patricia. 'Spatial Metaphor and the Politics of Empowerment: Mapping a Place for Feminism and Postmodernism in Geography?' *Antipode* 26, no. 3 (1994): 236–254.
Ra'ad, Basem L. *Hidden Histories: Palestine and the Eastern Mediterranean.* London: Pluto, 2010.
Radwan, 'Abdallah. 'Deformed.' In *Anthology of Modern Palestinian Literature*, edited by Salma Khadra Jayyusi, 263. New York: Columbia University Press, 1992.
Radwan, 'Abdallah. 'You Are Everything.' In *Anthology of Modern Palestinian Literature*, edited by Salma Khadra Jayyusi, 264. New York: Columbia University Press, 1992.
Rahman, Najat. *Literary Disinheritance: The Writing of Home in the Work of Mahmoud Darwish and Assia Djebar.* Lanham, MD: Lexington Books, 2008.
Rasheed, Harum Hashim. 'Poem to Jerusalem.' In *Anthology of Modern Palestinian Literature*, edited by Salma Khadra Jayyusi, 265–266. New York: Columbia University Press, 1992.
Reisz, Matthew. 'Samir El-Youssef: At Home with the Heretic.' *The Independent*, 19th January 2007. Accessed 27th July 2010. http://www.independent.co.uk/arts-entertainment/books/features/samir-elyoussef-at-home-with-the-heretic-432650.html.
Rich, Adrienne. 'Notes towards a Politics of Location.' In *Blood, Bread, and Poetry: Selected Prose 1979–1985*, 210–231. New York: W.W. Norton and Company, 1986.
Rich, B. Ruby. 'Bomb Culture.' *Sight and Sound* 16 (2006): 28–30.
Sa'ar, Amalia. 'Feminine Strength: Reflections on Power and Gender in Israeli-Palestinian Culture.' *Anthropological Quarterly* 79, no. 3 (2006): 397–430.
Sa'ar, Amalia. 'Many Ways of Becoming a Woman: The Case of Unmarried Israeli-Palestinian "Girls".' *Ethnology* 43, no. 1 (2004): 1–18.
Sa'ar, Amalia and Taghreed Yahia-Younis. 'Masculinity in Crisis: The Case of Palestinians in Israel.' *British Journal of Middle Eastern Studies* 35, no. 3 (2008): 305–323.
Sabbagh, Suha. 'Palestinian Women Writers and the Intifada.' *Social Text* 22 (1989): 62–78.
Sa'di, A.H. 'The Borders of Colonial Encounter: The Case of Israel's Wall.' *Asian Journal of Social Science* 38 (2010): 46–59.
Said, Edward. *Culture and Imperialism.* London: Vintage, 1994.
Said, Edward. *Culture and Resistance: Conversations with Edward Said.* Interviews by David Barsamian. Cambridge, MA: South End Press, 2003.
Said, Edward. *Humanism and Democratic Criticism.* New York: Columbia University Press, 2004.

Said, Edward. 'Introduction: Secular Criticism.' In *The World, the Text, and the Critic*, 1–30. Cambridge, MA: Harvard University Press, 1983.
Said, Edward. 'The Mind of Winter: Reflections on Life in Exile.' *Harper's* (September 1985): 49–55.
Said, Edward. *Orientalism*. 1978; London: Penguin, 2003.
Said, Edward. 'Permission to Narrate.' *Journal of Palestine Studies* 13, no. 3 (1984): 27–48.
Said, Edward. *The Question of Palestine*. New York: Vintage, 1992.
Said, Edward. 'Reflections on Exile.' In *Reflections on Exile and Other Literary and Cultural Essays*, 173–186. London: Granta, 2000.
Said, Edward. 'Review of Wedding in Galilee and Friendship's Death.' In *The Politics of Dispossession: The Struggle for Palestinian Self-Determination 1969–1994*, 130–136. London: Chatto and Windus, 1994.
Said, Edward. 'Speaking Truth to Power.' In *Representations of the Intellectual*, 85–102. New York: Vintage, 1996.
Said, Edward. 'Travelling Theory.' In *The World, the Text, and the Critic*, 226–247. Cambridge, MA: Harvard University Press, 1983.
Said, Edward. *The World, the Text, and the Critic*. Cambridge, MA: Harvard University Press, 1983.
Said, Edward with photographs by Jean Mohr. *After the Last Sky: Palestinian Lives*. New York: Pantheon Books, 1986.
Saliba, Therese. 'A Country beyond Reach: Liana Badr's Writings of the Palestinian Diaspora.' In *Intersections: Gender, Nation, and Community in Arab Women's Novels*, edited by Lisa Suhair Majaj, Paula W. Sunderman and Therese Saliba, 132–161. New York: Syracuse University Press, 2002.
Saliba, Therese and Jeanne Kattan. 'Palestinian Women and the Politics of Reception.' In *Going Global: The Transnational Reception of Third World Women Writers*, edited by Amal Amireh and Lisa Suhair Majaj, 84–112. New York: Garland Publishing, 2000.
Salma, Abu. 'We Shall Return.' In *Anthology of Modern Palestinian Literature*, edited by Salma Khadra Jayyusi, 96. New York: Columbia University Press, 1992.
Salzman, Philip Carl. 'Arab Culture and Postcolonial Theory.' In *Postcolonial Theory and the Arab-Israel Conflict*, edited by Philip Carl Salzman and Donna Robinson Divine, 160–166. Abingdon: Routledge, 2008.
Salzman, Philip Carl and Donna Robinson Divine, eds. *Postcolonial Theory and the Arab-Israel Conflict*. Abingdon: Routledge, 2008.
Sartre, Jean-Paul. 'Preface.' In *The Wretched of the Earth*, Frantz Fanon, 7–26. London: Penguin, 1969.
Sayigh, Mai. 'Elegy for Imm 'Ali.' In *Anthology of Modern Palestinian Literature*, edited by Salma Khadra Jayyusi, 280–281. New York: Columbia University, 1992.
Sayigh, Rosemary. *Palestinians: From Peasants to Revolutionaries*. London: Zed, 1979.
Sbait, Dirgham H. 'Debate in the Improvised-Sung Poetry of the Palestinians.' *Asian Folklore Studies* 52, no. 1 (1993): 93–117.
Schechla, David. 'The Invisible People Come to Light: Israel's "Internally Displaced" and the "Unrecognized Villages".' *Journal of Palestine Studies* 31, no. 1 (2001): 20–31.
Schild, Verónica. 'Transnational Links in the Making of Latin American Feminisms: A View from the Margins.' In *Émigré Feminisms: Transnational Perspectives*, edited by Alena Heitlinger, 67–94. Toronto: University of Toronto Press, 1999.
Schulz, Helena Lindholm. *The Reconstruction of Palestinian Nationalism: Between Revolution and Statehood*. Manchester: Manchester University Press, 1999.
Schultz, Helena Lindholm with Juliane Hammer. *The Palestinian Diaspora: Formation of Identities and Politics of Homeland*. London: Routledge, 2003.

Segal, Lynne. *Slow Motion: Changing Masculinities, Changing Men.* London: Virago, 1990.
Selby, Jan. *Water, Power and Politics in the Middle East: The Other Israel-Palestine Conflict.* London: I.B.Tauris, 2004.
Shaaban, Bouthaina. *Both Right and Left Handed: Arab Women Talk about Their Lives.* London: The Women's Press, 1988.
Shabana, 'Umar. 'From: The Book of Songs and Stones.' In *Anthology of Modern Palestinian Literature*, edited by Salma Khadra Jayyusi, 295. New York: Columbia University Press, 1992.
Shafir, Gershon. *Land, Labor and the Origins of the Israeli-Palestinian Conflict, 1882–1914.* Berkeley: University of California Press, 1996.
Shafik, Viola. *Arab Cinema: History and Cultural Identity.* Revised edition. Cairo: American University in Cairo Press, 2007.
Shaheen, Mahmoud. 'The Sacred River.' In *Anthology of Modern Palestinian Literature*, edited by Salma Khadra Jayyusi, 525–545. New York: Columbia University Press, 1992.
Shamoni, Gideon. 'Postcolonial Theory and the History of Zionism.' In *Postcolonial Theory and the Arab-Israel Conflict*, edited by Philip Carl Salzman and Donna Robinson Divine, 182–194. Abingdon: Routledge, 2008.
Shapira, Anita. *Land and Power.* Oxford: Oxford University Press, 1992.
Sharabi, Hisham. *Embers and Ashes: Memoirs of an Arab Intellectual.* Northampton, MA: Interlink, 2007.
Sharabi, Hisham. *Neopatriarchy: A Theory of Distorted Change in Arab Society.* Oxford: Oxford University Press, 1988.
Sharoni, Simona. *Gender and the Israeli-Palestinian Conflict: The Politics of Women's Resistance.* New York: Syracuse University Press, 1995.
Shehadeh, Raja. *Palestinian Walks: Notes on a Vanishing Landscape.* London: Profile Books, 2008.
Shehadeh, Raja. *The Third Way: A Journal of Life in the West Bank.* London: Quartet, 1992.
Sherwell, Tina. 'Imaging the Homeland: Gender and Palestinian National Discourses.' In *After Orientalism: Critical Entanglements, Productive Looks*, edited by Inge E. Boer, 123–146. New York: Rodopi, 2003.
Shibli, Adania. *Touch.* Translated by Paula Haydar. Northampton, MA: Clockroot Publishing, 2010.
Shihab Nye, Naomi. *19 Varieties of Gazelle: Poems of the Middle East.* New York: HarperTempest, 2005.
Shohat, Ella. 'Gender and Culture of Empire: Toward a Feminist Ethnography of the Cinema.' In *Otherness and the Media: The Ethnography of the Imagined and the Imaged*, edited by Hamid Naficy and Teshome H. Gabriel, 45–84. Poststrasse, Switzerland: Harwood, 1993.
Shohat, Ella. *Israeli Cinema: East/West and the Politics of Representation.* Austin: University of Texas Press, 1989.
Shohat, Ella. 'Notes on the "Post-colonial".' In *Taboo Memories, Diasporic Voices*, 232–249. Durham: Duke University Press, 2006.
Shohat, Ella. 'The "Postcolonial" in Translation: Reading Edward Said between English and Hebrew.' In *Taboo Memories, Diasporic Voices*, 359–384. Durham: Duke University Press, 2006.
Shohat, Ella. *Taboo Memories, Diasporic Voices.* Durham: Duke University Press, 2006.
Showalter, Elaine. *The Female Malady: Women, Madness and English Culture, 1830–1980.* London: Virago, 1987.
Shuqair, Mahmoud. 'The Villagers.' In *Anthology of Modern Palestinian Literature*, edited by Salma Khadra Jayyusi, 560–567. New York: Columbia University Press, 1992.

Siddiq, Muhammed. 'On Ropes of Memory: Narrating the Palestinian Refugees.' In *Mistrusting Refugees*, edited by E. Valentine Daniel and John Chr. Knudsen, 87–101. Berkeley: University of California Press, 1995.

Simpson, J.A. and E.S.C. Weiner. *Oxford English Dictionary*, volume 8. Second edition. Oxford: Clarendon Press, 1989.

Sinha, Mrinalini. *Colonial Masculinity: The 'Manly Englishman' and the 'Effeminate Bengali' in the Late Nineteenth Century*. Manchester: Manchester University Press, 1995.

Slymovics, Susan. 'The Gender of Transposed Space.' *Palestine-Israel Journal of Politics, Economics and Culture* 9, no. 4 (2002): 110–117.

Smith, Charles D. *Palestine and the Arab-Israeli Conflict: A History with Documents*. Sixth edition. Boston: Bedford/St Martin's, 2007.

Spivak, Gayatri Chakravorty. 'Can the Subaltern Speak?' In *Colonial Discourse and Postcolonial Theory: A Reader*, edited by Patrick Williams and Laura Chrisman, 66–111. Harlow: Pearson Education Limited, 1994.

Spivak, Gayatri. 'Criticism, Feminism, and the Institution.' In *The Post-colonial Critic: Interviews, Strategies, Dialogues*, edited by Sarah Harasym, 1–16. London: Routledge, 1990.

Spivak, Gayatri Chakravorty. 'French Feminism in an International Frame.' *Yale French Studies* 62 (1981): 154–184.

Stabile, Carol A. and Deepa Kumar. 'Unveiling Imperialism: Media, Gender and the War on Afghanistan.' *Media, Culture and Society* 27, no. 5 (2005): 765–782.

Stacey, Jackie and Sara Ahmed. 'Introduction: Dermographies.' In *Thinking through the Skin*, edited by Jackie Stacey and Sara Ahmed, 1–18. London: Routledge, 2001.

Stacey, Jackie and Sara Ahmed, eds. *Thinking through the Skin*. London: Routledge, 2001.

Stein, Rebecca L. 'The Ballad of the Sad Café: Israeli Leisure, Palestinian Terror, and the Post/Colonial Question.' In *Postcolonial Studies and Beyond*, edited by Ania Loomba, Suvir Kaul, Matti Bunzl, Antoinette Burton and Jed Esty, 317–336. Durham: Duke University Press, 2005.

Stein, Rebecca L. and Ted Swedenburg, eds. *Palestine, Israel, and the Politics of Popular Culture*. Durham: Duke University Press, 2005.

Stephen, Chris, Irina Kalashnikova and David Smith. 'After Playing a Crucial Role in the Uprising, Women Say It's Time They Shared Power.' *The Guardian*, 17th September 2011, 33.

Strum, Philippa. *The Women Are Marching: The Second Sex and the Palestinian Revolution*. New York: Lawrence Hill Books, 1992.

Suleiman, Elia. 'A Cinema of Nowhere.' *Journal of Palestine Studies* 29, no. 2 (2000): 95–101.

Sullivan, Nikki. *A Critical Introduction to Queer Theory*. Edinburgh: Edinburgh University Press, 2003.

Swedenburg, Ted. 'The Palestinian Peasant as National Signifier.' *Anthropological Quarterly* 63, no. 1 (1990): 18–30.

Tawil, Raymonda. *My Home, My Prison*. 1979; New York: Holt, Rinehart and Winston, 1980.

Tuqan, Fadwa. *A Mountainous Journey*. Translated by Olive Kenny. Saint Paul: Graywolf Press, 1990.

Turki, Fawaz. *The Dispossessed: Journal of a Palestinian Exile*. 1972; New York: Monthly Review Press, 1974.

Turki, Fawaz. *Soul in Exile: Lives of a Palestinian Revolutionary*. New York: Monthly Review Press, 1988.

Turner, Victor. 'Betwixt and Between: The Liminal Period in *Rites de Passage*.' In *The Forest of Symbols: Aspects of Ndembu Ritual*, 93–111. Ithaca: Cornell University Press, 1967.
Valassopoulos, Anastasia. *Contemporary Arab Women Writers: Cultural Expression in Context*. Abingdon: Routledge, 2007.
Verdery, Katherine. 'Beyond the Nation in Eastern Europe.' *Social Text* 38 (1994): 1–19.
Viner, Katherine. 'Despair as Usual for Palestinians.' *The Guardian*, 7th February 2001. Accessed 26th November 2010. http://www.guardian.co.uk/israel/Story/0,2763,434655,00.html.
Weizman, Eyal. *Hollow Land: Israel's Architecture of Occupation*. London: Verso, 2007.
Williams, Patrick. '"Outlines of a Better World": Rerouting Postcolonialism.' In *Rerouting the Postcolonial: New Directions for the New Millennium*, edited by Janet Wilson, Cristina Sandru and Sarah Lawson Welsh, 86–97. Abingdon: Routledge, 2010.
Williams, Patrick and Laura Chrisman, eds. *Colonial Discourse and Postcolonial Theory: A Reader*. Harlow: Pearson Education Limited, 1994.
Wilson, Rob and Wimal Dissanayak, eds. *Global/Local*. Durham: Duke University Press, 1996.
Wolff, Janet. 'On the Road Again: Metaphors of Travel in Cultural Criticism.' *Cultural Studies* 7, no. 2 (1993): 224–239.
Woodward, Keith and John Paul Jones III. 'On the Border with Deleuze and Guattari.' In *B/Ordering Space*, edited by Henk Van Houtum, Olivier Kramsch and Wolfgang Ziethofer, 235–248. Aldershot: Ashgate, 2005.
Woolf, Virginia. *Three Guineas*. New York: Harcourt Inc., 1938.
Yegenoglu, Meyda. *Colonial Fantasies: Towards a Feminist Reading of Orientalism*. Cambridge: Cambridge University Press, 1992.
Young, Elise G. *Keepers of the History: Women and the Israeli-Palestinian Conflict*. New York: Teachers College Press, 1992.
Young, Robert J.C. *Postcolonialism: A Very Short Introduction*. Oxford: Oxford University Press, 2003.
Yuval-Davis, Nira. *Gender and Nation*. London: Sage, 1997.
Yuval-Davis, Nira and Floya Anthias. *Woman-Nation-State*. London: Macmillan, 1989.
Yuval-Davis, Nira and Marcel Stoetzler. 'Imagined Boundaries and Borders: A Gendered Gaze.' *The European Journal of Women's Studies* 9, no. 3 (2002): 329–344.
Zayyad, Tawfiq. 'Here We Shall Stay.' In *Anthology of Modern Palestinian Literature*, edited by Salma Khadra Jayyusi, 328. New York: Columbia University Press, 1992.
Zayyad, Tawfiq. 'A Million Suns in My Blood.' In *Anthology of Modern Palestinian Literature*, edited by Salma Khadra Jayyusi, 329. New York: Columbia University Press, 1992.
Zayyad, Tawfiq. 'What Next?' Translated by Sharif Elmusa and Jack Collom. In *Anthology of Modern Palestinian Literature*, edited by Salma Khadra Jayyusi, 330. New York: Columbia University Press, 1992.
Zurayak, Constantine K. *The Meaning of the Disaster*. Translated by R. Bayly Winder. Beirut: Khayat's College Book Cooperative, 1956.

Filmography

Abourahme, Dahna, dir. *The Kingdom of Women*. Lebanon, 2010. Film release.
Abu-Assad, Hany, dir. *Ford Transit*. Palestine / Israel, 2002. Film release.
Abu-Assad, Hany, dir. *Paradise Now*. Palestine / France / Netherlands / Germany / Israel, 2005. Film release.
Abu-Assad, Hany, dir. *Rana's Wedding*. Palestine / Netherlands / UAE, 2002. Film release.
Abu Wael, Tawfik, dir. *'Atash*. Palestine / Israel, 2004. Film release.
Abu Wael, Tawfik, dir. *Diary of a Male Whore*. Palestine, 2001. Film release.
Abu Wael, Tawfik, dir. *Waiting for Salah Addin*. Palestine, 2001. Film release.
Arasoughly, Alia, dir. *This Is Not Living*. Palestine, 2001. Film release.
Badr, Liana, dir. *Fadwa: A Tale of a Poetess*. Palestine, 1999. Film release.
Badr, Liana, dir. *Zeitounat*. Palestine, 2000. Film release.
Badrakhan, Ahmed, dir. *Dananeer*. Egypt, 1940. Film release.
Elias, Hanna, dir. *The Olive Harvest*. Palestine, 2004. Film release.
Hatoum, Mona, dir. *Measures of Distance*. Vancouver: A West Front Video Production, 1988. Video recording.
Jacir, Annemarie, dir. *like twenty impossibles*. Palestine, 2003. Film release.
Jacir, Annemarie, dir. *Salt of This Sea*. Palestine, 2008. Film release.
Khleifi, Michel, dir. *Fertile Memory*. Palestine / Netherlands / Belgium, 1980. Film release.
Khleifi, Michel, dir. *Wedding in Galilee*. Palestine / Belgium / France, 1987. Film release.
Khleifi, Michel, dir. *Zindeeq*. Palestine / UK / Belgium / UAE, 2009. Film release.
Khoury, Buthina Canaan, dir. *Women in Struggle*. New York: Women Make Movies, 2004. DVD.
Mashrawi, Rashid, dir. *Ticket to Jerusalem*. Netherlands / Palestine / France / Australia, 2002. Film release.
Masri, Mai, dir. *Frontiers of Dreams and Fears*. 2001; Seattle: Arab Film Distribution, 2009. DVD.
Najjar, Najwa, dir. *Pomegranates and Myrrh*. Palestine, 2008. Film release.
Nasser-Eldin, Mahasen, dir. *Samia*. Palestine, 2009. Film release.
Suleiman, Elia, dir. *Chronicle of a Disappearance*. Palestine / Israel / France / Germany, 1997. Film release.
Suleiman, Elia, dir. *Divine Intervention*. France / Morocco / Germany / Palestine, 2002. Film release.
Suleiman, Elia, dir. *The Time that Remains*. UK / Italy / Belgium / France, 2009. Film release.
Wood, Sarah, dir. *For Cultural Purposes Only*. London: Animate Projects, 2009. http://www.animateprojects.org/films/by_date/2009/for_cultural. Short film. Accessed 16th May 2012.

Index

A
absurd, the, 84–6
Abu Salma, 46, 176n1
Abu Wael, Tawfik, 117; *'Atash*, 117–122; 190n60, 190n61
Abu-Assad, Hany, 90–100; *Paradise Now*, 90–98
Accad, Evelyn, 65–66, 68
Ahmed, Sara, 140–141
Allenby Bridge, 111
'Allush, Laila, 33–34
Al-Qasim, Samih, 42, 179n52
Anzaldúa, Gloria, 108, 118, 126, 128
Arafat, Yasser, 79, 81, 185n48, 186n50
Arasoughly, Alia, 71
armed resistance, 64–65, 91, 94, 111; rationalisation of violence, 92–93. *See also* martyrdom; masculinity: and violence; militancy, female.
Ashrawi, Hanan, 33, 35, 50, 178n27
autobiography, 53, 137, 138, 180n68

B
Badr, Liana, 61–69, 181n76, 186n68; *Compass for the Sunflower, A*, 61–69; 'Other Cities', 113–114
Balfour Declaration, 102, 167n15
Barghouty, Mourid, 111–112
Bhabha, Homi, 22, 109, 115, 128; 'Third Space', 117. *See also* hybridity.
body / embodiment, 105, 107, 109–112, 129, 136, 140, 143–144; skin, 142–143; touch, 142–143
border / boundary, 101–130, 133; borderland, 106, 116–127; 'border-consciousness', 106, 117, 127; 'border-guard', women as, 107–108, 112; 'borderless world', 124, 133; border-theory, 101, 106, 128, 187n3; border-writing, 121; Israeli-Lebanese, 142; patriarchal boundaries, 114, 120, 134 (*see also* space: public/private dichotomy).
Brah, Avtar, 105, 153–155
British mandate, 4, 54–55, 102
Butler, Judith, 72–73. *See also* performativity.

C
Cabral, Amilcar, 46, 61
Certeau, Michel de, 124
checkpoint, 88–89, 103, 106–7, 109–115, 123, 125; 'checkpoint heroine', 106–115
cinema, 'fourth period' of, 37
class, 57
Cleary, Joe, 73, 102
Clifford, James, 132–133
collective memory, 53, 137, 141–144
colonial 'rescue fantasy', 25, 47, 151
community, 131, 135, 147; diasporic, 145, 154–155; feminocentric, 138, 143, 145, 155; Palestinian American, 145, 147, 155; 'of strangers', 143, 148
comparative analysis, 12–14
contrapuntal consciousness, 97, 134, 151
Cooke, Miriam, 8, 11; and Badran, 9
'crisis heterotopia', 41
cultural expression / creativity: as target, 126; as healing, 146, 151, 160; as resistance, 2–3, 120–121, 122–123, 126

D
Darwish, Mahmoud, 29–30, 36, 96–97, 157, 174n57

Deleuze, Gilles and Guattari, Felix: 'becoming', 116, 190n52. *See also* nomad.
desire / longing, 27, 38–41, 118–122, 141, 152. *See also* sexuality.
diaspora, 61–62, 111, 112, 124, 131–156, 193n33
documentary, 71, 122–123, 136
domesticity, 55–58, 63, 67–68, 149, 151. *See also* space: public / private dichotomy.
'Dreams of a Nation', 3. *See also* Jacir, Annemarie.

E

El-Youssef, Samir, 79–84, 99–100; 'Day the Beast Got Thirsty, The', 80–84; *Illusion of Return, The*, 80
exile, 112–113, 131–133; exilic community, 143; and female identity, 134. *See also* diaspora.

F

family, 55, 112, 113–114, 117–122, 149, 189n44. *See also* motherhood; patriarchy.
Fanon, Frantz, 3, 48, 56, 64, 111, 157
female relationships, 137–146, 149–151, 152–153
femininity, 110; 'feminine aesthetic', 120–121; 'feminised language', 152
feminism, 47–52, 62; Arab, 8–9, 48; 'invisible feminism', 54; Islamic, 48; and pacifism, 150–151; Palestinian, 9, 49–52, 57; transnational feminism, 131, 135, 153, 155; Western, 57. *See also* postcolonial feminism; nationalism: and feminism.
film archive, 2–3, 126
filmmaking, 122–127
fitna, 55
Foucault, Michel, 19, 41. *See also* power/knowledge.
'fragmentation, aesthetic of', 86, 116, 122–127
Freud, Sigmund, 26

G

Gaza, political status of, 102–103
Glanville, Jo, 109; *Qissat*, 109–114
Grosz, Elizabeth, 140, 145

H

Hammad, Suheir, 145–154
Hassan, Waïl, 13
Hatoum, Mona, 136–137; *Measures of Distance*, 136–140, 143–145
Hicks, D. Emily, 121, 125–126, 128
home, 140–141, 143, 147–148; female body as, 144–145; 'rooting', 148
honour/shame, 34, 42, 50, 56, 66, 89, 120, 152–153, 175n77. *See also* land and honour.
hooks, bell, 100
humour, 81–82, 84, 86, 112
Husain, Rashid, 35
Husayn-McMahon Correspondence, 166n15
hybridity, 101, 106, 108, 116, 128, 133

I

identity papers / permits, 30, 103, 125–126
imagined community, 19, 76, 150
impotence, emasculation, 42, 82, 87–89, 120. *See also* masculinity in crisis.
imprisonment, 56–57, 77, 138
Intifada, 38, 50–51, 73, 79–81, 89, 92, 94, 103, 106, 141, 169n61
intimacy, 107, 123, 139–145
Israel, 2, 5–6, 19, 27–28, 33–34, 38, 74, 89, 91, 77, 80, 102–103, 106–107, 125, 127, 142, 162; withdrawal from South Lebanon, 142. *See also* occupation, Israeli; Zionism.

J

Jabra, Ibrahim Jabra, 32
Jacir, Annemarie, 2, 117, 122, 126; *like twenty impossibles*, 122–126; *Salt of This Sea*, 191n73
Jarrar, Randa, 111–113
Jayyusi, Salma Khadra, 14, 53, 119, 134, 170n67
Jordan, June, 147

K

Kanafani, Ghassan, 61, 72, 126, 188n19
Keret, Etgar, 80, 185n47
Khaled, Leila, 53, 64–65
Khalidi, Rashid, 5, 75, 103
Khalifeh, Sahar, 37, 77
Khalili, Laleh, 114–115, 157

Khleifi, George, 2, 14, 27, 105; 'roadblock movies', 105
Khleifi, Michel, 36–44; *Fertile Memory*, 37–38; *Wedding in Galilee*, 38–43; *Zindeeq*, 37
Kristeva, Julia, 134
kuffiya, 41

L

Lacan, Jacques, 140, 143–144
land, 32, 123–124; claims to, 102–103, 123, 118–119; feminisation of, 31–37, 121; and honour, 34, 66–67; and natural resources, 118–119, 121; sexualization of, 26, 29, 34–36; soil / earth, 25, 141, 143, 148; 'son of the soil', 31
Lewis, Reina, 8, 26, 41
liminality, 73, 95, 101–130, 190n51
literacy, 62–63, 121

M

Mahmoud, 'Abd al-Raheem, 31, 46, 176n1
male gaze, 41, 143–144
margins / marginality, 98, 100, 101, 105, 115, 120, 134
martyrdom, 91, 93, 95–98, 110–111; performativity of, 93–95. *See also* masculinity in crisis.
masculinity, 31; and Arab identity, 78; and colonisation, 75–77, 87; in crisis, 72–100; and nationhood, 76–77; and postcoloniality, 99–100; and violence, 92–93,114–115, 150–152. *See also* nation: and gender.
Masri, Mai, 136–137; *Frontiers of Dreams and Fears*, 136–138, 140–145
Massad, Joseph, 5–6, 28, 70, 76
materiality, 128–129, 161
McClintock, Anne, 7, 20, 24–25, 69
Mernissi, Fatima, 55–56
militancy, female, 64–65, 67. *See also* armed struggle; Khaled, Leila.
Mohanty, Chandra Talpade, 10, 57, 150, 156, 162
Moore, Lindsey, 8, 11, 57, 143
motherhood / maternity, 54–55, 67–68, 114, 138–9, 143–144, 149–150, 152; grandmother, 149–150. *See also* family; female relationships.
Mulvey, Laura, 41

music, 120, 123, 151; Fayrouz, 60–61; improvised-sung poetry, 195n67. *See also* contrapuntal consciousness.

N

Naficy, Hamid, 106, 127, 128
Najjar, Najwa, 70–71, 182n109
Nakba, 34, 49, 55, 59, 72, 87, 102, 131, 137, 147–148, 169n60
Naksa, 73, 87, 102, 132
Nasser-Eldin, Mahasen, 71
nation, 128–129: borders / boundaries, 101–105 (*see also* border / boundary); ethno-nation, 20; fragmentation of, 80–83, 85–88, 103, 131, 144; and gender, 20–21; 75–76, 89–90; 'nation as narration', 18–20; multiple narratives of, 37, 42–43, 69, 159; unity of, 39; 'woman-as-nation', 21, 31–32, 44–46, 63, 67, 108, 149 (*see also* border / boundary: 'borderguard', woman as).
nationalism, 75–76, 184n22, 184n24; and feminism, 47–52, 58–60, 62–71
neo-patriarchy, 77, 184n13
nomad: Braidotti, 144; Deleuze and Guattari, 133.
Nye, Naomi Shihab, 1, 17, 145–154, 194n51

O

occupation, Israeli, 5, 37, 51, 60, 81, 87–88, 90–91, 103, 113, 127, 152. *See also* Israel; Palestine, colonisation of.
Olive Harvest, The, 32–33
oppositional stance: to colonialism and imperialism, 150–153; to the occupation, *see* resistance; to academic debate on Palestine, 1, 159–160 (*see also* Palestine: self-representation, restriction of).
Orientalism, 19; and gender, 26; and desire/fear, 26–27; and Zionism, 28–29. *See also* Said, Edward: *Orientalism*.
Orientalist gaze, 41
Oslo Agreement, 86
'other' / 'otherness', 19, 27–28, 31, 33, 108, 114, 140, 143, 151–152, 156
Oz, Amos, 27–28; *My Michael*, 27–28

P

Palestine Liberation Organisation (PLO), 81, 83, 185n48. *See also* Arafat, Yasser.

Palestine: colonisation of, 4–6, 44, 73, 102–107, 118, 126–127, 132, 166n13 (*see also* occupation, Israeli); feminisation of, 26, 28–29, 30–31; as 'lover', 35; and the postcolonial, 4–7, 85, 128, 160, 131, 132; and postcolonial feminism, 7–11, 44, 49–52, 121 (*see also* postcolonial feminism); self-representation, restriction of, 1, 23–24, 32, 122, 125–126, 157; study within the 'Western' academy, 1, 159–160; as 'virgin territory', 23–25

pan-Arabism, 77, 184n22

Parry, Benita, 5

pathetic fallacy, 118

patriarchy, 21, 31, 39, 55, 76–77, 82, 85–88, 97, 119–120, 122, 172n19. *See also* masculinity; neo-patriarchy.

peace / pacifism, 146, 150–151, 156

peasant, figure of, 32

Peres, Shimon, 115

performativity, 72–78, 83–84. *See also* Butler, Judith.

poetry, significance in Arab culture 52, 179n39; elegiac poetry, 58; female tradition of, 58–59

political/personal dichotomy, 54, 57–60, 64, 69, 117

'politics of location', 16, 155, 162

polyphony, 159–160

postcolonial feminism, 2, 7–11, 60, 90, 97–98, 145, 153–163; and border-theory, 101, 106, 117, 122, 127; translation into Arab cultures, 9, 48–50. *See also* feminism.

postmodernity, 102, 122, 133

power/knowledge, 19, 21, 101. *See also* Foucault, Michel.

'present absentee', 23

psychoanalysis, 27, 140, 143. *See also* Freud; Lacan.

Q

queer theory, 117, 122, 125–127, 129, 191n70. *See also* Anzaldúa, Gloria; Butler, Judith.

R

Radwan, 'Abdallah, 31, 133

rape, 34–35

refugee: 132; camp, 79, 81, 83, 137

resistance, 46–71, 82; 'resistance literature', 61, 63; resistance fighter, 61–69; 'resistance narrative', 62, 65, 70; 'resistance poet', 122–123.

Resolution 181, 102

'Right of Return', 79–80, 125, 132, 191n73. *See also* diaspora, exile, refugee.

S

Sabra and Shatila massacres, 79, 137–138, 147

Said, Edward, 1, 10, 16, 43, 116; *Culture and Imperialism*, 19; on exile, 112–113, 132–134, 151; *Orientalism*, 19, 26, 28, 41; *The Question of Palestine*, 24–25; 'speaking truth to power', 153; 'worldliness', 19–20, 161. *See also* Orientalism.

Sartre, Jean-Paul, 5

Sayigh, Mai, 70

'scattered hegemonies', 135

seclusion of women, 55–57

September 11th 2001, post-, 131, 135, 147, 154

sexuality, 26, 56, 59

Shehadeh, Raja, 35–36; *Palestinian Walks: Notes on a Vanishing Landscape*, 23

Shibli, Adania, 71

Shohat, Ella, 5, 7–8, 26, 161

solidarity, 15, 82, 131, 146–147, 153–156, 161–162

space, 101–130; 'architecture of occupation', 102; desert, 119; 'East' / 'West' dichotomy, 150, 165n2 (*see also* Orientalism); 'internal closure', 103; as palimpsest, 149; public / private dichotomy, 39, 53–60, 70; 'social map', 108, 114, 128; 'tactical traversal of', 124; virtual / cyberspace, 141, 194n38. *See also* border / boundary; diaspora; travel / mobility.

Spivak, Gayatri Chakravorty, 47; strategic essentialism, 129, 191n84; subalternity, 69

statelessness, 102, 116

subterranean, 95–96

suicide bombing. *See* martyrdom.
Suleiman, Elia, 46, 85–90, 99–100, 102–103, 126; *Divine Intervention*, 85–90, 108–109
sumud, 37, 67, 77, 90, 107, 157

T

Taha, Raeda, 109–111
translation, 12–13, 121, 159. *See also* comparative analysis.
trauma, 92, 101, 107, 110, 113, 116, 137–138, 142, 144–145, 147, 149–150, 157. *See also Nakba*.
travel / mobility, 3, 123–125, 137, 150–152, 154; 'travelling theory', 10. *See also* checkpoint.
Tuqan, Fadwa, 52–61, 149; *Mountainous Journey, A*, 53–60
Tuqan, Ibrahim, 58, 149, 180n70
Turki, Fawaz, 116, 133

U

Ummah, 55
United States of America, 145; Civil Rights Movement, 147, 149; imperialism, contemporary, 148, 150–151, 156; musical culture of, 146–147, 149. *See also* community: Palestinian American; September 11th 2001, post-.

V

Valassopoulos, 8–9, 11
video art, 138–140, 143–145

visual media, 94

W

Wall ('Apartheid' or 'West Bank'; 'Separation Fence'), 103–105
wedding, 65; symbolic significance of, 35, 38
Weizman, Eyal, 103, 106–107, 110
West Bank, status as 'occupied territory', 102
witnessing, 87, 89, 94, 113, 127–128
Women's Charter, Palestinian, 51
Women's Movement, Palestinian, 49–51
writing: body / text relationship, 136, 141, 143–144; letter-writing / the epistolary, 138, 141, 143–144; 'writing back', 3, 127

Y

Young, Robert J.C., 153
Yuval-Davis, Nira, 21, 107–108

Z

Zayyad, Tawfiq, 31, 102, 122–123, 191n71
Zionism, 4–5; and colonialism, 4–6, 25; 'a land without a people', 24; gendering and sexualization of Palestine, 24–25; Herzl, Theodor, 25; 'Iron Wall, the', 103–4; Meir, Golda, 39; 'motherland', Palestine as, 28–9; and Orientalism, 28–29. *See also* Israel.
Zurayak, Constantine, 49

An environmentally friendly book printed and bound in England by www.printondemand-worldwide.com

This book is made entirely of sustainable materials; FSC paper for the cover and PEFC paper for the text pages.